New Dimensions in Photo Processes

Fifth Edition

New Dimensions in Photo Processes invites artists in all visual media to discover contemporary approaches to historical techniques. Painters, printmakers, and photographers alike will find value in this practical book, as these processes require little to no knowledge of photography, digital means, or chemistry.

Easy to use in a studio or lab, this edition highlights innovative work by internationally respected artists, such as Robert Rauschenberg, Chuck Close, Mike and Doug Starn, and Emmet Gowin.

In addition to including new sun-printing techniques, such as salted paper and lumen printing, this book has been updated throughout, from pinhole camera and digital methods of making color separations and contact negatives to making water color pigments photo-sensitive and more.

With step-by-step instructions and clear safety precautions, *New Dimensions in Photo Processes* will teach you how to:

- Reproduce original photographic art, collages, and drawings on paper, fabric, metal, and other unusual surfaces.
- Safely mix chemicals and apply antique light-sensitive emulsions by hand.
- Create imagery in and out of the tradiional darkroom and digital studio.
- Relocate photo imagery and make prints from real objects, photocopies, and pictures from magazines and newspapers, as well as from your digital files and black and white negatives.
- Alter black and white photographs, smart phone images, and digital prints.

Laura Blacklow teaches at the School of the (Boston) Museum of Fine Arts at Tufts University. A professional artist for over 40 years, she has received numerous grants and awards; her manipulated photographs are in the collection of the Addison Gallery of American Art, Harvard University's Fogg Museum, Chicago's Museum of Contemporary Art, and Polaroid's International Collection. Her work has also appeared in Christina Z. Anderson's *Gum Printing and Other Amazing Contact Printing Processes* (2017), Robert Hirsch's *Exploring Color Photography* (2015), and Robert Hirsch's *Light and Lens: Photography in the Digital Age* (2012).

New Dimensions in Photo Processes

A Step-by-Step Manual for Alternative Techniques

Fifth Edition

Laura Blacklow

Routledge
Taylor & Francis Group

LONDON AND NEW YORK

Fifth edition published 2018
by Routledge
2 Park Square, Milton Park, Abingdon, Oxon OX14 4RN

and by Routledge
52 Vanderbilt Avenue, New York, NY 10017

Routledge is an imprint of the Taylor & Francis Group, an informa business

Fourth edition published by Focal Press 2007

Library of Congress Cataloging in Publication Data
A catalog record for this book has been requested

ISBN 13: 978-1-138-63282-0 (hbk)
ISBN 13: 978-1-138-63283-7 (pbk)

Typeset in Slimbach and Helvetica
by Keystroke, Neville Lodge, Tettenhall, Wolverhampton

Contents

Acknowledgments

The writing of this book was undertaken almost by accident over 30 years ago, when we were a small community who were hand-making photographic prints. While I was freelancing as an illustrator, I showed my portfolio of altered photo images to Lista Duren, an editor at Curtin and London Publishing Company. Ms. Duren brought the portfolio to Dennis Curtin, who, on the spot, asked me to write a book about the techniques represented. Curtin and London subsequently ceased publishing photography books, and so Focal Press picked up the manuscript.

I wish to acknowledge the work of the staffs at Curtin and London and Focal Press, as well as the essential contribution of Virginia Holmes, who helped research and write the first draft decades ago. The current team at Taylor and Francis have been patient and responsive to me. Every day, I was reminded of how fortunate I am to teach at the School of the Museum of Fine Arts at Tufts University; Photo Department Technician Chris Maliga practically gave me a private room with scanner, computer, and WiFi; colleagues in the Department never complained about the gelatin (for printing, explained on page 35) in our shared refrigerator or the space that my belongings occupied in our office; and the stock room always had a good camera and tripod for the step-by-step photos, which were taken in the "non silver and mural printing" room. As a matter of fact, had it not been for the luck of meeting Joseph Moccia when he first came to the SMFA as a grad student, his enthusiasm and knowledge during repeated semesters as teaching assistant (Digital Photo 1 and Camera-less Photography), and his interest in historical processes, I am not sure I would have written this fifth edition. It was Joe's idea to do it, and his loyal and patient efforts in taking most of the step-by-step photos, as well as creating the lumen section, helping update the bibliography and supply sources, and collaborating on the greatly enlarged Making Negatives: Digital Method (Chapter 6) kept me going.

New chapters and techniques have been added to this edition by artists whom I respect and who volunteered to write from years of experience, such as France Scully Osterman's instructions on Salt Prints (Chapter 9); the expanded techniques in Transfers, Lifts, and DIY Printmaking (Chapter 1) offered by Peter Madden on gelatin printing and Polymer medium transfers, and from former Museum School graduate student Christine Tinsley on Photo-Lithography. The previous editions, which have been the bases for this fifth edition, were enriched by Gene Laughter, who wrote the thorough Bromoil Prints (Chapter 13) and was a delightful collaborator, even under pressure. I was fortunate that Gene could secure the photographic expertise of Wayne Firth, who took the step-by-step illustrations for that chapter and was the proofreader for this edition, now that Gene is, very sadly, no longer with us. I appreciate being educated to chromoskedasic painting (in Chapter 16, Visual Hybrids) by Birgit Blyth, who, fortunately, did not make up that word and updated the information for this fifth edition. Ever loyal friend and inspired artist, Elaine O'Neil, joined forces in organizing

and refining the original manuscript and updating Toning (Chapter 3) with her knowledge and images. In addition, her wonderful brown print quilt is reproduced in this book. Other chapters and sections were voluntarily written by artists of enormous talent: Juliana Swatko (Visual Hybrids: Layered Imagery, Chapter 16), who also offered the idea for her section; Jesseca Ferguson and Walter "Rusty" Crump who tapped their know-how to present detailed instructions for Making Pinhole Negatives, in Chapter 5; and Dorothy Imagire (Muscle Rub Transfers and Lazertran™ Inkjet Lifts in Chapter 1), who always is brimming with terrific ideas. The helpful folks at Impossible Project supplied the step-by-step photos for Emulsion Lifts in Chapter 1. For the fourth edition, which has affected this new edition, I want to thank graduates of the School of the Boston Museum of Fine Arts, Tyler Treadwell, who helped me untangle the web of the Daguerreotype (Becquerel, Chapter 15) process, with tips from Jerry Spagnoli, Bob Shlaer, and Alyssa Salomon, and Kathy Halamka, whose M.F.A. thesis was done with heat transfers onto wood (page 15). Others provided useful information: Robert Cone, manager of the Rockland Colloid Corporation; Bart DeVito retired from Luminos; Melody Bostick (Bostick and Sullivan), who helped me out then and with my recent Sun Printing Workshop at the University of the Arts (ISA) in Cuba; digital artist extraordinaire Carl Sesto; fabric artist Susan Podshadley; Robert Fairchild, electrician; Martyn Greenhalgh for providing me with information on U.K. suppliers; and Neil Gordon, president of E. J. Ardon's (until recently one of six graphic arts stores more than 50 years old in the United States). Originally, S.B.I. Sales in Boston, Massachusetts, loaned me photo materials; the E. Philip Levine Company of Boston lent new photo equipment; and Pictorico kindly gave me film for the book and my students in Guatemala. Even earlier versions were assisted by Helen Snively and Michele Brodie, most careful and accommodating typists/researchers; and to Sal Salerno, who tested my instructions. Barbara Hewitt and John Basye founders of Blueprints/Printables reviewed Chapter 7, Cyanotypes, and generously added information. Vicki Lewis thoroughly proofread the manuscript for the first edition. I would like to thank, in print, a friend, Judy Seigel, who edited and published for quite a few glorious issues *Post-Factory Photography*. In addition, David Du Busc, whose black and white step-by-step photos have been an important part of the first four editions, still let me use some of his pictures in Enlargement Emulsions and Tintypes, Chapter 14.

I owe my heartfelt gratitude to the artists whose artwork enlivens these pages. I was insistent on only showing you, the reader, what I consider to be the most innovative and relevant contemporary art (except when I was showing prints by an early user of a technique). I would like to acknowledge the many students in my classes, whose ideas and enthusiasm added immeasurably to the book.

I dedicate this book to my husband, Peter Fougere, an exceptional carpenter, photographer, and musician, whose support and feedback have proved invaluable, and who basically lived like a single man (after more than three decades of marriage) while I spent 12-hour days at School creating this manuscript.

Introduction

New Dimensions in Photo Processes (*Photo Imaging,* in the first edition) presents techniques that combine painterly concerns with printmaking ideas, photographic principles, and graphic design elements. Painters, for instance, think about the articulation of an image by the physical application of materials and by the selection of a surface onto which the materials will adhere. Printmakers are familiar with different types of paper and the variations that can be achieved in a print while creating an edition. Traditional photographers, used to the light sensitivity of certain substances, may think about the way a photographic technique can change the visual reading of a picture. Graphic designers and illustrators use special tools, procedures, and often text, developed for their profession or borrowed from others. I hope this book will speak to professional artists, teachers, students, and hobbyists who are comfortable employing technical methods and ideas from different image-making areas and will assist in the creation of more cogent visual statements.

Arising from a printmaking syntax,[1] photo imaging has always been affiliated with other art forms. William Henry Fox Talbot, in 1839, invented a process related to Van Dyke brown prints (see Chapter 8) partly out of frustration with his unsuccessful attempts at drawing. You see, in nineteenth-century British society, part of a gentleman's education was learning how to draw. His first book, illustrated with *photogenic drawings,* as he called his photographic prints, was titled *The PENCIL of Nature* (emphasis mine). The 1844 edition included Talbot's drawings, his early experiments with laying objects atop sensitized paper to produce photograms, and his pictures taken with a hand-built camera fitted with a microscope lens, which his wife is said to have called "mouse traps" (see illustration, page 170). Talbot also wrote about the difference between visual reporting and visual expression—distinctions we still debate today.

Many methods described in this book were presented in the 1830s and 1840s. That period in Europe and England saw a proliferation of home inventors, spawned by the mass printing of illustrated books and magazines dealing with experiments in science and technology. Sir John Herschel, for example, developed the cyanotype technique (see Chapter 7) as a method for reproducing his mathematical charts. Soon after, architects and engineers adapted the process for blueprinting their drawings, and by the beginning of the twentieth century, photographers were using the procedure for printing black-and-white negatives. Herschel is also credited with coining the terms *photography, snapshot, negative,* and *positive.*[2]

The business world adapted other photoprintmaking processes. The principle for gum bichromate printing was—and is—the basis for photo silkscreen, photolithography, and commercial offset printing. The gum arabic used for gum printing in 1839 was replaced later by bichromated gelatin. A coating of the light-sensitive gelatin on metal was exposed under a negative in print shops by 1850. Exposure and development hardened the gelatin (the positive), which was used to attract lithographic ink in commercial printing. A hardened gum-and-color-pigment positive is the finished product in a gum print.

Industrialization brought the mass production of factory-made photographic papers, films, and cameras. In 1898, George Eastman marketed the Kodak camera loaded with film, which could be used and then sent back to the Kodak factory by the photographer. The film was developed, prints were made, and the camera was reloaded with film. Eastman's method freed photographers from chemical manipulation and technical knowledge. Cyanotypes, Van Dyke brown, casein (see Chapter 11), and other hand-coated emulsions, therefore, lost favor with the public. These processes were not seen much until the 1960s and 1970s. Theories have been postulated about the reappearance of homemade photo techniques at a time when a significant segment of Western culture was revolting against the alienating aspects of technology. Now, I believe, all silver-based media will be regarded as "quaint," "historical," and "alternative" in the age of digital and electronic imaging.

I was additionally influenced by research into women's history, where handwork, especially on cloth, flourished. Most of this book's techniques can be printed on fabric as well as paper, and instructions for imaging on both surfaces is explained herein. Artists such as Betty Hahn and Bea Nettles exploited the possibilities of stitching photo imagery, and their manipulated images influenced other artists. Bea was my teacher in grad school at the Visual Studies Workshop, and I used her *Photo Media Cookbook* like. . . a studio cookbook!

These antique processes can make new statements, as you will see by viewing the color figures throughout the book. The picture maker does not need to have sophistication in chemistry, physics, or even photography. I have tried to write step-by-step directions that can be followed easily and without access to expensive equipment. It is hoped that the reader will enjoy learning these methods and that they will become second nature, so that

the technical aspects are of little concern compared to the visual possibilities and the challenge from working creatively.

The title of this book has been changed from *New Dimension in Photo Imaging*, the name of the first edition (1988) and second edition (1995), to *New Dimensions in Photo Processes* because now "photo imaging" has come to mean digital imaging. Also the chapter on Making Negatives in an analogue darkroom has been removed from the book due to the relative ease of digital means and rarer acquisition of graphic arts film. However, those instructions can be obtained by contacting me via my website, www.laurablacklow.com.

The book is divided into three parts. Part I presents methods that can be carried out in daylight and are therefore called *light-insensitive*. Innovative and influential artists, such as Robert Rauschenberg, whose artwork begins the Transfers, Lifts, and DIY Printmaking chapter, have utilized these techniques. Part II should be read before trying any of the light-sensitive methods. For instance, Chapter 4, Creating the Photo-Printmaking Studio, contains information on sizing paper, registering negatives, and building equipment such as an ultraviolet exposure unit. Chapter 5, Generating Imagery: Analogue Methods, greatly expanded in this edition, is about directly producing pictures and making transparencies in non-digital ways. Chapter 6, Making Negatives: Digital Method, goes into much more detail in this edition for crafting the image transparencies needed for contact printing. Part III consists of directions for ten light-sensitive processes. Some people refer to these methods as nonsilver photography, but the label is not entirely accurate. Silver nitrate is used in brown printing and salt printing, for instance. The terms alternative and nontraditional photography are also used, because the hand-coated emulsions are seen more rarely than digital photographs. Given the previously

described history and contemporary practice of photo imaging, there is some irony in these terms. Several processes, such as traditional Daguerreotype (I have offered directions for the less toxic Becquerrel Process), carbon printing, and photogravure, are not included because of their high cost or safety concerns. Books on these processes, however, are listed in the Annotated Bibliography.

The step-by-step procedures are separated from the rest of the text in order to allow you faster access to methods for each technique—*but always read the whole chapter before starting*. The Tips, for instance, will make your work sessions more enjoyable and productive. It is imperative that you pay attention to the Safety sections within each chapter so that you take care of your health as well as the physical condition of the environment. Supply Sources for needed equipment are listed in the back of the book. Please observe these symbols as you use this book:

Can work in **day light**. You can turn on room lights, and sunlight can illuminate the room.

Work in **subdued light**. You can use weak tungsten light at least four feet (1.25m) from the emulsion, a yellow bug light, or draw the blinds in your work space during the day. Some practitioners coat under a few strands of small, steadily illuminated Christmas tree lights. See the test below, under safelighted conditions, for making sure your situation is not too bright.

Work in **safe light conditions**. A safe light, available from a photography store, equipped with a Kodak safe light filter, number 1A (light red), a wratten OC (light amber) or equivalent, and a 15-watt bulb should be placed no closer than 4 ft (1.25 m) to the emulsion. To make sure the safe light is not so bright as to cause fogging, thereby exposing the emulsion accidentally, run a fog test. On your work surface, put a piece of

paper coated with the desired light-sensitive mixture and dried. Place two coins, side by side, on top and leave them there for 3–5 minutes, or a time equivalent to how long it takes you to prepare a substrate. Then remove one coin and carefully position the sheet with the other coin closer to the light source for another 3–5 minutes. (With enlargement emulsion (Chapter 14) and graphic arts film, put the prepared substrate under the enlarger and expose it for 1 second at f/16 or quickly turn an overhead light on and off.) Eliminate the second coin and develop the sheet. See if the spots where the coins were remain unaffected. If you see a silhouette where the coins were, move your coating area further from the light source or replace the bulb with one of weaker illumination.

Wear a **dust mask**. Use the kind with two straps to protect from dust and chemical particles (but not able to guard against solvents and other vapors).

Wear **protective gloves**. For these processes and for cleaning up, heavy, chemically resistant gloves such as neoprene are recommended. You can find them in a hardware store. Playtex now makes HandSaver gloves with latex and Neoprene, which can be purchased at a grocery store. After a work session, wash the gloves and inspect them; if they appear damaged, replace them. Wash the inside and outside of the gloves with a slightly acidic hand cleaner such as pHisoderm™, then hang them inside out to dry. If the gloves are not cleaned properly, they can actually increase your exposure to dangerous chemicals—dirty gloves promote the absorption of contaminants through the skin. Wash your hands before leaving your workspace, even if you wore gloves.

Wear a **respirator**. Please talk to your doctor before using a respirator. If you can use one, make sure a knowledge-

able person fits you. You will need a rubber half-mask air-purifying respirator with a filter for organic vapors and dusts and mists. You can choose between reusable or disposable respirators, but make sure that in the United States you purchase one approved by OSHA. You can purchase masks at automotive paint and body shops or good hardware and art stores. If you need help in selecting the right kind of respirator, consult insurance companies, the National Institute of Occupational Safety Hazards and Occupational Safety Hazard Administration personnel in the United States and the Workplace Hazardous Materials Information Systems in Canada, respirator manufacturers and distributors, or the Arts, Crafts, and Theater Safety (see Annotated Bibliography, page 327). Keep in mind that respirators cannot be used if anything interferes with the seal of the face piece against an individual's face, such as sideburns, beards, and eyeglasses. Store respirators in clean bags or other suitable containers in a clean and sanitary location. Inspect and maintain the respirator in accordance with the manufacturer's instructions. Pregnant women should not attempt any processes requiring a respirator because the mother's oxygen intake may be reduced, limiting the oxygen available to the fetus. If you have other health issues, such as heart problems, make sure you consult your doctor before using a respirator. One test for checking the fit of your respirator is to put it on, open a bottle of ammonia, then make sure you cannot smell the odor.

Wear **protective goggles** to avoid splashes, and always wear goggles if you use contact lenses.

Don't just take my word for it; when ordering chemicals, ask for the Material Safety Data Sheet, which gives specific information on handling and storing each chemical in order to reduce your exposure, as well as first aid and protective equipment to wear.

Good health habits in the studio and darkroom are lifesavers. Never eat, drink, or smoke while handling chemicals. Keep your hands away from your face. Wear a special lab coat or waterproof apron while working, not your unprotected clothes. Avoid splashing chemicals; if you think a procedure will cause splashing, wear goggles to protect your eyes. (When in doubt, put on goggles—and mask—especially if you wear contact lenses.) Clean up spills immediately, preferably with paper towels. Throw paper towels and other refuse into a covered trash can or into a plastic bag. Seal the container and move it to an outdoor receptacle after your work session. Avoid mixing liquid and solid wastes.

Try to limit your chemical mixing and coating to one table with a nonporous top, such as glass. I cover my table with the Sunday newspaper unfolded. Each time chemicals contaminate the top sheet of paper, I throw it into a plastic trash bag, which I secure with a tie. I learned from the former Palladio Co. that you can "evaporate used liquid chemicals and dispose of the sludge as toxic waste," but don't evaporate in your small darkroom. The volume once evaporated will be limited. I also learned from *The New Photography* (see Reeve and Sward in the Annotated Bibliography) that hazardous liquid chemicals, such as unused cyanotype mixtures, should be absorbed by kitty litter, put into a plastic bag, and placed in the trash outside the building, then brought to a toxic waste disposal site. Most towns near where I live have one or two days set aside for collection of such labeled materials. Fixer, used to enlarge graphic arts film, paint chromoskedasicly (page 305), and stabilize brown prints, is toxic to marine life. Contact a university or commercial darkroom and ask if you can pour your used fixer through their silver recovery unit. Otherwise, flush chemicals down the drain with large amounts of water after reversing the order, such as exhausted

hypo clear poured into used brown print fixer poured into dirty wash water in order to neutralize them first. Judy Seigel recommends cutting the narrow part of the spout off a large funnel (auto supply store) and inserting the spout into your drain to contain the flow during disposal of chemicals.

Keep all chemicals out of the reach of children and pets, and preferably in a locked cabinet away from heat and electric or other sparks. Most fire departments want to know the type and location of chemicals stored in your workspace.

Ventilation is necessary in the darkroom and the studio; an open window is not proper ventilation! The Center for Occupational Hazards urges that a small work area change air at least 20 times per hour. To determine the size fan required to change the air, compute the size of the room (in cubic feet) by multiplying the length by width by height, then divide that figure by six. Match that number to the fan's cfm rating.

Locate the exhaust fan so the vapors are pulled away from your face. Hence, the suggestion that you limit your chemical mixing and coating to one table becomes even more important. Because most vapors that result from photographic processes are heavier than air, it makes sense to install a vent near the floor or right where the vapors are released. Fresh air must enter the room in order for the ventilator to work properly. Cracks under the door or light-blocking vents are the solution.

If your workspace is also a living space, such as a bathroom, you need to be meticulous about your habits. Never use eating, storage, cleaning, or cooking utensils for making art, or vice versa. Separate chemically contaminated trash from household trash. If you must use your kitchen, limit your work to one area where you do not prepare or eat food.

NOTES

1 Jussim, Estelle. *Visual Communication and the Graphic Arts: Photographic Technologies in the 19th Century.* New York: R. R. Bowker (a Xerox Education Co.), 1974.

2 Gassan, Arnold. *A Chronology of Photography.* Athens, OH: Handbook Company, 1972, p. 23.

A professional artist and art educator, Laura Blacklow currently creates one-of-a kind and small edition artists' books and prints and is on the faculty of both the Photography and the Printmaking/Graphic Arts/Papermaking Departments at the School of the (Boston) Museum of Fine Arts at Tufts University. She is the recipient of The National Endowment for the Arts Regional fellowship for Works on Paper, the St. Botolph Club's Morton C. Bradley Award in Color, Polaroid Corporation's Artist Support Program, the Massachusetts Artists' Foundation Fellowship for her hand-colored, black-and-white photographs, and Harvard University's David Rockefeller Center for Latin American Studies Research Grant. From 1987–1992, she served on the Board of Directors of the Photographic Resource Center and is an active participant in the arts community as well as a long-term volunteer in Guatemala at Fotokids (www.fotokids original.org). Her manipulated photographic prints have been shown internationally, and her work has appeared in *Exploring Color Photography: From Film to Pixel*, *Photography Beyond Technique*, and *500 Handmade Books*. Laura received a Master's of Fine Arts in photography from the Visual Studies Workshop in Rochester, NY and a Bachelor's of Fine Arts in painting from Boston University.

Part I

Light-Insensitive Methods

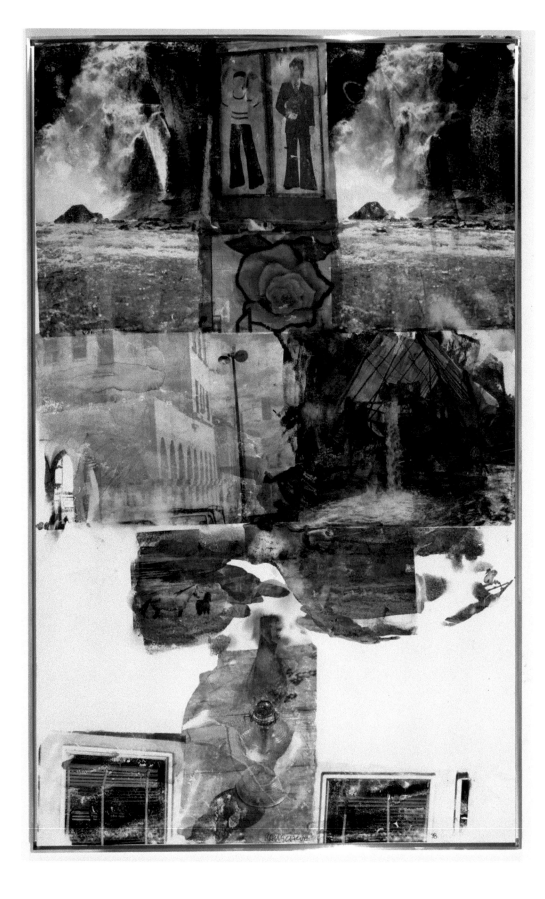

Transfers, Lifts, and DIY Printmaking

1.1 (opposite) Robert Rauschenberg, *Mother-in-Law* [Anagram (A Pun)], 97 ½ × 61 in. (247.7 × 154.9 cm), Inkjet pigment transfer on polylaminate, 1998. Private collection. ©Robert Rauschenberg Foundation.

The pursuit of new techniques has been a continuous theme of Rauschenberg's work. During a trip to Cuba in spring 1952, the artist first experimented with transfer drawings, taking printed images, primarily from newspapers and magazines, placing them face down on sheets of paper, and then rubbing the backs of the images (exploiting the gradations of tone achieved by changes in pressure from an empty ballpoint pen) or other burnishing device to transfer the original to the paper.[1] He also made life-size body cyanotypes (Chapter 7) on commercial, pre-coated blueprint paper in the early 1950s. By 1958, Rauschenberg employed a technical development in which he applied a chemical solvent, such as turpentine and, later, lighter fluid, to glossy magazine images, facilitating a clearer and more complete transfer. (Solvent transfers are the next item in this chapter, as well as the less toxic but closely related "muscle rub transfer" on page 12.) Subsequently, Rauschenberg sprayed a fine solvent mist on smooth and crumpled printed images, which he sent through a lithography press with natural fabrics underneath for his extraordinary *Hoarfrost* series. In 1991, he began using inkjet transfers (another method explained in this chapter on page 9) and eventually turned to biodegradable and soy-based dyes and water as the solvent, due to his concern for the environment.[2]

SOLVENT TRANSFERS

Please see "Muscle Rub Transfers," below, on page 12, for another way to transfer ink off magazine pages, photo copies, and newspaper pages. Although these processes are not risk-free, muscle rub is less harmful than solvents to your health.

A fast and simple technique, transferring allows you to remove the image only from a magazine, newspaper, photocopy, or digital print, and relocate it on various surfaces such as paper, fabric, frosted acetate, wood, or lithographic stones or plates. A combination of solvent and pressure dislodges the ink from the page and allow the image, without the original paper, to adhere to the receiving surface. Reproductions of photographs or drawings in black-and-white or color can be transferred. You can write or draw onto a transferred image or onto the receiving surface before or after transferring; you can sew into them, mix media processes with transfers, or locate one image on top of another. Because most inks are oil-based and not soluble in water, transfers on cloth remain permanent when washed in mild soaps.

SAFETY

Be sure to work in a well-ventilated area, a place that has not just an open window, but 20 air changes per hour. The solvents used in this process, even in marker pens, are highly flammable and noxious to breathe, irritating the eyes and respiratory passages, and they have a narcotic effect on the nervous system.

They also dry the skin and can cause serious damage to the kidneys and liver. If you use citrus solvent, do not be fooled by the label "natural"; rather, avoid contact with eyes and prolonged or repeated contact with skin.

Read all warning labels and wear neoprene gloves when handling solvents. Wear an organic solvent vapor mask when working in close proximity with solvents.

Immediately replace the cap or covering on solvent containers after use, and discard paper or other materials in a manner that prevents further release of the solvents into the air you are breathing.

Do not store solvents in inappropriate containers after use (e.g., solvent eats through Styrofoam™); use metal or glass containers.

Isolate solvents from heat, sparks, electrical equipment, oxidants, and open flames.

Fumes tend to cling to the transfer after it is made, so air it out in a well-ventilated area away from your living space until the solvents have evaporated.

METHOD OVERVIEW

1. Printed page or office photo copy to be transferred is removed from its source and prepared.
2. Solvent is applied, usually to the back of the page, which seeps through to dislodge the image on the front.
3. Transfer of the image from the page is made by rubbing the back of the image, forcing the ink off the front of the page and onto the receiver.

MATERIALS

1. Image. A photocopy made with carbon-based "ink," magazine page, or newspaper page will work well. Most magazines are printed on coated stock (clay-impregnated slick paper), which is very effective for transfers because the ink rests on the clay (kaolin), not on the paper. Make sure that the image to be transferred is not gravure-printed or varnished (as are magazine covers, generally). The newer the publication, the fresher the ink and the easier the transfer will be. The thinner the paper, such as newspaper, the less solvent and pressure needed for a transfer. Because you cannot transfer the same image material clearly more than once, copies of the same newspaper or magazine issue or photocopies of your own pictures offer an inexpensive source for multiple transfers. Expensive magazines tend to use finer reproduction methods, resulting in more detailed transfers. Even printed wallpapers can be

used. I have started with a black-and-white photograph, which I put on a color copier and reproduced in any or all of the colors available on the copier, but you can also make copies and scans from flat art. The copier's and digital printer's color balance and zoom functions add to your aesthetic choices, and you will find that some copiers accommodate sheet sizes up to 11 × 14 in. (28 × 35.5 cm) or larger. Another way to create large images is to grid several small transfers into one larger image.

2. Metal spoon or etching or lithography press.
3. Solvent. Only silkscreen supply stores carry transparent base, and the only brand I know of still available is Naz-Dar Transparent Base number 5530 (http://www.nazdar.com/portals/0/tds/NAZDAR_5500_SV_Screen_Series.pdf). Use it on the *back* of the image. Pantone and Admarker, to name two companies, make blender pens for their permanent ink felt-tip markers. (A more detailed description of how to use these pens appears in the Tips section.) Oil of wintergreen or of lavender, eucalyptus oil, fabric spot remover (such as Carbona™), lighter fluid, lacquer thinner, acetone, Citra-Solv, and offset blanket wash can be applied, but these are more difficult to work with because they evaporate more quickly. I know that some artists prefer to put these solvents on the front of the picture, but I prefer the more time-consuming method of applying to the back because the stain of the solvent never gets on the receiver.
4. White scrap paper. The paper should be larger than the size of the transfer image. Inexpensive bond paper is excellent.
5. Black permanent marker. In my method, I draw the shape of the image onto a frame, which I cut out, as explained in the step-by-steps. I use a light table (see material #11, below).
6. Scissors or stencil knife.
7. Tissues or paper towels. This process can become messy from the ink removed from the non-image side of a magazine page and from stains developed as the solvent spreads.

8. Masking tape or drafting tape. Drafting tape is less sticky than masking tape and will not rip artwork when removed. To make masking tape less sticky, press the tape first onto your clothing a few times before using it.
9. Hard, smooth work surface. Imperfections in your table or desk will show in the transfer and can tear paper receivers when you apply pressure.
10. Plastic bags. For solvent trash, to prevent continued release of solvent vapors into the air you breathe, wrap up and dispose of used materials, preferably outside the rooms where you work and live.
11. Light table or window with daylight. To draw an outline of where to apply the transparent base on the back of the page, you need to hold the image up to a light and to be able to see through from the front to the back. Chapter 4, Creating the Photo-Printmaking Studio, contains directions on making an inexpensive light table.
12. Receiver. Almost any paper will be fine, and I have used transfers extensively in personal journals including smooth graph paper and drawing paper pages and ones that I have hand-bound to include Rives Heavyweight and Arches 88. Papers with bumpy surfaces like traditional cold press and watercolor paper prove difficult. Fabric, such as flat silk and cotton, can be stretched in an embroidery hoop or stapled to chip board or some other smooth surface. On the other hand, bumpy fabric, such as corduroy and many knits, work against your efforts. You can make transfers onto smooth wood. Choose a light color substrate so that the image can be seen.
13. Vapor mask and gloves. All solvents are dangerous, so a respirator and gloves should be worn, no exception, and especially if you are spraying the solvent. See #14, below.
14. Atomizer for spraying the solvents, particularly solvents that need to be applied to the image side of the paper. I would rather apply solvent to the back and wait until liquid solvent seeps through the paper because I have more control that way.

MAKING A SOLVENT TRANSFER

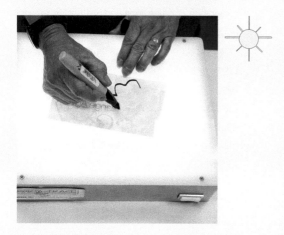

1.2 Preparing the Image

1. Prepare the image

Cut out the magazine picture or other image at least ¼ in. (6.5 mm) larger than the image all around. Working at your light table or against a day-lighted window with the image facing away from you, use a black ink marker on the back side of the image to draw the outline of the area you want transferred. Afterwards, place a piece of plain paper on the back side of the image and retrace the shape marked, using the light table or window to aid in the tracing. Leave lots of room around the shape. This method also allows you to get away from the rectangle, if you want.

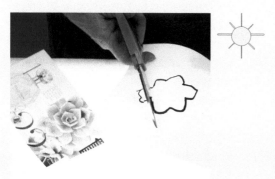

1.3 Making and Attaching the Cutout Frame

2. Make and attach the cutout frame

Cut out the shape marked on the scrap paper to create the cutout frame.

Place the image face up on your work surface. Adhere the masking or drafting tape onto the corners of the image's back side with the sticky side of the tape facing you and the tape extending beyond the edge of the paper. Place the cutout frame over the image so that the frame lines up with the image, pressing the cutout plain paper frame to the tape. This frame, later, will prevent solvent from staining your receiver.

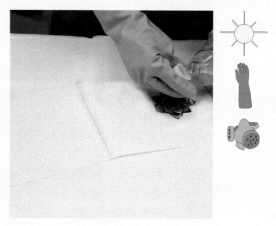

1.4 Applying the Solvent

3. Apply the solvent

Place the receiver surface face up. Position the cutout frame with the attached image face down, and tape this unit to the receiver so you form a hinge as shown in the illustration, Figure 1.4. Apply to the *back* of the image approximately ½ teaspoon (2.5 ml) transparent base or liquid solvent for a 5 × 7 in. (12.5 × 17.75 cm) image. Spread evenly and let the solvent sit away from the substrate for a few minutes while it absorbs into the page to chemically loosen the ink. The page will appear less opaque.

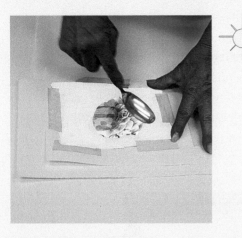

1.5 Transferring the Image

1.6 Checking the Transfer

4. Transfer the image

Using the *edge* of the spoon, vigorously rub the back of the paper within the cutout frame window. To achieve a smooth transfer, rub in small circular strokes. To achieve a more drawing-like appearance, rub back and forth.

5. Check the transfer

Pick up one corner and check the transfer periodically, until the image has transferred as completely as you want to the receiver material. If the picture is paler than you want, but there is more color left in the original, reposition the unit, apply more solvent if you need it, and rub carefully but vigorously on the back. Too much pressure can rip the magazine picture.

TIPS

The transferred image will appear the reverse of the original; this is an especially important consideration when transferring type. You can end up with correct-reading type by photocopying the art onto acetate, flopping the acetate, and making a wrong-reading photocopy on paper. (You can, in addition, transfer off acetate as describe on page 10.) When the wrong-reading image is transferred, it will look like the original art. With a scanned image, you can choose "mirror image" or "flip horizontal" in printer choices.

Since you are lifting the color layers from color printed material in the opposite order in which they were printed, even if the picture is black and white, hues may appear different in the transferred image. In general, select color pictures with bright, detailed highlights and deep, contrasty shadows so the transfer retains separation of tones. Low-contrast images can be frustrating to transfer with clarity, and you can waste energy trying to save such a transfer by drawing back into it because that is what the image always seems to look like: an effort at redeeming it.

The blender pen, which seems to keep odors down, can be used if you transfer small (2 in. or 5 cm square) areas at a time. Rub the marker on the back of the image, then quickly burnish. This method works best with color laser copies and computer laser prints, especially if you first copy the image onto acetate, rather than paper.

Transparencies can be made by transferring onto the dull side of frosted acetate or drafting vellum.

Older magazines and wallpaper may need more time and more solvent to penetrate and loosen the embedded ink.

1.7 Laura Blacklow, Page from Personal Journal, 8 ½ in. × 11 in. (21.6 × 28 cm), solvent transfer, rubber stamps, and ink on notebook paper. ©L.Blacklow.

I have been a journal-keeper since childhood and have developed a code, inspired by Doris Lessings's *The Golden Notebook*. However, rather than keep different colored notebooks for different parts of my life as Lessing did, I developed a color system for the text so that I can integrate my life's concurrent segments: dreams, personal observations, quotes from others, and political analysis, to name a few. I save magazine pictures in an alphabetical file ("A" is for ambulance, automobile, etc.) so I can grab one to illuminate my dream, and, ironically, I do dream in a photographic manner akin to the films of Fellini.

Crayola™ makes fabric crayons for iron-on transfers to synthetic fabrics from your non-glossy drawings on paper. For stationery, they also sell Magic Transfer Kits where you carve a design or, if you are not handy with drawing, rub your image onto their Styrofoam Transfer Printing Plates that are part of the kit. In addition, numerous companies make acceptable transfer sheets that you can put through a digital printer and afterwards dislodge the image using heat from an iron. Since good printmaking papers are rag, you can relocate photos onto the papers recommended in this book.

You can transfer onto a lithographic stone or plate. Use an acetic acid etch and then print normally. If you are using an etching or lithographic press, place the paper or cloth receiver *face up* on the bed of the press and place the image *face down* over the paper or cloth. Apply the solvent to the back of the image area and wipe off excess after it has absorbed into the paper—paper will be more transparent so that you can see through to the print on the other side. Make sure to place blotter paper on the back of the image to protect the felts of the press from the solvents, and run the complete setup with the felts through the press using the correct maximum pressure. Later in this chapter, Christine Tinsley offers Paper Photo Lithography on page 31, and that method does not require a printing press. To make transfers onto cloth, mist the front of the magazine image with spot remover (such as Carbona™) or the back with citrus solvent; you must work quickly because the spot remover evaporates.

Since images transfer in reverse, type will, in the end, print correctly for reading.

After you transfer an image, let it air out in a well-ventilated area away from the space where you are working.

TheMagicTouch, http://themagictouch.com/transfermedia.html, sells 8½ × 11 in. (size A4 in Europe) and 11 × 17 in. (size A3 in Europe) and offers an array of transfer sheets, including one that is used like Lazertran (page 28) with color or black-and-white copiers and laser printers to duplicate your image for transferring onto fabric, wood, metal, glass, or ceramic.

INKJET TRANSFERS

Although I do not know Robert Rauschenberg's exact method, as shown in the first illustration to this chapter, I do know a few techniques to transfer inkjet images onto other surfaces.

METHOD 1

SAFETY

I do not know of any health problems with the materials and method, but it is always smart to read the Materials Safety Data Sheet on each product.

METHOD OVERVIEW

1. Image is prepared on a computer and reversed horizontally.
2. Image is inkjet printed onto a waxy sheet.
3. Print is burnished onto dampened receiver.

MATERIALS

1. Image. You will need to horizontally reverse your color or black and white picture, especially if it has text. I use Photoshop® (Image > Image Rotation > Flip Image Horizontal).
2. Transfer sheet. Remove the labels from a sheet of sticky labels or shipping labels and use the waxy side of that letter-sized backing to print on. Less rigid wax paper (waxed on both sides) or freezer paper (waxed on one side) from a grocery store can be cut to size that your printer accommodates. Be careful when you insert it, and take care not to smear the wet toner after it exits the printer. In addition, there are many commercial inkjet transfer sheets that require you to put the transfer paper

through a printer, then transfer the image with heat from, for instance, an iron. HP and Epson make iron-on inkjet sheets, and William Paul and Associates, http://www.wmpaulstore.com/inkjetpaper/iron_on.htm, sells Vesta Iron On Transfer Paper from 8 ½ × 11 to 13 × 19 in. (33 cm × 48.3 cm). A transfer sheet for covering dark fabrics and paper is made by Tailor: http://www.junetailor.com/inkjet-landing.htm. For obtaining more detail on cloth, spray fabric first with spray starch before transferring. You can wash the fabric afterwards but many of these commercial sheets leave a layer on top of, rather than imbedded in, the cloth or paper.

3. Receiver. Smooth, hot press rag paper softens the picture a little, but if your inks/toners are archival, your print will be, too. A thinner, smooth cotton paper can be found at stationery stores and is made by Cranes: kid finish AS 811. You can also use harder, thicker paper surfaces. Bienfang makes an array of smooth surfaces that are acid free, which is not the same as archival, such as 148 pound Bristol or the lighter-weight 70 pound drawing paper and parchment calligraphy paper. The pound or grams usually indicates the thickness. You can also transfer onto smooth wood and fabric that does not stretch, such as cotton muslin and onto brushed aluminum. (I have used litho plates.)

4. Sponge and water. You dampen the substrate with clean water using a clean sponge.

5. Computer with Photoshop® and inkjet printer, as explained in the first item of this Materials list.

6. Burnisher. Use the edge of a metal spoon or credit card.

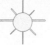

MAKING AN INKJET TRANSFER

1. Print the image onto the waxy side of the transfer sheet.
2. Lightly moisten the receiver.
3. Rub the back of waxy sheet, checking often to make sure that you have applied enough pressure for the toner to fully transfer.

TIPS

Do not worry if the image looks dull after it comes out of the printer; it will transfer with deeper tones.

This method works especially well for receivers that are too large to go through your printer or fabric, which can ruin your printer.

Tape waxed paper to index or copier paper before you run it through the printer. Later, tape the waxed paper print to the receiver surface so it does not shift while transferring.

METHOD 2

I particularly like this method because I found it the easiest way to get most of the toner to transfer due to how the ink lays on the surface of the acetate.

METHOD OVERVIEW

1. Image is prepared on a computer and reversed horizontally.
2. Special acetate or thin digital photo paper is inserted into an inkjet printer, and printed onto.
3. (Optional) Receiver is brushed with gel or polymer medium and the acetate is immediately placed on the coating.
4. The back is burnished to transfer the toner only.

MATERIALS

1. Image. You will need to reverse your color or black and white picture, especially if it has text. I use Photoshop® (Image > Image Rotation > Flip Image Horizontal).
2. Transfer acetate or inkjet print on thin digital paper. I have used Apollo, a company that makes acetate for inkjet, as well as for laser printers. Other photo quality inkjet transparency films are made by 3M or Pelikan. Make sure you use inkjet acetate if that is the kind of printer you are using. The acetate on a plastic folder from an office supplier, cut to letter size, is alleged to work, too. Although a little more challenging, you can print onto inexpensive, thin, glossy, or semi-matte digital paper and transfer the ink only.

3. Receiver can be paper, fabric, or wood. See the types of receivers suggested in Method 1.

4. For acetate print transfer, you will need either a brayer that you gently roll, bookbinder's bone folder, or even the side of your hand, because you do not need as much pressure as Method 1. A small picture could be transferred by wrapping your finger in a folded cosmetic cotton pad (for removing make up) or piece of felt. If you are starting with a digital print on photo paper, use a brayer with as much pressure as you can exert.

5. (Optional for acetate only.) I use Golden's gel matte medium to coat the receiver with a flat brush before I transfer, and I do that fairly quickly while the medium is still a bit sticky. Liquitex makes a similar product, as does PaperArtsy Satin Glaze Fresco Finish Acrylic. Make a thin but even layer on paper or flat fabric, applying it so that it rests on the surface of the receiver.

6. Double sided tape is effective if you are having trouble putting the acetate through the printer. Tape it onto regular copier paper, and then feed it with the taped end going through first. (I have used this method for printing on velum, also.)

MAKING AN INKJET TRANSFER

1. Follow the manufacturer's direction, which usually instruct you to print the image onto the dull side of the acetate, the side with a bit of tooth. If you are using thin digital paper, print normally.

2. Lightly moisten the receiver immediately with a brush and the gel. This procedure is optional for acetate; mandatory for digital paper.

3. So that you can make sure the image is making contact with the substrate, roll the image, rather than placing it down all at once, onto the gel with the image side down. Gently rub the back of the acetate, checking often to make sure that you have applied enough pressure for the toner to fully transfer. If you printed onto paper, use as much even pressure as you can.

TIPS

Do not burnish for more than a minute if you are using the gel, because you don't want the gel to actually dry like glue to the acetate or photo or to smudge the ink.

As you peel the original image, start at one corner, checking to make sure that it has transferred. If not, lay the sheet down and rub some more.

Brush the *receiver* with a liberal coating of gel or polymer medium. Before the medium can dry, quickly place the acetate, ink down, onto the medium. Do not let it move around as you rub the back with a brayer, spoon, or bookbinder's bone folder. Remove the acetate.

Some of my students have merely dampened the surface of hot press (smooth artist's) paper and laid the acetate ink jet print face down on the wet surface, thoroughly burnished the back without moving the acetate, and lifted off the acetate. The ink should be on the receiver, and the acetate should be fairly clear. In the illustrations at the beginning of this chapter, Robert Rauschenberg's inkjet transfer is said to have been done with water, too.

If you want more ideas for digital transfer methods I recommend *Digital Art Studio* (see Bibliography), a book full of thoroughly researched and clearly explained techniques.

MUSCLE RUB TRANSFERS

By Dorothy Imagire

Similar to solvent transfers, but without the dramatic toxicity, the "solvent" is in the thick muscle rub base. The dissolving and evaporating process is slow, allowing you to work on a larger area; however, since the base is thicker and slower than many traditional solvents, it needs to be applied to the front of the image to be transferred.

It seems that the active transfer ingredient is salicylate, so I look for tubes with high salicylate content, and it turns out the least expensive, Walgreen's own muscle rub, has been the most effective. (L.B.)

SAFETY

The most important warning is on the tube of muscle rub: avoid contact with the eyes, open wounds, or irritated skin. Do not ingest. Wear gloves to avoid prolonged contact and wear goggles to avoid contact with your eyes.

Methyl salicylate, an ingredient in some, but not all, muscle rubs, is a toxic extract of wintergreen that has killed children when swallowed in concentrated doses. In addition, rare but severe allergic reactions (rash; hives; itching; difficulty breathing; tightness in the chest; swelling of the mouth, face, lips, or tongue), skin redness, or irritation demands medical attention.

METHOD OVERVIEW

1. Printed page to be transferred is removed from its source and prepared.
2. Muscle rub is applied to the front of the page.
3. Transfer of the image from the page is made by rubbing the back of the image, forcing the ink off the front onto the receiver.

MATERIALS

1. Image. Same as solvent transfers, except that I do not recommend this method for use with pictures on digital photo paper. (L.B.)
 The image needs to be reversed to end up correct reading.
2. Burnisher, such as rubber brayer, metal spoon, bookbinder's bone folder, or etching press.
3. Muscle rub. Available at a pharmacy—for example, Bengay is a brand name and can be used. Many other generic brands are marketed as "ultra-strength" muscle rub and sometimes will also be

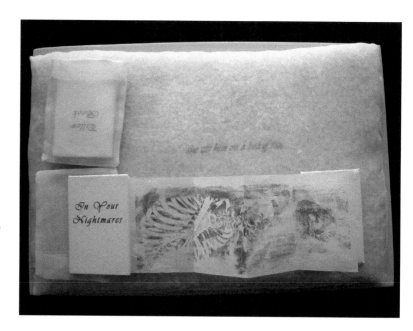

1.8 Dorothy Imagire, *On a Bed of Rice*, 4 × 11 × 7 in. (10.2 × 27.9 × 17.8 cm) wood, silk, rice, copy transfers on rice paper, 1998. © D. Imagire. See more of her work at www.Imagire.org.

labeled "external analgesic and greaseless cream for relief from minor arthritis, backache, muscle and joint pain." The generic brands seem to contain more water and are looser, but that quality is of no disadvantage because you will be trying to spread it anyway. The aroma does seem to linger, so airing out the print is helpful. The book's author noted that she finds the tube form of muscle rub more effective than the jar.

4. Brush. A soft 1½ in. (3.75 cm) goat hair Asian brush, or any other soft brush. Inexpensive brushes can be purchased at a hardware store.
5. White scrap paper for making a frame, as shown in Solvent Transfers, page 6.
6. Scissors or stencil knife.
7. Tissues or paper towels.
8. Tape. White artist's tape or blue painter's tape.
9. Hard, smooth work surface.
10. Receiver. Same as solvent transfer.
11. Goggles and gloves. These items are important in order to avoid contact with eyes, open wounds, and prolonged exposure of ink in the rub's trash to skin.

TIPS

This process is similar to solvent transfer, except that blender pens, film cleaner, or movie cleaner do not work in conjunction with the muscle rub.

I have successfully used a printing press, rolling the image through once. If you have one available, use it. Place your receiving paper on the bed first. Then coat the front of the transfer image with muscle rub and place it face down on the receiving paper. Put on felts and roll the image unit through the press. (You may want to use a barrier sheet so you do not dirty the felts. (L.B.))

You can create muscle rub transfers on fabric as well. The higher the thread count of the cloth, the more detail will be visible in the resultant image. Natural fibers such as cotton, silk, and linen absorb the ink better.

MAKING MUSCLE RUB TRANSFERS

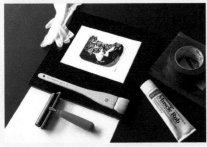

1.9 Preparing the Image. © D. Imagire

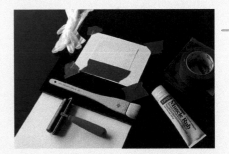
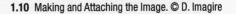

1.10 Making and Attaching the Image. © D. Imagire

1. Prepare the image

You do not have to cut out the image unless there is a background that you do not want to include. If it is a digital image, make sure it is flipped horizontally, or if it is a copy, have the copy reversed. Any image on nonglossy paper seems to work. In addition, you can use inside pages from magazines and newspapers.

2. Make and attach the image

With artist's or blue painter's tape, adhere the corners of the receiving paper so it does not move. Position the transfer image face-down on the receiving paper where you want the image. Tape across the top edge of the transfer image onto the receiving paper with the same tape (don't press too hard or it will be difficult to remove later). The transfer image should be able to freely swing up.

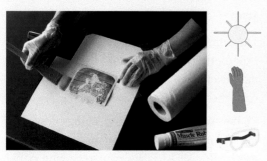

1.11 Applying the Muscle Rub. © D. Imagire

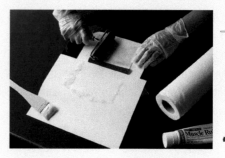

1.12 Transferring the Image. © D. Imagire

3. Apply the muscle rub

Lift the transfer image up and crease the tape so the image lies flat. Now the image side is up, although upside down. Place a piece of clean white scrap paper under the transfer image to protect the receiving paper and work space. With a 1 ½ in. soft brush, apply a medium coat of muscle rub on the face of the transfer image. Brush left to right, then up and down, making sure there are no visible brush strokes. Muscle rub does not work as quickly as solvent, giving you a bit more time to brush carefully. Be very cautious not to rub your eyes with muscle rub–coated hands because it will sting!

4. Transfer the image

Put the transfer image down into position on the receiving paper. Working from the top, smooth down the image with your gloved hands. Using a rubber brayer, roll down, then up, then side to side to smooth out the image and, at the same time, press it firmly onto the receiver. The paper should begin to become transparent. If the muscle rub does not appear to soak into the transfer image paper, brush more muscle rub onto the *back* of the image (the side that is now facing you). Use the rubber roller lightly to help spread the muscle rub and with firm pressure to transfer the image. You can peek under a corner to see how the image is transferring. Once the image has completely relocated, carefully remove the used picture and tape.

HEAT TRANSFERS

Described to the author by Kathy Halamka

1.13 Kathy Halamka, *Reconstruction*, 4 × 2 ft (1.2 × .6 m), charcoal and mixed media on birch with heat transfer from black and white photocopies, 2004.

MATERIALS

1. Heating tool. Associated with woodworking, options include the Lenk Heat Transfer tool (www.wlenk.com/store/113/72/Transfer-Tool.html) or Versatool by Walnut Hollow (www.walnuthollow.com). Make sure you get the model which has a handle similar to a wood burning tool but comes with a flat, round disk for the heatable head. (They are available in craft and art stores and online at Amazon, for instance. (L.B.)) You can also use a photography tacking iron or old-fashioned travel iron without steam holes.
2. Hard, firm, heat-resistant work surface.
3. Spray bottle or bowl of water to control scorching or accidental misapplication of the heat tool on the fingertips.
4. Receiver. You can use smooth paper, wood, or finely woven fabric (such as bridal or slipper satin, finely woven cotton, muslin, or rayon. (L.B.)).
5. Image. (Dry toner, darker than normal, and reversed horizontally. (L.B.)) Toner copies, such as photocopies from an office copier.
6. Low-tack tape.

MAKING A HEAT TRANSFER

1. Pre-warm your transfer tool for at least ten minutes. Sufficient heat is important for success, since dry toner's melting point is 212–248°F (100–120°C).
2. Place the photocopy image-side down onto the receiver. Lightly secure the edges with low-tack tape to make sure the image stays in position. (Work on top of a flat, smooth surface. (L.B.))
3. Apply the heat tool flat to the back of the copy. Press firmly over the back of the copy in a regular circular motion. Gently lift up one corner of the photocopy paper to see if the toner has transferred.
4. Lift off the photocopy when you have transferred the amount of an image you wish. Lightly reheating the receiver will help you remove any stubborn paper.

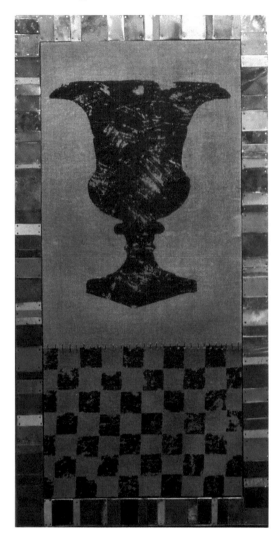

1.14 Peter Madden, *Urn with Checkerboard*, 16 in. × 2.5 ft. (40.64 × 76.2 cm), polymer medium transfer on linen with copper and brass border, 2001. Private collection. ©Peter Madden

POLYMER TRANSFERS

By Peter Madden

This is a technique that I began to explore in the early 90s. Although the process can be a bit finicky and sometimes unpredictable, it is inexpensive, water-based, non-toxic, and can yield striking results.

METHOD OVERVIEW

1. Apply a coat of matte gel painting medium to the receiver.
2. Adhere an office copier or laser print.
3. After drying the "sandwich," dampen and slowly remove the paper.
4. The toner or ink from the print is left embedded in the gel medium and receiver.

MATERIALS

1. Image. I found this process works best with images that are graphic and high contrast, because areas of the the picture can be lost when removing the paper.
2. Receiver. I have had the most luck transferring onto smooth wood, although I had some success with heavy printmaking papers that can withstand being wet and handled for a long amount of time and heavy fabric such as linen or old cotton bed sheets. Although the example at the beginning of this technical description is on linen, I think fabric is much more difficult to use than wood. You probably will need scrap paper when you force air bubbles from the back of the photocopy.
3. Matte acrylic gel medium, such as the one made by Liquitex, and, to apply the medium, a bristle house painting brush.
4. Burnisher. I use a towel or face cloth because the soft texture of the burnisher helps to work the photocopy into the grain of the wood. Soft paper toweling also is effective.
5. Tray with warm water and sink strainer to avoid clogging the drain with paper pulp.
6. Facial sponge made for exfoliating, to remove paper fibers. I wear thin gloves only because keeping hands in water for so long can dry the skin, but the removal of paper sometimes is assisted by the texture of your finger tips.

MAKING A GEL MEDIUM TRANSFER

1.15 Coat the Receiver

1. Coat the receiver

Brush the surface with a thin layer of matte gel medium, making sure to work the gel into the grain of the wood. A thin, even, thorough covering is all you need before applying another thin coating at a 90° angle to the first coating. The goal is to be thorough. Immediately wash the brush.

1.16 Place the Image

2. Position the image

As soon as the surface is coated, carefully place the image face down and burnish the back with a cloth or soft paper towel, making sure to smooth out bubbles or wrinkles and the image completely adheres.

1.17 Burnish the Image

3. Burnish the image

Exert a good amount of pressure and thoroughly burnish the whole image. Any excess gel medium will ooze out and can be wiped off. Because the paper is moist from the gel medium and can be fairly fragile, be careful not to tear it during this step. Keep an eye on it for about 10 to 15 minutes just to be sure that the print does not bubble or buckle as it begins to dry. If I notice such aberrations, I put a piece of scrap paper over the print and thoroughly burnish the image to the wood until the two are in as close contact as possible.

4. Dry the print-receiver unit

Allow the unit to dry thoroughly. I'll usually set up a few prints and allow all of them to sit overnight to assure that they are bone-dry before moving on to the next step. This technique will not work unless everything is thoroughly dry because the ink or toner must have time to bond with the gel medium.

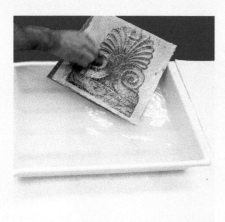

1.18 Soak the Print and Rub the Back

5. Soak the print and rub the back

Fully soak the back of the paper. I begin by running very warm water (90°F or 32.3°C) on it until the paper becomes slightly transparent. I then cover the unit with a wet cloth in order to completely drench the paper. While the paper is still saturated with water, gently rub it with your fingertips. The fiber of the paper will begin to delaminate and fall off.

Once the bulk of the paper has been removed, you'll be able to see your image clearly, although it will have a milky film over it from the remainder of the paper pulp. Continue to keep the print damp and gingerly remove the remaining paper. Use a facial sponge and carefully move it over the print with circular motions. This is the point where pieces of the image can be lost if you are too aggressive with it.

TIPS

You can transfer onto paper, but it should be substantial enough to hold up under soakings.

You cannot let the print-receiver unit dry too long—longer is better—before moving on to the soaking step.

As you soak the print, allow time for the water to sink in so that you can see the image through the paper before rubbing the back of the paper. Leave a wet rag on the paper if you have to take a break.

Since the paper can clog the drain, I work over a tray of warm water, continuing to wet the paper as I go along and letting the paper that I'm removing fall into the tray. I later strain the water and throw away the paper pulp.

I have used Scotchbrite® Heavy Duty Scouring Pads, available at grocery stores, to aid in paper removal.

Erring on the side of not rubbing too much during the first session with the print is better, since you can always go back, soak the print, and remove more pulp. In actual fact, after I think I am finished, I let the print dry again and take a look at areas where there is still a milky film of paper fiber on the image. Then, I will continue to wet and even more gently remove what remains.

As you can see from the example pictured here, I've managed to get flawless images with almost no loss of image. Sometimes I prefer prints where the loss of toner works well with my objective because the image looks scuffed, scratched or worn.

The prints are stable and, although it's not necessary, I sometimes apply a light coat of matte polyurethane, which will steep into the remains of any paper pulp and make them appear transparent.

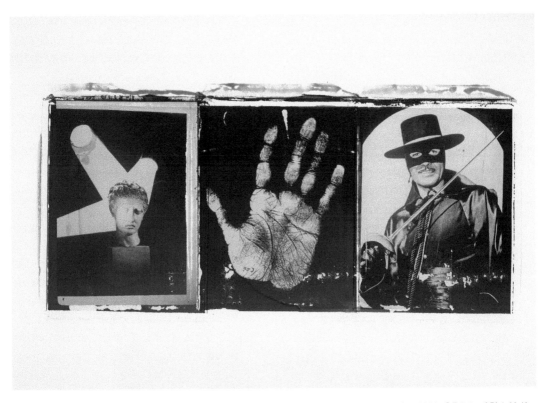

1.19 Rick McKee Hock, *Zorro*, from the series *Wild History*, 22 × 30 in. dye diffusion transfer print, 1989. ©Estate of Rick McKee Hock. Courtesy Visual Studies Workshop, Rochester, NY.

Rick Hock used text and images from the mass media and from fine arts. He copied comic book images, book reproductions, and other cultural artifacts onto black-and-white slide film. By inserting color filters into a Polaroid print processor, he selected the hues while he enlarged onto an 8 × 10 in. (20.25 × 25.5 cm) sheet of Polaroid film. He then used a spoon to rub the matrix image onto paper. Relishing the disadvantage of not being able to exactly repeat something and the uncertainty of his results, Hock arranged the images so that their new context changed the viewer's understanding of hackneyed or stereotyped subject matter. Sadly, Rick died in 2015.

The contemporary equivalent of Polaroid products is made by the Impossible Project, described below. You cannot make transfers with their film, but you can make lifts. For those of you who never had the pleasure of Polaroid self-developing film and color palette, Impossible Project offers you a chance.

IMPOSSIBLE PROJECT IMAGE LIFTS

SAFETY

Read warning labels and wear protective gloves when making lifts.

A sac containing an alkaline processing gel is discharged when the film is pulled through the film holder or camera rollers. In case of contact, wipe it off immediately and quickly wash the skin with lots of water.

Be careful not to discard trash where children or pets can reach it.

Hot water can scald, so be extra careful when you use it.

METHOD OVERVIEW

1. Create a black and white or color photograph on IP film.
2. Soak the film in warm water and peel off the actual image layer of photographic dyes.
3. Adhere the photographic imagery to your substrate.

MATERIALS

1. Polaroid and/or Impossible Project equipment. Several approaches to creating a lift exist. You can start with an Impossible Universal Lab printer which is about the same price as a small camera and transforms images on a smartphone or tablet to a physical photograph with a free app. You can also shoot "live" imagery, such as a still-life, portrait, or landscape with IP I-1 analogue instant camera, which connects to a free app via Bluetooth so you can also take self portraits, double exposures, long exposures, and scan photos. Impossible Project sells and repairs Polaroid cameras, which you can load with the appropriate IP film. In addition, you can use a large-format camera outfitted with a Polaroid back (they sell and repair old ones) and their 8 ×10 in. (20.5 × 25.5 cm) film. As an aside, I understand that Cindy Sherman used a medium format and, later, a 35mm camera, with special Polaroid backs, to test lighting and props for her directorial mode[3] pictures before digital devices were around.

2. Impossible Project black and white or color film. Film should be at room temperature when you use it, but storing it in a refrigerator—not a freezer—can prolong its life.

3. Receiver. You will need a paper that does not easily delaminate, such as printmaking paper. Arches makes a heavy 140 pound watercolor paper. Other papers that work well are Aquarelle watercolor (bright white), frosted acetate, drafting vellum, rice paper (softens and textures the image), and even wood veneer. Remember that smoother surfaces, such as hot-press paper, will retain more detail, while cold-press papers will create a rougher or more textured look. My students and I have attached emulsion lifts to furniture, glass, ceramics, mirrors, bottle cap interiors, plastic goggles, and other surfaces. We have used fabrics such as silk and fine cotton, where closer weaves retain more detail. Dark-colored surfaces are inclined to obscure the image, so light colors are preferable. See the section on supports in Chapter 4 for more details.

4. Hot water, thermometer, and 2 *ridge-less* trays. Prepare both trays with hot (160°F or 71°C) water. I use an electric fry pan for keeping the water hot because I can set the temperature to exactly 160° F. A plug-in tea pot and thermometer work, too. Using distilled water eliminates variables that might cause problems.

5. Board and drafting tape (optional). For thin paper receivers, I have used a smooth surface, such as a piece of clean Plexiglas™ or Formica™ onto which paper is adhered, a method that allows you to immerse the paper in water and not risk it curling up. Of course, the board and paper have to be smaller than the tray of water. With this method you are also unlikely to rip the paper while you attach the image.

6. Clear acetate or Mylar® sheet (optional). After the photograph's emulsion detaches from the support, it might end up backward. Gently roll it under water onto a sheet of acetate or Mylar® so you can flip the emulsion over and place it on the receiver. In addition, my students have used acetate in order to remove the lift out of the water and attach it to large sculptural objects. Two sheets of acetate are useful: one for reversing the direction and one if you are adhering the emulsion to an object.

7. Scissors, soft brushes, and pencil. You must exactly cut—do not peel—the film's border from the image area. In addition, a variety of round and flat watercolor brushes help remove excess chemistry and to position the emulsion. I use a pencil to lightly mark where I want to place the image on the receiver.

8. Protective gloves. The process can be messy and the chemicals caustic, so use gloves. The more tightly the gloves fit your hands, the more easily you can work.

9. Traditional marking materials (optional). You can embellish the receptor with color pencils, watercolors, pastels, dry pigment, and so forth before you apply the emulsion, and the marks can be seen in the light areas of the photo, which are the clearer areas of the emulsion.

10. Clock, phone or watch with seconds.

MAKING AN EMULSION LIFT

Photos courtesy Impossible Project

1.20 Take the Picture

1. Take the picture

Expose and fully process an instant photograph as the manufacturer recommends. Color pictures can take 30 minutes to fully develop, while black and white photos need 5–10 minutes. Fresh pictures are easier to lift than old ones. Meanwhile, heat the water and pour it into a tray or leave the hot water in an electric frying pan. Use a thermometer to check the temperature, because you may need to add more hot water at intervals. Make another tray of warm water.

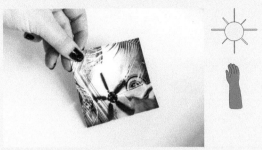

1.22 Soak the Image

3. Soak the image

Gently submerge the photo face up in the first tray of hot water. Let it sit for a few minutes. You will see white flakes in the water. Now turn the photo over with your gloved hand, and you will see the white layer beginning to separate from the emulsion. You can gently direct the water towards the photograph without actually touching it, and that will encourage the separation to continue. Brush the white from the emulsion, a process that takes quite a few minutes. If the water cools, add more hot water.

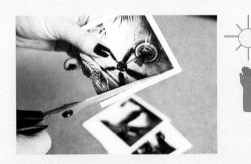

1.21 Trim the Photograph

2. Trim the photograph

Using scissors, carefully cut the white border from the photographic image, which exposes the different physical layers that actually make the photo.

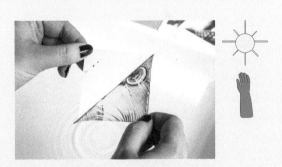

1.23 Remove the Positive from the Negative

4. Remove the positive from the negative

Start in one corner and gently *roll* the positive image diagonally from the white negative sheet under the water, where you can control it more.

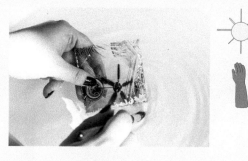

1.24 Clean the Emulsion

5. Clean the emulsion

Wearing gloves, gently remove any residual white chemicals. This step is easier if done under the water.

1.25 Remove the Plastic Backing

6. Detach the plastic backing

Still at the bottom of the tray, gently separate the print, image-side up, from the plastic top layer, with the flat bristles of a small, soft brush. With your other hand, slowly push and lift the emulsion from the edges of the plastic so that it floats in the water.

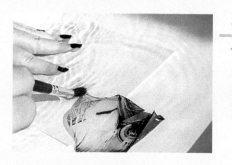

1.26 Maneuver the Emulsion

7. Maneuver the emulsion

If the emulsion rolls up on itself, use the brush under water to flatten it and remove it from the plastic. (In addition, in order for the finished piece to read correctly, slip a piece of acetate or Mylar® under the floating image and maneuver the image onto it. Flip the acetate/image over so that the image is face down in the water, then remove the Mylar®.)

1.27 Adhere the Emulsion

8. Adhering the image

If the image is already correct-reading, quickly move it to the clean water tray. Place the substrate under it in the water and, using your fingers or a soft brush, guide the image as nearly as you can to the penciled receptor area, then pinch two corners of the photo to the receiver. Gently scoop up the whole unit with the image on top. (If the image is wrong-reading, first lift the acetate with the image from the water and carefully turn the unit, image side down, onto your wet paper or substrate.) Remove any debris still left on the image.

Gently rub and straighten the image, then very lightly roll the emulsion with your fingers from the middle outward, assuring the even adhesion of the emulsion to your chosen substrate. You can further position the image by dipping a corner of the emulsion-substrate unit into the water again. To perfect the placement and smooth the emulsion onto the substrate, use a wet brush above the water on the dampened receiver to move the emulsion. A flat piece of Plexiglas® underneath is helpful.

Let the image dry in a clean, arid, horizontal area.

TIPS

Lifts from live imagery with any film, although more uncertain due to the one-of-a-kind nature of the process, allow for adjustments in composition, focus, lighting, and exposure.

You can double-expose in-camera or adhere one image on top of another.

Stretching or manipulating the emulsion is easier to do while the receiver and image are wet, partially submerged in a tray of water. Thin papers, such as rice paper and tissue paper, cannot be soaked in the tray of water. Instead, try an atomizer with warm water before you attempt to attach the emulsion lift.

If you are working on a slippery substrate, such as vellum or silk, taping the receptor to a stiff backing helps to prevent it from sliding while you adhere the emulsion.

Do not touch the emulsion unnecessarily or it will rip while it is wet. You have to be patient and allow the water to do most of the work.

As you finish, you can use a small brush dipped in water to gently get under the emulsion and stretch or shape the emulsion and purposely create wrinkles.

If bubbles appear as soon as the lift is drying, use a wet, broad, flat brush to flatten the emulsion.

Keep records of your procedure as you work so you can determine the effects of different variables. The direction of the grain of the paper, for instance, can influence the natural curl of the paper and the results.

All common color photography is sensitive to ultraviolet (UV) light, heat, and humidity, so images should be stored in archival boxes with silica gel (I recycle the packets that come with vitamins) away from light and contaminants or framed and sealed under UV protective glass.

After the emulsion lift is completed and dry, you may want to spray it with fixative so that it is not as easily damaged. However, fixative is extremely toxic and hangs in the air after it is used. So, wear a respirator and gloves and spray outside or in a spray booth.

I use archival interleaving from art or framing shops to wrap around and store the print.

I advise wearing gloves as you clean the trays.

After a session, always clean the rollers in the camera or the Polaroid back and the film exit slot because dirt can cause scratch lines on the image, and old chemicals can create brown stains and clear spots. I use a lint-free material, such as Webril wipes or Photowipes™ with rubbing alcohol.

The Impossible Instant Lab Universal appears to be a wonderful device for when you are traveling and want hard copy. It is (rechargeable) battery powered, you attach your smart phone to it in order to make actual photographs, and then it collapses.

MAGAZINE AND COPIER LIFTS

Lifts provide another simple, versatile method of removing a printed image from its page. Lifts are made by adhering either heavy tape or acrylic (polymer) medium to a printed image and separating the ink embedded in the coating of the paper from the mass of the paper. The lift can be employed as a transparent page in a book, mounted in a holder and scanned (see page 128 of the Digital Negatives chapter), stuffed and stitched, or warmed and sculpted. Another application is to enlarge or contact print a lift in a darkroom onto ortho film (see the chapter entitled "Generating Imagery: Analogue Method") to make a positive transparency. Lifts can be used as the transparent halftone positive for photo silkscreen or as a decal to be adhered to surfaces such as fabric, acetate, paper, wood, glass, and ceramic.

SAFETY

No special precautions need be taken with materials used for making magazine lifts.

METHOD OVERVIEW

1. Printed image is selected and prepared.
2. Transparent tape, clear contact paper, or acrylic medium is applied to the front of the image.
3. When dry, the taped or coated image is then soaked in water until the paper dissolves, separating the inked image from the paper.

MATERIALS

1. Image. The inside pages of glossy magazines work best because the paper is coated with clay (kaolin), which is water-soluble. The ink rests on the kaolin, not the paper. Front and back covers do not work well because they are usually varnished, and this seals in the ink. Newspaper pages are thinner and often the images on both sides of the paper get lifted. For the decal technique, color images from high-quality magazines are the most reliable. Choose slightly contrasty images with bright, detailed highlights and clear shadows to retain tonal separation.

2. Heavy transparent tape, clear contact paper, or clear acrylic polymer medium. These are the adherents used in the different lift methods. Transparent tape usually is available in hardware stores for winterizing windows or for mail room use (also known as clear packing tape) and is effective for smaller pictures. Clear contact paper used for lining shelves works with large pictures. Clear acrylic polymer gloss (which dries clear) medium (Grumbacher Hyplar™, Golden™, Liquitex™) is sold at art stores and provides the best flexibility in the final lift. With it, you will need a brush, and inexpensive polyfoam brushes are best for laying down an even coating. Immediately after using the polymer medium, you must wash brushes with warm—not hot—water and soap or the bristles will harden.

3. Metal spoon, burnisher, bookbinder's bone folder (my favorite tool), etching press, or paint brush. These are the applicators used in the various lift methods to assure adhesion of the magazine page to tape or contact paper, or, with the paintbrush, to apply the polymer medium; a 1½ in. (4 cm) width soft brush is recommended.

4. Brayer. This is a printer's ink roller, usually used for linoleum printing but also practical for the polymer lift method when transferring onto fabric or acetate. Brayers can be purchased at art stores or hobby shops. Inexpensive substitutes include a kitchen rolling pin or a straight wine bottle rolled on its side.

5. Tub, sink, or dish pan and water.

6. Scissors.

7. Soft cloth. A clean, pressed piece of cloth is needed if you want to lift onto fabric, and another piece of absorbent cloth is necessary for blotting the fabric.

8. Blotter. For fabric lifts, a blotter the size of the fabric is needed.

9. Sheet of glass.

10. Receiver. Almost any paper, fabric, or surface will work. Fabric, if used, should be of medium weight

and fine-woven texture for best results. Natural fibers and natural-synthetic blends work better than synthetics. When applied to clear acetate, lifts can be layered, stitched, and stuffed. When heat-sealed to each other, lifts can be inflated to create sculptural forms.

11. Hair dryer. A hair dryer hastens drying time for polymer lifts and softens the polymer for sculpting decals.
12. White paper and acetate. For lifts onto clear acetate, you need a large piece of white paper, such as shelving paper.

MAKING A LIFT

METHOD 1: TAPE METHOD

1. Cut and adhere the image

Cut out the magazine drawing, photograph, graphic, or type slightly larger than the image area. Press the sticky side of the tape or contact paper onto the image side. Thoroughly rub the back side of the image with a spoon or burnisher, or put this sandwich construction through an etching press.

2. Soak and dry the image

Float the taped or contact-papered image face-up in warm water for at least 15 minutes. The paper will start to delaminate. Gently rub the back of the paper, removing the paper fibers but leaving the picture's ink stuck to the tape or contact paper.

Remove the unit from water. Weight down the lift by the corners until the piece dries, then trim as desired with scissors.

METHOD 2: ACRYLIC-MEDIUM AND MAGAZINE PICTURES METHOD

1. Prepare and coat the image

Cut out the image to be lifted, trimming off all extraneous areas. Place the image face up on a sheet of glass. Apply a thin, even layer of acrylic medium by brushing with strokes going in the same direction. Air dry or blow dry with the cool setting, and coat again at a 90° angle to the first brushing. Dry again and coat again, repeating for a total of six to eight layers, alternating the direction of the brush strokes and drying thoroughly after each coating. The polymer medium should dry clear. Wait 24 hours until you start the next step.

2. Soak and dry the image

Float the acrylic-coated image face up in warm water and soak it for 15 minutes. The paper will become soft and start to delaminate. Gently rub the back of the paper to remove the paper fibers, leaving the inked image adhered to the acrylic medium. Artist Tricia Neumyer has had great success using a handheld steamer to remove the paper. Air dry or blow-dry, if heat is needed to make the lift pliable.

TIPS

The acrylic medium method works best if you do not brush on thick coatings; otherwise the medium will penetrate too deeply into the paper fibers making delamination difficult. Rubbing or scrubbing the image as you apply the medium can smear the ink.

Acrylic lifts can be used like decals. Make sure that the surface on which you want to place the decal is clean and dry. Then coat the surface with an even layer of polymer medium. Smooth the lift made by the acrylic (polymer) medium method onto the surface with the

image right side up. Hold in place for several minutes. Remove excess medium with a moist cloth.

To apply an acrylic medium lift to curved surfaces, gently heat the lift with a hair dryer until it becomes pliable, then apply the decal lift to a correctly prepared surface.

When using acrylic polymer medium, be sure to immediately wipe excess medium off your work surfaces or receiver surfaces and implements using warm water and a sponge.

To brighten the image after the fabric has dried, apply 80 percent watered-down coating of the medium to the image transfer area only.

Acrylic lifts are sensitive to heat and cold. They will soften when warmed and become brittle when chilled, even if left outside on a cold day.

METHOD 3: ACRYLIC MEDIUM LIFTS ON FABRIC

Just by making simple alterations in the lift process, you can transfer images to fabric. Note that these transfers will have the image reversed, whereas the methods described previously produce images that read correctly. Lifts transferred to fabrics will be pliable in addition to being reversed.

1. Prepare the fabric and the image

Place a clean, pressed piece of fabric on a flat, hard surface. Select your image and trim all excess before placing it *face up* on a sheet of glass. Brush on an even, heavy coat of acrylic medium and wait about 30 seconds. The paper of the image will curl and look semi-transparent, indicating that the medium has penetrated through the paper.

2. Combine the image and the fabric

Carefully set the wet, coated image face down on the fabric. Roll a brayer over the back of the image, pressing the fabric and picture tightly together, making sure to remove wrinkles. Turn the entire piece—image and fabric—over, and roll the brayer across the fabric. Test the image piece to see if it has adhered to the fabric by picking up the edges. If the image does not cling, remove the entire piece and recoat as in Step 1 above, and reaffix the image piece to the fabric as described in this step.

3. Remove the paper backing and drying

Let the united fabric and image piece dry thoroughly, preferably overnight; then place the unit in a tub of warm water. After soaking for several minutes, the paper backing should peel away from the image with gentle rubbing. Remove the fabric from the water and lay it on a blotter, image side up. Gently wipe the image with a damp cloth to remove any pieces of paper that may remain. Hang the fabric to dry, and *do not wring* it.

If any part of the image peels or pulls from the fabric along with the paper backing, re-submerge the whole unit and begin peeling from the center to avoid damaging the edges. Once the fabric has dried, use polymer medium to re-glue the loose areas of the transfer.

METHOD 4: ACETATE LIFT

Images can be transferred onto acetate sheets, which are available at art stores. Like the lifts on fabric method above, this technique uses the acrylic-polymer medium to remove solely images from printed material to transfer onto a second receiver. In addition to providing a more rigid base, the transparency of the acetate together with the transparency of the dried polymer medium offer an alternative solution to the correct-reading/reverse-reading problem. The finished piece can be framed, attached to glass/mirror with gloss medium that dries clear, or used as a clear page in a hand-bound book.

1. Prepare the image

Cover a flat work surface with a large white piece of paper, such as shelving paper, drawing paper, or typing paper, and secure this sheet to the work surface. Place the trimmed image page face up on the paper and carefully set a clean sheet of acetate over the image. Tape one whole edge of the acetate sheet to the white paper, creating a hinge, and then lift the acetate back open. Mark the outline of the image piece on the white sheet of paper.

2. Coat the image

Place the image face up on a sheet of glass, and apply an even coat of acrylic polymer medium. Return the picture coated side up to the outlined position on the white sheet of paper. Lower the acetate sheet and completely smooth it over onto the image piece. Untape the acetate sheet and turn it and the adhering picture over in order to totally roll the brayer across the back of the image. Lay the acetate-image unit on a flat surface, acetate side down, and wipe off any excess medium from the acetate with a damp cloth. Allow this unit to dry thoroughly, until the medium turns transparent.

3. Remove the paper backing

Place the acetate-image unit in a tray of warm water, paper side down. Soak for several minutes until the paper backing to the image piece is soft, then turn the unit over; gently rub the paper from the acrylic coating the acetate. Blot gently and allow the acetate sheet with the image adhered to it to dry.

METHOD 5: LASER LIFT

1. Prepare the image on a computer as before, but do not use an inkjet printer. Make sure you print onto copier paper with a laser printer and that you allocate a substantial border on all four side of the picture. Or, skip the computer, use the glass platen of the copier, and make a laser copy that way.
2. Coat the image with a thin layer of acrylic gel medium.
3. Allow the medium to completely dry, then tape the paper, image side up, to a flat, smooth surface, such as a piece of glass.
4. Using a spoon, art store spatula, or palette knife, scoop out a generous amount of gloss acrylic gel and place a line of it along one border of the printed image. Brush a generous layer of the gel onto the image and smooth it with the palette knife or spatula while maintaining the layer's thickness.
5. Allow the unit to dry for at least eight hours.
6. Cut the laser print's border or peel the tape to separate the image from the glass or whatever surface you used as a coating area.
7. Place the coated paper image in a tray of warm water. After a few minutes, rub the front so as to dislodge and delaminate the paper from the image. Go gently because that image is imbedded solely in the gel.

LAZERTRAN™ INKJET LIFTS

By Dorothy Imagire

A Lazertran™ inkjet lift is similar in look to Impossible Project emulsion lifts, but much easier to do, and you can go directly from camera to digital printer. It does not "wiggle" like emulsion lifts—the decal is much firmer—yet somewhat flexible. Any image you have on your computer, whether scanned, imported, or created, can be printed out on Lazertran™.

SAFETY

No particular safety measures are required. Make sure you use a thermometer so you don't burn yourself with hot water.

METHOD OVERVIEW

1. Inkjet print your image onto Lazertran™ Inkjet Decal paper. Let the image dry.
2. Put the decal paper into warm water until it loosens from the backing paper.
3. Place the decal face up onto nonabsorbent receiving material.
4. If the receiving material is absorbent, coat the material first with an acrylic medium.

MATERIALS

1. Image. You can use any image that is in your computer. Higher contrast and/or brighter colors show up better if placed on darker receiving material or transparent glass.

Figure 1.28 Dorothy Imagire, *Tahirih, Feminist Martyr Iran*, 1852, 96 in. (2.44 m) circle installation with 50 Lazertran™ decaled stones on rose buds, 2005. © D. Imagire.

Tahirih was born in Persia—now Iran—in 1817. She was an intellectual and a poet, who refused to wear the veil. In 1852, she died a martyr for her beliefs; she was strangled to death by her own white silk scarf at night in a garden in Tehran. Her body was thrown down a dry well and covered with stones. Imagire captures her spirit by using Lazertran™ inkjet decals of Tahirih's poetry in Arabic and Persian, with some English translations, on the stones. The stones circling the rosebuds (originating in Iran, also mentioned in Tahirih's poetry) suggest a walled garden (our word "paradise" is of Iranian origin, which literally translated means "walled garden").

As a young girl, Imagire, of the Baha'i faith, grew up knowing that Tahirih was the first woman martyr for the Babi/Baha'is. Imagire's mother was born and raised in Iran. See more of her art work on www.Imagire.org.

2. Lazertran™ Inkjet decal paper. You can purchase Lazertran™ online from www.lazertran.com. They have changed the name of some of their products, but look for "inkjet" and "waterslide" or "decal." They also make a nice inkjet iron-on transfer as well as many other "cool" products. They are based in England, but they also have a warehouse in the United States so that your order is shipped quickly in either location.

3. Receiving material. For porous materials such as paper, canvas, wood, or stone, you can attach the decal with acrylic medium while it is wet or attach it later when it is dry. In either case, coat the porous material with the medium, place the decal, and add another coat of medium on top of the decal. Make sure you brush from the center out to remove any trapped air. Lazertran™ also works well on nonporous materials such as glass, ceramic, and shiny metals without acrylic medium, adhering with just the gum on the back of the decal. Make sure you squeegee out any air bubbles and excess water.

4. Scissors. Small nail scissors work well when cutting intricate images.

5. Acrylic medium or varnish. Your can use either matte or gloss. You can even use oil varnish, but in this case you should allow the decal to dry after it has been soaked off in water. Slide the decal onto a sheet of freezer paper or waxed paper until it is dry.

6. Freezer paper or waxed paper. Both are found in the grocery store. Freezer paper, which I prefer, has a plastic nonstick coating on one side (this is the side the decal should be placed on so it will not stick as it dries). Waxed paper sometimes works, but there is a chance the decal will stick to it.

7. Brush. Any soft brush you feel comfortable with.

8. Flat container or tray. Use any dish or pan that is larger than your cutout decal image and not too deep—about two or three inches.

9. Thermometer. An instant-read kitchen thermometer works quickly and is inexpensive, small, and easy to find. *Do not* use it for both cooking and nonfood processes.

10. Squeegee. May be useful on flat, nonporous surfaces.

11. Tissues or paper towels.

MAKING LAZERTRAN™ LIFTS

Please read all the steps before starting.

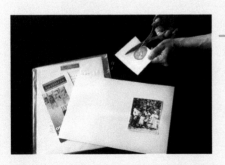

1.29 Making and Preparing the Image. © D. Imagire

1. Make and prepare the image

Your image will not be reversed, so you do not have to flip it. Print on the cream side of Lazertran™ in an inkjet printer using "color-life" setting if you have it. If you do not have the "colorlife" setting, the "matte" setting works well (whatever setting that does not use too much ink). Use the highest quality photograph setting at the highest dpi (1440 dpi if you have it) and do not check "high speed." Allow the inks to dry at least 30 minutes before continuing to the next step. Cut your image out, as the borders are visible when dry.

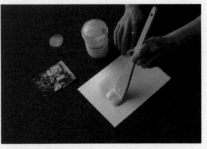

1.30 Preparing Your Receiver. © D. Imagire

2. Prepare your receiving material

If you are using porous material, such as paper or canvas, you must cover the receiver first with acrylic medium. Using a soft brush, evenly coat one layer of acrylic medium.

If you are using nonporous material, such as glass or metal, you do not need to coat it with acrylic. It should be clean and grease-free.

1.31 Releasing the Decal. © D. Imagire

3. Release the decal

Fill a shallow pan, large enough to hold your image, with warm water at about 110°F (43.3°C). Lower the image into the water bath. Let it soak for 30 seconds to one minute. It will curl up then slowly flatten out again. Test to see if the backing slips away from the decal. If it slips away, take it out of the water, gently shaking off excess water.

1.32 Attaching the Image on Porous Material. © D. Imagire

4. Attaching the image on porous material

Have your receiving material ready and at hand, coated with fresh, wet acrylic medium. Pull the decal one-quarter inch away from the backing and lay the image on the receiver

face up. Now slide the rest of the Lazertran™ backing out from under the decal. Using a soft brush, add another coat of medium on top, working air and moisture out from the middle to the edges. The image will become more visible as it dries.

1.33 Attaching the Image on Nonporous Material. © D. Imagire

5. Attaching the image on nonporous material

You do not have to use the acrylic medium. Place the decal face up and gently squeegee (the image is fragile while wet) with the side of your finger to push out air bubbles from the middle to the edges. Leave the unit to dry. The image will become more visible as it dries.

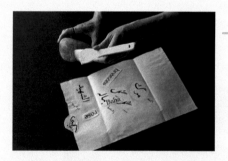

1.34 Attaching the Image Dry. © D. Imagire

6. Attaching the image dry

If you want to dry the decal first, pull the backing one-quarter inch (5 cm) away on one side of the image and slide it onto a sheet of freezer paper. Now slide the rest of the backing out from under the decal. Let it dry until you are ready to use it. When you are ready, coat the receiving material (whether porous or not) with acrylic medium. Place the dried

decal on the medium and brush on another coat of medium, working any air out from the middle to the edges.

Allow the image to dry atop the glass or nonporous surface. You can hand-color with acrylic paints, then glue the dry image to your art work.

TIPS

For porous materials that need to be prepared with a coat of acrylic medium, you might want to brush the whole area, even beyond the image, because the medium is slightly visible. If the medium has dried, just apply a thin, wet coating before applying the decal.

Nonporous materials do not need to be coated with acrylic medium, if the decal is applied wet. However if the decal has dried (a more practical method, which allows you more time to arrange images), attach the decal as you would on porous materials by first coating with acrylic medium, then applying a top coat of the medium.

Clear or white areas on your image will not be see-through but slightly milky.

PAPER PHOTO-LITHOGRAPHY

By Christine Tinsley

SAFETY

Mineral spirits, aka "white spirits" and other solvents, are hazardous from inhalation (high concentrations of mineral spirits can result in respiratory irritation or even pulmonary edema), ingestion (can be aspired into the lungs), and, to a lesser degree, by absorption (can remove protective skin oils and increase the possibility of a rash or dermatitis). Wear protective gloves and respirator, avoid eye contact (goggles help), and wash skin when contaminated. In addition, less toxic methods of clean up, such as using orange oil (CitraSolv, De-Solv-it, and the most eco-

friendly ZAcryl D-Solv) are readily available, show no carcinogenic or neurotoxin hazards comparable to petrochemical solvents, and are biodegradable. However, handle these products with care: ensure good ventilation and take fire precautions when using orange oil solvents.

Stay away from the more toxic turpentine. (L.B.)

All paints contain a binder with pigment particles, but some—such as lead (found in flake white), cadmium, cobolt, and manganese and mercurial sulfides—are riskier that others. Chrome yellow and zinc yellow may cause lung cancer, skin ulcerations, and rashes, while lamp black and carbon black may cause skin cancer. So, use the least toxic forms of the pigment's color instead. (L.B.)

If the color is labeled a "hue," the manufacturer is indicating that the color does not

1.35 Christine Tinsley, *Yahaida*, from the *SisterVet Series*, Photo-lithograph from copier image using Winsor & Newton oil paints on Rives BFK, 11 × 14 in. (28 × 35.56 cm), 2016. ©Christine Tinsley, www.ChristineTinsley.com.

contain a level of toxic metal to worry about. When in doubt, look up the Materials Safety Data Sheet on your supplies. (L.B.)

Do not eat, drink, or smoke near paint and solvents. You risk accidentally carrying toxins to your mouth and skin. (L.B.)

Although gum arabic can be found as an additive to food and cough medicines, it can interact with many medications, especially ones for respiratory disease, and create complications.

Pregnant and breast-feeding women should avoid gum arabic. (L.B.)

METHOD OVERVIEW

1. A high-contrast black and white photo copy is made.
2. The copy "plate" is rubbed with gum arabic.
3. The copy is sponged with water, then inked; the arabic acts as a paint attractor while the water repels.
4. Paper is pressed onto the copy, transferring the ink/paint only and creating a print on the receiver.

MATERIALS

1. Two soft rubber brayers. Available in the printmaking section of an art store, one will be used for inking and the other, for applying pressure.
2. Disposable palette (best) or waxed paper.
3. Palette knife.
4. Protective gloves, respirator (especially if you are unsure of the ventilation).
5. Sponges. You will need two, from the grocery store.
6. Two water containers. Each should hold at least 64 oz. (2 L) and not be used for any other purpose.
7. Oil paints. Winsor & Newton and Grumbacher are dependable, readily available brands.
8. Gum arabic. Found in an art store, usually the weight is 14° baume.
9. Solvent and mask. Orange zest solvents, named in the Safety section, above, are probably the safest. Mineral Spirits, for cleaning up, seem to be less toxic than other petro-chemicals. Wear an organic vapor mask. Never use benzene.
10. High contrast photo copies. Make two copies of each image, so one can be used as the trial and one for the finished print.
11. Flat, smooth, covering, such as Plexiglas®, for inking the image. You will also need paper towels.
12. Receiver. Rag paper is more resilient.
13. Baby wipes for cleaning the image border and the equipment.

MAKING A PAPER PHOTO-LITHOGRAPH

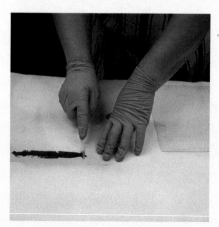

1. Prepare the ink

Along one edge of the palette, squeeze out a 1 ½ to 2 in. (3.8 to 5 cm) link of oil paint. In U.S. currency, the dollop of ink should be about the size of a quarter. Then, using a palette knife, spread it into a line.

1.36 Prepare the Ink

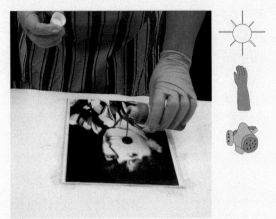

1.37 Prepare the Plate

2. Prepare the plate

Pour out a quarter (coin) size of gum arabic onto the dry Plexiglas®. With your gloved hand, smooth the arabic over the entire area. Place the copy, image side up, on the plexi, and pour another dollop of gum arabic in the middle of the image. With your gloved hand, smooth the arabic to completely cover the whole sheet of copier paper, starting in the center and carefully removing air bubbles with the side of your hand as you evenly spread it to the edge of the paper. You will notice that the gum does not stick to the white areas.

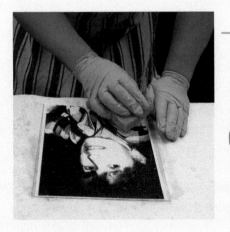

1.38 Wet the Paper

3. Wet the paper

Once the copy is flat, use your gloved hand to rub another dollop of gum Arabic over the image and onto the borders. With the sponge, load it with water, then soak the paper by squeezing the sponge over the print. Lift up excess water by blotting the image with a sponge. Repeat this wetting and blotting procedure, making sure that the paper is evenly soaking wet.

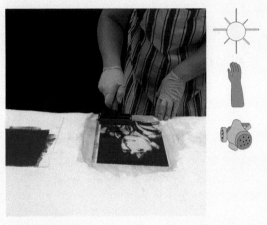

1.39 Ink the Image

4. Ink the image

Use the brayer to make a flat, even rectangle of ink on the palette. Make sure the ink is evenly sticking to the roller, then roll the ink onto the image. First go in one direction, completely covering the black parts of the image, then pick up some more ink and roll at a 90° angle onto the print. In order to make sure the roller is loading completely and also inking completely, a special motion it used: when the brayer comes to the end of the rectangle of ink (or rectangle of the image), lift it and let it spin before putting it down again. This is called charging or discharging the ink.

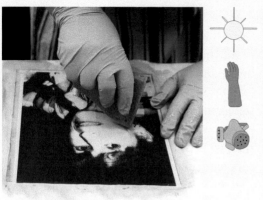

1.40 Keep the White Areas Clean

1.41 Create a Hinge and Make the First Print

5. Keep the white areas clean

Using the sponge, pick up water and soak the print again. Delicately blot, then use the edge of the sponge to lightly lift up spots where ink might have stuck to the white of the image. Repeat Steps 3–5 at least three times. At the final stage, delicately rub the white border with baby wipes to remove excess ink.

6. Create a hinge and make the first print

Tape one edge of the copier paper to one edge of the receiver paper. With a clean brayer, press the back of the receiver up and down, then side to side. The amount of pressure determines the amount of ink that will deposit on the receiver. Some artists put the unit through a press at this point. Take off your gloves so as not to dirty the receiver, and at the hinge, lift up the receiver paper to see the image. If it is not dark enough, repeat Steps 3–5 and check the print quality again. Do not remove the hinge, because it is the device that keeps the inked print and receiver aligned.

TIPS

One way to make sure that the plexi does not move while you are using it is to create a suction by sprinkling a few drops of water on your work table and laying the dry plexi on top.

If the gum arabic is resisting being evenly distributed over the image and is too sticky, add a few drops of water and continue spreading it. You may need to add more gum, too.

The more times you wet, then ink and print the copy image, the darker the resultant reproduction on the receiver.

The inked copy can be dried and used as the art, too.

Using baby wipes to start the cleaning-up process limits your exposure to toxins. However, in order to completely remove paint from the brayer, the next step is orange zest solvents, then, as a last resort, mineral spirits. Wear a vapor mask and gloves. (L.B.)

The historical solvent, used by painters hundreds of years ago, was spike lavender oil, and it is available again from makers such as The Oil Treehouse, a manufacturer which does not use any turpentine, mineral spirts, lead, cobalt, or cadmium in any of their products. (L.B.)

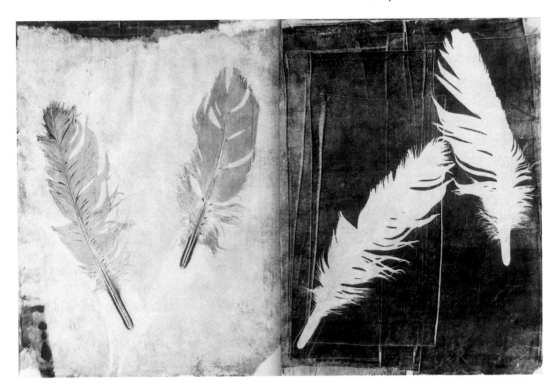

1.42 Peter Madden, detail, *Icarus 2*, Gelatin print on Lama Li paper, 9 × 24 in. (22.86 × 61 cm), 2016. ©Peter Madden The example shown here is a double page from a one-of-a-kind, handmade book of monochromatic gelatin prints. See more on www. PeterMadden.com.

GELATIN PRINTS

By Peter Madden

Although this method is not literally made from any photographically derived image, it *looks* photographic and is so direct and stress-free, I could not resist putting it into this book. The manufacturers claim that water-based ink is non-toxic and gluten free(!). (L.B.)

The original process, developed in the late 1950s by Francis S. Merrit, Director of Haystack Mountain School of Crafts in Maine, utilized large plates of gelatin that were poured inside a clay perimeter on a large sheet of heavy glass. Because the early process needed huge drums of industrial strength gelatin composed of grains that were large and time-consuming to dissolve, this variation is much easier; I was taught this technique at Haystack Mountain School of Crafts on Deer Isle, Maine. It is fast, water-based, non-toxic, inexpensive and

has endless possibilities that provide results ranging from images that appear to be some sort of photographic process to prints that are more traditionally painterly. It is akin to monoprinting, but rather than working on a hard glass or plexiglass surface, a supple plate of gelatin is used with water-based inks.

METHOD OVERVIEW

1. Commercial gelatin is prepared, poured into a pan, and allowed to harden.
2. Gelatin is inked, and a shallow object is pressed into ink.
3. Paper is placed onto the ink and rubbed from the back.
4. Paper or receiver is lifted off the surface and allowed to dry.

MATERIALS

The proportions below are for making a printing surface in a 9 × 12 in. (22.86 × 30.48 cm) pan and can be multiplied accordingly to create a larger printing surface.

1. Shallow pan, cookie sheet, disposable aluminum baking pan, or plastic lunch tray without too high a lip, because a tall brim makes inking the surface and pressing the print difficult. Containers for take-out sushi or salads are convenient because they have a lid which assists in preserving the gelatin "plate" for reuse. Otherwise, plastic wrap carefully sealed around the gelatin and receptacle can be used.

2. Eight envelopes of Knox or similar gelatin available at a grocery store totaling 8 oz. (226.8 g).

3. Water. You will need 1 cup (236.5 cc) cold water and 3 cups (709.76 cc) water heated to boiling. (I found 2 cups (473.2 cc) cold and 2 cups hot water easier to mix. (L.B.))

4. Ink. I use Speedball water-based wood-block printing inks. Stay away from oil-based inks, because they immediately damage the gelatin.

5. Brayer. You will need one *soft* brayer that fits into the pan into which the gelatin is poured. Wider brayers (and containers) end up with less brayer marks in the final print; however, I enjoy the marks that the brayer leaves from uneven rolls of ink. If you want strokes in the print, apply ink with a brush.

6. Object. Any object with a texture, such as keys, scissors, feathers, doll clothes, sea shells, clothes pins, paint brushes, your own hand, lace, coins, stencils, twine or rope, leaves, rubber stamps, knitted or crocheted items.

7. Receiver. Papers without a lot of texture, such as Japanese papers, work best for picking up detail. Any thin material with a smooth surface and some absorbency should work easily, such as paper bags, paper towels, gift wrapping tissue, vellum, copier paper, and printed book pages or maps. I have used wood, cardboard, Rives heavy weight printmaking paper, and book boards as substrates, also.

8. Waxed paper and tape to secure it to your work table or a disposable paper palette.

9. Tweezers are helpful for lifting up an object from the inked gelatin. A rubber spatula helps mix the gelatin and prevents scraping a metal pan when you are removing the gelatin.

10. Sponge or paper towels and cool water to wipe the gelatin after making a print and before rolling ink again or changing the color of the ink.

11. Ink retarder (optional). Speedball makes Block Printing Retarder, Waterbased, and Liquitex sells Slo-Dry Fluid Retarder that reduce the speed with which the rolled-out ink dries. Retarder is especially helpful if you are creating a large print.

12. Fork or kitchen wire whisk for mixing the gelatin and spoon for scooping out lumps and air bubbles from the gelatin.

13. Mixing bowl, such as Pyrex™ that will withstand hot water and hold 32 oz. (946.35 cc).

MAKING A GELATIN PRINT

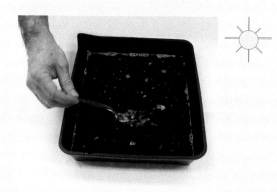

1. Make the gelatin

Pour the cold water into a mixing bowl and sprinkle the gelatin on the cold water. Tip and shake the bowl a bit to assure that all of the gelatin has been moistened, but do not stir it because the motion will cause lumps that are difficult to remove later. Allow this mixture to sit while the water boils. Slowly and gently pour in the boiling water, being careful not to create bubbles.

1.43 Make the Gelatin

Making sure not to create any bubbles or foam, slowly stir the gelatin mixture again with a fork or whisk until the gelatin is thoroughly dissolved and there are no lumps.

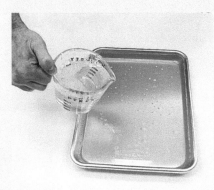

1.44 Form the Gelatin

2. Form the gelatin

Pour the gelatin into a cookie sheet or similar mold.

Any lumps or bubbles can be pushed to the edge and scooped out with a spoon. The surface should be as smooth as possible so as not to interfere with picking up clear details when printing. The plate can be left out in cool air or put in the refrigerator for approximately ten minutes to speed the process or solidifying.

1.45 Ink the Gelatin

3. Ink the gelatin

At this point, there are several different ways to proceed, and each method produces different results. The following instructions are for making prints similar to the example at the beginning of this chapter.

Using a soft rubber brayer, roll the ink out on a palette or a piece of waxed paper taped to your work table. The aim is to spread the ink evenly so you get a thin, even coating on the brayer. Colors can be mixed with a spoon on your palette and then rolled out evenly or left unblended in order to create a split palette/rainbow on the brayer.

Apply a very thin coating of the ink to the surface of the gelatin plate with the rubber brayer. The layer of ink should be thin enough that it is still transparent. Be vigilant as you go over the surface with your brayer; with careful rolling, you can erase any marks that the brayer leaves.

1.46 Prepare the Image

4. Prepare the image

Gently place the object where you want it on the surface of the gelatin. Be careful not to slide it around, as this movement will result in a blurry print. Softly press the object into the gelatin, bearing in mind that you only want to make an impression in the ink's surface and not a deep mark in the gelatin. Carefully

remove the object, making sure not to leave any fingerprints—sometimes a pair of tweezers comes in handy. You should be able to see a clear imprint of the object on the surface of the ink.

1.48 Create a Positive

1.47 Pull the Print

5. Pull the print

Take a piece of paper (or cardboard or wood), gently lay it down on the gelatin plate and softly press it with the flattened palm of your hand, making sure the substrate closely contacts the inked surface in order to pick up all the detail. Remove the paper, and there you have your first print!

VARIATIONS ON GELATIN PRINTING

The way of printing described above will give you a "positive" image from your object on a solid background.

6. Create a positive

A way to get a different sort of print is to ink the gelatin, place an object on the ink, gently press a piece of paper *over the object* and pick up all the ink around the object as described in the steps above. (At the same time, the action of making the first print creates a crisp impression of the object in the ink.) Remove the paper, and you will have created a silhouette print of the object. Take away the object *after* you make the silhouette. Now, place another piece of paper and gently rub, which will pick up the image's marks that have been left behind on the gelatin-inked surface. This method gives you a crisp image of your object on a clean background because all of the surrounding ink has been removed by the first piece of paper.

TIPS

When I incorporated the simpler version, rather than the original industrial-strength method, into my book arts curriculum 25 years ago, I found that using easily dissolved Knox gelatin works just as well. In addition, the gelatin is readily available in the baking section of any supermarket.

Using an aluminum baking tin from a grocery store works fine as the carrier for the gelatin and is simpler, too. Use a pan with a low lip, such as a cookie sheet.

When pouring the gelatin into a pan, make sure the pan is not angled but is horizontal so that the gel settles evenly. In addition, if you

put the pan in a refrigerator, make sure the pan remains horizontal as it cools.

Cooling the gelatin in a refrigerator is a good idea in warm temperatures or high humidity. However, the plate should be allowed to return to room temperature for printing.

Depending on your location and the temperature, it may be difficult to use this technique unless you can work in an air-conditioned room. For instance, I attempted to teach this process in Greece, but with the high temperature and bright sun, the plates completely dissolved within a few minutes.

Because this process recently has become popular, a quick Google search will show the myriad of objects artists have been using. One of the great pleasures is experimenting with a variety of materials that can get a bit of ink on them and which later can be washed.

Inevitably, an object you're working with may break the surface of the gelatin, creating a mark that will show on any other prints that you do. Not the end of the world! Gently rinse the ink off the surface of the gelatin with cool water. Try to run the water on the edge of the pan and not directly on the gelatin. Gently rub your gloved hand over the ink to clean the gelatin. Blot it dry with a paper towel.

In addition, you can utilize this rinse if you are changing colors and want to completely remove the color you had been working with.

In order to re-use the "plate" if it has started to lose its smooth surface, scrape the gelatin into a microwave-safe bowl with a splash of water, heat until the gelatin is liquefied, and re-pour and cool the mold.

Two other ways of using the gelatin plate are to simply to use the entire surface to draw or write on, creating one-of-a-kind prints, or to carve into the gelatin, as you would with a linoleum block or wood block, creating a matrix that can be printed over and over again.

A refrigerated gelatin plate can be stored with a tight cover in a refrigerator for about a week and can produce, literally, hundreds of prints. I used a gelatin plate into which I had carved, to make my holiday cards one year—I was able to print over 150 of them, each slightly different, in less than an hour.

You can clean the pan by pouring hot water on the gelatin to melt it.

The prints will dry quickly and can be printed over with a different color ink for a more complex image, or you can combine them with the processes in this book.

NOTES

1 Solomon R. Guggenheim Museum website: https://www.guggenheim.org/artwork/5207.

2 Robert Rauschenberg Foundation website: http://www.rauschenbergfoundation.org/artist/chronology.

3 *Directorial mode* is a term coined by A. D. Coleman in his still-interesting book of essays, *Light Readings*. Albuquerque: University of New Mexico Press, 2nd rev. ed., 1998. Respected critic Lucy Soutter used the term *narrative photography* in the 1990s. Both writers are describing photographs in which the pictures look "taken" but are actually set up and "made."

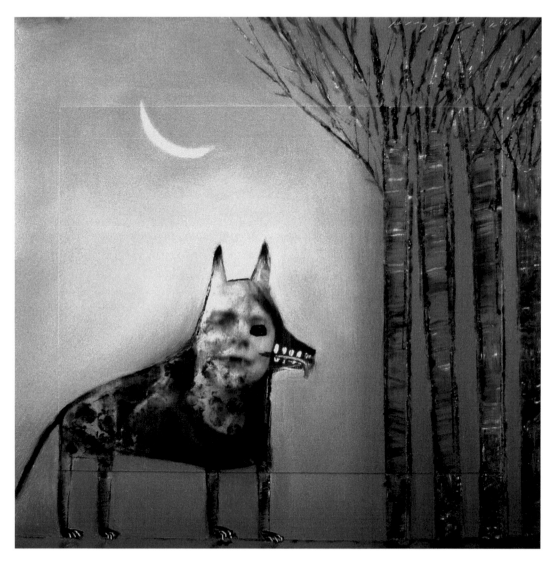

2.1 Holly Roberts, *Small Wolf with Forest*, 12 × 12 in. (30.48 cm), black and white gelatin silver print adhered to panel with oil paint over, 2000. Courtesy the artist.

Roberts has been blending painting and photography for over three decades. Her work challenges not only technical notions but also psychological ideas, and it offers no pat answers. Although the photo is of her daughter, Roberts says she wanted to address the wild nature inherent in every kid, but especially her youngest child, Teal.

2

Hand Coloring

Hand coloring is a means by which you can add color to a photograph, photographic printing technique in this book, or digital print and expand the visual and psychological impact. Those who do not feel comfortable drawing but feel the need for painterly expression may find satisfaction in hand coloring a photograph or digital print; modeling, perspective, and anatomy are already apparent in the image. One need not have a darkroom because there are numerous shops that will print for you or rent to you, and I have listed but a few later in this introduction. Hand coloring should be done in indirect daylight or under daylight-balanced fluorescent or blue-frosted daylight bulbs.

From the beginning of photography, daguerreotypes (see Chapter 15), which were the first practical photographic process and announced publicly in 1839, were hand colored by the very men and women who had previously been hired by patrons to paint miniature portraits. The neutral gray tones were not popular with sitters, so studios devised a method of dusting or lightly stippling with a fine brush a powdered pigment and mixing it with gum arabic on the delicate picture, then "fixing" the surface with the painter's breath. Or, the colors were mixed in alcohol and brushed on so that they would dry rapidly to a visible tint. (You might mistake the pale blue areas in daguerreotype highlights with hand coloring, but the azure tinge often was due to over exposure. Jerry Spagnoli purposely uses that blue, as you can see on page 295) Yet, right from the beginning, an ethical and aesthetic debate arose whether it was "impossible to add by the brush to the exquisite workings of nature's pencillings."[1] Even today, I know of traditionalists who find altering the "truthfulness" of photographs to be offensive, yet every time a photographer frames the world and excludes part of it, the image is just that— an image.

A few decades later, tintypes, a less expensive and, therefore, more popular form of photography with clientele from diverse economic backgrounds, were sometimes hand colored.

Both the amount of time taken to paint and the reputation of the painter influenced the price, so less affluent sitters might ask for only rosy cheeks, whereas more expensive and completely colored portraits were seen as status symbols.[2] The process of overpainting, where the layers of pigment are so dense that the photographic image is largely hidden, is seen in the following figure. Some of the questionable advantages of such a method, used before airbrushing and Adobe Photoshop®, were to hide "flaws" and even to pass as a painting!

Before color photography became widely available and relatively inexpensive in the 1960s, studio photographers hired artists to apply transparent layers of thinned oil paints or water-based aniline dyes onto black-and-white portrait photographs, a method also referred to as hand tinting. One of those original companies, Marshall's, is still very much alive, and I have used both their oils and pencils and listed them in Supply Sources under OmegaBrandess. Multiple layers of color were built up as the artist allowed each coating of paint or dye to dry and harden before adding another layer. Advertising firms sometimes use hand-colored touch-ups of color photographs to infuse objects with more vibrant color than they originally possessed, although digital imaging and touch-up are more common. Colorists also were sometimes hired to add color into black-and-white photographic murals. I often use a system of purposely creating gray-and-white digital prints or photocopies on paper from my black-and-white negatives or digital RAW shots, then opaquely pasteling over them, because certain inkjet and printmaking papers also can be covered with oil-based and chalk-based mediums, detailed later in this chapter. I advise against trying to salvage an unsuccessful photograph; it will look like a bad photo with colors on top.

If you do not know how to use an analogue darkroom, you can hire someone to make black and white photographs. For instance, offering a dazzling array of services are MV Labs in Newburgh, NY: http://www.mvlabs.com; Digital Silver Imaging in Boston, MA: http://www.digitalsilverimaging.com; the family-run Cox Lab near Sacramento, CA: http://www.coxblackandwhitelab.com; rental darkrooms, as well as digital facility and alt. process workshops at London's Photo Fusion: http://www.photofusion.org; rental color and b/w darkrooms and gallery in Tokyo's M Place: http://www.placem.com/darkroom_en.html); black and white film, toy camera, and cross-processing of color film (Hybrid Color chapter) at the Darkroom in San Clemente, CA (https://thedarkroom.com).

The two major categories of materials for hand coloring traditional photographs are water-based (toners, dyes, and watercolors) and oil-based (oil paints and special photo oils), which may be used alone or in combination with each other. If you combine the two methods, it is advisable to apply water-based colors first, because oil-based materials will adhere to water-based ones, while water-based materials do not cover well over oil. Although I use pastels over digital prints on rag drawing paper, special matte or pearl resin-coated photo papers, such as ones made by Ilford, also accept pastels.

Selection of the coloring agent depends on whether you wish to apply color to a glossy photograph (water-based materials work more easily) or matte photograph (either oil- or water-based colors can be used), and the effect you wish to achieve (water-based colors seep into the gelatin coating of a photograph or the image area of a print allowing the detail of the photograph and texture of the paper to show; oil paints rest on the surface of the picture and can cover up photographic detail and the texture of the paper). Both oil-based and water-based colors can be applied to selective areas or the entire image, on paper as well

as fabric. If you are hand coloring a digital print, the oil-based method does not work well because the oil seeps into the paper fiber and can yellow it over time.

When using a photograph, always start with a completely processed and carefully washed print. Oil paints work best on dry photos, while water colors, toners, and dyes work best on damp prints. Both can be applied to inkjet prints. If you have never painted before, you can purchase a color wheel or go to http://www.color-chart.org/color-wheel.php to see an approximation of what will happen when you mix hues.

Enjoy the hours you might spend hand coloring by providing yourself with a comfortable chair and work table, preferably near a window or skylight.

2.2 Erica Daborn, *Men Only*, from the *Interplay Series*, 21½ × 21¾ in. (54.6 × 55.2 cm), gouache, pencil, and ink drawing over inkjet print of enlarged bookplate, 2005. Courtesy the artist.

The drawings are made over carefully selected 1940s and 1950s photographic book pages, but the idea of transformation is central. The photographic fragment and what might be a deliberately crude drawing are forced to "live" together, thereby breaking down the distinction between traditional notions of the document and invention.

WATER-BASED METHOD

Water-based materials come in a wide variety of colors and types, and they work well on many surfaces. Once you feel comfortable with the suggested procedure for water-based coloring, don't be afraid to experiment. Many exciting results come from techniques that are not supposed to work.

SAFETY

Certain colors, such as emerald green, cobalt violet, true Naples yellow, all cadmium pigments, flake white, chrome yellow, manganese blue and violet, burnt umber, raw umber, Mars brown, lamp black, and vermillion, can lead to poisoning and other complications if they are ingested or inhaled frequently. When in doubt, look up the Materials Safety Data Sheet on your supplies.

Wearing a respirator and protective hand cream, working in a ventilated area, and carefully washing hands and cleaning fingernails with soap and water—not solvents—after using these pigments can help prevent accidental poisoning or ingestion of the colors. Never point the tip of a brush by putting it in your mouth.

Wear goggles and protective gloves to avoid eye contact with wetting agents and other chemicals.

Never smoke or eat while you are painting.

METHOD OVERVIEW

1. Photograph or photographic print is prepared.
2. In daylight or mixture of fluorescent and incandescent light, colors are applied to build up areas or layers.
3. Print is fixed to protect colors, or print is allowed to dry.

MATERIALS

1. Image. Black-and-white, toned, or color photographs are fine. There are two kinds of substrates: fiber (which takes longer to process but is considered more archival) and RC (a resin coating speeds up processing but can leave a plastic-y feel). In addition, the papers can be either variable contrast, which allows the darkroom practitioner to use almost any contrast b/w negative because the contrast can be changed at the enlarger with filters; or graded, which means that you need the correct kind of negative to obtain richer blacks than usually possible with VC paper.

2. Almost any fiber-based photo paper works well with water-based materials, and that is the kind of paper I use and will list here. Lastly, the finish can be glossy, matte, or semi-matte/luster/pearl, and the tones can be neutral or warm. Bergger makes one of the highest quality fiber papers, Prestige Glossy or Semi Gloss Warmtone. Ultrafine Silver Eagle, which I have not used, makes both glossy and matte variable contrast fiber paper. A limited quantity of Kentmere Select VC RC Lustre surface is good for hand coloring. In addition. Foma's Fomotone Graded Matte is their premium paper, but they also make a VC warm tone paper and many others. Ilford Galerie is their ultra-high quality fiber paper, but they also manufacture a matte, textured art paper, specifically recommended for hand coloring, as well as cool and warm toned semi matte paper. Oriental Seagull, another one of my favorites, comes as VC fiber Warmtone or neutral VC fiber papers Adox Premium fiber VC Glossy or Semi Matte, Arista fiber VC fine Grain Glossy or Semi-Matte. An almost unfathomable selection can be purchased at Freestyle Sales in the United States, listed in the Supply Sources!

3. Using the antique methods described later in this book, photographic prints on artists' rag paper will take water-based colors, but both photo paper and drawing/water color paper must be flattened because a crack or crease will show up as a dark streak when you color the picture. If you are working on a glossy print, use less water when mixing the tint. Natural or natural-synthetic fabrics will accept water-based colorants more easily if the cloth is ironed or tightened over canvas stretchers first, although most water-based paints fade when fabric is washed.

4. In addition, water colors can be applied directly onto rag inkjet pictures; it seems that the digital coating acts like a sizing (see Chapter 4: Creating the Photo-Printmaking Studio for more about sizings.) I advise, however, that you let the inkjet print "set" for 24 hours before you apply water color and/or acrylic paint.

5. Colors. Water-based substances include Marshall's Retouch Colors, Nicholson's Peerless Transparent Watercolors, PEBEO Colorex ink, artists' water colors and acrylic paints, food coloring, coffee, tea, batik dyes, photo chemicals (see Chapter 16, Chromoskedasic Painting and Lumen sections) and felt tip pens. I have found Dr. Ph. Martin's Synchromatic Transparent Colors to be the most intense (https://www.docmartins.com). Marshall's retouch colors and Dr. Martin's colors come in bottles of concentrated dyes that can be purchased at photography stores or directly form the producer. They can be diluted with water before use and they also can be air brushed, as can Badger Air Brush Colors. You can also use white opaque water colors (gouache) to cover small dark areas.

6. Nicholson's Peerless Watercolors, available at art stores, come in two forms: concentrated liquid and dry sheet. They are made for application on black-and-white photographic paper and the dry sheets are great to travel with because they are packaged as booklets of color-saturated sheets. They can be wetted with a brush for application directly onto the image. Or a piece of the sheet can be cut off, placed in a bowl, and covered with just enough water to dissolve the color from the sheet. Excess color can be blotted off with the blotter supplied in the booklet or removed entirely by immersing the print face down in a pan of water.

7. Food coloring found in grocery stores (the least expensive, but also a fugitive coloring agent) or tubes of water color paints from art stores can be applied to photos if a wetting agent, such as Kodak Photo-Flo or Ox Gall, purchased at an art store, is added to either of them before use. Food coloring, however, is difficult to remove from a print after it has been applied. Ralph Hattersley suggests using medicinal dyes, such as merthiolate (shocking pink) and gentian violet (purple) to extend the limited range of food colors (*Photographic Printing*, 1977, p. 221). See the tips on page 71 at the end of Toning, Chapter 3, for more ideas concerning medicinal and food dyes.

8. On black-and-white photos, I have taken to drawing with color spotting pens, which are intended for getting rid of problems in color photos. Alcohol-based permanent markers can add a wet-on-wet color quality to glossy photographs and laser color copies, while nonpermanent felt-tip pens are great for tiny areas. But most ingenious of all is Zig Photo twin tip markers, which look like markers but have both a fine and broad brush on each pen. They can be used to tint photos and write or draw and are both light-fast and acid free. And one colorist recommends fluid makeup from any cosmetic manufacturer, if you use it on a matte surface and let it dry thoroughly for a few minutes after applying it.

9. Photographic prints on sized or unsized artists' papers and fabric images made by the techniques described in this book take to water-based materials in varying degrees. On rag paper and fabric, artists-quality water color paints and water-based felt pens work well, as do retouch colors and Peerless colors, colored pencils (Prisma is my favorite brand), crayons, and pastels. Prisma also markets Col-erase colored pencils once used on blueprints and engineering drawings, and they come in 24 colors. For fabric, Binney and Smith makes Crayola Craft™ fabric crayons and fabric markers, and Pentel makes Fabricfun™ acid-free pastel dye sticks, which become permanent when heated. Perusing the aisles of a craft store will offer imaginative possibilities for adding color to fabric and rag paper. I have liked using procion natural dyes with an alginate thickener so that I can paint without the color bleeding on natural fabrics. Because these dyes change the color of each fiber, rather than staining or sitting atop the fabric, they are more permanent. I cannot always use water-based materials to color digital prints because sometimes they will dissolve the digital ink, so I test first.

10. Toothpicks, skewers, cotton swabs, absorbent cotton, sable water color brushes, such as Winsor & Newton series 7 No. 0 and No. 2, or cosmetic sponge. By wrapping a thin piece of absorbent or surgical cotton—not synthetic cotton—around a toothpick or a bamboo skewer (available in butcher shops and barbeque suppliers), you can make an inexpensive, disposable tool for coloring details. Marshall's packages either metal or wood skewers in their kits. A damp sponge or cotton ball lightly wiped over the surface of a photograph facilitates the application of colors in large areas.

11. Ilford Ilfotol, Kodak Photo-Flo, Edwal Wetting Agent, Ox Gall, liquid dish soap, or an equivalent wetting agent by other manufacturers can be purchased from a photography store (wetting agents are usually used when developing film) or art store. See Item 2 above about food coloring. Mixing a strong solution of wetting agent, such as a few drops to 2 oz. (59 ml) distilled water will create a solution that can be carefully swabbed onto an unwanted color to remove it from an area that has been hand colored. I also use it to prepare the photo emulsion to accept color.

12. Water. You do not need running water, but you will need a tray of 32 oz. (946 ml) of water at room temperature. You may need a beaker to dilute the wetting agent with water.

13. Household ammonia can be diluted with water, picked up on a cotton swab, and gently rubbed in a circular motion on undesirable color for partial removal of that color. Then, swab the area with clean water-dampened cotton, making sure to gradually remove all the ammonia. Too much rubbing, however, will lift off the emulsion of that image. Allow the area to dry before you apply more liquid colors.

14. Masking tape is needed to secure the print to your work surface. Make the tape less sticky and less likely to damage your print by patting a length of it onto your clothes before using it. When you are finished coloring, you can remove the tape easily, leaving the print with clean borders. For prints on artists' paper, drafting tape is less sticky and will not rip artwork when removed. I prefer the acid-free artists' masking tape for archival reasons. In addition, the application with a brush of masking liquid, rubber cement, or frisket will assure white borders and is easily removed. Brushes may need to be cleaned in solvent, so wear gloves and respirator. Only wear a respirator mask if you are neither pregnant nor suffer from heart and lung diseases. Consult with a doctor.

15. Newspaper or glass protects a tabletop from stains caused by the dyes. Make sure that your work surface is smooth, because indentations show up as imperfections in the colored area of the image and roomy so that you do not have to worry about spills.

16. Facial tissues, such as Scott Precision Wipes, can blot liquid color and wipe the brush of excess color. Or, you can use white blotter paper to gain control over the strength of the applied color. Protective silicon hand cream from a hardware store is needed if you plan to apply color without wearing gloves.

17. Medicine dropper, available at drug stores or Photographers' Formulary, controls the dilution of mixed solutions. A measuring cup is needed for mixing the solution. Some colorists use a magnifying glass or lamp with magnifying lens for detailed work.

18. Bowls, flat white palette, or paper cups. Use small white bowls or paper cups to hold diluted colors. A white ice cube tray also makes an efficient palette, as does the white plastic watercolor palettes available at an art supply store.

WATER COLORING METHOD

2.3 Prepare the Work Space and Tools

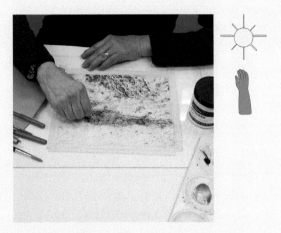

2.4 Prepare the Palette and Apply the Color

1. Prepare the work space and tools

Press 2 in. (5 cm) wide masking or drafting tape to the work surface and picture. Continue pressing half the tape flush to the border of the image, and half the tape to the work surface. Tape down all sides of the print in this fashion. Rubber cement (used as described in the toning chapter) also can mask out areas that you do not want to tint. Using a medicine dropper and a measuring cup, mix one drop of wetting agent to 4 oz. (114 ml) of water. With a wad of cotton or sponge soaked in the Photo Flo-water solution, spread the liquid over the photograph's surface. While it is soaking in, make the toothpicks or skewers for coloring or "erasing" small areas: wrap a thin amount of absorbent cotton around a toothpick that has been dipped in water.

2. Prepare the palette and apply the color

Squirt one drop of each color or squeeze a pea-sized amount of pigment into separate bowls or cups, or mix different colors in the same white saucer to create new hues. I re-create a color wheel in the way I lay out pigments.

Add drops of the diluted wetting agent to each bowl of color until you make the color a shade lighter than you want on the print. Mix thoroughly. Save the unused, diluted wetting agent.

Saturate another cotton ball with the wetting agent/color mixture, then apply the color lightly to a large area (such as the background) by quickly stroking the image with the color. If the hue is too light, re-saturate the cotton ball and reapply the wetting agent and color to the picture.

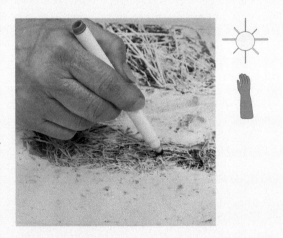

2.5 Remove the Color

3. Remove color (optional) and add more color

In a cup, mix one drop of bleach to ten drops of water. Saturate a cotton swab with this mixture, and lightly rub an area of unwanted color with the swab. Blot the area dry with tissues or blotter paper. Dip a fresh cotton swab into another bowl of color, and stroke the swab in

a new area of the image. Remove unwanted color if you need to. A cotton-wrapped toothpick, pointed sable brush with less color, or a felt tip pen works in small areas. Clean brushes after each use.

4. Finish the print

Air dry the colored print overnight. If you want to work further on the print, you can use more water-based color or oil-based pigments. Carefully remove the masking tape after you have completed coloring.

TIPS

As with numerous processes in art, new painters will avoid some frustrations if they start small, get used to the procedure, and then work larger if desired. I recommend you start with an 8 × 10 in. (20.5 × 25.5 cm) photo that does not contain many small details. If you cannot afford the lamps with fluorescent and incandescent bulbs, set up near a window so that you work with a combination of indirect sunlight and a desk lamp.

If the liquid dyes dry out, you can add a little distilled water to make them usable again.

It is better to start with too light a hue because you can always add more layers, but removing dye is much more difficult.

If you apply too much color, quickly blot with a paper towel.

If one hue is too brilliant, add a touch of a neutral color, such as brown, or add a small amount of its opposite color on the color wheel.

Highlights, shadows, and modeling in the photographic print can show through the layers of paint. Start with a color lighter than you want, and slowly build up layers until the desired chroma is achieved.

I enjoy using a color you might not expect to find in a certain area as an accent or detail.

If you allow a large border around your print, you can test colors before you apply them. Mark Morrisoe (https://www.visualaids.org/artists/detail/mark-morrisroe), who went to the Museum School, kept the marks visible on his finished work.

Some photo paper companies make mural paper in rolls. The toning chapter details the processing system used at the Museum School.

OIL-BASED METHOD

Oil-based hand-coloring materials are easier to control and apply than water-based ones. Mistakes made with oil paints and photo oils can be removed easily, and prints can be reworked, yet oil-based paints have the greatest permanence of all hand-coloring materials.

SAFETY

Turpentine (found in Marshall's Photo Oils Prepared Medium Solution) can cause skin and respiratory irritation, allergic reaction, and kidney damage, sometimes years after exposure. It is highly poisonous if ingested and should be stored out of children's reach. Wear a respirator if you are neither pregnant nor suffer from heart and lung diseases. Consult with a doctor.

Wear protective gloves and work in a well-ventilated area.

Certain pigments, as listed in the safety section above for the water-based method, can be toxic.

Never smoke or eat while painting, and do not allow any painting materials to come into contact with your face.

Marshall's Pre-Color Spray and other primers are toxic and highly flammable, so do not use them near an open flame or throw the empty can into a fire. Spray outdoors or in a very well-ventilated room while you wear a mask.

Trichlorethylene, found in Marshall's Marlene, is a suspected cancer-producing agent. It is highly toxic by inhalation and ingestion, causing possible nervous system disorders and reproductive system problems. Trichlorethylene products have been associated with a risk of "Sudden Sniffing Death" due to fatal heart abnormalities. I strongly urge you not to use it, but if you must, be sure to wear protective gloves and a vapor mask and work in a well-ventilated area (i.e., one that has 20 changes of air per hour). In the presence of flames, even lighted cigarettes, and ultraviolet light, trichlorethylene can decompose into a toxic gas. It is flammable if heated. Instead, substitute less toxic solvents, such as orange oil (CitraSolv, De-Solv-it, and the most eco-friendly ZAcryl D-Solv) because they show no carcinogenic or neurotoxin hazards comparable to petrochemical solvents, and are biodegradable. Use with caution gum turpentine, which is toxic by skin contact and inhalation but extremely toxic by ingestion. Chronic exposure to turpentine can cause serious kidney problems and allergic sensitization, which may not show up until after years of exposure.

METHOD OVERVIEW

1. Photograph or photographic print is prepared.
2. In daylight or mixture of fluorescent and incandescent light, colors are applied to build up areas or layers.
3. Print is fixed to protect colors, or print is allowed to dry.

MATERIALS

1. Image. Black-and-white, toned, or color fiber based and not RC photographs work fine. Suitable fiber papers include Bergger Semi Matte, Forte Matte, Kentmere, and some of the smaller manufacturers, who will probably be the sole sources of any kind black-and-white photo papers in short time. More papers and their descriptions are listed above, in the Materials section of Water-Based Method. Check out Freestyle Sales (see Supply Sources) because they carry Adox with its high silver content and Foma contact speed. I have used glossy photo paper because I like the way it renders strong blacks, but matte and semimatte are much easier to work on. If you are starting with a glossy print, a layer of Marshall's Pre-Color Spray makes the surface easier on which to apply color, but is not obligatory. Wear a mask if you spray, and spray outdoors.

Photographs should be dry and flat, because a crack in a print will show up as a dark streak of color. Work from a technically good and slightly light photograph—it is difficult to conceal a muddy image. Some photographers prefer first toning the photo (Chapter 3) before hand coloring so they can change the blacks and even the paper base. Other variables to consider include the contrast, or amount of black, white, and gray; the image tone (whether it is a warm brown-black, a cool blue-black, or a neutral green-black); and the base of the photo paper itself, which can be bright white or off-white. You might find it less frustrating and less expensive to start with an 8 × 10 in. (20.5 × 25.5 cm) image with simple shapes and work up to larger, more complicated pictures. Making several copies of the same image frees you up to practice and experiment.

Use the light-sensitive techniques in this book on fabrics such as linen and other natural fibers, which accept oil-based colorants and work best if first ironed or pulled over canvas stretchers.

If you want to oil paint on a digital print, try inkjet media canvas, which has a digital coating. In addition, some commercial labs print on prepared

canvas. I advise, however, that you let the inkjet print "set" for 48 hours before you stretch it and apply paint.

2. Oil-based colors. Paints made especially for application onto photographs include Marshall's Photo Oil Colors, and, for saturated hues, see Brandess/Kalt and Marshall's Extra Strong Colors in the Supply Sources. Marshall's also manufactures Photo Oil Pencils and pencil blender, great for coloring small details, and extender, which has a variety of uses; the addition of extender to Marshall's oil colors creates more subtle hues, helps move color across the photo's surface, and works well for cleaning paint away from small areas. The extender, Grumbacher Transparentizer Gel for *Oil Paints*, Gamblin Solvent-Free, non-toxic Gel Medium for oil colors, or Weber Res-N-Gel Oil Painting Medium, in art stores, can be mixed with traditional artists' oil paints for easier application onto photos or for thinning a color so that the highlight detail, shadow, and modeling of the photograph show through the layer of color. Marshall's Introductory Kit, which I recommend if this is your first effort, contains everything you will require, but it does not include extender, but you can buy a separate tube if you need it.

The photograph acts like a painter's underpainting, and the layers of color act like a painter's glazes. Allow one layer of color to dry before adding another.

3. Cotton balls and cotton swabs. Surgical cotton—not synthetic—balls or absorbent cotton apply color in large areas of the picture, while swabs such as Q-tips blend the edges of areas of different colors. Both products are available in drugstores. See Item 3 above and the first step-by-step photo in Water Coloring Method for more details.

4. Toothpicks, bamboo or metal skewers, sandwich toothpicks, and pointed red sable brushes. By wrapping a thin piece of absorbent cotton around a toothpick or a wooden hibachi skewer (available in butcher shops), you can make an inexpensive, disposable tool for coloring details and removing unwanted paint from small areas. Because the hibachi skewer is long, it is great for reaching the bottom of an almost-empty bottle. You can order extra Marshall's skewers and cotton from Brandess/Kalt/Aetna (see Supply Sources). Keep applicators, whether brushes or cotton on skewers, clean so that you will not end up with muddy colors.

5. Palette. A sheet of glass underlined with white paper or a white china plate best displays true colors, and you can mix colors on such a palette. The disposable paper palettes available in art stores, acetate, or interleafing clipped to white cardboard also work well. Wax paper is not advisable because the wax can chip into the paint.

6. Surface preparation. Rectified gum turpentine (sold at art stores) or Marshall's Prepared Medium Solution is wiped over the surface of an uncolored photograph to make the colors spread more easily. Kira Brown, in *Photo Techniques Magazine* (September/October, 2000), advises to be careful not to oversaturate the surface or the colors will not stay on the photograph well, a problem particularly frustrating if the photo has a glossy surface. Squeeze most of the liquid out of a cotton ball before beginning and do not press down too hard. Allow the solution to dry until the surface is soft, but not slick. In addition, either of these solvents soaked onto a cotton swab can be used to soften the tips of colored pencils for a less streaky effect. Use Turpentine and PM (prepared media) solution to clean unwanted oil paint or try the less harmful orange oil (CitraSolv, De-Solv-it, and the most eco-friendly ZAcryl D-Solv).

Grumbacher's or Marshall's Pre-Color Spray dulls glossy photos and thus makes the image surface easier to work on. Marshall's recommends using Marlene to remove unwanted paint, but it will also strip these primer sprays off the photo. Use a kneaded eraser instead.

You do not have to prepare photographic prints on traditional artists' paper unless the paper grips colors too much for you to control; Marshall's Pre-Color Spray helps avoid stains from the paints.

7. Kneaded eraser or Marshall's Prepared Medium Solution can remove small areas of unwanted color—this must be done before the paint dries and hardens. Kneaded erasers, such as Faber Castell Peel-Off Magic Rub nonabrasive erasers, are sold at art stores and are made of malleable rubber that can be worked to a fine point. Eraser particles can be dusted off with canned air, and I find them the most effective way of "erasing." PM solution is really helpful to prepare the surface to accept colors.

8. Fixative (optional) can be used to protect the surface after an image has been painted and dried. Fixatives are sold in art stores, but not all are of archival quality because they can yellow a print within a few years. Spray fixatives are toxic if inhaled, and a respirator should be worn when you use them. Schminke et al., in *Digital Art Studio* (see Bibliography), offer a postcoat formula you can mix from acrylic-matte medium and isopropyl alcohol.

9. Facial tissues without additives such as aloe or oil. Because of health risks (refer to Safety section), color should be smoothed on with a finger covered with a tissue, such as Scott Precision wipes, or a soft piece of cloth, such as an old handkerchief. Protective silicon hand cream from a hardware store or art store is needed if you plan to rub color in with your bare fingers.

10. Masking tape is needed to secure the print to your work surface. Make it less sticky and less likely to damage your print by patting a length onto your clothes before using it. When you are finished coloring, you can remove the tape easily, leaving the print with clean borders. For prints on artists' paper, drafting tape, which is less sticky, is advised because it will not rip your artwork when removed. Or, use the tape to avoid getting color onto the border if you want the edges to be clean.

Badger's Foto Frisket Film can keep the borders white as well as temporarily seal a color when you apply another color near it. The film comes in sheets that are cut with a sharp blade in daylight. Many art companies make liquid frisket, and some are specifically intended for photos. I also use neutral pH rubber cement, which I mix with red food coloring so that I can see where I have laid down the mask. Apply to a dry photograph.

11. Newspaper or glass protects a tabletop from stains caused by turpentine and oils. Make sure that your work surface is smooth, because indentations will show up as imperfections in the colored area of the image. Paper towels under your hand help protect a wet area from smudging and from collecting fingerprints and perspiration.

12. Spotting fluids, retouch colors, or spotting pens, available at photography supply sources, eliminate white marks on the photo, often caused by dust on the negative when it is being printed. Follow the manufacturer's instructions and spot before you paint.

OIL-PAINTING METHOD

Please note: in these step-by-step pictures, I am applying oil paint on top of water-based colors.

1. Prepare the work space, tools, and photograph

Press a length of masking or drafting tape half to the work surface and half along the border of the image and beyond the print. Tape down all sides of the print in this fashion. Use Frisket along the white border (optional).

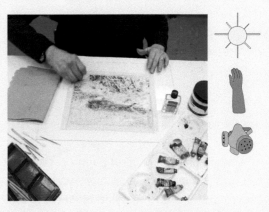

2.6 Prepare the Work Space, Tools, and Photograph

Spot the print to eliminate printing imperfections.

Set out all colors by squeezing pea-sized amounts onto the palette. Arranging in color groups, as suggested by a color wheel, may make work easier.

Fray the edges of a ½ × ½ in. (1.25 × 1.25 cm) piece of cotton to make a painting tool, as shown in Step 1, Water Coloring Method, above.

Saturate a cotton ball with PM solution or turpentine. Carefully rub the entire photograph with the cotton, then use a facial tissue to evenly wipe off the excess until the print appears dry. You may need to re-prime areas if you continue to work a day or two later. Prepare glossy surfaces with Marshall's Pre-Color Spray. Hold the can 12 in. (30.5 cm) from the print and spray back and forth. After the coating has dried, spray the print using an up-and-down motion. Matte surfaces may need no preparation.

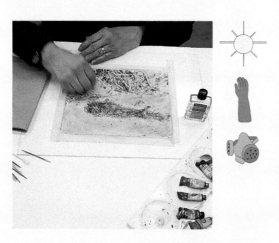

2.7 Apply Color

2. Apply color

Use colors straight or mix colors on the palette by blending paint with a cotton swab. Pick up approximately ⅛ tsp. of paint on a cotton ball and rub it into a large area, such as the background. Do not worry about keeping the color within a border, but keep rubbing the color until it is smooth and does not glisten when viewed from an angle. If color overruns an area, clean it off with a cotton-wrapped skewer dipped in Marlene, extender, or turpentine. Blot the area dry with a tissue. Use a kneaded eraser to remove excess paint from prints treated with Pre-Color Spray.

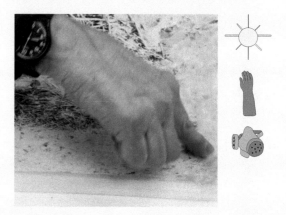

2.8 Blend the Colors

3. Blend the colors

Use your finger, safeguarded with silicon protective cream, a tissue, or dry cotton, to rub paint and blend edges of an area. Always rub down each area and remove excess paint before applying color to an adjacent area.

Use a fresh cotton swab and ¹⁄₁₆ tsp. of paint to apply another color to a medium-sized area. Clean the print as previously described. A cotton-wrapped toothpick with less paint or photo pencils will work to apply color in small areas. Paint as much of the image as you want, taking into account how the actual tones of the photo affect the colors.

4. Finish the print

Air dry the colored print overnight. If you want to work color into a print that has been colored and dried, use extender or gel mixed into the new pigment, which makes a color lighter and more sheer. Remove the masking tape after you have completed the coloring or use a kneaded eraser to clean up the border.

TIPS

See tips for water-based materials, in the first part of this chapter.

Almost any brand of artists' colored and graphite pencils, crayons, dry dyes, and pastels can be used on photographs if you prepare the surface beforehand with a layer of workable fixative, or Grumbacher's or Marshall's Pre-Color Spray, available at art stores. All of these sprays are toxic and flammable, so treat photos outdoors or in a strongly ventilated area. After applying pencil color to the print surface, rub it in with a cotton ball or swab.

Highlights, shadows, and modeling in the photographic print can show through the layers of paint. Start with a color paler than what you want and slowly build up layers until the desired chroma is reached. Once a color has dried onto the photograph, never use PM solution or turpentine to work more color into that area—these preparations can loosen the underpainting.

I tend to work from the inside to the outside of an image and to turn the photo upside down so as not to smudge paint already on it. I also find it easier to work with a sheet of clean paper toweling under my wrist and to wait a few hours for the first layer of color to set before adding a hue on top. In addition, you do not need to worry about "staying within the lines" because you can always precisely remove paint later.

Days later, paint on a palette may dry and form a skin, but you can prick the skin with a toothpick, remove it, and use the loose paint underneath. (If a cap on a tube of paint sticks, you can loosen it by holding a lighted match under the cap for a few seconds.)

The Marshall's kits are packaged with what, at first, I considered hilarious instructions for how to, for instance, paint "flesh." However, I realize now that, with some thought and looking, you can take the basic instructions and modify them to your purposes, or deliberately do the opposite!

You can completely remove a color, even after it has dried, with Marshall's Marlene, but remember to re-apply PM solution before you re-work that area.

When using the Marshall's or Prisma pencils, be careful not to press so hard that you leave an indentation.

You can also use fabrics especially manufactured for digital printers with mediums, such as oil paints, but you should test the substrate first by placing a drop of linseed or vegetable oil on the coated side, then seeing if the oil goes through and stains the back after a day, indicating that it will not work.

My students have successfully ironed thin papers and fabrics onto wax paper, sent the two through a printer, then easily peeled the wax paper off afterward.

When color office copiers were first being introduced, I was invited to try one out by the Massachusetts Institute of Technology. I think I might have given the technicians a heart attack when I applied and ironed many layers of spray starch on the back of synthetic satin, but this method stiffened the fabric so it behaved like paper, and it worked! William Paul & Associates (see Supply Sources) sells Vesta inkjet cotton canvas, and Brandess/Kalt/Aetna (see Supply Sources) sells Marshall's InkJet Canvas and Photo Oil sets for running through digital printers. They are water-resistant and have a matte surface.

Schminke et al., the authors of *Digital Art Studio* (see Bibliography), explain how to use digital printers with leather, matte board, corrugated cardboard, and other surfaces, but they are careful to use a special precoat and to make sure that the materials are not too thick to fit through the printer.

2.9 Laura Blacklow, *Shards*, 22 × 30 in. (56 × 76.2 cm), pastels on black and white inkjet print on rag vellum paper. ©LBlacklow.

I made this piece with words excerpted from my journal. At the time, which was more than a decade ago, the only rag digital paper at the Museum School, where I teach, was vellum. It is challenging to work on because synthetic vellum stretches a bit, rips fairly easily, and does not like to hold layers of chalky hues. On the other hand, the surface has a translucency that seems to make the colors glow, and I apply the pastels to a low contrast (mostly gray) under-image. I had to cover my studio wall with flat white matte board to which I attached the vellum because it would otherwise pick up the texture of the plaster wall. In addition, I utilized a restaurant-size exhaust fan, so that I could spray fixative as I worked or walk out of my studio at the end of the day.

CHALK-BASED METHOD

SAFETY

You need to protect yourself and others from breathing in pastel's chalky particles, and some colors are toxic (particularly alizarin, benzadine, chrome, cobolt, cadmium, manganese, and lead but not so much ultramarine and iron). If your studio is in your living area, change your clothes and shoes before closing the door and leaving. Do not let children into the studio.

Wear a respirator mask if you are neither pregnant nor suffer from heart and lung diseases. Consult with a doctor.

Work in a well-ventilated area that pulls air away from your face.

METHOD OVERVIEW

1. Digital image is printed in black and white on digital rag paper or picture in an historical technique is created on rag or printmaking paper.
2. Color is applied and usually is eventually blended.
3. Pastels are spray fixed. More color can be added later, then fixed again.

MATERIALS

1. Substrate. Slightly textured rag digital papers, akin to the printmaking papers recommended for the

hand-coated processes in this book, are available. My favorites are those made by Hahnemühle, Somerset, Moab (I use their Duo for two-sided pages in my hand-bound books), and Platine. If you are going to make a digital picture for your base, I advise that you use the more archival pigment inks in your printer and test on small pieces of paper to save money and the environment by discarding less paper. If you are willing to work on traditional rag paper, rather than specially coated digital rag paper, your job is a bit easier, as the pastels glide across the surface more easily. Non-digital paper does absorb more ink.

I start with a digital print or a pale—maybe 10–15 percent lighter—hand-coated print created from one of the techniques in this book. If you have used one of the hand-coating processes in this book, you can employ either pastel sticks or pastel pencils and all the other materials in this section.

2. Pastels. I use traditional dry and not oil pastels while wearing a dust mask and skin-protecting lotion. I have found that the colors apply without streaks if I rub the chalk onto scrap paper first, then pick up that dust with my (protected) fingers and rub onto the paper. Carefully done, you can smoothly apply pastel to larger areas by removing the wrapper and using the chalk on its side.

My favorite brand is the French Sennelier Soft pastels, a company started in 1887 by a chemist, and a close second is Germany's Schmincke Soft pastels, a business founded in 1861. For the method I use, I find these silky pastels the most malleable. http://www.sennelier-colors.com/en/Atelier_58.html has tutorials. Pastel pencils are also available, and I use them in small areas or the picture.

The traditional order is to work from hard pastel to soft pastel, a practice I sometimes ignore.

3. Helpful tools. In addition to your fingers, you can spread and smooth pastels with a soft paint brush; pastel shapers, which come in assorted shaped rubber points and look a bit like a paint brush, some of which also have a brush at the other end of the handle; tortillons or stumps made from tightly wrapped paper and shaped like crayons (When the tip looks dirty from use, you unwrap the paper to expose a clean end. I actually have one for each primary and secondary hue on the color wheel); Q-tips or the equivalent generic brand, which are good for blending small areas, even though I prefer tortillons; and chamois to blend large areas of colors, but I have found it removes too much color, although it lasts forever because all you do is wash and dry it, then use it again.

Finger cots protect your skin from becoming raw—mine dries out from the chalk and washing. Moist cleaning wipes are helpful, even if they dry your skin a bit.

A kneaded eraser is really helpful for taking away color, a process that also keeps the whites white. You can change it from the rectangular block when you purchase it by easily "sculpting" it into whatever shape you need. After the eraser collects chalk, twist and break off that area.

4. Fixative is used to protect the surface after an image has been colored and to improve its lightfastness. Fixatives are sold in art stores, but not all are of archival quality, because some yellow a print within a few years. Some are called workable fixatives, and they are less permanent, making them the solution if you want to layer without completely blending. Not only do fixatives darken the color, a factor you can keep in mind so that you work lighter than the desired end result, but also they impart a bit of a gloss. Most spray fixatives are toxic if inhaled, flammable, and possible carcinogens. So a respirator mask should be worn when you use them; you should spray outside or in a room from which you can walk away leaving a window open, even with a fan. I have found no way around fixative; even after you frame a chalked print, the dust can migrate to the Plexiglas™. Even storing without fixative does not work for me because the colors come off either onto interleafing or the back of the next print unless each print is overmatted. Do not use hair spray, which does not disperse evenly and contains additives for hair!

Sennelier makes my favorite fixative, which is supposed to be sprayed lightly and repeatedly. Spectra

makes one made from milk casein with water, grain alcohol, and isopropyl alcohol, and it comes in a fine mist pump sprayer; the manufacturer says that it minimally alters the value and does not change the hue of pastels. Make sure that you carefully and evenly spray by positioning the print at an angle and at a distance of one foot (30.5 cm) or more when spraying. Always wait for fixatives to dry before applying more color.

Degas made his own fixative with secret ingredients, but historians think it was a mixture of shellac and maybe alcohol. An old recipe includes gum arabic and water mixed with glycerin and sprayed via an atomizer. I have heard of contemporary pastel painters using watered down polymer medium in an airbrush or atomizer.

5. Protective gloves or special hand crème, available at an art store.
6. Acid-free or drafting/artist's tape at least 1 in. (2.5 cm) wide.
7. Disposable floor covering (optional) or table covering. I use smooth Plexiglas™ that I can wash clean.

PASTELS METHOD

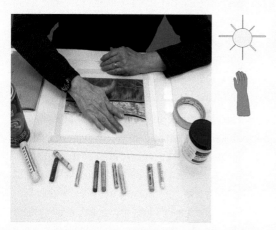

2.10 Apply the Chalk

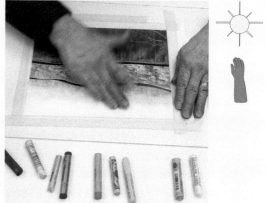

2.11 Create New Colors

1. Apply the chalk

You can tape your print to a vertical wall, but first put a covering on the floor to catch the toxic dust so you can wrap it up and throw it out at the end of each session. Or, you can work on a smooth table. Tape the whole picture down, not only to keep it in place, but also to maintain white borders if you want them. I apply barrier cream to my hands, then often start coloring the part of the photo that is furthest away in the scene.

2. Create new colors

Blend other colors into the ones you have laid down. Why not? If you want a more representative appearance, you can always shoot and print a color photograph! If you are blending with your fingers, clean your hands regularly so as not to create a muddy color, but then put on fresh barrier cream again. You can keep your print horizontal as you spray *workable* fixative to partially preserve layers before you add new ones, like Edgar Degas did.

3. Finish the print

Once you see that the picture is how you want it, spray it with fixative outdoors. For the final coating of fixative, stand the artwork upright, avoid a swinging motion, but be sure that the nozzle is always the same distance (approximately 18 in. or 45.72 cm) away.

TIPS

Spray the fixative so that the draw from a fan or direction of wind will not carry the fumes by your nose.

You will notice that the spray also darkens the color a bit. Spray in good light with a smooth, even motion; you will know if you have consistently covered your art by how evenly the colors darken.

Grumbacher advises that fixatives first be tested on a small, inconspicuous area and let dry; that fixative be used about 65°F (18.3°C) and humidity below 65 percent; that it be sprayed lightly; and that you allow the fixative to completely dry before touching the work.

You should rinse the nozzle of your spray bottle with alcohol to prevent it from clogging.

To frame the work, make sure you use an over-matte so that the pastel does not touch the glass. With large pieces, you may be forced to use Plexiglas™, which, due to static electricity, will attract unfixed chalk particles.

NOTES

1 A quote sent to me by Matthew Isenburg from an old explanation of the American daguerreotype process.

2 Henisch, Heinz K., and Bridget A. Henisch. *The Painted Photograph, 1839–1914: Origins, Techniques, Aspirations*. University Park: Pennsylvania State University Press, 1996.

2.12 Gabriel Garcia Román, *Carlos and Fernando*, 18 × 15 in. (45.72 × 38.1 cm), photogravure portraits with chine-collé and silkscreened text, 2016.

Although the techniques used in Roman's "Queer Icons" are not covered in this book, the ideas and visual impact could be inspiring in any medium. The artist invited the subjects to write, then he used their handwriting as an environment for the portraits. I think that, by giving "outsiders" a voice, Roman has humanized them. The translation is: "FVCKTM 2015 Raised on beans and family Two pour-overs and sweet bread. We were in NYC, PHX, SB & now puro Los Angeles I am 1978 California Parents from Michoacan. Pure fucking Queer! A little nook for the family. Dreamers and bad asses. We are in love with our animals, those personalities. We are cosmic Chicanos from the stars.

Dancing. Searching. Running. Nor from here but neither from there. Educated Pochos. American We are Latinos for Obama and Juan-Ga during the morning. AH-Ha! Learning how to let go to hold on... I am 1977. E L A and Pico. Bicultural. Pure heart. Stuffed peppers, Parents to Vida, Kiko, Montse and Teo We are non-profit love. Breathing happiness."

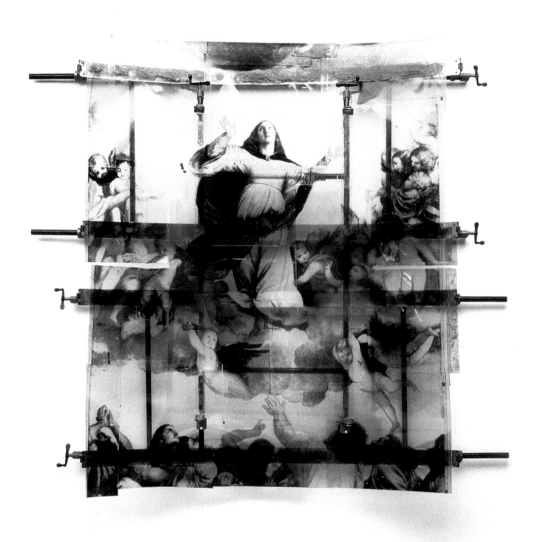

3.1 Doug and Mike Starn, *Yellow Assumption*, 84 × 72 in. (213.36 × 182.88 cm), toner on orthochromatic film, silicon and pipe clamps, 1993.

The twin Starn brothers have been collaborating on artwork for over three decades. In this piece, they first applied Berg Golden Yellow toner to the photographic positive image printed on lith film. They employed clamps and bars to form scaffolding that holds the sheets of film in tension. The clamps force the film panel to bow out in simple arcs formed only by pressure. This visual, physical tension underscores the Starns' concern with their understanding of "anti-stasis," while the subject matter and materiality refer to the transformative aspects of the passage of time. (Lith film is described in Chapter 5, Generating Imagery: Analogue Methods)

3

Toning

By Elaine O'Neil and Laura Blacklow

Toning adds color to a silver-based image, such as a gelatin silver black-and-white photograph, enlargement emulsion print (see Chapter 14), Van Dyke brown print (see Chapter 8), salted paper print (see Chapter 9), or graphic arts/lith film transparency (see Chapter 5), by immersion in, or the selective application of, chemical agents. This process can be performed in ordinary room light as an added step after the print has been completely processed and thoroughly washed. The type of enlarging paper emulsion, or the substrate itself, in combination with the processing time, temperature, dilution, and age of the chemicals used for processing the print, will cause variations in color and

affect the finished appearance of each toned image. Therefore, consistency in the making of the original prints and toning afterward is imperative if uniform results are desired.

Historically, commercial gelatin silver black-and-white photographic papers were available with silver chloride, silver bromide, and chlorobromide emulsions. Silver chloride paper, which renders an image in tones that vary from quite cool to slightly warm, has a very slow emulsion and is generally used for contact printing. Lodima Fine Art (http://lodima. org) manufactures and distributes silver chloride paper as well as Amidol developer in the United States. Photographers' Formulary's Amidol paper developer is alkaline-based,

and the prints resulting from it are similar to those obtained using Weston's Amidol Paper Developer—cold tones and deep blacks.

At the time this edition was ready for print, there was one importer of silver chloride contact printing paper, and it seemed that silver bromide enlargement printing papers, which gave cool tone blacks, are no longer manufactured. However, chlorobromide enlargement papers are readily available from a number of companies in both fiber-based and resin-coated varieties. Often it is ivory or a white paper, rather than emulsion design, which gives the image a warm or cool tone.

Three different groups of toners will be described in this chapter. The first group contains toners which replace the metallic silver in the print with inorganic salts, changing black areas to other colors. The second group, called *color coupler toners*, plate the silver with a color dye. The third group, *dye toners*, give a uniform color to both image and paper.

Toners in the first group convert metallic silver into other insoluble substances, creating new colors in the image areas but leaving the paper unchanged. An added benefit of these toners is that the emulsion is protected from pollutants, which extends print life. Obtainable colors range from a slight brown, blue, or purple tinge to bright pinks or reds, with the more vibrant variations usually produced by using the toners in conjunction with one another. The image alters in relation to its density (the amount of silver buildup or darkness); some solutions tone the highlights first, while others begin to color the print's shadows. *Split toning* takes advantage of this characteristic by stopping the toning process prematurely when the highlights and shadows are different colors. Some photographers use two different toners, one after another, creating one color in the highlights, another in the shadows, and sometimes a third in the mid-tones.

Color coupler dyes also attach to the silver of the image and leave the paper base white. Because the dyes are not dramatically affected by variations in chemistry, time, and temperature during the initial processing of the print, you can anticipate with some certainty what color the toner will impart. The major drawback of these toners is that the dyes lack stability and can fade with prolonged exposure to light.

Generally, *dye toners* color both the image and the base on which it is printed. However, Laura has used Berg (see Supply Sources), a company that makes the Color-Tone Professional Multi-Color Toning Kit for Black and White Prints or Transparencies with an activator and colors such as red, blue, yellow, green, and violet, and, purchased separately, Clearing Solution for Color Toning White Restoration, which Laura has used. The distributor's website is http://www.omegabrandess.com/products/ Toning-Products-Berg/CS. The result ranges from a light tint to a highly saturated color. These toners can be used alone or as an additional color in a print toned with one or more of the toners described above. The entire print can be toned, or color can be selectively added to the picture in a number of ways. Toners may be applied to specific areas with a brush or spray bottle, or parts of the print may be masked before the print is placed into the toning solution. Careful notes will aid in the development of personal methods for controlling color across the surface of a print.

SAFETY

Before starting to work with any toner, carefully read the manufacturer's instructions, note precautions, and follow the safe-handling guidelines.

Most toners give off a disagreeable odor and some can, particularly in accidental combination with common darkroom chemicals, give off a toxic gas, e.g., selenium will emit toxic fumes when contaminated by concentrated acids, such as stop bath. Toning must be done in a well-ventilated area, which means

ten complete changes of air per hour, and that the exhaust is pumped outside the building. Selenium toner and sulfide toners, such as Polytoner, should only be used under local exhaust. Or, work outdoors.

Selenium is a skin and eye irritant and can cause kidney damage. Gold can produce allergic reactions and asthma, especially in fair-haired people. So, wear gloves and goggles.

With two-bath toners, such as sulfide toners, make sure you rinse the print well after bleaching and before dipping it in the sulfide developer.

In order to prevent any accidental mixing of chemicals on the print, thoroughly wash photos before toning.

Do not inhale powdered chemicals. Wear an appropriate mask.

Add acids to water, not water to acids.

3.2 Emmet Gowin, *Alluvial Fan*, Natural Drainage near the Yuma Proving Ground and the Arizona-California Border, 9 ⅝ × 9 ⅝ in. (24.4 × 24.4 cm) Kodak Poly-Toner on Agfa Portriga Rapid paper, 1988. ©Emmet and Edith Gowin. Courtesy Pace/MacGill Gallery, New York.

The artist explained that he employed a short toning time followed by a long wash. Unfortunately, Agfa papers no longer are available; it was a warm-toned fiber paper with rich silver emulsion, and rather than using filters to change the contrast, it was graded.

Contact with the toners can cause allergic reactions, contact dermatitis, and even poisoning. Neoprene gloves must be worn. Immediately rinse off any toning solution that splashes onto the skin. Toning solutions can permanently stain clothing.

Contact your local poison center immediately should you ingest any of the toners.

Discuss your plans to continue your photographic work during pregnancy with your doctor.

When disposing the solutions used for toning, flush the sink basin and drain with water after pouring out each chemical. Selenium is considered a hazardous waste. Check the facilities within your local areas or contact a waste disposal company. The equipment you use also can become stained; therefore, you might want to have a separate setup for toning. Commercially available tray cleaners may remove some of the stains, but thoroughly wash the trays and flush the sink and drain before you apply cleaners, or you may create toxic fumes.

METHOD OVERVIEW

1. For selective toning, a mask or frisket can be applied to cover up part of the print.
2. Print is presoaked for at least ten minutes (30 seconds for resin-coated paper).
3. Print is immersed in the toner, or toner is applied to selected areas.
4. Print is cleared, washed, and dried. Mask is removed.
5. For multiple toning, the clearing bath in Step 4 is omitted, but the print is thoroughly washed, and Steps 3 and 4 are repeated.

MATERIALS

1. Image

Most conventional photographic papers will tone to some degree, but the most dramatic results will be obtained by using a chloride paper like Lodima. Not sensitive enough for use under an enlarger, the recommended light sources for contact printing are either an incandescent R-40 300 light bulb or an ultraviolet light with the enlarged negatives or photograms described in this book (see Chapter 5, Generating Imagery: Analogue Methods and 6, Making Negatives: Digital Method). Developed in Amidol they produce quite cool to slightly warm prints. Purchase information and instructions can be found at http://lodima.org and at Photographers' Formulary.

Enlargement Emulsions (see Chapter 14), Bergger Prestige and Silver Supreme Photo Paper, a limited quantity of Kentmere Fine Print Variaable Contrast Glossy manufactured in the U.K., Ilford Ilfobrom Galerie and Multigrade IV Deluxe, and Oriental Seagull Warm Tone Variable Contrast Glossy Paper are known to tone well. Resin-coated (RC) papers can be toned, but they do not react in the same way as fiber-based papers, so refer to the instructions packaged with the toner before you start. Note that Berg does make a Rapid Sepia/RC toner for use with resin coated (RC) or fiber papers. RC paper cannot be left to soak so tone, wash, and dry each print separately. Both the printing and toning processes require constant care so that the prints are not bent or cracked. You will benefit from making test strips, test prints, and finished prints of each image.

Different toners best serve photographs with different characteristics. For instance the metal replacement toner Berg Brilliant Blue works best with a slightly light print, while Sepia, Green, and Copper/Red toners require one that is somewhat dark. Split tones, where the mid-tones partially change to a warm red-black from selenium, are best obtained by using moderately high-contrast negatives on a low-contrast grade of paper to render a print with a normal, but punchy, tonal range. Experimentation will be needed to find correct

paper, and tonal range that best works with the tendencies of the toner you have chosen.

The type of chemistry, time in the processing solutions, and temperature of the chemistry when making the original photograph will affect both the overall color and the intensity of a split in color. Developers vary the hue, contrast, and tonal range or emulsions. Any developer can be used with any photographic paper to yield results which will be judged as more or less acceptable. Each combination will give a different result when toned; in addition, changing the dilution or temperature of the developer or fixer prior to processing the print will further influence the final effect of the toner on the print. Using fresh developer and fixer will help ensure a crisp, rather than muddy, print and keep the highlights clean after toning. To experiment with what kind of photograph will render the best toning results, make prints using two or three different exposures. All toned photographs look different when they dry, so keep notes in pencil beyond the image area on the back of the print of all the variables you employed. Laura tones one picture at a time, partially blots dry the back of the photograph and writes information with a black permanent felt-tip marker. Elaine numbers the dry paper with a pencil, then writes the records for that print in a notebook.

To avoid mottling the paper base when you later tone the photo, use fresh stop bath at the recommended dilution for the proper amount of time. Elaine always uses two fixing baths, each for five minutes, in order to prevent the formation of compounds that can lead to staining and a less-permanent print. (This is particularly important with blue toners). Fixers can be mixed to different strengths that will have some effect on color, but no matter what fixer or dilution you use, do not over-fix the print. Fixer without hardener will result in a print that will tone more rapidly and evenly, with fuller tones,

than prints hardened prior to toning. Fixers available at the date of this edition include Kodak Rapid Fix without the addition of the hardening solution in the B bottle, Ilford II powder or Ilford II powder or Ilford Rapid Fix liquid, and Sodium Thiosulfate (Hypo), available from Photographers' Formulary. Please note: with enlargement emulsions (Chapter 14), the manufacturers usually recommend eliminating stop bath and using two trays of fixer with hardener.

Adequate washing is imperative. Traces of fixer in the photo or print can cause uneven toning. The advisability of using Hypoclear or Fixer Remover before toning varies from toner to toner, so read the instructions packaged with both the paper and toner before you process the prints. Laura uses Berg Bath™ Hypo Eliminator after fixing and after each toning bath to keep the prints clean. If a tray is used for the final wash the water must be changed periodically. If either a tray or a tray-and-siphon is used for washing, the prints must be constantly agitated by sliding the bottom print out and laying it on the top to ensure that they are completely free of chemical residue. If you are not sure whether you fixed or washed enough, redo those steps. Prints processed with different toners must not be washed together.

Van Dyke brown prints (see Chapter 8) and salted paper prints (see Chapter 9) contain silver and can be toned. Proper sizing of the paper, as described on pages 89–91, can prevent an unevenly sized surface or fibrillation of silver nitrate in the fibers of the paper that might cause staining. Van Dyke brown prints can be toned prior to fixing; this process is described later in this section under Gold Toner for the Printing-Out Process. In general, the toning process will affect the density of a Van Dyke brown print, so based on the information given previously for black-and-white paper, start with an image that is either lighter or darker than normal.

2. Toners

Selenium, Sepia Redevelopment, Thiourea, and Polysulfide are some of the toners that convert silver to other substances, thus increasing the stability of the print. Gold toners provide stability by plating the silver molecules with gold.

Toners which replace the metallic silver in the print include Copper, Blue, Yellow, Red, and Green. The toners in this group provide little to no protection of the image. As the investigation into the affects of toning are begun, there are number of suppliers including Kodak, Ilford, and Fotospeed (which also sells almost all supplies and equipment for analogue), Berg, and The Photographers' Formulary prepackaged products, whose merchandise will create a wide range of colors. Macodirect (macodirect. de) in Germany sells Rollei Silenia.

If you decide on a specific paper and toner combination, you may wish to mix toners from raw chemicals to save money. Formulas appear online and in many photographic publications. Used copies of an excellent resource, *The Photo Lab Index*, (Dobbs Ferry, NY: Morgan and Morgan) can be found for sale online. *Processing Chemicals and Formulas for Black-and-White Photography* (Kodak professional data book, number J-1), from 1973, is online as a PDF file at http://www.bonavolta.ch/hobby/files/Kodak%20j-1.pdf and as a used booklet. On the website for Photographers' Formulary (see Supply Sources), you also can purchase the components. If you are unfamiliar with mixing raw chemicals, learn about safe handling and mixing techniques before you start to work.

Treat enlargement emulsion prints (Chapter 14) just as you would conventional prints, but remember that the surface may be more delicate, so extra care must be taken to avoid damaging the emulsion—we use hardener in the fixers and take that factor into account when we tone.

To start, read the instructions packaged with a given toner, tone a print that way, and then begin your variations. Do not exceed the capacity listed in the instructions for the toner you have chosen. Often the toner continues to work in the wash water, so remove the print from the toner before it becomes the color you want.

The following general guidelines tell you what to expect when a specific toner is used on a photograph, an enlargement emulsion print, or a Van Dyke brown print. These are suggestions for where to begin experimentation, and are not to be taken as a complete list of possibilities.

Selenium Toner may improve image permanence, can deepen the blacks if used for a short time, or turns a print purple-black if left to soak for an extended period. Some papers mentioned above will split, with the shadows and midtones turning reddish brown and the highlights remaining silvery gray. For a tone change, dilute 1 part toner with 3 to 19 parts of water; if split tones are desired, try a dilution of 1:7 to start. Toning should occur in 2–8 minutes at 68°F (20°C). Presoaking a photograph in very warm water before toning, and then toning in a 1 part selenium to 7 parts water (or stronger) dilution of selenium, and washing afterward in warm water, may quicken and dramatize its effect. Do not heat the toner, because a toxic fume is released.

Selenium toner will increase the contrast of a Van Dyke brown print and change its color to a purplish brown. After exposure, rinse the print until the water is clear rather than milky. Place the print in the toner. Watch for a split in tones between the highlights and shadows, pull the print from the toner, then fix and wash as usual. Try a dilution of at least 1:20, and watch the print carefully as toning occurs rapidly and pales the print.

The distinctive image colors in the two prints in Figures 3.3 and 3.4 are the result of the tonal ranges of the negatives and the difference in bleaching time.

3.3 Elaine O'Neil, *Munich, Germany*, 18 × 12 in. (20.32 × 30.48 cm), Sepia toned Kodak Poly-Fiber paper (two-bleach method). ©1977.

3.4 Elaine O'Neil, *Common Emu*, British Museum, London, 18 × 12 in. (30.48 × 20.32 cm), Sepia toned Kodak Poly-Fiber paper (two-bleach method). ©1977.

Sepia Redevelopment Toner will impart a warm brown color to the image. This toner requires the use of a bleach bath to prepare the silver in the print to accept the toner, and only the silver that has been affected by the bleach will change color. Because the bleach attacks the highlights first, the length of time in the bleach bath can be varied to achieve differing results. Bleaching for 5–20 seconds before toning will produce a warm brown/cold black split, while bleaching until the image disappears completely before toning will render a brown and white print. Because the bleach works quickly, Elaine sometimes dilutes it beyond the manufacturer's recommendations. Then Elaine washes and examines the print before placing the photograph in the toning bath. After toning, the print may be partially bleached again after the toning bath, carefully washed, and toned in another color, such as Gold 231, available through Photographers' Formulary. Or the bleach alone with no subsequent toning bath may be used to alter the look of a print. Note that after a second bleach,

3.5 Elaine O'Neil, *Tiger Balm Garden, Hong Kong*, 16 × 23 in. (40.64 × 58.42 cm), Sepia toned Kodak Poly-fiber paper (two-beach method). ©1987.

3.6 Elaine O'Neil, *Air China Ticket Office, Hong Kong*, 16 × 23 in. (40.64 × 58.42 cm). Kodak Poly-toner (dilution 1:32) on Kodak Elete paper. ©1987.

all traces of yellow must be washed away, and the print should be fixed and washed, placed in a hypo-clearing bath, and washed for the time recommended by the paper manufacturer.

Mix the toner and bleach according to the directions on the package, and take care not to contaminate the two solutions with one other.

A short time in toner and long wash method was employed. Using these methods, both affect the white areas of a print first. In these two pictures, it is evident that Sepia has

affected every silver molecule, white the effect of Poly-toner is only seen in the highlights.

Kodak Poly-Toner has been discontinued, but in 2005 Kodak published the formula and instruction for this Sepia/Selenium toner. A downloadable file of *Mixing and Using a Substitute for Kodak Poly-toner* (CIS-268) can be found at the following url: http://imaging.kodakalaris.com/sistes/prod/files/files/recources/CIS268.pdf. The selenium powder required is available from

3.7 Elaine O'Neil, *Moslem Quarter from Damascus Gate, Jerusalem*, 4 × 5 in. (10.16 × 12.7 cm), untoned Van Dyke Brown print in Rives BFK printmaking paper, exposed using black light ultraviolet exposure unit. ©1983.

3.8 Elaine O'Neil, *Moslem Quarter from Damascus Gate, Jerusalem*, 4 × 5 in. (10.16 × 12.7 cm), gold toned Van Dyke Brown on Rives BFK printmaking paper showing shift in tone and increased contrast, exposed using black light ultraviolet exposure unit. ©1983.

chemical supply companies. Given the toxicity of some of the ingredients, and unless you are familiar with working with raw chemicals, we recommend that you begin with a commercial toner such as Photographers' Formulary Polysulfide Toner, which will give a similar effect. After Van Dyke brown prints have been fixed, Polysulfide can be used to reduce contrast and shift the color to a warm yellow-brown. When making the print, give it extra exposure to compensate for the bleaching action of the toner.

Photographers' Formulary Polysulfide Toner renders colors that range from the cold black of selenium through the warm brown of sepia, and past that to orange. A chart on the Formulary website (see Supply Sources) shows how to dilute the toner and amount of time needed to produce the color wanted.

Chapter 4, Creating the Photo-Printmaking Studio, describes how to build an ultraviolet, black light fluourescent exposure unit.

Gold Toner 231, Tetenal Gold Toner, and Berg Protective Gold Toner will produce delicate to rich blue-blacks in a previously untoned print or can be used after sepia toning to get brilliant reds or split tones. Be sure to wash the print thoroughly and, to conserve the gold in the toner, cut away any excess exposed print area prior to toning. Instructions for Formulary 231 and Berg Protective Gold Toner are included in the packages.

Formulary Gold Toner for the Printing-Out Process is an excellent toner for increasing the contrast and intensifying the shadow areas of a Van Dyke brown print when used before the print is fixed. Although pre-coated printing out paper no longer can be purchased, Salt Prints, Chapter 9, page 189, explains how to make your own. The toner can be mail-ordered from the Photographers' Formulary and includes mixing instructions. After exposure, rinse the print until the water is clear rather than milky, trim the exposed edges of the print to conserve the gold, and place the print in the toner. Watch for a split in tones between the highlights and shadows, pull the print from the toner, then fix and wash as usual.

Copper Brown Toners produce a much more reddish brown than sepia. Many brands, such as Berg Brown/Copper Toner liquid and Photographers' Formulary Copper Toner powder, are readily available in the US. Tetenal Copper and Speedibrew's (powder) Copper toners are available through Silverprint, UK (listed in the Supply Sources). When non-hardening fixer is used to process the photograph, the image will turn completely brown, but when a hardening fixing bath is used it will split to copper shadows and gray highlights, particularly when Ilford paper is used. Mix and use according to the instructions packaged with the toner, but for split tones you may want to remove the print from the toner prematurely, because it continues to tone as it washes. If you have a problem with pink staining on the print, some photographers recommend adding a few grams of potassium citrate to the toning solution. Mixing from powders requires safety precautions, such as goggles and a mask. See blue toners, next, about reversing the color.

Berg Brilliant Blue, Tetenal Blue, Speedibrews (powder) Blue and Prussian Blue, and Porcelain Blue Toners, which will give you a bright blue image equal in intensity to a cyanotype, work best with a print that is lighter than normal. (Actually, many blue toners are made from 1 part cyanotype A and a bit more than 1 part cyanotype B, as described in Chapter 7, plus 60 parts water, and 7 parts 28 percent acetic acid.)

A solution of black-and-white photographic paper developer diluted three or even more times more than the manufacturer recommends will reverse the effect of either copper or brilliant blue toner. Laura suggests 1 part developer to 20 parts of water so that the redevelopment is slower and you can pull the print for a partially toned effect or put it in another toner. With either method, a partially redeveloped print immediately should be put in stop bath, then water, but not fixer. A print can be selectively redeveloped by brushing developer onto chosen areas or coating the area to remain unchanged with a masking agent/frisket. Before the print is immersed in any liquid, apply the frisket with a 000 watercolor brush; after the print is completely dry, you remove the frisket merely by lightly rubbing it off. Wash the frisket off the brush before it dries on the bristles. Rubber cement frisket needs solvent to clean the brush. Painter Liz Awalt recommends that you use watercolor wash-out tape when securing fragile papers, because it will not lift up when saturated but you can remove it without harming your work. So, you can also use it like a frisket that resists the coating if you are trying to make an area that shows the paper and not the emulsion.

Rockland Halo Chrome converts the photographic image to a metallic silver-and-white or black-on-silver print. Specific instructions are packaged with the toner. Combine it with dye toners, described below, to produce silver-on-color pictures. It is not recommended for use on enlargement emulsion prints.

Color Coupler Toners include Edwal Color Toners and the Fotospeed Color Toning System. Edwal Color Toners come in red, yellow, blue, green, and brown. In the darkroom before toning, a fixer clearing agent should be used to ensure that the prints are completely free of fixer. Blue toner must not be mixed with other colors. However, new colors can be created by mixing the other toners together before use. Another way to achieve intermediate colors is to use the toners one after the other, allowing each new toner to change the color of the previous toning layer. To avoid contaminating one color with another, be sure to wash the print well between toning baths. Dilute the toners according to the directions, and use immediately.

Rockland Polytoner and Berg Color Toning System (not to be confused with the previously described Berg toners) also come in a wide range of colors and can be used like the Edwal toners described above. One advantage the Berg system has over the Edwal toners is that the Berg is packaged with an activator that helps prevent color from appearing in the white areas of the print. Berg includes a clearing solution, and colors can be reversed.

Dye Toners include the Rockland Printint Colorants, Fotospeed Antique Dye (brown), and the Fotodye Kit. Printint comes in red, yellow, and blue and can be mixed to make other colors. Both Printint and Antique Dye stain the paper. They can be used as a bath to tone the entire print or can be applied with a brush. However, they may not be suitable for selective toning using a masking agent, because the paper base is susceptible to the action of the toner. Selective toning of the emulsion without staining the paper can be done with an 11 color Fotodye Kit. Do not wash the print after using these products.

All these toners can be used separately or sequentially, but the silver-converting toners are most effective in the following order: sepia, poly, copper, selenium, gold. They should be used before toners from the color coupler group, and either group should be used prior to the dye toners. Laura's students have created greens in mid-tones by using sepia or Berg Blue first, then Berg Copper. We have gotten purples from Berg copper before blue. Ilford and Fotospeed additionally suggest that sepia and then selenium produce brown purples, selenium and then gold produce purplish blue mid-tones, and blue before selenium creates blue shadows and buff highlights. The print must be thoroughly washed between toning baths to prevent the contamination of one toner with another.

3. Trays

You will need at least three trays: one for holding wet prints prior to toning, one for the toning solution, and one for washing the print after toning. You may need more trays for other toners, print developer, or stop bath. Prints toned in different toners cannot be washed in the same tray, as the toners will migrate from print to print.

The trays must be made of glass, plastic, or enamel and bear no chips or cracks. Metal trays will react to the toning solution and should be avoided. Dish pans can be substituted for photographic trays, but obviously they never can be used in the kitchen again. In order to avoid uneven toning, the tray must be large enough to accommodate the entire print. The trays often get stained by the toners and can contaminate prints. These stains can be removed using commercial tray cleaners after all traces of toner have been washed away and the drain has been flushed with water.

4. Masking/Frisket Material

Many art supply companies, such as Winsor and Newton, Speedball, Grafix, Dr. Ph. Martin's, or Grumbacher make products that can be used to mask areas of a dry print before toning and are easily removed when the print has dried. Laura likes the Martin's and the Grafix White Mask Liquid because it can be seen after they have been applied. Please see Chapter 4, page 93, Creating the Photo-Printmaking Studio, for further explanations about other friskets.

Rubber cement is readily available and inexpensive. However, its transparency makes it difficult to see during application, and its consistency makes it difficult to control. These disadvantages multiply when one is trying to mask in a precise and detailed manner. A solution is to mix equal parts of acid-free rubber cement and rubber cement thinner with a few drops of red food coloring prior to use. Rubber cement thinner is also useful for cleaning the brush/applicator, although removing the mask from paper simply entails letting the print completely dry and lightly rubbing it off.

For precise masking, use a 000 (triple zero) brush and magnifying glass or desk lamp. Wash the brush immediately afterward, as masking fluid dries quickly.

5. Applicators

Inexpensive watercolor brushes, cotton swabs, or sponges can be used to apply a mask to the print prior to toning and to prepare selective areas to tone. Because brushes may be ruined during these processes, use cheap ones. If you intend to use a brush with a metal ferrule to selectively apply toner, coat the ferrule with rubber cement beforehand as a protective measure. Japanese Bamboo Sumi and Hake painting brushes are excellent because they lack a metal band, but Hake brushes can be somewhat expensive.

6. Water

Running water near the toning area is required for presoaking, washing the print, and for the immediate removal of any splashes or spills. Because impurities and high mineral content in tap water may prevent prints from toning evenly, distilled water is helpful when mixing toner chemistry.

In addition, some photographers pre-soak their prints in a solution of 1 tablespoon balanced alkali and 32 oz. (1 L) distilled water, rather than plain tap water, because they claim that the photo paper accepts the toner better when it has a neutral acidity. Wear a respirator with toxic dust filter, gloves, and goggles when mixing the powder, and keep your hands and eyes protected when using the solution. Do not ingest.

7. Vapor mask and protective gear

When mixing powders, such as certain toners or balanced alkali, you will need a toxic dust filter on the mask, goggles, and gloves.

8. Miscellaneous

Pencil or marker pen, 16 oz. (500 ml) or larger graduates, mixing rods, tongs, a sheet of glass with sanded edges or Plexiglas™ to rest the print on when selectively applying toner, a print squeegee, a darkroom thermometer, a tray siphon or print washer from a photography store, and brown bottles to hold 32 oz. (1 L) or more fluid. Paper towels are needed to blot the back of the print so that technical notes can be written.

TIPS

Most commercially made photos are ink on paper prints; thus they contain no silver and cannot be toned.

As indicated in the Materials section, not all toners are suitable for each of the three methods listed above; therefore, first use a test

print to check the activity of the toner and the final color. If you like the result, repeat exactly what you did with the test print. Notes that itemize all the steps a particular print has been through should be made on the back of each print using a pencil or permanent marker such as a Sharpie.

It is often helpful to place a wet, untoned print, made on the same paper as the prints to be toned, next to the tray of toner. Because the action of some toners will not be apparent until change is radical, the use of a comparison print will help you to see subtle changes in color.

To eliminate the green tint from the black in a black-and-white photograph, increase the lifespan of your photograph, and clean up the highlights, dissolve 1 part liquid selenium toner in 11 parts Heico Perma-wash™ or other fixer remover. After exposing, develop the print normally but use a fixer without hardener as the package directs. Quickly transfer one print at a time to a tray of toner and Perma-wash™. With constant agitation and under good lighting, tone the print until the whites clear up and the blacks turn purplish. Pull the photograph out, place it in a tray of wash water, and wash normally. Use with adequate ventilation, and, if selenium toner gets on the skin, flush the area with water.

You can tint (change the color of the emulsion and the paper substrate) with medicinal and food colors. The skin of Bermuda onions, after boiling in water, make a purple liquid; regular onions treated similarly and brewed coffee or tea yield browns. After any of these tinting liquids have cooled to room temperature, pour the fluid in a photo tray and immerse your photograph with gentle agitation until you achieve the desired color. A few drops of iodine in water make a yellow tinting agent,

while mercurochrome handled in the same way produces red. A bath of red wine imparts pink to red hues.

Persistent yellow stains can be removed in a properly washed blue-toned print. Make a tray of 1 tablespoon table salt diluted in 1 qt. (1 L) water and pass the print quickly through it or use a cotton swab soaked in this solution in the effected areas. Rinse the whole print again. Manufacturers also advise an 80 percent solution of acetic acid on a cotton ball to remove residue scum, but rinse the print after using this mixture.

Kentmere, Bergger Prestige, Ilford, and Seagull manufacture double-weight, black-and-white fiber paper in rolls, which is handled normally in the darkroom. Ilford offers the most numbers of surfaces, contrasts, and paper base color. At the Museum School, we tipped the head of an adjustable enlarger and, with the beam of light parallel to the floor, the image can be projected onto paper pinned into a wall. Mural printing necessitates two people; one person stands at the enlarger and manipulates it while the other person stands at the wall and, on a blank sheet of paper within the image area, uses a magnifying loupe to see the grains of silver while communicating directions for focusing the image. In addition, we employed a system of plant troughs, available from a garden center or DIY store, for the chemicals. The paper is rolled up before processing, then unrolled into the tray of chemicals. While being processed, the print is rolled and rerolled continually. Two people rolling the paper back makes agitating much easier. After the image was dried on a clothes line, it could be torn, toned, or drawn onto with artists' colored pencils and other media (see Hand Coloring, Chapter 2)

TONING THE ENTIRE PRINT

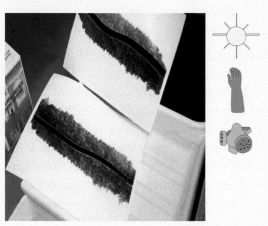

3.9 Presoaking and Toning

3.10 Washing

1. Presoaking and toning the entire print

If the prints are dry, presoak for at least ten minutes by placing all the prints, one at a time, in a tray of room temperature water. Note that resin-coated prints should be handled individually and should be presoaked for a maximum of 30 seconds. Remove one print from the presoak, and squeegee the front. Slide it, image side up, in the tray of toner, while constantly rocking the tray gently to help ensure even toning. Remove the print when the color is a little less intense than desired. With blue toners, tone past the point you want to be and wash the print back. Prolonged washing will regenerate the blue tone to black-and-white, which can be very effective for getting a really clean, crisp blue tone.

2. Washing

Wash the print for at least 20 minutes (for resin-coated prints, 2–4 minutes) in rapidly changing 68°F (20°C) water. The prints must not touch while washing, or stains may develop. Handle the print carefully, as toning often softens the emulsion, making it susceptible to damage. Step 1 can be repeated using the same or different toners. Be sure the print is thoroughly washed before it is placed in a new toner.

SPLIT TONING

1. Presoaking and toning

Place all the prints, one at a time, as in Step 1, Toning the Entire Print. Keep a wet, untoned print next to the tray of toner to determine, by comparison, when to stop toning (probably 25 percent less time than you would use for toning the entire print). Immerse the print in the toning bath and pull it out as soon as the shadow or highlight areas, depending on the type of toner, start shifting color. You can either stop at this point or

3.11 Presoaking and Toning

wash the print and immerse it in a second tray of a different color toner until you see the hues you want. As shown in this illustration, with Berg toners, you can deliberately overtone in the first toner, immerse the print in developer, then stop bath, and pick another toner color to replace the black areas you have redeveloped.

2. Washing

(See illustration for Step 2 of Toning the Entire Print.)

Wash the print for at least 20 minutes (resin-coated prints, 2–4 minutes) in rapidly changing water. The prints must not touch while washing, or stains can develop. Handle the print carefully, as toning often softens the emulsion and makes it susceptible to damage. Some toners, such as selenium, will intensify while being washed, so do not judge the print until it is completely washed and dried. Dry using a blotter roll or image side up on screens.

SELECTIVE TONING

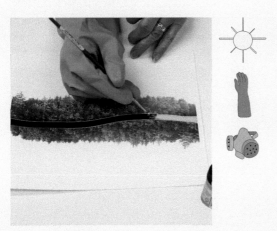

3.12 Masking the Print

1. Masking the print

Thoroughly coat the areas that are to remain untoned with a generous amount of rubber cement or masking liquid. Any small spots which are missed will tone and will be obvious in the final print. Allow the mask to dry completely.

2. Pre-soaking and toning

(See illustration for Step 1 of Toning the Entire Print.)

Soak the prints as in Step 1, Toning the Entire Print. Remove one print from the presoak and slide it, image side up, in the tray of toner, while constantly rocking the tray gently. Avoid extremely long toning times, when toner might seep under the mask.

3. Washing

(See illustration for step 2 of Toning the Entire Print.)

Thoroughly and carefully wash the print for at least 20 minutes (resin-coated prints, 2–4 minutes) in rapidly changing water. Prints must not touch while they are washing or stains may develop. Handle the print carefully, because toning often softens the emulsion, making it susceptible to damage. Air dry face up.

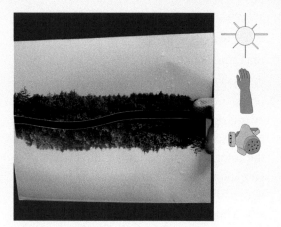

3.13 Removing the Mask

4. Removing the mask and optional re-toning

When the print is thoroughly dry, use celluloid tape on a corner or carefully rub the surface of the print to peel the mask. If desired, the print could be masked again, the untoned areas of the print split-toned, or the entire print placed in a different toning bath.

TIP

Masking is a good way to maintain white edges on the paper.

Part II

Preparation for Light-Sensitive Methods

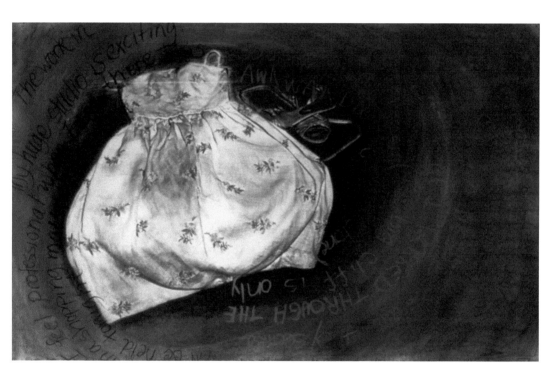

4.1 Laura Blacklow, *Prom Dream*, 36 × 58 in. (91.4 × 147 cm) Black and white digital print on vellum and pastels. My process is explained more in Chapter 2, Hand Coloring.

4

Creating the Photo-Printmaking Studio

Many of the printmaking processes described in Part III, Light-Sensitive Methods, are accomplished without a photographic darkroom, film developing area, or digital studio, although an artist may want access to these facilities for making large contact negatives that are the size of the intended image. Cyanotype, Van Dyke brown, gum bichromate, casein pigment, platinum/palladium, and salt print emulsions are applied to paper or fabric in subdued daylight, dried, exposed to bright ultraviolet light under black and white contact size transparencies, and processed. A light box for viewing negatives, a contact printing frame for holding negatives in place against the photo-printmaking emulsion, and an exposure unit of ultraviolet light all become indispensable once you start using them. This chapter shows how to build these items easily and relatively inexpensively. Please note that technical information on choosing and sizing paper, registering negatives, and utilizing graphic arts aids is in the Materials and Procedure section beginning on page 85 of this chapter, and more information pertinent to a technique is also found in the relevant chapter.

THE LIGHT BOX

Most art and photography stores and online suppliers sell light boxes for viewing and touching up transparencies and for cutting and taping them into masking sheets or holding them in place on clear acetate. If you buy one, make sure it has a glass top or buy a sheet of glass to fit on top, so that when you cut with a stencil knife you will not scratch the Plexiglas™ or white plastic viewing surface.

You can create a simple light-viewing system with a desk lamp, old storm window, velum, and three chairs. Just set up a gooseneck lamp on a floor so that the light bulb faces upward. Using clear cellophane tape, attach a sheet of tracing paper or drafting vellum to one side of the window. Use three chairs of equal height, placing two on either side of the lamp and one behind it. Lay the storm window, glass side up and vellum side down, securely on the chair seat. Make sure that the lamp is far enough away from the paper or vellum (used to diffuse the light) that it does not overheat.

THE CONTACT PRINTING FRAME

An altered contact printing frame showing registration buttons inside frame.

Whether creating multicolored images or monochrome pictures, you will need a way to hold the negative in strict contact with the photo-printmaking emulsion during the exposure. If the negative is not tightly touching the emulsion, a blurry or double-exposed image might result, causing problems in the readability of the image. If you like blurry images, however, you have more control if the negative itself is out of focus. If you want to check on an exposure, this method helps prevent the image receiver, which also needs to be kept in place, and the negative aligned. It is indispensible for making multi-colored gum or casein or for combining one technique on top of another.

You can buy a contact printing frame at a photography store, usually as a special-order item. Common, useful ones are made by Photographer's' Formulary and Bostick & Sullivan (see Supply Sources). You might find a bargain-priced contact frame at a flea market or online; after all, the originators of these photo-printmaking processes made their exposures in sunlight with a contact printing frame, as illustrated on page 170, "Panorama of Talbot's Reading Establishment." The frame, which usually comes in standard photographic paper—not printmaking paper—sizes such as 8 × 10 in. (20.25 × 25.5 cm), 11 × 14 in. (28 × 35.5 cm), and 16 × 20 in. (40.5 × 50.75 cm), is a piece of glass surrounded by wood for the top and a hinged, two-piece wood bottom lined with felt or foam. Spring clips on the back slip under the frame to lock it, thus securing the contact between emulsion and negative, sandwiched inside. One of the spring clips can be released during the exposure without disturbing the position of the negative, part of the bottom can be opened at the hinge, and the emulsion/image can be checked. This feature is particularly helpful with cyanotype and Van Dyke brown printing, where exposure time is based on a visible change of the emulsion's color.

If you intend to use a registration system for lining up negatives when creating multicolored prints, you need to buy a frame one size larger than the print size in order to accommodate the registration pins and masking

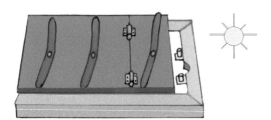

4.2 An Altered Contact Printing Fram

sheets. To avoid breaking the glass when you close the frame, you will also need to saw off about ½ in. (1.25 cm) from the wood back and tape the registration pins onto the glass at this margin.

An alternative to buying a contact frame is making one, quickly and for one-third the price.

SAFETY

To lessen the risk of cuts when you handle sheet glass, either have the glass beveled or sanded or use heavy tape to cover all edges. Be aware that tape will block light during an exposure.

MATERIALS

1. Registration pins. Registration pins are metal buttons mounted on thin sheets of steel. They can be purchased at graphic arts, silkscreen/art, and commercial printing supply stores. The height of the buttons varies from $3/64$ in. (1.75 mm) to $3/8$ in. (1.5 mm); diameters usually are ¼ in. (9.75 mm). You will need at least four pins, which must match the diameter of the hole punch listed next. Two to three registration pins must be mounted on a light table for lining up and punching holes in the negatives or masking sheets, and two to three more are needed on the contact printing frame. More about registering the negatives on a light table is explained on pages 78 of this chapter and page 214 of Chapter 10.

2. Registration hole punch. For images 11 × 14 in. (28 × 35.5 cm) or smaller, you need to purchase an inexpensive two-hole punch at an office or offset printing supply store; larger negatives require a three-hole punch. Make sure that the punch creates holes with a diameter to match the diameter of your registration pins, usually ¼ in. or 9.75 mm. I use an Acco/Swingline®, model 74101, which I purchased at a stationery store.

3. Masonite or plate glass. The board, which becomes the backing, should be at least 1½ in. (3.75 cm)

longer and 1½ in. wider than the sheets of paper on which you print because you need extra space for the registration pins. Make sure the board is not warped. Richard Sullivan suggests using plate glass instead of board (*Labnotes*, p. 9; see Annotated Bibliography), and I concur. I, too, have used plate glass for years for my large pieces.

If you use perforated hardboard from a lumber yard, you could build a Plexiglas™ box to go over it, attach the hose from a vacuum cleaner, and you would have a vacuum pin registration board that will not allow paper to move even slightly. Or, you could attach the pins to a sheet of glass with silicon cement to create a transmission pin registration board.

4. Glass. A sheet of plate glass, although expensive, is worth the extra investment because it really weights the negative down. Hardware store window glass, which is ¼ in. (9.75 mm) thick, will do as a distant second choice, or a discarded storm window can be recycled. The glass should be slightly larger than the printing paper. Make sure the glass is not the kind that blocks ultraviolet light.

5. Tape. You will need 1½ in. (3.75 cm) wide cloth or duct tape for two purposes: adhering the registration pins and hinging the glass. You may also need it for masking the sharp edges of the glass.

6. Foam rubber or polyurethane foam (optional). For extra "give" when the glass presses down on the negative and to create stricter contact between the negative and the emulsion, a sheet of absolutely consistently ⅛ in. (5 mm) thick foam, a sponge rubber pad such as the type used for an area rug, or felt can be attached to the board with glue. It should be the same size as and line up with the glass. If you use this foam backing, buy registration pins taller than ⅛ in.

I have discarded the foam I used to use, because I found that eventually it became worn down in different areas, so the strict contact was compromised. You will need strong spring clips, but be careful that the pressure does not break the glass. I use large plastic-jaw heavy duty clamps.

7. Index card stock or scrap sheet film. You will need a sheet the same length as your hole punch.

8. Marker. A red ballpoint pen, permanent felt tip marker, or lithographic red pen sold in graphic art stores is necessary.

MAKING A CONTACT PRINTING FRAME

4.3 Attaching Registration Pins

4.4 Attaching the Glass

1. Attaching registration pins

Insert index stock to the far inside edge guide of the hole punch, and make a set of holes in it. Relocate the index stock on the piece of Masonite so that holes are close to the board's edge on the lower half of the board. Insert registration pins through the holes from the underside and tape them to the board.

2. Attaching the glass

Remove the index stock. Place the glass so that one of its edges abuts the registration pins. The edge of the glass that is at a right angle to the registration pins and near the edge of the board should be lined up with the board. Using a strip of strong tape, hinge the glass to the board on the opposite side. If you want to check on an exposure, this method helps the image's receiver, which also needs to be kept in place, and the negative aligned. It is indispensible for making multi-colored gum or casein or for combining one technique on top of another.

TIPS

If you have taped around the edge of the glass to prevent cutting your hands, the tape will block light during the exposure and result in a border on printing paper.

If you want to work to the edge of the paper, you will need to tape your negatives to hole-punched masking sheets or clear sheets of cellophane, as explained on page 86. You can buy inexpensive, reusable registration tabs from a commercial printing supplier or graphic arts store. Attach them to the board with dura-ble tape so that the edges of the printing paper fit underneath. Be careful not to move them while you work. Other tabs can be made from photo corners or shirtboard folded and taped into the shape of photo corners.

You can replace broken glass with nonultraviolet protecting window glass from a hardware store. Bostick & Sullivan sell a hinged-back frame, and Photographers' Formulary sell a few different models, one of which they call their economy contact print frame.

Another less stable, but usable, frame can be made simply with heavy bulldog clips from a hardware store, window glass, and a Masonite backing. Joe Moccia, who has written in this book in a couple of chapters (Digital Negatives, lumen printing), uses an old picture frame with glass.

To make a printing frame for fabric, I use canvas stretchers or plastic embroidery hoops. I pull and attach the fabric backward; that is, the "good" side of the fabric faces toward the back of the stretchers, creating a basin in which the negative and the glass can fit. In addition, I coat the stretched fabric with a foam brush. This method conserves the amount of emulsion needed because I can coat with the frame standing up, rather than lying on a table covered with scrap paper that absorbs much of the emulsion.

THE EXPOSURE UNIT

Graphic arts and printers' suppliers sell plate makers, which are a contact printing frame and exposure unit combined. They are terrific for photo-printmaking but extremely expensive. If you do buy one, make sure that the light source is not carbon arc, which gives off dangerous fumes, that it is thoroughly vented. NuArc and Edwards Engineered Products manufacture excellent exposure units.

An inexpensive exposure unit can be made by hanging a reflector with a sun lamp bulb (not a red infrared bulb) or a 500-watt or 1000-watt photoflood bulb approximately 15 in. (38.1 cm) to 30 in. (76.25 cm) above the photo print. Using a 750- to 1000-watt quartz light bought at a professional photography store is more expensive, but more efficient. Be careful not to look at the bulb when it is on, or you will damage your eyes, so always wear ultraviolet protective goggles. The problem with these methods is that the exposure

times are long, and if you bring the light closer you must check to make sure that the glass on the print frame does not overheat and crack and that the exposure area more than covers the image area.

Sunlight is the least expensive method, and it is splendid for cyanotypes and Van Dyke brown prints, where you can watch the emulsion change color until it is "cooked." Unfortunately, for critical techniques, such as casein, gum, and salt printing, or an expensive emulsion, such as Palladium, sunlight is not dependable year round and is not consistent throughout a day, making for varying exposure times even with the same emulsion, paper, and negative.

I have found that building an exposure unit with black light fluorescent tubes is well worth the investment. Relative to buying a unit, the one in this book is relatively inexpensive (under $450 in U.S. dollars), and given access to basic tools, the labor is fairly simple. Please note that you can purchase a kit with almost all the requisite precut components from Edwards Engineered Products, listed in Supply Sources (http://www.eepjon.com/). As you probably know from most experiences in life, there is a trade-off: the kit is ready to assemble and even has a pull-out drawer for the exposure frame, but is much more expensive than gathering your own materials as described below.

I used to include plans for making a complete unit, including the wiring for the unit, and if you contact me via my website, www.laura blacklow.com, I can send you scans from the fourth edition. The following instructions are for making a unit that will expose an area up to standard printmaking paper 26 × 40 in. (66 × 101.5cm). They can be adapted for larger or smaller images if you remember that each fluorescent tube will expose a 4 in. (10 cm) width when placed 4 to 6 in. (10.16 to 15.25 cm) above the printing frame, and if

you make sure the fixtures remain approximately 2¼ in. (5.75 cm) apart. Light fixtures and tubes come in different lengths, but make sure that they are around 4 to 6 in. away from the emulsion, or you can see streaks that look like the tubes in the finished print. If one of the bulbs is out, you get an unexposed strip where that bulb was supposed to shine.

IMPORTANT TIPS

Following the advice of the former Palladio Co., I have mounted a 115-volt, 100 cubic feet per minute (CFM), 4¹¹⁄₁₆ in. (11.9 cm) axial fan through a hole cut in the side of my fluorescent light unit because the bulbs heat up as they are used. Once they surpass 100°F (38°C), they give off less light, demanding an increase in exposure time, which in turn means the bulbs burn longer and heat up more. In addition, you cut an air cooling slot on the end wood piece as advised by Dick Sullivan and Carl Weese in *The New Platinum Print* (see Annotated Bibliography). The slot is close to, but not against, a wall, so you do not look at ultraviolet light when the unit is on. An even more efficient approach would be to drill 1 to 2 in. (2.5 to 5 cm) holes on each side of the unit and put ultrathin foam dust filters for fans or a vent over each one, so that air, but not light or dust, passes through. Either system works well with the axial fan, so that warm air, but not light, passes out exits. Edwards Scientific, who will also build a u-v unit to your specifications, additionally inserts a dust filter with the fan.

SAFETY

Never purposely break a fluorescent tube—it contains poisonous metals, and the glass can cut.

Do not connect other electrical appliances on the same socket as the exposure unit.

Electrical work can be dangerous if approached incorrectly. Instructions in this book are intended as a guide so that you can discuss the job with an expert. All installations should adhere to local codes.

Although the information in this book is as near to complete as possible at the time of publication, the publisher and author cannot assume liability for any changes, errors, or omissions leading to problems you may encounter.

Make sure you read the Tips section *before* you start.

MATERIALS

1. Tools. You will need a metal tape measure or yard/meter stick; pencil; hand-saw, jigsaw, or skill saw (if you are cutting the wood); drill and ¹⁄₁₆ in. (2.5 mm) drill bit; Phillips-head screwdriver; hammer; small-slotted screwdriver; and a T-square or combination square.

2. Wood. One 10 ft. (3 m) length of 1 × 10 in. (2.5 × 25.5 cm) #2 common pine board will be cut to two 31¼ in. (79.5 cm) lengths and one 42 in. (106.75 cm) length to make legs. A sheet of 32 × 42 in. (81.25 × 106.75 cm) plywood ½ in. (1.25 cm) thick is used to build the top. When you go to the lumberyard, you can have them cut the 1 × 10 board and the plywood. Insist that the grain of the plywood matches the direction of the 42 in. length. Otherwise, the weight of the bulbs and fixtures will eventually cause the wood to sag.

3. Fluorescent tubes. Buy twelve 24 in. (61.9cm) black light *fluorescent* tubes, labeled F20T12/BL by General Electric or Sylvania, available at an electrical supplier. They are a specialty item and should not be confused with the much more expensive black-light, blue-plant grow lights. Dick Arentz (*Platinum and Palladium Printing*, see Annotated Bibliography) recommends SA (Super Actinic), which are stronger but slightly more contrasty according to Judy Seigel (editor of the former Post Factory Photography), and AQA (Aquarium) tubes as more efficient. Edward Engineered Products warns that the black light u-v bulbs are rated at 7500 hours, while most bulbs are rated at 1000

hours. They advise that you may want to replace the tubes after 2000-3000 hours of use because there will be a 12% reduction in intensity at these times, and 1 year of 8-hour work days equals 2080 hours. Two thousand hours would be 5 years for most artists who use the unit twice a week.

4. Fluorescent fixtures from a home supply company. These fixtures hold one lamp/tube and usually are mounted under kitchen cabinets or as "shop" fixtures. Besides being easier to install, a great advantage over my previous instructions, which included assembly and wiring directions, is that you only turn on as many lights as you need. So, if you are working small, you do not waste electricity illuminating the whole unit. Make sure the fixtures are for 24 in. (60.96 cm) fluorescent T12 (that has to do with the actual end piece/ballast that inserts into a fixture)—not other types—of tubes. You will need 12 fixtures that hold 1 tube. You will want to make sure that the model you buy allows you to permanently remove the plastic lamp cover. The perfect unit, which is made to go with the exact lamp for the unit, and is four inches across (the exact distance you need for even coverage), can be found at Build.com, who will ship overseas. Ask their helpful sales people for Lithonia Lighting 2UC 120 SWR M6 undercabinet light with on/off switch. You can contact Build.com at https://www.build.com/ and more information about them is in the Supply Sources. In addition, they recommend that the best price on the needed bulbs can be found at https://www.1000bulbs.com/product/2220/F-20T12BL.html?gclid=CODx7pKs2dlCFUlNfgod8csHYA.

5. Power strip cord with surge protector. Most industrial power strips have six outlets and a circuit breaker, so you will probably need two. Depending on the wiring in your studio, you may need more than one electric wall socket.

6. Nails and hammer. Although the lighting fixtures come with their own hardware, you will need seventeen 2 in. (5 cm) nails and a hammer to put together the wood structure to which the fixtures attach.

7. Tape (optional). Aluminum, stainless steel, electrical, or cloth tape approximately 1½ in. (3.75 cm) wide may be used as you work to secure the wires to the sides of the exposure unit to keep them out of the way as you work.

METHOD OVERVIEW

1. Three wooden legs are nailed to a larger sheet of plywood, two on either short side and one on the side opposite the switch.

2. The plywood is turned over, and the light fixtures are mounted inside. Each one is about 4 inches wide, so they should be flush to each other.

3. Unit is turned right side up; bulbs are inserted and dusted.

4. Fixtures are plugged into surge protector, then that unit is inserted into a wall socket or timer and wall socket.

BUILDING THE EXPOSURE UNIT

1. Mounting the fixtures

On the plywood, draw lines 1 in. (2.5 cm) from both of the 32 in. edges to indicate where the 1 × 10 pine board legs eventually will be nailed. Draw lines 2³⁄₈ in. (6 cm) in from the 1 in. lines to represent the spaces between the legs and the end fixtures. Each fixture is 4 in. (10 cm) wide, and there will be no space in between them if you bought fixtures that hold one tube. Continue by drawing lines for the fixtures and remaining spaces.

4.5 Mounting the Fixtures

Lay out the fixtures, centered vertically, on the plywood, with the channel facing up. Put a pencil through the screw holes to mark the wood. After removing the fixtures, drill shallow holes at each of the marks. Replace the fixtures and screw—but do not tighten them—into the plywood.

4.7 Testing the Fixtures

4.6 Making the Legs

2. Making the legs

From the 1 × 10 board, use a tape measure, combination square, and pencil to mark off two 31¼ in. (79.5 cm) pieces and one 42 in. (106.5 cm) piece. Cut the pieces or have a lumberyard cut them. Abut the shorter pieces to the longer piece on either end of the longer piece. Starting 2 in. (5 cm) in from the top and bottom, hammer four nails into the corners. (Do not nail the short pieces to the end grain of the 42 in. piece.) Place the fixtures mounted on the board on top of the newly constructed legs. Nail from the outside of the plywood to the width of the 1 × 10s. Use four nails, spaced evenly and starting 2 in. (5 cm) from either end, on each of the short sides. Hammer nine nails along the 42 in. side, again starting 2 in. (5 cm) in from the corners and spacing evenly.

3. Testing the fixtures

Insert the fluorescent bulbs in each fixture by fitting the prongs into the channels on the lamp holders and gently twisting them until they take hold. Plug the lights into two power strip cords, then into a wall socket with a

ground fault interrupt circuit (GFIC), turn it on briefly, and make sure it works. *Do not look directly at the bulbs unless you are wearing special ultraviolet goggles.* If the lights do not go on, unplug the system and make sure that the bulbs are inserted correctly.

4.8 Finishing the Exposure Unit

4. Finishing the exposure unit

Remove the bulbs, unplug the cords, and turn the unit over so that the switches face you. Reinsert the bulbs, plug the unit into a wall socket, turn it on, and go to work! You may want to install the fan mentioned on page 82 and handles for transportability of the unit and a removable opaque flap/door on the front to prevent your accidentally viewing dangerous ultraviolet rays. My exposure unit is mounted under my work table, to save room, and it has a hinged door. Six in. (15.25 cm) under the unit is a pull-out shelf where I place the paper and glass for an exposure.

TIPS

Dust bulbs before using the exposure unit and at monthly intervals. Accumulated dust will block light, thereby lengthening exposure times.

I made one exposure unit with a galvanized aluminum lining and found that because the light reflected off the shiny metal, exposure times for printmaking were shorter. I have also seen exposure units painted white on the inside or lined with aluminum foil from the grocery store.

I plug my exposure unit into a darkroom timer then plug the timer into a wall socket. At school, the unit is plugged into a surge protector strip, which is connected to the timer. In addition, the switch on the power strip makes it easy to turn all the lights on and off, so you do not need to look at the bulbs because you do not need to use the switch near the bulbs.

Fluorescent lights will deactivate magnetic cards, such as charge cards, placed under them.

MATERIALS AND PROCEDURES, INCLUDING PAPER AND SIZING

The photo-printmaking techniques described in Part III are liquid, light-sensitive emulsions (or coatings) that you mix and apply to paper or fabric. You should read the preparation procedures described below before you start any of the processes. They may save you time and prevent frustration.

MATERIALS

1. Image

You will need a transparent or semitransparent image, which can be used over and over again. Except for daguerreotypes in Chapter 15, bromoil in Chapter 13, enlargement emulsions in Chapter 14, and the layered photograph, part of Chapter 16, the printmaking processes that follow are contact-speed; that is, they are not light-sensitive enough to take into a darkroom and enlarge onto. You need to create negatives that are the same size as the finished pictures. The emulsions reverse the negative transparencies to a positive print, or vice versa.

As described in Chapters 5 and 6, transparencies can be made photographically in a darkroom or on a computer, or non-photographically by hand. You can place the negatives wherever you want on the emulsion. The edges

of the transparency should be trimmed precisely, because the excess black film around an image will print as a random white border. In addition, you can coat the paper selectively but place the entire enlarged negative over those areas so that you print parts of the image, which is a great way to get away from the omnipresent rectangle.

Blue Printables (see Supply Sources) produces yards of printed fabric without a transparency—they use flowers, vegetables (like red hot chili peppers!), and chain-link fencing to block light, thereby creating solid shapes and patterns.

4.9 Registration pins attached to light table and see-through rubylith masking sheet punched to match pins.

2. Masking sheets

Red acetate ruby masking film, which you cut to the size of your printing paper, are available from graphic arts, art, and offset printing suppliers and stationers. Although see-through, masking sheets do block ultraviolet light and keep the covered paper—even paper with emulsion on it—unchanged. As described below, you will cut a window slightly smaller than the negative, which is affixed to the masking sheet with narrow-width ruby or red cellophane tape. Do not use yellow amberlith or paper masking sheets, because they do not block enough of the exposure light. (If you want the coating to show, negatives can be attached with clear cellophane tape or, even better, motion picture filmmakers' clear tape, to sheets of clear acetate or cellophane.)

To mask gum and casein, where you will probably employ more than one coating of emulsion or for different colors, you may use many negatives, printing from a negative to make a positive image in one color on top of a positive dry print of the same image made from another negative and another color.

Photographic color separations, or the related color posterizations (based on different contrast negatives from the same continuous tone image), for instance, as described in Chapter 10, are made according to what color you want the image layer to be. You might use, for example, dark green pigment with the shadow negative of an image, and then use red pigment and a negative that captures midtones and highlights of the same image. Or, you could make a monotone print in the same way with a set of posterized negatives: use black with the shadow negative, middle gray with the midtone negative, and pale gray for the highlight negative. Some practitioners combine two processes, such as palladium to print the shadows and cyanotype to print the highlights as described in Chapter 7.

All negatives to be printed one color are attached to a masking sheet in the exact position where you want them to print. This precise positioning of negatives is called *registration*, and to register large negatives properly, you really need a light table, registration board, and registration pins, as described on page 79 of this chapter. Read that section before proceeding with the following instructions.

HOW TO MASK AND REGISTER NEGATIVES

1. Strip negatives to masking sheet

Whether you are using a one-color process or a multi-color technique, you will need to follow this first step. Insert index stock to the far-inside edge guide of a hole punch and make a set of holes in it. Relocate the index stock onto a light table where you insert registration pins through the holes from the underside. Tape the pins to the light table. Remove the index stock and place a masking sheet, previously cut to the size of your printing paper, under the index stock so that the edges of the masking sheet and index stock are flush. Use a permanent marker to

4.10 Strip Negatives to Masking Sheet

draw circles through the holes onto the masking sheet, and punch holes at those positions.

Put the holes of the masking sheet onto the light table registration pins. Place the negatives intended for the same coating of emulsion so

that they read correctly on the light table. Attach tape, sticky side up, halfway onto the borders of the negatives and half unattached. Move the negatives until they are positioned under the masking sheet, then pat the masking sheet to the unattached half of the tape. Use a sharp stencil knife to cut and remove windows made on the masking sheets slightly smaller than the negative. This is called *stripping* the negative.

2. Line up negatives and masking sheets

4.11 Line Up Negatives and Masking Sheets

If you are using a multi-layered/multi-colored procedure, punch holes in another masking sheet as you did before. Place it over the first masking sheet. Attach tape as you did before to all the negatives intended for the second coating of emulsion and adhere them, one by one, to the underside of the second masking sheet, making sure you have visually lined up the negatives with the ones from the first masking sheet. Continue in this manner with each set of negatives, cutting windows as you need them.

Tape a set of registration pins to the contact printing frame (page 79 of this chapter) in the same way you just taped them to the light table. A stripped-up masking sheet plus the identically punched printing paper will be held in place during each exposure by the pins.

I have also used rubylith shapes *on top* of the glass during part of an exposure to hold back light from an area that becomes too dark in the print. If you place the rubylith piece under the glass, it leaves a sharp edge in the print. In addition, you can remove the ruby without disturbing the negative and paper under the glass. Photographers: this would be the equivalent of "dodging" in the darkroom.

3. Supports

Paper can be made from a variety of materials, usually wood pulp or natural rags. Acid aids in the manufacturing process, and poorly refined wood pulp paper decomposes quickly. Some relatively inexpensive pulp papers are buffered to produce neutral acidity, which extends their life span. In general buffers are alkaline and do not respond well to the iron-based cyanotype, Van Dyke, and palladium processes, where you might see the emulsion darken as you coat it and fade after you are finished.

The printmaking or water color—no digital—rag papers, although more expensive, tend to be long-lasting and of pleasing tactility, and there is an impressive array to choose from. Those made with 100 percent cotton or linen really print well with all the photo processes. Stay away from etching papers because they absorb too much emulsion and abrade easily as they are coated. CM Cotton Fabriano is slow to expose, and Arches Print falls apart in liquids. Based on availability, absorbency, archival properties, and expense, I recommend one of the following for all the hand-coating processes (except gum printing, which responds to rougher cold press papers): Buxton with its extra white appearance; Arches 90 lb. hot press (whiter)/cold press for

gum printing; Rives heavyweight or its equivalent, Arches 140 lb. hot press/cold press for gum; Rives BFK, which comes in white and a few colors; Saunder's Waterford; Strathmore one-ply hot press watercolor or tracing vellum (100 percent cotton and translucent) or its equivalent by a different manufacturer, Bienfang 360; most rice papers; and Mohawk superfine cover stock, all available at good art supply stores. I find that, from year to year, the manufacturer might change the "recipe" some, and the paper I always depended on no longer works. My new favorite is Magnani Prescia, which comes in white, off-white, and pale blue, but it is soft, so I recommend that you print on a sheet that can be trimmed afterwards, in case finger or glove prints leave a mark. In addition, I have taken to using the very expensive Arches Platine for everything I want to do without any last-minute problems; I even use the back of Platine, which is rougher, for gum prints. Not only does Platine feel as soft as old bed sheets, but the internal sizing (explained in Item 4) is really effective. Dan Burkholder (www.danburkholder.com, where he also lists workshops he teaches) prints a color image with archival digital inks under hand-coated palladiums on Crane Museo. Arches ("sized to the core with natural gelatin" and with numerous choices of weight) Aquarelle is tricky to coat because it absorbs so much emulsion and it takes longer to wash, but the paper is a sparkling white and is great for transfers (see Chapter 1). The relatively inexpensive Biengang no. 501 drawing pad is fine. In Central America, my students in Guatemala City have successfully used Gurarro Watercolor paper, which is partly rag.

Another excellent paper is the smooth-surfaced and off-white Weston Diploma Parchment Platinum-Palladium (but good for many processes) from Butler-Dearden Paper Mill in Boylston, MA (http://www.butlerdearden.com/weston-diploma-platinum-palladium/).

Subtly textured Hahnemuhle Platinum rag, 300 gm^2 is uncoated and good for salt and other processes. The company, founded in 1584, is one of the oldest German papermakers.

In the following chapters, especially Chapter 12, Platinum and Palladium Printing, additional papers are specifically mentioned for a method, but you might try them with other processes. Some art stores will charge a nominal fee to sell you small samples. Mike Ware, who invented the New Cyanotype process mentioned in Chapter 7, has worked with Ruscombe Mills, located in France, to produce the Platinotype papers, Hershel, from 100 percent linen cellulose fiber and 200 g/m^2, and Buxton, from flax. Our School Store has been carrying the Hershel (named for my hero—see the Cyanotype chapter and the history of Van Dyke in Chapter 8), and it is quite good.

Make sure that the paper you choose is not buffered nor too soft or absorbent and will withstand repeated immersion in water. To test it, soak the paper in water for ten minutes. If the paper fibers rise or separate, the paper will not hold up in these printmaking processes. If you hold rag paper in front of a light, you will notice a subtle water mark, which usually is embedded in the paper with the manufacturer's name and identification of the paper when it is made. Magnani Prescia is represented by a trident, which does not have a correct way to read it, so you have to look for mesh screen marks to find the wrong side. Some papers, such as Aquarelle, display an embossed (raised on the surface) label. Use the side of the paper on which the water mark reads correctly. Don't be surprised if a paper you have worked with successfully gives you trouble after you purchase more sheets. As I explained in the previous paragraph, sometimes the manufacturer, without warning, changes the components, such as the internal sizing, which changes how the paper responds to the photo-printmaking chemicals.

Although many other papers will work, avoid multiple-layered (aka multi-ply) papers, which delaminate in liquids, and etching papers, which absorb so much of the emulsion that the chemicals will not wash out where you want them to.

Keep in mind that if you plan to make multiple exposures or to combine processes, you should preshrink paper before printing in order to ensure better negative registration. Preshrinking can be accomplished by the method described in Chapter 10, page 208 of the Gum chapter, or by immersing the paper in a tray of very hot water for ten minutes. Preshrinking can be combined with the sizing recipe listed in Item 4. Hang the paper, without weighting it, to dry.

Catherine Reeve, coauthor of *The New Photography* (see Annotated Bibliography), fully describes how to make paper by hand for the photo-printmaking processes. (An abbreviated version appeared in the July/August 1986 issue of *Darkroom Photography* magazine.) Please note that some paper makers recommend "curing" paper sized with a ketene dimer emulsion as an internal size with heat or by letting it sit for 30 days before using it. Reeve does not mention this step. I have observed that papers made from abaca—or abaca mixed with cotton linter—gampi, and kozo do not need sizing, yet they produce impressively rich print colors. You can also buy Japanese Kozo or Hosho paper at a good art store, such as the ones listed in the Supply Sources at the back of this book. Hemp needs lots of sizing.

For a mural, my students and I used Tyvek on a long roll we purchased at a building supplier, and we found that Van Dyke brown prints (Chapter 8) actually looked black on it, but we could not get cyanotype to work at all. Tyvek also comes as interleaving sheets available at a good frame shop or as waterproof envelopes sold in a stationery store.

Fabric can be used with all the processes, both light-sensitive and light-insensitive. Natural fabrics, such as muslin, cotton, linen, or silk, work best with Impossible Project image transfer, cyanotype, Van Dyke brown, gum bichromate, and casein pigment printing. Mercerized cotton, which is cotton that has been specially treated in manufacturing, displays an affinity for photo emulsions and will yield intense color. Some synthetics, such as Dacron and cotton blend or acetate bridal satin, available in a wide array of colors, are fine for Van Dyke and gum. Natural and synthetic fabrics accept magazine transfers and enlargement emulsions. To print multiple coatings and exposures of any process on fabric, make sure that you preshrink material, like rag (fabric) paper in hot water, which also aids in ridding the cloth of the heavy sizing many manufacturers use. These sizings and finishes help protect the fabric but make it unsuitable for photo-printmaking because they repel the emulsion. Iron the material flat after washing and before starting. An unwrinkled surface makes coating easier and provides for better contact between fabric and negative, or follow my instructions for coating cyanotype on fabric, page 165, for other processes. When coating many pieces of porous fabric at one time, you can avoid wasting chemicals by stacking pieces so that excess emulsion bleeds through the top piece to the one underneath. And don't forget that the originators of these processes worked on leather and wood!

Store finished prints, whether on fabric or paper, in acid-free, unbuffered, paper or polypropylene and archival storage boxes.

4. Sizing

Sizing fills the spaces between the fibers in paper pulp or fabric with a water-resistant material, which strengthens the support while it holds the image on the surface, improves definition and tonal separation, and helps

prevent staining. Because sizing is time consuming and slightly messy, you may find sizing several sheets at once easiest. You can apply sizing with a warm damp sponge, sponge brush, or spray bottle or by soaking your support in a tray of sizing solution. Be sure to remove all bubbles and blotches, or they will interfere with the coating of the emulsion. Different sizings can affect the color of the final print, so experiment. I never have found it necessary to size with cyanotypes unless I use a heavy paper such as Rives BFK. Remember to wear protective gloves and a respirator during the mixing and coating procedures. Read Item 3 first.

TYPE OF SIZING

Alum and spray starch	Cyanotype, gum, casein, platinum/palladium
Gelatin and hardener	Cyanotype Van Dyke, gum, casein, platinum/palladium
Arrowroot or cornstarch	Cyanotype, gum, casein, platinum/palladium

Alum and spray starch. This recipe, developed by Todd Walker, does not change the appearance of the emulsion or feel of the paper. Spray or pump starch from the grocer and potassium (aluminum potassium sulfate) or ammonium alum from a photo store (or pickling alum from a drugstore) work well to prevent stains with cyanotype, Van Dyke brown, and platinum/palladium printing. I use this recipe first then use only one layer of spray starch in between each coating for gum and casein printing. In addition, this method preshrinks the paper, which helps with multiple-coating processes.

For ten minutes, soak paper in tray of 1 tablespoon alum mixed with 1 qt. (1 L) water at 90°F (32°C). Hang or fan-dry paper.

Cover paper evenly with one layer of spray starch, sprayed in a horizontal motion. Using a clean sponge brush, lightly work starch into paper with horizontal strokes.

Hang or fan dry paper.

Spray vertically and lightly sponge vertically in same way. Hang or fan dry paper.

Soak paper again in tray of plain 70°F (21°C) water for five minutes to remove excess alum.

Hang to dry.

Before each new color is applied, spray picture with starch and dry.

For gum and casein, gum over palladium, or gum over cyanotype, a layer of spray starch is needed before applying the gum bichromate emulsion.

You can substitute 1 part liquid starch mixed with 1 part water for the spray starch. This solution is applied to paper or fabric, but iron the fabric while still damp to set the starch.

Gelatin and hardener. Another sizing that retains the suppleness of paper and preshrinks at the same time utilizes unflavored gelatin, sold in grocery stores.

Dissolve four envelopes or 4 tablespoons (28 g) of gelatin into 1 qt. (0.95 L) cold distilled water. Let this mixture stand and swell for ten minutes.

Heat the mixture to approximately 122°F (50°C), then pour it into a clean shallow tray.

Dip both sides of a sheet of paper into the tray for one minute, turning the sheet over a few times.

Remove bubbles and squeegee excess size by pulling paper over a towel rod or clean, rounded edge of a tray, or by wiping the surplus carefully with a clean brush.

Hang paper, unweighted, in clean area to dry. It will shrink as it dries.

Gelatin solution can be stored in a refrigerator and reused for up to a week. To prevent the gelatin from being washed off during

processing later, the old recipes called for the size to be hardened in a bath of ⅞ oz. (25 ml) formaldehyde with 1 qt. (0.95 L) water. However, formaldehyde is so toxic that you cannot purchase it in many places, and I do not recommend its use. Instead, substitute alum hardener found in photography stores or standard 40 percent solution of glyoxal (see Art Craft Chemicals in Supply Sources). Make the following solution in a well-ventilated area: dissolve 1 oz. (30 ml) 40 percent glyoxal in water to make 1 qt. (1 L). Immerse the gelatin-sized and dried paper in a tray of this hardener bath for five minutes, rinse in a tray of room temperature running water for two minutes, and hang to dry.

Arrowroot. An old recipe for sizing combines 1½ tablespoons (20 g) arrowroot (available in the spice section of grocery stores) with 1 oz. (29.5 ml) hot water. Mix to a paste consistency. Add 1 qt. (900 ml) hot distilled water and boil the mixture to a thick cream for five to ten minutes, stirring constantly. Pour it into a tray and use it at room temperature. Or, try 1 tablespoon (14.5 ml) Argo Starch (from the grocery store) mixed with 2 cups (473 ml) water. Boil it for exactly three minutes before using it warm.

With all recipes, make sure to remove lumps or scum.

Polymer medium. If you are confronted by highlights that do not clear while gum printing, the following sizing will work but requires a little finessing. Although it will alter the softness of rag paper, polymer will not permit any shrinking of the paper after it is applied. This procedure requires you, after each exposure and development of the emulsion, to dry the paper and reapply just one layer of this size before adding another coating of chemicals.

Dilute 1 part white glue, polymer medium, or gesso (found in art stores) with 9 parts water at room temperature.

Use a wide brush or sponge and coat in horizontal strokes. Dry. Then, brush or sponge on another layer using vertical strokes. Air or fan dry paper.

Apply a third coating with diagonal strokes. Air or fan dry.

If you use diluted gesso, it will change the color of the paper slightly; gesso mixed with a little acrylic paint will change the paper to any color you want. Sand the gesso on canvas or paper before coating an emulsion.

5. Applicators

Soft house-painting brushes, which provide for a coating where the brush stroke can be seen, or polyfoam brushes, which render a flat, even coating, are available relatively inexpensively at hardware stores. Round off the pointed corners to eliminate lines in the coating, Christina Z. Anderson recommends, in *Gum Printing and Other Amazing Contact Printing Processes,* listed in the Bibliography. Another option is a latex paint foam roller. Or you can make an old-fashioned disposable Blanchard brush used by the originators of many of these processes: wrap a length of flannel or cheap velvet around a narrow sheet of glass or the plastic paddle inside a polyfoam brush and secure the fabric with an elastic band near the handle that might become contaminated by chemicals. The Blanchard brush is especially useful for gum printing (Chapter 10), where you need to buff the coating. Some printers swear by the much more expensive Jack Richeson #9010 series synthetic blend spalter flat brushes with razor edges and the DaVinci #7055 series artist bristle flat spalter brush.

Flat wood-handled and stitched white goat-hair bristled Hake brushes, available at art

supply stores, or bristle pastry brushes from a cooking shop, work because they do not have metal ferrules. You will see me using Hake brushes in the step-by-step photographs. I use a different one for each process and trim the bristles to approximately ½ in. (1.3 mm) so that the brush does not pick up too much emulsion. In addition, I dampen the bristles only slightly for the same reason.

The conventional way to coat with a brush is to use light, even strokes in one direction, then to push that same emulsion at a 90° angle. Although the first inclination might be to load paper with lots of emulsion in hopes of obtaining a dark color in the finished print, quite the opposite is true. Ultraviolet light seems to react more quickly on a thin layer of emulsion, except with very heavy papers. In order to remove excess solution after coating, draw the brush over the lip of the dish where you have poured the working solution. One can wait until the first thin layer is almost dry and put on a second thin layer to obtain much darker tones.

Paper can be dripped or sprayed onto with old atomizer bottles, although I disagree with some who suggest directly pouring emulsion onto thin papers because I have found that the emulsion will leave a stain all the way through to the back. Bostick & Sullivan (see Supply Sources) sells a glass (never dimensionally unstable, nor emulsion absorbing plastic) coating tube ("The Tube" or "Puddle Pusher") and Photographers' Formulary sells a similar device, the "Floater Coater," that facilitate an extremely smooth coating and save on chemistry. Bostick & Sullivan suggest that to use a coating rod, you set up on a flat surface such as a piece of plate glass with sanded edges. Next, add a couple of sheets of newsprint paper to provide a slight cushion then lay down the piece of paper to be coated. Alan Greene, in *Primitive Photography* (see Annotated Bibliography), recommends using a nylon string rather than a coating rod. Any of

these devices save on the amount of emulsion used because you make a thin line of solution on the paper to beyond the image area and along the rod's front edge, pull the rod and emulsion down the paper, then push it back up the paper. If the coating does not look even, try one more pass, but the more you practice—you can try plain water first—the easier it is to coat in one forward-and-back motion. Remember, though, that all applicators should be washed after each work session, and applicators for one process should not be contaminated with chemicals from other processes.

Some printers took to using Tween 20, which they dilute one drop with five drops of water to make a stock solution. One or two drops of this mixture are added to enough emulsion to coat an 8 × 10 in. (20.3 × 25.5 cm) piece of paper so that the sheet absorbs the emulsion correctly. Although I have not personally used it, now I am hearing complaints that it might cause problems, but you can order it from www.caymanchem.com and check the Material Safety Data Sheet on their website. Tween is supposed to prevent streaking in the coating if you let the Tween plus emulsion "sink in" for one to two minutes before hair drying it.

The late, great platinum printer and John Cage colleague, Michael Silver, who once was in my class, but taught me so much, showed me this method for working on thin papers.

Draw the area you want to coat on Bristol board or matte board.

Place the thin paper on top. Use brushes that will not abrade the paper, such as one made by Winsor-Newton with acrylic bristles. Slightly dampen the brush in distilled water, then blot the excess.

Pick up a small amount of emulsion with the brush and, holding it straight up and down, lightly push the emulsion across the paper and inside the drawn coating area that you can see through the paper. Be careful not to over-brush; this should be a light coating.

Hang the thin paper on a clothesline with potato chip bag clips. Because the paper has a tendency to curl, you need long clips on the top and bottom edges. Dry in the dark.

When the paper is ready, on four corners, secure it with Post-It Correction and Cover-Up tape (#658 by 3M) onto an old resin-coated (RC) black-and-white or color photograph. Expose the paper/RC unit for approximately 20 percent less time than you would for thicker paper.

Process the paper, still adhered to the RC print, in a deep tub, not a photo tray. Wet the unit then gently stick a gloved thumb under the paper as you dunk and dip the items in still water. In this way, the water/developer gets behind the paper and allows for a more thorough washing. Go slowly so the water does not agitate too much. Use three buckets of water/developer, or keep changing the liquid as it becomes contaminated. Gently smooth the paper onto the RC print with the side of your gloved hand, then hang the whole unit to dry. Clip the RC paper to the clothesline and weight it on the bottom two corners with more clips. Before the coated paper completely dries, remove it from the RC backing and blot the print dry in a sketchbook or blotter book. Or, put two sheets of sketching paper over the print only and iron the entity, then let the paper alone continue to dry overnight.

Paper can be floated on one side in a tray of emulsion. In order to conserve the emulsion, pour a small amount of it in a glass or porcelain tray and prop the tray at a 45° angle while dipping the paper. As a matter of fact, in order to remove excess solution after floating, I encourage students to draw the paper over the lip of the tray where they have poured the working solution.

Painter Liz Awalt recommends that you use watercolor wash-out tape when securing fragile papers because of two important qualities: it will not lift up when saturated, but you can remove it without harming your work.

In addition, you can use it like a frisket that resists the wet coating if you are trying to create an image area that shows the paper and not the emulsion. I have known other artists to use hand cream on paper as a frisket.

6. Trays

Nonmetallic trays larger than the dimensions of the support are recommended. Photographic trays, dish pans from the hardware store, large plastic bussing tubs purchased through restaurant equipment suppliers, or glass baking pans from flea markets also work well. I use trays without ridges in order to avoid possibly damaging the print.

7. Contact printing frame

Buy one or build one, as described starting on page 78. Make sure that the glass does not block ultraviolet light and is clean with each use.

8. Light source

The contact-printing, photo-printmaking techniques need ultraviolet light for making the exposures. Detailed explanations of ultraviolet sources were listed earlier in this chapter. Avoid carbon arc lamps since they emit imperceptible gases that are extremely toxic when inhaled.

9. Brown bottles

Recycled 1 qt. (0.94 L) brown fruit juice bottles with tops, thoroughly washed, make excellent storage containers for the light-sensitive emulsions. Wash out empty beer bottles, discard the metal screw top, and buy plastic caps at a pharmacy or liquor store. Or, you can buy brown bottles at a photography store or drugstore. I like to avoid plastic, which tends to absorb the liquid chemicals, but it is getting hard to find glass. Label each bottle with a permanent marker as to contents, date mixed, and safety precautions.

10. Washer

Most prints need to be washed. You can use a siphon washer, available at photography stores and on eBay, or you can drill holes near the top of the sides of a tub or tray and place near the bottom a hose with running water. Both methods allow clean water to enter while contaminated water drains. You may want to purchase a photographic sponge to blot excess water from the print after the final wash. Avoid rubber squeegees, which often shred the paper.

11. Water

Use distilled water for mixing the emulsions; usually tap water suffices for washing prints.

12. Plexiglas™

A sheet of plastic or the smooth, clean back of a tray angled in the sink helps process the emulsions that call for a running water development. The plastic is first wetted, the paper is smoothly stuck to it, and water is gently sprayed on the print. The unused emulsion drips down and off the print.

Nylon screening stretched over a wooden frame that measures slightly smaller than the inside of your trays, or a length of the screening fitted with two wooden dowels on either end, helps prevent delicate papers from ripping during processing. I secure the paper with clothespins. Anne Pelikan, a wonderful Museum School colleague in book arts, which we both teach, recommends pellon (sewer's interfacing) for the same reason. Another similar one is Reemay, which comes in various thicknesses and is used in gardening, but its "best quality is the surface isn't as thready and doesn't catch on paper fibers," Anne advises.

13. Fan

Air drying with a fan is the fastest and safest way to dry sizing, emulsion, and printed images. Try a hair dryer with a cool setting to both sides of the support (heat can destroy the emulsion and accidentally shrink paper and fabric). Or, air dry on frames stretched with nylon screening from a hardware store.

Sometimes when I am working, either sizing or coating paper, I hang up the sheets to dry. To avoid contamination from different processes, I have found that if I use a plastic-coated clothesline and different colored plastic clothes pins coded to different processes, I make my job a lot easier. Both can be easily cleaned.

TIPS

If your tap water contains contaminants, use distilled water to make sizing and emulsion and to wash the print. Fill the wash tray with clean water after discarding used water every five minutes for an hour.

A stack of unfolded newspapers on the coating area prevents contamination. As you coat, strip off the top layer of newspaper when it absorbs emulsion. Or cover the work area with oil cloth available from the Vermont Country Store, which carries homey patterns, and Buckaroo's Mercantile, which carries lively Mexican patterns (see Supply Sources), and regularly wipe the surface clean.

Wash mixing utensils thoroughly after contact with each chemical.

By lightly drawing around your negative with a pencil on paper, you can indicate where to coat. Coat beyond the image area or coat an extra swatch of paper in order to watch the change in color during the exposure of cyanotypes and Van Dyke brown prints. Some Printers prefer to double coat. They let the first layer mostly dry before coating a second

layer, claiming that they obtain richer hues. I find that a good negative exposed properly on the emulsion is the real secret to rich prints. With cyanotype and Van Dyke, the (free) sun is the best! Virginia Boehm Worthen (gini@ ix.netcom.com, but found on www.duke. usask.ca/) notes that conventional exposure meters are of little value, but she uses a coin to provide information. When she coats paper beyond the boundaries of the image, she puts the paper and negative in a print frame then places a coin on top of the glass in the sun. By moving the coin aside periodically, she determines the degree of exposure by comparing the contrast between the area under the coin and the area surrounding it. She can also judge whether the sun has moved too low in the sky because the shape of the coin's imprint becomes oval. In addition, when the print is properly developed and exposed, the area under the coin should return to the original color of the paper.

Your negatives can be damaged if they come in contact with wet chemistry, so make sure that coated emulsion is *absolutely dry*. Use a fan or a hair dryer on a cool setting; air dry flat or hang the coated paper or fabric to create drip patterns. If you hang the coated piece on a clothesline with clothespins, wash them before the next use to prevent stains on future paper or fabric.

If you are using plants or other living matter under glass as your "negative," place a sheet of clear cellophane or plastic wrap from a grocery store on top of the emulsion and under the plants. They sweat as they heat up under ultraviolet light, and the liquid produced can stain the print. If you do not place plants under glass, they will not sweat, and you can expose them atop *wet* emulsion! The exposures are much faster, but the plants may be ruined by the emulsion.

Tall objects can be placed on top of the glass during an exposure. They can cast shadows.

Do not take a coating brush into sunlight or leave the brush sitting around—chemicals left on the bristles will be exposed, ruining the next coating. Wash and carefully dry the brush after each use.

Exposure times vary. The level of sunlight, time of the year, and time of day affect the exposures; with artificial ultraviolet, the age of the bulb and its distance from the emulsion alter the exposures. Dust on bulbs can cause longer exposures.

Double exposures can be produced by moving the negatives halfway through the exposure.

Do not develop the print in bright sunlight: you risk overexposing the print from further contact with ultraviolet light (although I have had students do it that way on purpose to create a solarized effect).

Cold-water procion dyes, embroidery thread, and appliqué offer additional possibilities on a fabric—or pure rag paper—print. Oil and watercolor paints, pencils, and markers can extend the design of a print on paper.

Keep a small hand towel near you. I buy used ones at the thrift store, throw one over my shoulder while I work, and know I am helping the environment by not using paper towels.

A dry-mount press is helpful for flattening your finished prints. Or, use an iron set for cotton on the back of rag paper. The heat often darkens the emulsion, a result you may be pleased by. I advise against dry-mounting your prints; you can photo-corner them or hinge them onto a backing.

SAFETY

Completely read each chapter's directions before starting.

Always read and follow manufacturers' warning labels.

Most of the chemicals are poisonous. Store them beyond the reach of children, preferably in a locked cabinet.

When mixing powder chemicals, wear a respirator containing a dust/mist filter, available at hardware stores. For black-and-white photochemistry, use a respirator with a combination acid gas/organic vapor cartridge, such as ones made by 3M or North. Mix chemicals in a well-ventilated area. Details on health and safety precautions are found near the end of the Introduction to this book, and suppliers are located in the back of the book under Supply Sources.

Mix and coat chemicals in a well-ventilated area to avoid inhaling fumes and particles. Wear protective gloves to avoid skin contact. Wear goggles to evade accidents with your eyes.

Never mix ammonia or ammoniated products with chlorine bleach—you will create deadly fumes. Wear a respirator mask when handling ammonia.

Add acids to water, but *never* water to acids.

Do not store, prepare, or eat food near chemicals, ink, or solvents.

Do not use mixing utensils for other purposes. Thoroughly wash paraphernalia after contact with each chemical.

Never look directly into the exposure light. You can purchase special ultraviolet protective goggles at a laboratory safety supplier. Avoid carbon arc lamps since they emit imperceptible gases that are extremely toxic when inhaled.

Do not discard nearly perfect prints. Experiment with them!

14. Storage

All finished prints are sensitive to ultraviolet light, heat, surrounding pollutants, and humidity. I have lost prints after years of storage in wooden flat files, so I have moved them to metallic flat files and stored them in archival boxes with silica gel (I recycle the packets that come with vitamins) or I have stored them framed under u-v protective glass. I use archival interleaving from art or framing shops to wrap the print or archival envelopes recycled from stamps purchased at the U.S. Post Office, before I put the prints in a box.

5.1 Christian Marclay, *Untitled* (*Madonna, Thy Word and Sonic Youth*), 2008. Cyanotype on Aquarelle Arches Natural White Hot Press Watercolor Paper, 300 g/m², 22 ¾ × 30 ⅛ in. (57.8 × 76.5 cm), frame: 26 ½ × 33 ⅞ in. (67.3 × 86 cm) © Christian Marclay. Courtesy Paula Cooper Gallery, New York.

Christian Marclay is one of the most interesting multimedia artists and composers working today. He has produced "recycled records" by breaking apart, then re-assembling and playing, fragments of vinyl records. He has also created sculptures from recombining or exaggerating parts of already existing instruments, and collages using sound-related images found in popular culture combined in new and provocative ways. In the example above, he turns to hand-made photography to create a cyanotype photogram from cassette tapes. In all these forms, Marclay uses technologies that have become or are becoming outdated and obsolete, to comment, often with humor, on our current times.

5

Generating Imagery: Analogue Methods

Most of the hand-coated techniques described in the Light Sensitive Methods part of this book require a negative transparency to be made and placed in contact with the photographic emulsion you mix and coat, and then that combination is exposed to light. The negative is removed, and the exposed emulsion is processed, yielding a final positive image the same size as the negative. Therefore, old black-and-white negatives could be used because those images tend to be clearly seen. Color film negatives do not translate well, and small negatives might become lost.

There are two main analogue ways to generate large negatives: (1) using analogue procedures, such as a traditional photographic darkroom or using non-photographic methods, such as drawings on acetate (discussed in this chapter), or (2) using digital methods as explained in Chapter 6. Any of these systems can be used alone or in combination with each other. Negatives or objects can be used repeatedly, and they can be moved during the exposure to create double exposures.

WITH A DARKROOM

If you use a darkroom, you can make a negative with an enlarger, with an enlarger converted into a copy/stat camera, or with black-and-white photographs used as paper negatives. Instructions, which used to be in this book, are now available by contacting the author through her website, www.laurablacklow. com. As of the preparation of this manuscript, few companies still manufacture the sheet film called "orthochromatic" that can be handled in a darkroom under a red safe light. One product is made by Freestyle Sales and is their own Arista Ortho Litho Film (http://www. freestylephoto.biz/531812-Arista-Ortho-Litho-Film-3.0-8x10-25-Sheets) and the other is Ilford Ortho Plus (http://www.ilfordphoto.com/ products/product.asp?n = 55), which comes as either 4 × 5 in. (10 × 12.7 cm) or 8 × 10 in. (20.3 × 25.4 cm). If you want to enlarge a negative onto ortho film, you will end up with a positive. Therefore, make a positive with as much detail as you can capture and that will fit into your enlarger so you can project it onto a new sheet of ortho film to make a negative with the amount of detail you want. Or, make the first positive the exact size you want the new negative to be; you only need to contact print it onto a new sheet of ortho film to obtain the full-size negative. Don't throw away the intermediate positives in case you are of an experimental nature! You handle both items like photographic paper by using a safe light and putting ortho film through trays of either dilute film or paper developer, stop bath, and fixer. Because the film is not sensitive to conventional paper filters, you can change the amount of grays by using the developer straight (very contrasty) or by diluting the developer (the more water added to the developer, the flatter or less contrasty the resultant transparency) or by heating up the developer (never use very cold developer because it will not have any effect). You can find developer formulae online, at the Ilford website, and

APUG's (Analog Photography Users Group) website. Check http://www.ilfordphoto.com/ photocommunity/darkroom.asp for a list of rental darkrooms worldwide. See Chapter 12 on platinum and palladium printing, where I have explained about ortho film and developers under "Image."

Detailed instructions for using a stat or process camera have been eliminated from the book, but they can be accessed by contacting me via my website, www.laurablacklow.com.

Good news! New55PN, a film that is equivalent to the discontinued Polaroid Type 55, Positive-Negative film for large format, 4 × 5 cameras, is finally available! Save your 545 series film holders and enjoy making instant black and white positives and negatives, both at the same time. Relish the incredible tonal range that rivals the old Polaroid emulsion. You only need a tray of Ilford Rapid Fixer and a tray of water with this new film. You can buy the film and refurbished Polaroid 545 holders at http://shop.new55. net/collections/frontpage/products/new55-pn?variant = 22471703811.

WITHOUT A DARKROOM

You can create alternative photographic prints without stepping into a darkroom, simply by producing imagery from real objects or stencils, drawings or photocopies on acetate, or old photographs made transparent. These techniques can be combined with each other.

TIP

The longer you expose through the object or transparency, the darker the hand-coated emulsion will become.

MAKING PHOTOGRAMS

You can place objects directly onto the paper or fabric you have coated with one of

the alternative photographic emulsions, as Christian Marclay did in this chapter's opening image. An opposite, or negative print is made when the paper and objects are exposed to light—because wherever the object is, light is blocked and the paper or fabric shows. Wherever there is no object, light will act on the emulsion, and the color of the coating will show. If you move objects during part of the exposure or if you use semitransparent materials such as rice paper, tissue paper, or fabric printed with a pattern, you will obtain intermediate shades of the coating's color on the print.

Flat, semitransparent objects yield the most detail when placed under a piece of glass during contact printing to the emulsion; this also prevents the object from being blown around during outdoor exposures. For safety in handling, tape the edges of the glass and make sure the glass is larger than the paper or fabric; otherwise, the tape will leave a mark on the print.

As briefly explained above (With a Darkroom) and available by contacting me via my website, for exactly repeating results or for making positive prints, you can place an object directly on ortho/graphic arts film and expose it to light to make a photographic negative. You do not have to use an enlarger. Exposing the film with a flashlight, overhead light, or directional light in the darkroom can yield interesting results. Or you can put the object on a scanner and make a big negative, as explained in Chapter 6, Making Negatives: Digital Method.

I discovered more ideas in Virna Haffer's *Making Photograms: Creative Process of Painting with Light*, published in 1969 and listed in the Bibliography.

Set a piece of glass several inches larger than the paper on children's building blocks, which are placed several inches beyond the borders of your paper. From one piece of opaque black paper cut a grid of perhaps four windows[, with space between each window if you want white separations of the grid in the print], and place the black paper on the plate glass. Place fairly flat, dense objects, such as fish bones, on the paper within the area of each window. Working with a normal exposure, varying the time based on tests you have conducted for the emulsion you are using, remove one window and make the exposure. Replace that unit. Remove the next cutout and expose again, either for the same time as the first, or for less time. Keep repeating for all sections. You may need to run tests first, but you can end up with soft-edged white shapes on dark squares of different tones.

TIPS

If you are photogramming the pattern of a thin, printed fabric, place the printed side toward the emulsion and under heavy glass that does not block ultraviolet light.

Fresh vegetation and other living matter can sweat moisture under glass and thus stain the print, so use a large piece of acetate, cellophane, or clear plastic wrap available in grocery stores to cover the emulsion. Place the vegetation on top of the clear wrap, and then cover the set-up with the glass. For different results, eliminate the glass and place or pin the vegetation directly on the emulsion. Depending on the time of day or direction of the ultraviolet light, the vegetation will cast shadows that show up in the print.

USING STENCILS, MASKS, AND DISTRESSING NEGATIVES

5.2 Carol Golemboski, *Hush*, from the series *Psychometry*, 13 ½ x13 ½ in. (34 × 34 cm), black and white negative and Mylar drawing printed on Ilford Multigrade fiber-based glossy silver gelatin paper toned with Kodak sepia toner, 2001 © Carol Golemboski.

The artist combed flea markets, auctions, antique shops, and estate sales looking for ordinary objects that transcend their material nature to evoke the "elusive presence of the past." First, she photographed an old baby bonnet because, more than most other pieces of clothing, she noticed that hats evoke pathos as they retain the form of the human body long after the body is gone. The image was created through a combination of scratching the original negative, then enlarging that negative through a sheet of Mylar with abstract drawings and tracings of text from antique brass stencils. Golemboski's method could be used with any of the light-sensitive methods in this book, and her particular system directly relates to enlargement emulsions, Chapter 14, and toning, Chapter 3.

Graphic arts and some stationery stores carry a non-photographic red film called Rubylith® masking sheets (http://www.ulano.com/knifecut/masking.htm) to create clean borders. It blocks light and is easily cut with a stencil knife. Rubylith® is fairly transparent to your eye (but opaque to the emulsion), so it can be placed on top of a picture or transparency on a light table while the shape to be blocked out is traced and cut, creating a red window to which you tape your negative. Red masking sheets can be bought with a sticky backing, so that red shapes can be adhered to clear acetate to create functional negatives. In addition, I have used Rubylith® or a cut-out portion of the same—but reject—print *on top of* glass to dodge (hold back light to make a portion of the image lighter) the print during an exposure. If I were to put the Rubylith® cutout *under* the glass, the edge of the shape would be too sharp and visible on the print. You also can find Rubylith® in the form of a tape of various widths. More details are given in Chapter 4: Creating the Photo-Printmaking Studio.

Photographic film exposed to white light or the black border of processed film can also mask light.

TIPS

Try using precut stencils, such as the opaque lettering guides found in art stores, to create text. (Look closely at the Golemboski image in Figure 5.2 above, or John Wood's image on page 164 of the Cyanotype chapter.)

MAKING A PHOTO PAPER NEGATIVE

Photographer Walter Crump, whose pinhole image is in this chapter on page 110, saves boxes of different brands of expired black and white photographic paper that he has been using randomly for his recent still life pinhole photographs. For the image in this chapter, Crump used old Ilford MGIV glossy fiber base multigrade 5 × 7 in. (12.7 × 17.8 cm) double weight paper. He has mostly used glossy double weight paper, even when making contact prints from pinhole paper negatives up to 20 × 24 in. (50.8 × 61 cm). Most mat papers have a mechanical textured surface that can show up on the positive print, while double weight fiber base paper is quite transparent, so there is no problem making contact prints using a high wattage light bulb connected to a timer or an enlarger with the enlarger lens aperture set to wide open. Alternatively, the enlarger lens and lens board can be removed in

order to obtain optimum light intensity. Also, the fibers in fiber-based paper add a slight texture to the positive print, which Crump likes. Currently, he scans his paper negatives; he even scans the 20 × 24 paper negative in smaller sections and uses Photoshop > File > Automate > Photomerge to seamlessly stitch the segments together. See Chapter 6, Making Negatives: Digital Method, for more about scanning.

If you have actual photographs made on thin, single-weight, black-and-white photo paper, you can use these (positive) pictures as transparencies to create images in alternative photographic printmaking techniques. Because a photograph is a positive, however, you will end up with a negative final print, and exposures for the hand-applied emulsion described in this book will take longer. Compared with film negatives, paper negatives produce less detailed results, but you can use a pencil on the photo. Don't think you are cheating: Felice (aka "Felix") Beato, who lived from 1832 to 1909 and was one of the first war photographers, used graphite to darken areas where he wanted to heighten detail or block out areas before he printed. In actual fact, the original practitioners of these processes not only enhanced their negatives, but they also dipped their paper negatives in a shallow tray of heated wax to make them more transparent, then they ironed the paper negative between blotters to get rid of excess wax as a way of flattening the paper before using it as a negative. Make sure you place the photo paper image-side down onto paper, which should be emulsion-side facing the light source, and both should be weighted under heavy glass. Run tests for the correct time, but anticipate longer exposures.

You can enlarge a slide, which is a positive, onto black-and-white, single-weight paper in the darkroom and achieve a negative image, which can be used as the paper negative to produce a positive alternative photographic print. Black and white photocopies can be used, as explained later in this chapter.

If you have a photograph on resin-coated paper, which is the usual type from drug stores, you can separate the plastic layer with the image from the backing by using a razor blade between the layers of one corner, then gently peeling the resin coating off. If you are having a problem, soak the photo in warm water, then try peeling again. You will have a positive transparency ready for use. Or, try the emulsion transfer method described in Chapter 1, but transfer onto frosted acetate.

Even magazine pages on thin paper or newspapers can be used, but bear in mind that both sides of the page will print. Robert Heiniken used this "accident" in his Are You Rea portfolio, which can be seen at http://www.mocp. org/detail.php?type = related&kv = 7228&t = people. The inventors of these processes started by coating tissue paper with emulsion, making an exposure either with photogram materials or with the tissue loaded in a camera, then contacting that processed and dried image to another piece of heavier paper coated with emulsion. In Chapter 4, I have described how to use thin paper on page 92.

With all these methods, the transparency must be weighted with glass during the exposure.

USING CAST SHADOWS

5.3 Tom Fels, *Catalpa* 8-26-14 -1, 2014. Cyanotype on Sun Print Paper, 36 × 24 in. (91.4 × 61 cm) 2014, ©Tom Fels. (Left image of triptych)

The artist's large prints are life-sized images and made in a most direct way. He finds appropriate trees or bushes and holds the paper up to them. The cyanotypes are, more or less, prints from nature, because they include motion and other hard-to-control elements, an interesting idea to represent visually because you cannot actually see the wind. He found out right away that shadows themselves were not strong enough to create solid images. Technically, these images are like shadows, but really they come from the leaves touching or coming close to the paper, but not photogrammed under glass.

Selecting one of the printmaking formulas described in this book, coat paper or fabric in your studio, dry it, and load it into an opaque envelope such as black 4 ml polyethylene (available at hardware stores for garden mulching or as discarded packing from photographic sheet film and paper). Take the envelope outside, remove the coated paper or fabric, and place it so a shadow is cast on it. Exposure times will vary with the light of the day and the season of the year.

In addition, if you tip the paper at an angle, the object casts oblique shadows.

TIPS

First practice on a plain sheet of white paper to previsualize whether you will get a blur from the wind moving objects, for instance. Focus by moving the paper closer to or farther from the object casting the shadow, or create distorted patterns by angling the paper.

Use a board and tape under the paper if you want it to be held at an angle.

Try folding paper or fabric loosely and allowing it to cast shadows on itself.

IMAGES ON CLEAR ACETATE AND GLASS

5.4 Katarína Hutníková, *Untitled* from the series *TIME*, cliché verre negative printed on Fomaspeed black and white photographic paper, 240 × 180 mm (9.4 × 7 in.), 2011© Katarína Hutníková.

Multimedia Slovak artist Hutníková based her series on the combination of memories and photographic evidence of personal events. By utilizing her own handwork and collage method in the cliché-verre process, Hutníková preserves the memory in her own unique way, as a" photograph of our imagination." To make the negative, she used transparent foil, which she spray painted with black and white acrylic color, being careful not to make the layer uniform. Next, she inspected to see how the light would pass through each tone. She then scratched the painted surface with an etching needle. In addition, the artist projected light through glass microscopic slides with small patterns when she was printing on photo paper in the darkroom.

Clear media, frosted, or process acetate, found in art and graphic design stores, can be used as the vehicle for drawings made with black permanent markers, crayons, grease pencils, stamps and ink pads, typewriters, spray paints, or pressure-sensitive graphics (press-type). To make a negative with sharp detail, contact print the acetate image face-down onto the emulsion by weighting it with sheet glass, or soften the image by eliminating the glass. Some acetates may slightly block ultraviolet light, requiring a little extra exposure when you print.

Cliché-verre, which goes back to the nineteenth century (see another contemporary example in Laurie Snyder's cyanotype on page 163), translates to "glass picture" or ink drawings made on transparent material today. It is also known as glass etching or hyalography

(from the Greek word for glass). Corot, Millet, Delacroix, and their contemporaries from the Barbizon School of painting took a piece of flat glass, smoked it over a tallow candle, and then scratched a drawing in the smoke-covered surface with a sharp pointed instrument. Where the soot was completely scratched off, black lines would show when the glass was contact printed on to black and white photo paper under subdued light. To utilize the older method with contemporary materials, cover glass, frosted mylar, or acetate with opaque black acrylic paint or use a drop of dishwashing liquid and water to dilute paint for gray tones; several varying layers of black india ink to create different light-blocking gradations; or water-based black nail polish. Then, scratch with sharp tools or wipe areas almost clean and place the image side in contact with the emulsion. Expose to light and develop as you would normally. With school children, I have used an overhead light suspended three or four feet away, switched on and off, in a room with subdued light to expose out-of-date photo paper that I purchased inexpensively, or an enlarger light for a few seconds to make the exposure in a traditional darkroom. You can also use this method under an ultraviolet exposure unit with the hand-coated emulsions described in this book.

Discovered by William Henry Fox Talbot around 1835, the method has been re-discovered many times, including by Katarína Hutníková, whose work is reproduced in Figure 5.4 above.

TIP

Special acetates, available at photocopy centers and art stores, can be run through office copier machines to produce a positive transparency from a real object, pictures, or writing laid on the glass platen. Make sure you use the correct acetate for your machine, the specifics for which usually can be found on the manufacturer's website.

FOUND IMAGES

5.5 Binh Danh, *Transitional Justice* from series, *In the Eclipse of Angkor*, 17 × 16 ½ in. (43 × 42 cm), chlorophyll print and resin, 2008. Courtesy the artist and Haines Gallery, San Francisco.

Binh Danh was born in Viet Nam and immigrated to the United States as a baby. He has invented a technique for printing photographic images on the surface of leaves by exploiting the natural process of photosynthesis. He picks a tropical leaf, puts the stem in a baggie of water so it does not dry out, places a negative or a positive on top of it in a homemade exposure frame, and exposes the unit to sunlight from a week to several months. (See http://www.alternativephotography.com/wp/processes/chlorophyll-process/the-chlorophyll-process for more instructions.) Coined "chlorophyll prints" by the artist, the fragile works about Southeast Asian culture and history are encapsulated and made permanent through casing them in solid blocks of resin. The piece reproduced in Figure 5.5 above utilizes imagery taken in 1975–79 by the Khmer Rouge dictatorship, who photographed many of their 2 million victims before assassinating them in what is now known as the Cambodian Killing Fields.

Old negatives of varying sizes can be found in family albums, flea markets, and auctions, and usually are rich in detail. The ones on glass can be contact printed as is to hand-applied emulsions; the ones on plastic need to be held down with a sheet of glass. In addition, newspaper publishers sometimes give away old negatives of type and halftone-dotted pictures.

TRANSPARENTIZING OFFICE COPIES

You can run a special clear acetate, onion-skin paper, or reversal film with adhesive back through certain office photocopiers. The Boston Museum School's Store stocks PPC1000C Transparency film clear 11 × 17 in. (28 × 43 cm) at http://teamplasticscom.homestead.com/ART-MATERIALS.html at an impressively reasonable price. The reliable Rockland Colloid company that makes Liquid Light© (see Chapter 14) also makes laser copier acetate: http://rockaloid.com/digital-imaging/Transparency-Film-Laser. Not all machines will take these materials, so check first with the manufacturer or technician. Or, you take your original art to many copy stores and order a transparency made to your specifications. Some copy centers will reverse your positive to a negative, too. If the original is large, the operator can make copies of smaller parts of it that you later tile together. "Adversity" can be an advantage!

Or, you can transparentize a photocopy on regular paper by rubbing Canola or another cooking oil onto it, letting it soak in for a day, then wiping dry the excess with a paper towel. You will know when the oil has sunk in by holding the copy up toward a light and looking at it from the back to make sure that the whole image area is transparent. The oil will not transparentize the paper indefinitely, because it starts to dry immediately and is gone in a few months.

Remember that you have a positive transparency, which will print as a negative image later. Place a piece of cellophane or plastic wrap between the oiled photocopy and the hand-applied emulsion to prevent grease stains on your final print. In addition, if you use melted paraffin wax, you can achieve the same effect without the wait.

USING SPECIAL EFFECTS SCREENS AND DRY TRANSFER TYPE

5.6 Edie Bresler, *Perpetual Notions*, Cyanotype and Van Dyke brown Print on Arches Platine paper, 24 × 20 in. (61 x 50.8 cm), © 2007 Edie Bresler, all rights reserved.

Bresler's mother passed away when she was a teenager and years later, several weeks before her son was born, her father died. Seeking a visual language for difficult, layered emotions, the artist borrowed ideas from the Surrealist game, The Exquisite Corpse, by randomly selecting words from a public library card catalogue as her guide for imagery (for example, "mazes" to "milky way" and then "mourning"). Inspired by memories of her mother embroidering and to create a "negative," Bresler cut, quilted, and sewed window screens with imagery responding to the catalogue prompts, then contact-printed it onto hand-coated rag paper. The resulting traces reference the absence of her parents, along with the concurrent disappearance of card catalogues.

Although the wonderful art work by Edie Bresler in Figure 5.6 above literally employs a window screen, some art stores and online sites, like Ebay, stock a limited variety of adhesive-backed or pressure-sensitive printed patterns and letters on a wax paper backing. I have even found small sheets in the greeting card section of stationery, drug stores, and craft shops, and found my favorite manufacturer online at http://www.letraset.com/products/90-Letraset-Transfers/. I bought a wonderful array, reduced in price, from an art college's store in Maine because the management was discontinuing the products. They were especially attractive to me because the letters had started to dry, so the transfers ended up being cracked and imperfect. Some stores might still have grids, textures, lines, dots, topographics, and architectural symbols. Press them onto clear acetate to make a contact-size or enlargeable negative and consider combining them with such household items as open-weave fabrics and doilies or with black ink drawn on the acetate.

SENDING OUT COPY

Architects, designers, and mechanical engineers often send original artwork to print shops specializing in making large high-contrast or halftone negatives. Sometimes custom photography labs will make enlarged continuous-tone, black-and-white negatives from your camera negatives or photos. More likely, you can have enlarged negatives made digitally at a service bureau. If you look under "computers" in the Yellow Pages or search online, you will find service bureaus able to output a black and white negative from your file in either 8½ × 11 in. (21.5 × 28 cm) or 11 × 17 in. (28 × 43 cm). Lana Z Caplan hired a service bureau to make a positive for the tintype shown on page 279.

SEWING AND EMBELLISHING

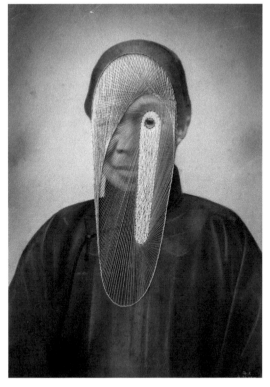 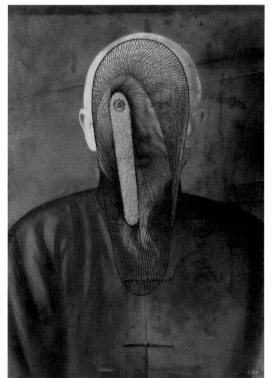

Figures 5.7a and 5.7b Maurizio Anzeri, *Mia and Mio*, embroidery on old photographs, 48 × 33 cm (19 × 13 in.) each, 2014. Image courtesy of Maurizio Anzeri and the Saatchi Gallery, London.

Anzeri has used thread as a drawing device as he sews directly onto vintage photographs. His needlework also sets up a psychological and cultural experience between the viewer and the partially hidden subject in the picture and between the past and the insistent power of the thread in the present.

5.8 Eileen Quinlan, *Top Down*, gelatin silver print on matte black and white fiber paper from Polaroid negative, 25 × 20 in. (63.5x 50.8 cm), 2013. Courtesy of the Artist and Miguel Abreu Gallery.

The artist, who graduated from the School of the Museum of Fine Arts a while ago, wrote, "I start by putting my film in a camera and photographing something. I shoot with Polaroid 55, so it's all expired, usually by 10 years or more. The results are unpredictable at best. If the film fails utterly, or the image is too soft, I'll let the negatives soak in water and other random substances for days or even weeks. What's left is a kind of residue—sometimes barely anything—only dust; other times, shards of emulsion remain. The film almost images itself, but somehow it remains haunted by an underlying photograph."

USING OUT OF DATE MATERIALS

Quinlan's experimental procedure could be used to make film negatives for any of the light-sensitive processes or with an Enlargement Emulsion (Chapter 14). Please see the illustration on the previous page.

PHYSICAL ALTERATION

Marco Breuer has made camera-less pictures on black and white paper exposed to bomb fuses and on nearly obsolete color chromogenic paper by sanding, shooting bullets through, folding, slicing, perforating, and burning the surface. He also made a series of cyanotypes (Chapter 7), gum bichromate (Chapter 10) prints, and pinhole photographs (explained below). While his approaches seem to challenge traditional notions of photography with, for starters, their lack of representational space, they also relate to painting and drawing in their physical methods and gestural results. I respect someone trained in large format photography at a technical program, who is an artist questioning the very nature of the materials he works with. His gum bichromate prints involve layers of gum-pigment-sensitizer, exposure, development, physical modification, then more coating, exposing, and developing, but never with a negative. Mark Alice Durant has written an insightful essay at http://saint-lucy.com/essays/marco-breuer-the-material-in-question/.

5.9 Marco Breuer, *Untitled* (E-100), 18 ¹⁵⁄₁₆ × 14 ¼ in. (47.8 × 36.2 cm), unique folded/abraded gum print on Fabriano paper, 2005. Courtesy of the artist and Yossi Milo Gallery, NYC.

PINHOLE PHOTOGRAPHY

Text by Jesseca Ferguson and Step-by-Step Photographs by Walter Crump

The authors are Boston-based artists who have worked with pinhole cameras for many years—Crump since 1987 and Ferguson since 1991. Their pinhole work has been published, exhibited, and collected in the United States and abroad, and they each have taught numerous pinhole workshops.

In an age when experience is becoming more virtual, the handmade aspects of photography seem more important to the maker and the viewer alike. Contemporary images may be hybrids that combine digital methods with hand coloring, collage, and a nineteenth-century technique or two. In this climate of experimental imaging, pinhole photography offers unique possibilities.

Whether you think of your pinhole camera as a sculpture that takes pictures, a recycled object, or a large-format camera, it will be uniquely yours. You can customize, decorate, or embellish your pinhole camera any way you like. The design of your camera, when exhibited alongside the images it takes, can make a visual or political statement not possible with any other imaging method. There are many reasons to experiment with pinhole photography: the incredible distortions you

5.10 Walter Crump, *Totem Machine,* 18 × 17 in. (45.7 × 43 cm), pinhole photograph from scanned paper negative, digitally toned pigment print on Hahnemuhle Baryta FB paper. © W. Crump.

With this still life photograph, Crump resurrects discarded mechanisms and weathered debris, bringing life to apparatuses from another time and creating an homage to once-useful machines that today have no purpose.

can get in your images, economy, infinite depth of field (all objects depicted are equally in soft focus), multi-pinholes (allowing multiple views simultaneously, large or unusual formats, etc.). Almost any object can become a camera!

5.11 Some of Walter Crump's homemade pinhole cameras. © W. Crump.

SAFETY

Please read Chapter 14, Enlargement Emulsions and Tintypes, page 268, which you can obtain by contacting Laura via www.laurablacklow. com, to become familiar with proper handling of darkroom chemistry.

Observe sound safety practices when operating power tools, or working with scissors or mat knives.

MATERIALS

1. Darkroom. See Making Negatives: Analogue Method by contacting me. In addition, http://www. ilfordphoto.com/photocommunity/darkroom.asp lists locales for rental darkrooms worldwide.
2. Orthochromatic film or black-and-white photographic paper. Any film will work in a pinhole camera, but Ilford and Freestyle Sales (see above, With a Darkroom) still make ortho film, and how to use it is described on the last version of New Dimensions and is available by contacting me via my website, www.laurablacklow.com. Ortho film

can be handled under a safelight and is thus a good film to start with. You can also load your camera with panchromatic film, but you must do so in total darkness, and it must be developed either professionally or in a completely dark room.
3. Potential camera. Choose a can, box, or other possible light tight container that will easily accommodate the insertion and removal of film or paper. If your pinhole camera is made from mat board or a cardboard container, make sure the board is thick enough to prevent light from filtering through. Good examples include paint cans, oatmeal boxes, lunch boxes, purses, suitcases, guitar cases, 35mm film canisters, garbage cans with lids, etc. Metal tins with tight-fitting lids, such as the ones used to package cookies or loose tea, have a high success rate as first-time pinhole cameras. A conventional camera (any format) can be modified to become a pinhole camera. Simply remove the lens and replace it with a pinhole mounted in light-tight material, such as a lens cap.
4. Mat knife, scissors. These implements are useful for cutting metal stock for pinholes or for building a camera from scratch out of mat board or cardboard. In addition, you can cut strips of mat board or foam core to act as channels, keeping the film or photo paper in place inside the pinhole camera.
5. Black spray paint. Matte or dull finish black spray paint can be used to darken the interior of your camera (especially recommended for white or reflective camera interiors). Lightly sand the inside of a metal box for better spray paint adhesion. Two light, even coats of spray paint will give you the best results. Let the first coat dry before applying the second.
6. Lightweight sheet metal. Brass shim stock (available from hardware stores and hobby shops), the flat part of an aluminum pie plate, or the side of a soda can can all provide metal suitable for making a pinhole. Aluminum foil will also work, but it tears easily.
7. Sewing, beading, or acupuncture needles or push-pin. These are used to "drill" the pinhole.
8. Emery sandpaper. Sandpaper designed for metal is used to smooth away the burr created when drilling the pinhole.

9. Drill, files. These tools are used for cutting and smoothing holes in metal tins, wooden boxes, or other items being transformed into pinhole cameras.

10. Magnifying glass or photo loupe. These items are used to check your pinhole for roundness and lack of debris.

11. Canned air. A puff of air, available from a good photography store, will clean pinholes of any debris left from sanding.

12. Black photo tape or Gaffer's tape, ½ to 2 in. (14–28 cm) wide. Black photo tape blocks light well and, therefore, is good for making a simple shutter or for mending light leaks. Aluminum foil tape is a durable, quick, and efficient way to assemble pinhole cameras from scratch; it is strong and saves considerable time because you need only to tape the sides of your camera together, and you are finished. If you make a mistake, peel or cut the tape and reconfigure. This tape is, essentially, a heavy-duty foil with an adhesive back. It is light tight and malleable, so all the wrinkles can be smoothed out with burnishing, and is found in most hardware stores, Home Depot, and heating supply firms.

5.12 Foil tape can take the place of glue for assembling a pinhole camera. © W. Crump.

13. Permanent black markers, black acrylic paint, pencil. Either markers or paint is good for touch-ups to reduce reflections from the shiny metal sheet where the pinhole has been drilled. Thick black acrylic paint can patch small light leaks. A pencil with an eraser is handy for helping you make the pinhole.

14. Weight or tripod for cameras made with tripod mounts. These items can be used to steady your pinhole camera when working outside on a windy day. A brick can simply be placed on top of a camera, or a small metal weight can be attached to the top or bottom of a camera. A good fastening method is removable, reusable adhesive putty available from art supply stores.

5.13 Tripod mount for pinhole camera. © W. Crump.

15. Watch, notebook, permanent paper labels to attached to your camera, pen, and (optional) smart phone notes application. These items help record your exposure times and results. Keeping good records will make your subsequent exposure times more accurate.

METHOD OVERVIEW

1. An ordinary object, such as an oatmeal tin, is turned into a pinhole camera. The interior of the would-be camera is blackened to cut down on interior reflections.

2. An opening is cut into one side or one end of the potential camera.

3. A pinhole, drilled into a 1 × 1 in. (2.5 × 2.5 cm) or larger square of lightweight metal, is taped in place behind the slightly larger opening in the side of the camera using black photo tape.

4. A flap of black photo tape or gaffer's tape is created to act as a simple shutter.

MAKING A PINHOLE CAMERA

5.14 Create the Camera. © W. Crump.

1. Create the camera

Once the camera-to-be is chosen, spray paint the interior matte black (unless the interior is already a dark, non-reflective surface). Double check for potential light leaks, such as around the hinges and handle of a child's lunchbox, and repair them with black photo tape. Next, using a mat knife or a drill bit ½ in. (1.25 cm) or larger, cut a small window in the side or end of your camera, preferably centered (for better image coverage). As this opening will accommodate your pinhole, be sure to make it smaller than the approximately 1 × 1 in. (2.5 × 2.5 cm) square of metal containing your pinhole. File and sand down the rough edges around this window carefully, so that your pinhole metal can be taped in place snugly behind it with black photo tape.

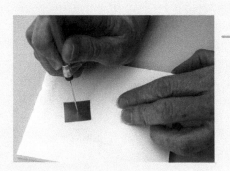

5.15 Make the Pinhole. © W. Crump.

2. Make the pinhole

To make the pinhole itself, cut an approximately 1 × 1 in. (2.5 × 2.5 cm) square of

metal, and place it on a piece of cardboard or foam core. Using a pushpin of a sewing needle with the blunt end covered in tape or embedded in the eraser of a wooden pencil (in order to cushion your finger), press down into the center of the metal square until the needle pierces the metal, leaving a burr on the opposite side.

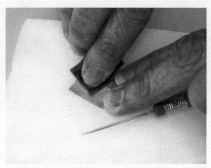

5.16 Refine the Pinhole. © W. Crump.

3. Refine the pinhole

Sand the burr down, using emery sanding paper, on both sides of the metal. Reinsert the needle into the hole as needed to drill and burnish the inside of the pinhole by gently spinning the metal around the shaft of the needle. Your goal is a perfectly round hole, free of metal debris, in a smooth metal plane. Holding the metal up to a light source, use a film loupe or magnifier to verify that your pinhole is round and free of debris.

5.17 Install the Pinhole. © W. Crump.

4. Install the pinhole

Center the pinhole behind the larger opening in your camera, and tape it into place with black photo tape. Attach your black tape shutter flap, and you are ready to go into the darkroom and load your camera.

5.18 Load the Film or Paper. © W. Crump.

5. Load the film or paper

In the darkroom, insert your light-sensitive material at the back of the camera, with the emulsion (light sensitive side) facing the pinhole. Hold the film or paper in position using reusable adhesive putty or tape (at the corners or in "rolls" at the back of your film or paper). This method also allows you to cut your film or paper into odd shapes. Remember to place your shutter made of black photo tape on the outside of the camera and over the pinhole before leaving the darkroom.

5.19 Make an Exposure. © W. Crump.

6. Make an exposure

For your first exposures, work outside, because your exposures will be faster than inside (unless you have studio lights) using a mixed light and shade situation and facing away from the sky, choosing indirect sun. Work closer to your subject than you normally would with a lens camera, and time your exposure in seconds or tens of seconds, even minutes, depending upon the light situation. (See tips, below.) To expose, remove the tape shutter and replace it at the end of the exposure.

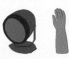

7. Develop the negative

In the darkroom, unload the "negative" from your pinhole camera and develop your ortho film or photo paper in a traditional darkroom set-up. Develop by eye, in paper developer (1–7 minutes), followed by stop bath (30 seconds), and fixer with hardener (5 minutes) for film, and without hardener for paper. Water rinse as the manufacturer directs (shortened for film by using fixer remover). Contact Laura via www.laurablacklow.com to request detailed information on negatives and the processing of ortho film.

Experiment, get to know your camera, have fun—and welcome to the world of pinhole photography!

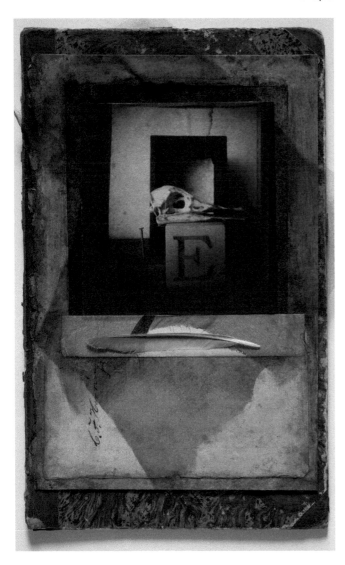

5.20 Jesseca Ferguson, *Bird skull/feather* (constructed), 11 ½ × 7 ¼ (irregular edges) × ⅛ in. (20.32 × 25.4 × .03 cm), pinhole cyanotype collaged onto nineteenth-century book board with found papers, feather, silk and ink, © 2014 Jesseca Ferguson. Courtesy of the artist. See more of her work at www. museumofmemory.com Photo credit: Peter S. Harris.

This collage incorporates a cyanotype print Ferguson made from a 2001 pinhole negative, which she called "E"; in the artist's mind, the letter referred to Emily Dickinson. She used cyanotype because it seemed the right visual counterpart to the feather and other materials she used in this collage. The negative was made with Polaroid's detailed, continuous tone Type 55 film. This 4 × 5 in. (10 × 12.7 cm) instant positive/negative, black and white film produced negatives that worked perfectly with handmade, contact-printed photographic processes and sometimes can be found, with its necessary Polaroid back, for sale on Ebay. A new company, appropriately named New55 positive-negative film (see With a Darkroom and the art work by Eileen Quinlan, above, and Supply Sources at the end of this book), is making their Type 55, which produces the same kind of continuous tones. The difference is that, with Polaroid, you cleared the negative in sodium sulfite, whereas the New 55 must be fixed in Ilford fixer.

TIPS

You can buy pinhole cameras, including stereo and multi-pinhole types, or convert almost any kind of camera at the suppliers listed in the back of this book, worldwide online, and at Gallery and Embassy stores listed on https://shop.lomography.com/en/cameras/pinhole-cameras.

In the cyanotype in Figure 5.20 above, Jesseca Ferguson used a wooden 4 × 5 in. (10 × 12.7 cm) Santa Barbara lensless camera.

Use black photo tape (with one end folded almost all the way back, but leaving a margin to stick to the camera), to make a simple shutter, which you place over the pinhole when not exposing your film or photo paper.

If your lens is placed in the middle (halfway between the top and bottom) of your camera, the horizon line will always be in the middle of your image unless you tip the camera up or down. By placing your lens a little above or below the middle, you will have an asymmetrical horizon line with either more sky or more ground depending on whether you expose your camera placed right-side up or upside down. You could also have two pinholes: for example, one in the middle and

another pinhole ⅓ above or below the middle. This method allows you to decide on the fly where you want to put the horizon line in your pinhole image by picking one of the 2 pinholes. The unused hole is covered with a tape "shutter," as explained above.

Malin Fabbri writes about making multiple pinholes in one camera in order to obtain a "cubist" effect: http://www.alternativephotography.com/multi-pinhole-cameras/.

For exposure times, work by trial and error, keeping the following four factors in mind:

1. Light conditions (inside/outside, time of year, time of day, geographical location).
2. Speed of light-sensitive material (film or paper) being exposed in your pinhole camera.
3. Size of your pinhole (smaller pinhole is slower, larger pinhole is faster).
4. "Focal length," or the distance from your pinhole to your film/paper. A shorter distance means faster exposure, with more of a wide-angle view. A longer distance means a longer exposure, with a more "normal" or telescopic view.

If you work consistently with one camera and keep notes on each exposure, you will learn a lot about light, about pinhole photography in general, and about your pinhole camera in particular. For those desiring more exact methods, see the exposure charts provided by Eric Renner in *Pinhole Photography: Rediscovering a Historic Technique* and other resources listed in the Annotated Bibliography.

Angle of view (normal, wide angle, telephoto). To get a "normal" looking image, measure your film/paper diagonally, then build a camera with a pinhole that is that same distance away from the film or paper. Thus, to produce a "normal" 4 × 5 in. (10 × 12.7 cm) pinhole image, build a camera that is 6 in. (15.24 cm) deep (the diagonal measurement of the 4 × 5 in. film). This 1:1 ratio is based on human sight: the diagonal measure of the receptors in the back of the human eye is equal to the eye's

diameter. ("Normal" presumes that your film plane is flat, not curved, as in an oatmeal-box camera.)

Image coverage/focal length ratio. As the cone of light entering your camera from the pinhole is interrupted by the plane of film, you will get different areas of coverage, depending upon the distance between pinhole and film plane (focal length). Pinhole expert and author Eric Renner discusses what he calls "the image-diameter-to-focal-length ratio" in his book *Pinhole Photography* (see Annotated Bibliography). Image diameter is approximately 3½ times the size of your camera's focal length. Thus, a 2 in. (5 cm) deep camera would give you approximately 7 in. (17.78 cm) coverage (7 in. diameter circular image). Keep this ratio in mind when making multi-pinhole cameras.

Image coverage and avoiding unwanted vignetting (gradual darkening of an image toward its edges). The camera-to-be should not have thick walls, lest you create a "tunnel" effect that prohibits the light admitted by the pinhole from exposing much of the film or photo paper in the camera, thus resulting in a vignetted image. If your chosen camera object has thick walls, simply make the original hole larger in order to permit a broader beam of light to enter the camera interior.

Walter Crump recommends Justin Quinnell's directions for making a special pinhole camera that creates solargraphs, created with a six month to year-long exposure, at http://www.pinholephotography.org/Solargraph%20instructions%202.htm. The results are 160° wide-angle views that capture, as Quinnell states, "a period of time far beyond our own vision."

Reducing potential glare. The back of the pinhole metal may be blackened with a marker to reduce glare, but be careful not to accidentally "fill in" your pinhole with ink.

There are a few methods for determining exposure times for your pinhole camera:

1. Light meter cell phone applications. There are a number of free light meter apps for your cell phone that are helpful for determining exposure times for pinhole cameras. Search for "light meter" in your cell phone Apps section. "Pocket Meter" and "myLightMeter" are two free apps that are recommended.

2. Digital or analogue camera. Another good way to determine proper exposure times for your pinhole camera is to compare equivalent exposure times with a digital or film camera. Set your SLR camera on manual and keep your ISO and aperture set to a constant setting (Crump sets his camera to ISO 400 based on the manufacturer's recommendation for the film he employs and the aperture to 5.6 based on the size of the pinhole he uses). You will use the traditional camera's shutter speed-reading to determine the correct exposure time for your pinhole camera. You begin by metering the subject with your camera and recording both the shutter speed of your Single Lens Reflex camera and the exposure times of your pinhole camera. Once you have found the correct exposure time that produces a good working negative, such as a two-minute exposure with your pinhole camera and the shutter speed on your SLR camera reads 1/60, then you know that any time your digital or film camera reads 1/60 you need to expose your pinhole camera for two minutes. For those who are used to traditional photography, you only need to have three or so readings to be able to interpolate the other readings using those known exposures.

3. Interpolating exposure times. Remember when metering with a normal camera, the aperture (F Stop) and shutter speed numbers progress geometrically; i.e., shutter speed numbers multiply or divide by nearly two times, from 60 to 125 to 250, etc. The same equation is true for pinhole cameras except the times are longer: such as, from two minutes to four minutes. So, if you have a few readings from different light conditions, you can easily figure out an unknown exposure time for your pinhole camera that fall some where within your established readings. For example, say a five-minute exposure is the equivalent shutter speed-reading of $\frac{1}{60}$ of a second on your normal camera, then a shutter speed of $\frac{1}{30}$, which is twice as long as $\frac{1}{60}$ of a second, would equal a ten-minute pinhole exposure. Conversely, a $\frac{1}{125}$ of a second, which is half as long as $\frac{1}{60}$ of a second, shutter speed on a traditional camera meter would be the equivalent of a 2 ½ minute exposure for the pinhole camera, and so on.

4. Determining exposure times by trial and error. Because F-stops and shutter speeds progress geometrically, you should be able to determine correct pinhole exposures fairly quickly. When testing, rather than changing your exposure time arbitrarily or in small increments, work geometrically. For example, if a five-minute exposure is too slow, try an exposure of ten minutes (plus one stop) or 20 minutes (plus two stops).

Keep in mind that exposure times for a pinhole camera will never be as precise as those for a digital or film camera because there are too many variables in a pinhole camera, but using these techniques will help you get close to proper exposures; the rest is up to your intuition. Ferguson does not use any light metering methods. She works by trial and error inside her studio, using only natural light, and keeps notes on exposure times, light conditions, and how she develops her sheet film (type of developer, dilution, time developed).

Pinhole size. Any size hole will work, but a smaller hole yields a sharper image, needing longer exposure time. For details on aperture size and focal length, see Chapters 5 and 6 of Eric Renner's *Pinhole Photography*, 4th edition, or Jim Shull's *The Hole Thing*, listed in the Annotated Bibliography.

Additionally, http://www.freestylephoto.biz/pinhole-camera-aperture-chart lists the diameter of sewing needles and http://www.mrpinhole.com/calcpinh.php provides a calculator.

Built-in holder for film or paper. If you will be using a consistent size or shape of film or paper, you can make a simple in-camera film holder using channels cut from foam core or mat board, glued into place opposite the pinhole.

Avoiding unintended blurring of image. Keep your camera steady on a firm surface throughout the entire exposure. (Move camera or subject for deliberate blurs.)

Troubleshooting negatives. If your negatives are completely dark, or are dark in certain blotched or streaked areas only, your camera may have one or more light leaks. Check your (empty) camera for light leaks by peering inside as you hold it up against a light source. Another good way to find hidden light leaks is first to mark your film or paper with labels you will understand, such as "top" and "bottom", then take your loaded camera into strong light without opening the shutter; move the camera around. Develop the film or paper and place it back in the camera the same way you originally loaded it. You will see where the light leaks, if any are coming from. Crump always does this first with every new camera he makes so he does not confuse exposure problems with light leaks. Make any necessary repairs with black photo tape or black acrylic paint.

If you can see some image, but the overall negative is too dark, you may be overexposing your film or paper. Reduce the light entering your camera by shortening exposure time or by exposing in a less light-filled setting. Rarely will you need to correct overexposure by making a smaller pinhole.

If your negatives show little or no image at all, you may simply be underexposing them, due to the light situation, pinhole size, camera depth (focal length), and speed of film or paper you are using. Possibly you may have forgotten to open the shutter, or have loaded the film or paper backward (emulsion side away from the pinhole, whereas the emulsion should face the light source or pinhole). With ortho film in a safe-lighted room, you can see the emulsion side, which usually is slightly lighter, sticky, and dull, while the non-emulsion side actually has a dye in it, so it is darker. If you gently roll a sheet of film at an angle, the difference in light and dark tones is more obvious. An additional word to the wise with ortho film: be sure to buy *only* ortho film that says "OK to open under safelight conditions." It is possible to get a package labeled as ortho film—but it is not good for use under a safelight.

Additionally, Walter Crump recommends loading a pinhole camera with Harman Direct Positive FB (fiber based) black and white photo paper, which can be developed in a conventional black and white darkroom. The camera will produce a direct positive, so there is no need for a negative, but use an ISO of 3 when you are calculating the exposure time. It also can be used under an enlarger to make photograms (see suggestions in the first part of this chapter) and is available from suppliers listed in the back of this book, such as at B & H Photo, Adorama, and Amazon.

A new addition to the market is Atomic-X -ISO 100 4 × 5 Panchromatic Sheet FilmBottom of Form. This black and white, 4 × 5 in. (10 × 12.7 cm) film offers a "classic tonal range from deep blacks through sublime mid-grays to soft and striking highlights." This is the same special cubic-grained emulsion used in New55 positive-negative film (see With a Darkroom, above). Try *Atomic-X* in your pinhole camera. Develop the negative with your favorite developer-stop-fix darkroom process or with New55 film›s convenient r5 monobath developer. Find the film at a good photo shop or at http://shop.new55.net/collections/frontpage/products/atomic-x-iso-100-4x5-panchromatic-sheet-film?variant = 11659375619.

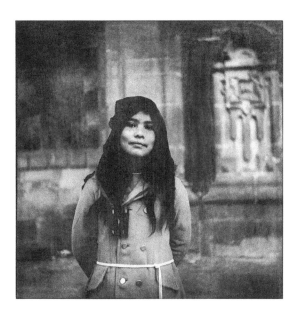

6.1 Laura Blacklow, *Mexican Girl*, Van Dyke brown print from enlarged digital negative printed on Rives BFK paper, 8 × 6 ¾ in, (20.3 × 17.1 cm). © L.Blacklow.

Before I made the brown print, I scanned the original black and white negative, added a grayscale, changed the contrast in Photoshop® on a curve adjustment layer, then inverted the image to a negative, reversed it right to left, and printed it on Pictorico OHP transparent film with an inkjet printer. This chapter explains how to do that process starting with either film, digital camera, a smart phone, or appropriating pictures from the Internet.

6

Making Negatives: Digital Method

By Joseph Moccia and Laura Blacklow

Acknowledgment: The fourth edition of this book contained a thorough explanation and step-by-step illustrations of digital negative-making by Young Suk Suh. We owe a great debt to him; you can see more of his work at http://www.youngsuksuh.com. Knowledgeable collaborator Joe Moccia and I have updated and added to the information and some of the illustrations.

L.B.

Please note: you will need a computer with Photoshop® and an inkjet printer. In addition, we suggest that you look over this whole chapter, because some information will become clearer if you see all the illustrations.

PART I: CAPTURING AND SCANNING IMAGES

GENERAL INTRODUCTION

For all the light-sensitive processes in this book, you need a black and white negative. This chapter will explain how to obtain that contact-size negative, even if you start with a color positive image. Utilizing digitally made negatives, beginning with (for instance) a phone picture and ending up with (for example) a Van Dyke brown print is so much faster and less frustrating than the old darkroom methods. It used to take nearly a half-day to make a contact-size negative tailored to a specific technique, but now we can do it in an hour! On the other hand, the subtle appearance of a print made from a large format camera negative's silver particles, or enlarging onto sheet film that has been directly contacted on top of one of the light-sensitive methods in this book, results in a different quality than using digital "film" with pixels to make a print. However, even large format negatives often need to be scanned so that they can either be enlarged or changed to create a digital negative made specifically for a particular process.

When shooting with digital cameras, bracketing your exposure—deliberately overexposing, underexposing, and shooting what you think is just right—would be a good practice. In addition, most digital cameras have on-camera histogram displays (histogram is explained below, on page 125) of each captured image so you can double-check your exposure. If you know about HDR—High Dynamic Range—on phones and digital cameras, you can automatically make a single image that takes into account that you may be shooting in an area with bright highlights and deep shadows. If you know how to tailor the selections in your camera, you are going to bracket the exposures, then you can save time by toggling between HDR for one shot and deselecting the HDR button for the second shot.

Resembling traditional darkroom photography, the quality of your negative or digital file affects the quality of the print. Underexposed or overexposed negatives can create muddy prints. However, the image capture process is a way to acquire the most tonal information possible from the primary material (film negative, two-dimensional original, smart phone, scanned object, or digital camera). This does not necessarily mean traditionally "good looking" scans. In fact, good image capture often results in somewhat flat contrast. At this scanning stage of the digital imaging process, you need to make sure that you have the most tonal detail, especially in shadow and high-

light areas, even if you choose to eliminate it later. In order to achieve this goal, it helps to understand digital imaging applications such as various scanning programs, how to send smart phone images to a computer, or raw file-processing applications from a digital camera. Eventually, you will need to use Adobe Photoshop®, which we will cover in the next section of this chapter.

WITH A DIGITAL CAMERA

Try to use a camera that allows you to shoot in RAW, which saves the image without losing information. However, if your camera does not offer the RAW option, choose a JPEG that is the largest dimension possible. When you are done shooting, you first need to transfer (called "downloading") all the images into a file on your computer via a USB cord or WiFi. If you shot in RAW, your computer will not understand the format unless you get Microsoft Codec Pack for Windows (free at http://www.microsoft.com/en-us/download/confirmation.aspx?id = 39196) or with Apple updates such as the relatively inexpensive but useful Adobe Lightroom, which is available on the creative cloud for a monthly fee. Then, go to page 133, where we explain how to use Photoshop.

WITH A SMART PHONE

When you shoot with a phone, pick the application that shows an icon of a camera. On most phones, you can make a JPEG ("joint photographic experts group," which you probably will never need to know) or a TIFF ("tagged image file format," another obscure piece of knowledge). We recommend a TIFF, which, unlike a JPEG, retains quality no matter how many times you open, work on it, save, and re-open the image file. As of the writing of this book, some, but not all, smart phones offer the best choice, RAW (which is not an acronym for anything, but means that you are capturing raw data), as an option with a special application for each brand of smart phone you download from the Internet. You can transfer a phone picture to your computer via a USB cord, WiFi, BlueTooth®, or setting your phone to save images in "cloud storage."

WITH A SCANNER

How to Operate a Scanner

Make sure the scanner is properly connected to the computer, plugged into an electrical source, and turned on. In addition, you can create a labeled folder on the desktop where you send all your scans.

If you are scanning color originals, such as a painting or color negatives, the next set of instructions is for you. Particular details pertaining to scanning transparencies, such as negatives, is a little further down, but we urge you to read these upcoming instructions first.

6.2 Dock, Showing Epson Scan Icon

1. Open Epson Scan Application

On the dock of your computer screen, you will see a small icon that looks like a drawing of a scanner. Click on it once to open it.

2. Set the correct application mode
(number 1 in Figure 6.3)

If the window that opens doesn't look like Figure 6.3, it is probably because it is set with a different mode. Epson Scan gives you three different modes to choose from in the drop-down menu next to the words "Epson Scan": Full Auto, Home, and Professional Mode. *Professional Mode* is the only option that gives you full manual control over every aspect of your scanning; therefore, first set your scanner to Professional Mode.

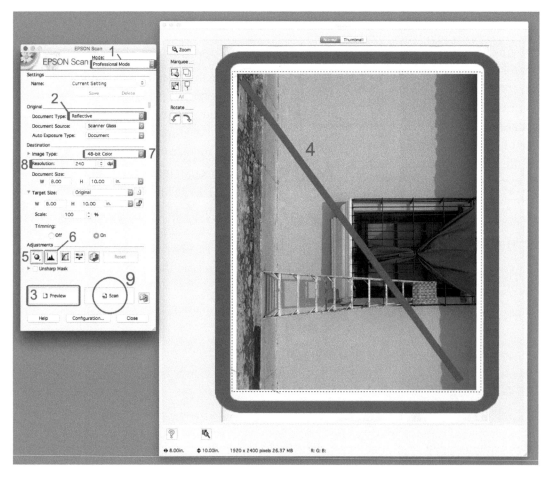

6.3 Epson Scan Window. Photograph ©L Blacklow

3. Select the correct document type

As illustrated in the figure for Epson scan, you will find a drop down menu with choices describing the *original* such as Reflective (meaning you cannot see through it like a transparency) or Film. Pick the choice that matches your original (number 2 in Figure 6.3) and under document type: number 2: choose "Document Table" and "Photo" or "Document."

4. Preview scan

During this process, the scanner makes a quick inspection of your original to give you a screen view size image. This procedure has nothing to do with specifics of the scan's quality, such as resolution, file size, and bit-depth, which are described later in this chapter; rather, it simply shows on your screen a picture of what you scanned. See number 3 in the figure for Epson Scan Window.

5. Select the scanning area (number 4 in Figure 6.3)

By dragging your cursor from one corner to the diagonally opposite corner of the preview image, make a selection of the scanning area before you decide on a resolution for your scan, especially if you plan to crop your image, as represented by the red diagonal line. The image/file size you are creating will establish the maximum size of your printed output and is determined by the resolution at which you choose to scan and the size of the selected image area.

Even if you are planning to scan the entire screen view, select the actual image area because every scanner has to make a certain degree of automatic tonal adjustments, especially when you are scanning negatives. Therefore, you need to remove unnecessary information such as the orange base of color negatives. To perform this function correctly, scanners need to analyze the density of any given original. If it includes unnecessary areas such as the opaque mount of negative holders, it will not make a correct analysis, but will give you incorrect colors and tones.

6. Perform the automatic correction

Although it is our intention to control every aspect of the scanning process manually, built-in automatic correction functions of most scanners do a decent job in terms of correcting colors; it is the tonal information that this process tends to sacrifice. Automatic correction would be a good place to start your scan, and in the next step you will resurrect tonal information that is lost by the process. Click the "Automatic Correction," which is number 5 on the Epson Scan illustration.

7. Correct manually

Most scanners give you a tool to manually control tonal information in highlight and shadow areas. The ability and options vary depending on the design of the application by each manufacturer.

Epson Scan gives you a powerful tool to control this aspect of the scan called Histogram Adjustment. Click the Histogram Adjustment button, which is numbered 6 in the Epson scan figure. It will open another window that looks like the one in Figure 6.4.

6.4 A Histogram Window

The entire rectangular histogram box within the larger window represents the possible tonal range the scanner can cover. You can see that the histogram created from your preview scan probably takes only a small portion of the horizontal scale. This means that the density range of the original material is much smaller than what the scanner can do. On the bottom of the rectangular box are three triangular sliders colored in black, gray, and white from left to right (see red circles in the figure to this step). These sliders are the tools that allow you to control the range of tones you are going to scan from the original, because the scanner will only assess the tonal range in between the black and the white sliders. Notice that the sliders are already near both ends of the histogram. If you use the cursor to drag these sliders away from where they are now and toward both edges of the box, you allow wider tonal ranges to be scanned, as demonstrated in the next figure. Leaving the sliders tightly close to the end of your histogram make the shadow darker and the highlight lighter creating a high-contrast image.

6.5 Using the Sliders to Change the Contrast

Unfortunately, you risk losing some tonal details near the shadow and highlight area because any tones left outside the sliders will become total black or white. To prevent this loss of detail, we recommend you drag the sliders a little bit toward the end of the box. How

much you drag them is up to your judgment. If you drag them too much, the resulting image will be too flat. It should look just flat enough to have all the tonal variations in shadow and highlight, as you saw in the illustrations at the beginning of this chapter. (Black and white analogue photographers: this digital option is similar to putting filters in the enlarger.)

If you are scanning a color original, there is one important step you need to be aware of, after you have previewed the image:

When using the histogram adjustment, you can make more exact color corrections. Using "Channels/RGB" and selecting each color (R = red, G = green, B = blue, the projected light primary colors) one at a time, you can move the far left and far right sliders to get rid of the clipping that was explained in Step 7. More about histograms is explained below, under "From Black and White Originals." But you will end up with one negative that is full color. Later, in Photoshop®, we explain how you will change the different channels to get one grayscale image, which is what you need for most of the hand-coated techniques in this book, except casein and gum printing, where the traditional method, explained in the Making Gum Prints chapter, is to make black and white negatives that represent each of the primary printing colors.

8. Other correction tips

Scanners also provide you with additional correction tools such as curves and color balance. Although moderately using these tools in the scanning stage can be beneficial, Adobe Photoshop® offers most of these tools with much more sophisticated control, which we will discuss in the following section, so we advise not using Epson's choices.

Most scanners these days give you an option of scanning higher than 8 bits per channel. This option allows you to keep the smoothness of tonal gradation from breaking down and creating banding. The range of bit-depth

varies from 8 to 16 to 24 to 48. But, if you are using a black-and-white original, you can go solely from 8 to 16 bit, and with color, you can go from 24 to 48, although we expect that in the near future, the bit depth choices will increase. While using higher bit-depth is beneficial to subtly gradated images, it makes the file size larger, and when you use Adobe Photoshop® later, the size grows exponentially. Also some printers will not work above 16 bits. Again, this factor may change in the future. Epson gives you a choice of 8 bits per channel and 16 bits per channel, which are the primary photo colors of red, green, and blue. Choose the lowest bit size that goes with your original (gray or color) for general purposes such as our tests.

9. Check the resolution and size

Although you might be tempted to type in the printed output size and resolution to determine the size of your scan, there is a risk in doing so because each scanner has its physical limit for resolution, called the optical resolution. If you exceed the optical resolution, the scanning application will increase the file size by digitally making up more pixels. This process, called *interpolation* or *resampling*, results in degradation of the image quality. Avoid this process by finding out the optical resolution of your scanner (you can normally get this information in the specification sheet or user's manual of your scanner or on the manufacturer's website under the scanner's model number), and when you scan, make sure that you do so at the optical resolution or lower. However, this method leaves you without knowing what size output you can get. The chart in Figure 6.6 shows you the estimated file sizes for standard output sizes. You should type in a resolution in the scanning application and watch for the resulting size at the bottom of the preview window that matches or is larger than the desired output size shown in Figure 6.6.

For example, if you want to make an 8 × 10 in. (20.32 × 25.4cm) or smaller inkjet print from your 8 × 10 in. original image, you will need close to a 9.2 Megabyte (MB) file for a black and white/grayscale and around 27.6 MB for a color scan. After a preview scan and making an image perimeter selection, you would type in, where the scanner program provides a box that is labeled "Resolution," a number that is smaller than or the same as the optical resolution of the scanner. We suggest that at first, you type 240–300 dpi if you are not enlarging your original, but use a much higher resolution if you want to make your original image into a bigger negative. For instance, the scanning software allows you to select a target finish size. Going smaller is not a problem if you stick with 240–300 dpi, but making your original larger necessitates greater resolution in the scan.

To allow extra room for additional cropping or to factor in different proportions for the image, you might aim at a size that is about 10 percent larger than the size you want.

If you are scanning a color original, there is one important step you need to be aware of, after you have previewed the image. When using the histogram adjustment (see Step 7, above), you can make more exact color corrections. Using "Channels/RGB" and selecting

Original Picture Size to scan	Print Size you want to Print	Great Print Scan	Very Good Scan
4×6 or 5×7	4×6, 5×7 (same size)	300dpi	200dpi
4×6 or 5×7	8×10, 11×14 (larger)	600dpi	300dpi
4×6 or 5×7	16×20, 18×24, 20×30 (much larger)	1200dpi	600dpi
8×10 or 11×14	4×6, 5×7 (smaller)	150dpi	100dpi
8×10 or 11×14	8×10, 11×14 (same size)	300dpi	150dpi
8×10 or 11×14	16×20, 18×24, 20×30 (larger)	600dpi	

6.6

each color (R = red, G = green, B = blue, the primary color for projected light) one at a time, you can move the far left and far right sliders to get rid of the clipping that was explained in Step 7. More about histograms are explained below, under "From Black and White Originals." But you will end up with one negative that is full color. Later, in Photoshop®, we explain how you will change the different channels to get one grayscale image, which is what you need for most of the hand-coated techniques in this book, except casein and gum printing, where the traditional method, explained in the Making Gum Prints chapter, is to make black and white negatives that represent each of the primary printing colors.

10. Make a scan

By clicking the "Scan" button you will eventually produce an actual scanned image. First, a dialogue box will pop up and in it, the "File Save" options allow you to choose where you want to save the image, such as on your desktop in a folder; a file format, such as JPEG or TIFF for the image; what to name and number your image. (See number 8 in the Epson Scan Window figure.) We suggest you always use TIFF for printing purposes because this file does not degrade after opening it and closing it, whereas a JPEG is affected. Click the "Scan" button on Epson scan software to make a scan. (See number 9 in the same figure to Step 1.)

WITH COLOR FILM ORIGINALS

6.7 Film in Scanner's Carrier with Opaque Top Removed

If you are starting with a roll of developed film, most scanners can scan a strip or an entire roll. There are different holders that allow you to scan different film formats, and they are made not only to lift the negative slightly off the glass (and prevent Newton rings that interfere with the appearance of the negative's scan), but also to notify the scanner where the original transparencies are placed. Notice in the photograph in Figure 6.7 that the negatives are being cleaned with canned air and that the solid white backing, also known as the document mat, on the scanner's top has been removed to reveal one of the sets of scanner lights and needs to be replaced when you are done scanning transparencies because almost all scanners also act as document scanners as well.

6.8 Negative Holder Correctly Placed on Scanner Glass

Once you have arranged your negatives, shiny side up and emulsion/dull side down, in the holder and you have aligned the holder to the upper right corner's white arrows by the scanner glass, gently close the top, make sure that your monitor shows Epson's Professional Mode (number 1 on Epson Scan Window illustration above), that the original document type is "Film with Film Holder" in older

6.9 Thumbnail Preview

models and "Transparency," "Color Negative Film"—use this option even if your negatives are black and white, "Color Positive—slides—Film" in other models (number 2), and under number 2: choose "Scanner Glass" and "Photo" in that illustration. Click "Preview" (number 3).

You will see that Epson scanners display a Thumbnail Scan button in the application window so that you can have small preview images to choose from, shown in the illustration labeled "Thumbnail Preview." You also need to be able to choose which negative or positive you want to preview and scan.

6.10 All Scanned Negatives Selected

To get a preview scan of one negative, you can select that particular image by clicking the check mark in the white box under that shot as shown in the illustration, "Thumbnail Selection," which is explained in the next paragraph. (If all the frames have checked boxes under them, you can uncheck the frames you are not interested in by clicking in the box next to the frame number.)

If you are scanning a color original, there is one important step you need to be aware of, after

you have previewed the image: when using the histogram adjustment (see Step 7, above), you can make more exact color corrections. Using "Channels/RGB" and selecting each color (R = red, G = green, B = blue, the projected light primary colors) one at a time, you can move the far left and far right sliders to get rid of the clipping that was explained in Step 7. More about histograms is explained below, under "From Black and White Originals." The goal is to end up with one negative that is full color. Later, in Photoshop®, we explain how you will change the different channels to get one grayscale image, which is what you need for most of the hand-coated techniques in this book, except casein and gum printing, where the traditional method, explained in the Making Gum Prints chapter, is to make black and white negatives that represent each of the primary printing colors.

6.11 Thumbnail Selection

As shown in the Thumbnail Selection illustration, white dotted lines are made by dragging your cursor from one corner to the diagonally opposite corner of the thumbnail image. Select the actual image area—not the white

border or black strips between rows of nega-
tives—because every scanner has to make a
certain degree of automatic tonal adjustments,
especially when you are scanning negatives;
and if the selection is not exactly what you
want, the scanner will make an exposure that
might be incorrect.

Choose "Scan" or option 9 in the illustration
with the yellow wall, of the Epson scan win-
dow.

You can elect to save that scan in your desk-
top file.

6.13 Grayscale Image. ©Young Suk Suh.

WITH BLACK AND WHITE ORIGINALS

Scanning: Capturing Images on an Epson Scanner

The histogram, shown on page 125 of Step 7
above, represents the tonal data of an image in
a linear diagram from dark to light tones and
from left to right. The entire box is divided
horizontally into 256 steps of brightness. The
left end of the box represents value 0, the
darkest black, and the right end value is 255;
the brightest white. (Note that the white is
not value 256. The total number of tonal vari-
ation is 256.) All other tones in an image fall
in between these two numbers. Figures 6.12
and 6.13 show you a grayscale image and a
histogram.

6.12 Histogram

The mountain-shaped diagram you see in the
histogram represents the number of pixels
(the basic unit of an image in the form of a
dot) at any given tonal value. The diagram in
this image begins to rise a little bit to the right
of the left end at the value of about 10 and
descend to the bottom at about 245. There is
no peak going up at either end of the box. This
means the image does not have any tone from
0 to 9 in the shadow areas and from 246 to 255
in the highlight areas. The darkest tone of this
image is about 10 and the lightest about 245.
At about value 180 the histogram shows the
highest peak of the image, which means that
180 is the value most common in the image.
Depending on different types of images, you
will have different graph shapes and locations
of peaks. If the image is hi-key the histogram
will have a lump of high peaks toward the
right since the image has a lot of high val-
ued tones. The opposite is true as well—dark
images will peak toward the left. Examples of
both are shown in Figures 6.14 and 6.15.

To obtain a good image capture, you must
avoid 0 or 255 by controlling various tools in
your image capture applications such as scan-
ning software, smart phone apps, or digital
cameras combined with RAW file-processing
applications. Having either 0 or 255 can mean
that you lost tonal variation in the shadow or

6.14 Example of Hi-Key Image.
©Young Suk Suh.

6.15 Example of Low-Key Image.
©Young Suk Suh.

highlight area. Although many contemporary manufacturers take this problem into account when designing their image capture devices and software, automatic correction processes implemented in these devices often result in extreme values because it is an easy way of achieving high-contrast images, which many people consider to be "good looking," "clear," or "bright" (all arbitrary ways of describing the images).

Although the first impression the image gives you is a clean, bright look, with a closer inspection you can find imperfect tonal details in the highlight and shadow areas. The highlight area is washed out and the shadow blocked up so that it loses detail. Even though this effect might be desired for your aesthetic, it is not a good way to capture an image because you lose an option to create a different interpretation of the image. The bottom line is, once you lose the tonal variation in the capturing process, there is no way to resurrect the information unless you recapture the image. It might be okay for some people to rescan the same negative several times, but in many cases it is a time-consuming task to do and sometimes costly if you are renting a high quality scanner, or impossible if captured directly by a digital or phone camera.

With careful scanning you can control this important aspect of capturing by manually controlling the scanning software. Directions for you to continue the scan are on page 124, Steps 1–10.

6.16 Example of Image That Has Lost
Tonal Details. ©Young Suk Suh.

WITH OBJECTS: SCAN-O-GRAMS

Read Steps 1–10 at the beginning of this chapter.

Make sure the glass is clean and protect it from scratches with thin plastic (or use colored acetate as an aesthetic element in the scan). Be aware that the actual focus area (depth of field) is fairly shallow.

Select "Reflective," 24-bit color, 1200 dpi for resolution so you are making a TIFF larger than what you might need. The higher the resolution, the slower the scan; so, if you want to move something during the scan, pick an even greater resolution. You can always change the resolution later if you need a smaller JPEG or TIFF file.

6.17 Using a Special Cloth to Clean the Glass

6.18 Objects Placed on Glass Covered with Acetate

6.19 A Slow Scan While Moving the Paint Brush

Cover the set-up with opaque cloth, or turn off the room lights. I use black velvet, but, when desperate, have thrown my winter coat over the scanner. (L.B.)

Make a preview scan and decide if you want to change the arrangement. Before you make a final scan, choose where to save the image, such as on the desktop, where you have created a folder. Name and number the scan in the pop-up window and also choose "TIFF" in the drop-down menu that appears when you select "Scan." Then, go on to Part II: Making a Digital Negative.

WITH APPROPRIATED IMAGERY

Please be sure that you are not breaking any plagiarism laws, which are different in different countries. There are websites, such as http://lifehacker.com/follow-this-chart-to-know-if-you-can-use-an-image-from-1615584870, that answer many of your questions for U.S. users. When in doubt, see if you can obtain written permission from the creator of the picture.

If you do a search for a picture, you can choose "images," next to "web" when your subject's list of links appears. You will then see a grid probably of more depictions than you ever imagined! Across the top of the page, you can choose the size of the picture, and I suggest you limit the search to "large." Then, click on your choice to see the individual picture larger and, therefore, with more detail. When you select "view image," the size, in pixels, appears under "window" on the gray bar at the top of your monitor.

Depending on how big a negative you are going to make, aim for what seems like an enormous size, such as 3,000 pixels in the long direction, because most web pictures are low quality (72 dpi), and you might want to start with a generous dpi so you can eventually reduce the size in Photoshop®. You really lose quality if you start with a small image and try to make it larger in Photoshop®.

If you put your cursor in the center of the picture and *right click*, a menu appears. Select "Save image as," then a new menu materializes. I would suggest that you make sure the title makes sense or change it to one that you can remember, then save it to the "desktop" as a JPEG. An arrow above the picture may draw your attention; it is indicating the download is in progress. In the next section, Making a Digital Negative, you will find directions on how to change the quality in Photoshop®, (Image > Image Size).

PART II: MAKING A DIGITAL NEGATIVE

STEP-BY-STEP DIRECTIONS FOR USING PHOTOSHOP®

1. Open Photoshop®.

6.20 Mac Dock

Adobe Design Standard CS5
Adobe Bridge CS5
Adobe Device Central CS5
Adobe ExtendScript Toolkit CS5
Adobe Extension Manager CS5
Adobe Illustrator CS5
Adobe InDesign CS5
Adobe Media Encoder CS5
Adobe Photoshop CS5 (64 Bit)
Adobe Photoshop CS5

6.21 Windows Choices. Please note: the numbered version of Photoshop Creative Suites, or CS, may change with time.

2. Make sure that Photoshop® is on the dock of your computer screen. It will look like a black square with the blue letters "PS." Click on the icon to open it, and you will see a big, black rectangle on your computer screen.

To make your image appear in the Photoshop® window, just pull its icon to the PS box and let go. Or, use the PS choice bar at the top of your monitor: File > Open + Your Image when the choices appear.

3. In the pull-down menu at the top of the monitor, where it says "Photoshop" or "Photoshop CC," look under the word "Window," and individually select the most important choices: application frame, layers, history, tools, options by clicking on them with the cursor.

IMAGE CORRECTION

Although image correction can be elaborated with many details and examples, we will try to keep this section to only essential concepts and tools for making digital negatives. There are many tutorials on this subject, and some are listed in this book's Bibliography.

ADJUSTMENT LAYER

One of the most important features in Adobe Photoshop®'s image editing system is the use of layers. One type of layer is called the adjustment layer. This layer does not contain physical information about your image but only adjustment information. This allows you to keep the original data intact no matter how many adjustment steps you apply to the original image, which is a great advantage because many other corrections are destructive to the integrity of the original gradation. By using adjustment layers you can minimize degradation of tonal data. If you keep applying new corrections successively to your image, it will start losing some of the tones that are essential to maintaining the smoothness of tonal gradation, and will result in banding (exaggerations). Adjustment layers keep the correction separate from your original data (usually named as the background layer) and make it possible for you to re-adjust existing corrections and to apply multiple corrections. You can access these layers either by going to the layers menu at the top of the Photoshop® box called the menu and choosing Adjustments Layer followed by the option described below, or you can click the "Adjustment Layer" button

at the bottom of the layers palette. It looks a bit like a yin-yang symbol.

6.22 There are numerous options to choose from, but we will discuss only two: levels and curves, which are essential to tonal correction techniques.

6.23 Levels Adjustment

1. Make the Levels Adjustment

(Layer > New Adjustment Layer > Levels + Okay or directly select it via the yin-yang symbol). Once you open the Levels Adjustment, you will notice, in the layers window next to the image window, that it looks very similar Histogram Adjustment in Epson Scan. In fact, both use exactly the same information with a slightly different function. Apply this tool to re-adjust highlight and shadow values by dragging the white and/or black slides in the input box. If your scan is made correctly, you don't really need to use this output box. Make sure both sliders stay slightly outside the histogram. (See numbers 1 and 3 in Figure 6.23.) Use the middle slider to control the overall brightness of your image (see 3 in the same figure).

6.25 Changing the Gradation Direction in the Curves Layer (Optional)

that automatically opened, the striped square in the upper right shown in Figure 6.25. In the pull-down menu, select "curves display option." Then pick either "light" or "pigment /ink" (whichever is not selected). Hit "okay."

6.24 The Curves Dialogue Box

2. Use the Curves Adjustment

The Curves Adjustment layer allows you to control the brightness and contrast of your image. (Layer > Adjustment Layer > Curves + Okay or directly from the yin-yang symbol.) The histogram appears as a gray mountain behind the grid, which represents your image linearly from shadow to highlight, just like the Levels Adjustment layer.

In order to coordinate the direction of shadows to highlight progression in curves so that it matches levels, select, in the properties tab

6.26

To make the image brighter you can click the middle and move the diagonal line upward. For more precision, click and then use the arrow keys on your keyboard, rather than dragging the spot with your mouse. If you put your cursor at the exact center of the line to create a point, you can push it upward and create the same effect as moving the middle slider in the Levels layer to the right. (See 2 in the curves dialogue box.) To make the image

darker, drag the curve down. You can also notice that as you drag the curve the entire diagonal line changes its shape; even though you used one point at a specific tone, Adobe Photoshop® automatically figures out how other tones near the point should change to keep the smoothness of the tonal scale.

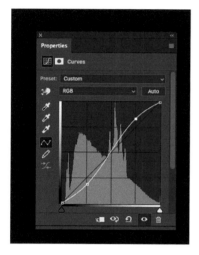

6.27 Increasing Contrast

For example, even if you click on a point in the shadow area of the curve and drag it up so as to achieve more detail in a dark tone, you can see that the middle part of the curve has also gone up and makes the entire image lighter. The Curves Adjustment layer allows you to use more than one point so that you can control different tonal areas separately. This does not mean that it allows you to change tones in an isolated area, such as dodging and burning techniques in the darkroom, which we will discuss later. However, you can perform a contrast control of your image using this capability like using a filter in a black and white darkroom. After all, to increase contrast means to make highlights brighter than the original and to make shadows darker. To decrease contrast means to make highlights darker and shadows lighter. As a result, a low contrast image will show many middle gray tones.

To make an image high contrast you can click on a point somewhere in the highlight area (for instance, somewhere between the center and right) and drag it up. (See 1 in figure Contrast Control number 1: increasing contrast) Then click on another point in the shadow area and drag it down. (See 2 in the same figure.) Use the eyeball button (circled in red) in the Curves Dialogue box to compare the image with and without the change. Readjust the position of the points either up and down or left and right to fine-tune the contrast. If it looks fine, click the "X" in the upper left corner of the Curves dialogue box and the change you made will be stored in the layer. You can also use more than one Adjustment Layer. Try not to make too complicated a curve; limit the points to less than four or five because you want to keep the curve as simple as possible in order to preserve the natural tonal progression. Figures 6.28 and 6.29 show you different types of curves.

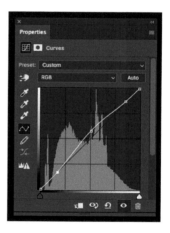

6.28 Decreasing Contrast

You can save the curve in Photoshop® and apply it to other negatives because, if you repeat a light-sensitive technique using a similar contrast image, the same solution and paper, the curve should be the same. All you need to do is: after you have finished making the curve, select and hold your cursor over the small box with parallel lines in the upper

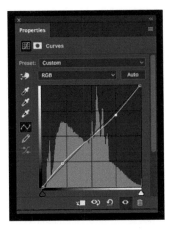

6.29a Brightening Midtone Without Changing Highlights and Shadows

6.29b Increasing Contrast Without Changing Highlights and Shadows

right side of the curve layer next to the word "Properties." Select "Save Preset" and a bigger window will appear. Type a name and click "Save." To apply the curve to a different negative, select a curves layer but then, go to that same small box and this time select "Load Curves Preset." Again, a larger window will appear, and you will see the name of the preset, which you select by clicking on and highlighting it; then choose "Open" at the bottom of that window, and you will see a new curves layer has been applied to your image.

3. Add layer masks

To isolate adjustments to a specific area of an image, which is equivalent to dodging and burning in a traditional darkroom, you need to use another great feature of Adobe Photoshop® called Layer Masks. Although there are tools like dodging and burning in the toolbox, using such selections is not helpful because these tools permanently change your original tonal data in the background layer. Instead, you can use the same adjustment layers such as Curves and utilize the layer masks that are already in the adjustment layers. The mask options are indicated as blank white boxes in each adjustment layer. (See 1 in the Figure 6.30.) Although they are initially white,

6.30 A Layer Mask with Options

which has no effect on your image, if you fill black in the layer mask, you will completely block your adjustment from showing its effect as though you turned off the eye of the adjustment layer. (See 2 in Figure 6.30.)

Make a Curves Adjustment layer and drag the curve up to make the image lighter. When you are done, click the "X" above the word "Properties" to close the dialogue box. Click once on the Layer Mask to make sure that it is activated. Then open the Edit pull-down menu on the top menu bar and choose Fill, as shown in Figure 6.31.

6.31 In the dialogue box that appears, choose "black" in "content" and leave the opacity at 100 percent.

6.36 Move the mouse to the area of the image you want to lighten and start making strokes by clicking-and-dragging. Frequently check the difference by turning on and off the eye icon of the layer in the layers palette. You will see the area you are stroking with the brush because it should be getting lighter, as if you were dodging in the traditional darkroom.

6.32 Click OK, and immediately your adjustment on your image will disappear. You can also see that the layer mask turned black on the layer palette. By creating the black layer mask, you can make the adjustment reappear only in the area where you want.

6.37 You will use exactly the same brush technique for burning/darkening except for slight changes in the Curves Adjustment. To burn an area of the image, make a new curve in a separate layer so that the image appears darker. Then, follow exactly the same steps as the dodging technique described above.

6.33 You will use the Paint Brush to do this. In the toolbox on the left side of the screen, choose Paint Brush.

6.38 Brush Size, Brush Edge, and Opacity Choices

6.34 Paint Brush Icon

Make the foreground color white by clicking the small black-and-white square on the corner and switching between foreground and background colors.

6.35 Foreground and Background Color Choices

At the top option bar, set the opacity of the brush at around 30 percent, set the hardness of the brush at 0 percent, and change the brush size in the brush control menu until it is large enough to cover the area you will lighten up with a few brush strokes by using the brush control menu.

HOW TO ADJUST A COLOR SCAN TO MAKE A BLACK AND WHITE NEGATIVE

Make another layer, by opting for Image > Adjustments > Black and White. Under "Properties," you will see a list of color sliders. Using only Reds, Greens, Blues (and not cyans, magentas, yellows), you can adjust the appearance of your image. This is the reason for originally scanning in color: you get to adjust each channel of the three channels, thereby making a more precise negative. Move the slider for each of the three colors until you get a value that is equivalent to the original image by comparing the grayscale to the color with the eyeball icon at the bottom of the Properties screen. Before you print, you will need to go to Image > Flatten Image. File > Save As > TIFF, as explained on page 128. A good idea is to go to Image > Duplicate + Save before you flatten the image so you can access the layers later for making adjustments.

HOW TO USE THE NEW NEGATIVE TO MAKE A PRINT

Although we will use cyanotype as a primary process in our explanation of making digital

negatives, the techniques explained in this chapter can be used for other contact printing processes, such as Van Dyke brown prints, Platinum Palladium, Gum Bichromate (which is further explained in that chapter), Lumen, Salt, and Casein among many. We will reference Mitsubishi Imaging's Pictorico OHP film throughout this next section. It is an almost-clear acetate with a special surface to capture ink. You insert it into the printer with the notched edge to the upper right in order to make sure that the correct side is toward the ink jets. Clear instructions are packaged with the film. Although there are other films, we recommend this brand, which is carried at most outlets in the supply sources.

In the traditional darkroom processes, tonal control of the cyanotype print can be achieved by using various exposure times and chemical solutions. In the digital negative process, we do not recommend changing exposure times or chemical solutions to control print density; instead you can achieve a more sophisticated degree of tonal control by changing the density of the negative itself. Additionally, once the negative is made to your liking, you can make more than one copy (called "editioning"). In order to limit the variables, you will have to choose a combination of exposure time and chemical solution and keep it for the entire process.

Finding DMax

Before making a digital negative, we recommend that you coat a small sheet of the paper you will use for your final print, put a strip of the OHP acetate over it, then run tests under ultraviolet light to find out which was the minimum time needed to print the darkest blue, or DMax, through the film because it does have slight light-blocking properties. *This is a very important step!*

Next, you go through the scanning and image correction processes described in the previous sections of this chapter so that you have

a "good looking" image on the monitor. The corrected image can be inverted to a negative in the digital printing stage and printed out on the OHP. The density of the negative produced by inverting to a negative from a positive image without any adjustment does not normally create a full tonal scale, although the resulting prints can vary depending on the range of values inherent to a specific technique and material you use. In making digital negatives, readjusting the density of each negative for each combination of method and material is the crucial step to achieve a full tonal scale in printing. Although it may seem more time-consuming, in the end, you will save time.

Figures 6.39 and 6.40 show a digital image scanned from a 4 × 5 black and white negative,

6.39 An uncorrected scanned image. ©Young Suk Suh.

6.40 A cyanotype from the scanned image, inverted to a negative and printed on OHP. ©Young Suk Suh.

corrected in Adobe Photoshop®, and the resulting prints made with the cyanotype process from a negative directly inverted from the file and printed on a sheet of Pictorico film, which we will tell you about in more detail as you read on.

After figuring out the best exposure time with the DMax test described on page 139, that exposure should be maintained throughout all the cyanotypes. It is the negative that changes. The highlight on the top portion (the ceiling) of the print is mostly washed out due to the high density of the negative; the midtone and the shadow areas look too dark because of the low density. This appearance means that the cyanotype process is not capable of producing the full tonal scale from the negative made by inverting a "good-looking" image, due to innate properties of cyanotype and the harsh density range that the printer and the substrate used in this test. You might say that it is somewhat similar to the typical cyanotype made from a traditional silver-based black-and-white negative. However, the ability to control density in digital negatives makes it possible to produce a full tonal scale print. Figure 6.41 is the final version of a cyanotype print made from the same original image but completed after adjusting the density and

6.41 The final cyanotype from a corrected negative. ©Young Suk Suh.

reprinting negatives several times, and testing each negative in the cyanotype technique.

In order to achieve a full tonal scale in your prints, you need to go through a series of test prints until you create a good density adjustment curve. Once you achieve the right adjustment, the curve can be used for other images on similar paper with the same technique (Image > Adjustment > Curve). Click and hold on the cog wheel to the right of the preset dropdown window. Choose "save preset." A new save dialogue window appears. Name it, such as "cyanotype + platine." Hit "save." In the future, if you want to put that curves layer on another image, you can go to Image > Adjustment > Curve and you can find your saved curve in the preset dropdown window. Each choice of paper, chemicals, type of exposure unit, and the amount of exposure, as well as the choice of inkjet printer and substrate, can change the result. For these reasons, we recommend everyone do their own tests.

In the following procedure we will explain how these experiments are accomplished step-by-step. As mentioned, note that the numbers we came up with in the following test are only true when the same material and conditions are used later.

The next list shows you the fixed variables that Young Suk Suh used in this test:

Paper: Arches Platine; chemical solution: Bostick & Sullivan Cyanotype A and B; exposure unit and time: the one described in the fourth edition of this book, but essentially the same as the one in Chapter 7, 20 minutes, which was the minimum time needed to print the darkest blue through the Pictorico film; printer: Epson inkjet printer with Color and Matte Photo Black ink. (Any dye-based or pigment-based inkjet printer would work fine, but different printers can produce different density negatives from the same file. Keep using one printer throughout the test. However, it is worth noting that matte black

ink blocks ultraviolet light better and is rec-ommended with some substrates.)

Make sure that the bit depth of both the gray-scale and your Photoshop® image are the same.

1. Make a 13-Step Grayscale

In order to be able to make more accurate decisions on density control of your nega-tive, we recommend you make a grayscale step tablet divided in 13 steps. Alternatively, you can download a larger grayscale at http://www.freestylephoto.biz/alternative-process/making-digital-negatives or on http://www.alternativephotography.com/8bit-stepwedge/, which will work too. Also, you can buy a more subdivided transpar-ent gray step at http://www.freestylephoto.biz/19721-Stouffer-Transmission-Step-Wedge-Gray-Scale-T2115-21-Step-(1-2-inch-x 5 inch).

6.42 Photoshop Already on the Desktop

6.43

1. Go to File > New in the top menu bar.

6.44

2. Make a file that is 2 × 13 in. (5 × 32.5 cm) with 240–360 pixels per inch (ppi) resolution that matches the pixels in your image, in the same mode as you made your image, such as grayscale mode or RGB (but do not adjust the saturation).
3. Go to View > Ruler from the menu bar.
4. Go to View > Show > Grid from the menu bar.
5. Go to View > Snap > Grid from the menu bar.

6.45

6. Choose the rectangular Marquee tool in the tool-box. It looks like Figure 6.45: a square made of dashes. It may be hiding under a circle made of dashes. If you don't see a rectangle, hold your

cursor over the tiny triangle/arrow in the lower right corner of any of the tools, and you will see the other options. You can just click on the one you want in order to activate it.

6.46

7. Click and drag a rectangular box at the size of 2 × 1 in. (5 × 2.5 cm) at the topmost portion of the image. Remember: the image and the gray-scale have to fit, with space in between the two, on whatever size film you have.

6.47

8. Go to Edit > Fill in the menu bar.
9. Choose "Black" (but don't worry if you are starting with RGB) in "Content" and make "Opacity" 100 percent and click OK.
10. Move the rectangular marquee selection down 1 in. by dragging the selection.
11. Go to Edit > Fill again.
12. Choose "Black" in "Content" and make "Opacity" 95 percent and click OK.
13. Repeat Steps 10–12 and change "Opacity" in Step 12 so that you create tonal steps that are 100 percent, 95 percent, 90 percent, 80 percent, 70 percent, 60 percent, 50 percent, 40 percent, 30 percent, 20 percent, 10 percent, 5 percent, and 0 percent. Please note that Laura has taken to writing the percentage numbers, using the Type tool, next to or in each box.
14. Go to View > Show > Grid from the menu bar and uncheck Grid to turn off the frame lines.
15. Save the file (File > Save). Figure 6.48 is the resulting image. If you are working with film smaller than 13 inches (7.62 cm), you will have to make the gray scale's length smaller in Image > Image Size.

6.48 Negative Holder Correctly Placed on Scanner Glass

2. Create a File for Printing Tests

1. Open the 13-step file.
2. Open the image you want to make prints of.
3. Go to Image > Duplicate in the menu bar to duplicate the image file.
4. Go to Layer > Flatten.
5. Go to Image > Image Size and make the file size about 5 × 8 in (2.54 × 20.32) or smaller at 240–300 ppi, depending on what your printer can accommodate and what quality your image is.

Please note: those of you who use a different system might have A4, for instance, so your calculations will be slightly different. The point is to make sure that you can fit all files within the size of your film, leave a margin between them, and still take into account that printers do not copy all the way to the edge of the film.

6. Go to File > New and make, at the correct ppi, an 8 × 9½ in. (20.32 × 24.13 cm) file and name it "Test_01."

7. Choose the 13-step table file by clicking on it but make sure the "Test_01" file is visible in the background.

6.49 Dragging the 13-Step File

8. Go to Image > Image Size and type "4" in (10.16 cm) Height and "300" in Resolution.

6.50 The Move Tool

9. Choose the Move tool in the tool box.

10. Click in the middle of the 13-step file and drag over to the visible area of the Test_01 file. (See figure with Step 7.)

11. The Test_01 file will now be on the foreground with the 13-step image copied. Drag the 13-step image to an unused border space.

12. Your final image should look like Figure 6.51.

13. Save the file: (File > Save).

6.51 The final (positive) image with 13-step grayscale. ©Young Suk Suh.

STEPS TO MAKING DIGITAL NEGATIVES

The First Negative

1. Open the Test_01 file in Adobe Photoshop®.
2. Go to Image > Canvas Size in the menu bar. You might, for instance choose 8.5 × 11, and your image will be 5 × 7, so the new size allows you to fit the grayscale as well. Be sure to flatten the image (Layers > Flatten Layers) afterwards.
3. Choose the size of paper so the dimensions match your acetate and set the orientation according to your image orientation. Vertical is "portrait" and horizontal is "landscape."
4. Click OK.
5. Go to Image > Image size.
6. Check the Constrain Proportion (it looks like a chain) and Resample Image checkboxes. Then, make Width or Height *smaller* than your film size and set Resolution at 240 to 360 ppi (depending what your printer can render and what your image is; these printer and image numbers should match).

6.52 Selecting the Image Size Before You Print

7. Click OK.

6.53 Photoshop Print Settings window. Image ©Young Suk Suh.

8. Go to File > Print in the menu bar, to open a window called "Photoshop Print Settings," then select Printer Setup > Printer + Your Printer (number 1 in the Figure 6.53).
9. Under Color Management > Color Handling > select Printer Manages Color. (See 2 in the Figure 6.53.)
10. For Rendering Intent: Perceptual. (Number 3 in Figure 6.53, "Photoshop Print Settings" window.)
11. Under Layout, select the icon that represents either vertical or horizontal (it should match your earlier choice, which is number 4 in Figure 6.53). You might need to adjust your image on the preview screen's left side, if it isn't fitting correctly within the black and white striped margin on the Epson (but not Canon of HP) window. You can do this by clicking and holding down your image and moving it within the box to better center it.
12. Next, scroll down (number 5 in Figure 6.53) to "Functions" and check the boxes "Emulsion Down" and "Negative," which will change the orientation of your image as well as its appearance, as shown in the next figure.

6.54 Printing Choices Selected

13. Click on Print Settings and another dialogue box will appear. You may have to press a smaller window's "Show Details," outlined in a red rectangle, below, to get to the correct window, if "Hide Details," outlined in a red oval, was selected by accident.

6.55

14. Make sure "Copies" says 1, then choose your film size from the drop-down menu labeled "Paper Size." Note that, with a Canon, rather than an Epson, printer, the windows look a bit different.

6.56

15. As shown in the image of the print window in Figure 6.56, back at the top of the Photoshop Print Settings dialogue box, select "Print Settings"; this will open an additional box labeled "Print."

16. Change Layout to Printer Settings (1 in the Print window in Figure 6.56) in the drop-down menu.

17. Set this dialogue box/page set up as the following:

 Media type: Premium Photo Paper Glossy (2 in Figure 6.56).

 Ink: Photo Black if you are using OHP (3 in the figure).

Choose Adobe RGB under "Color Mode" (4 indicates the color mode in the figure, and "RGB" is on the pull-down menu). In the newest printers, choose Epson controls > Adobe RGB.

Choose "Superfine-2880 dpi" (older printers say "1440," which is okay, too) under output resolution, number 5 as in Figure 6.56.

Use the highest resolution available on your printer, and try the recommended printer settings below or equivalent media settings. Due to variations among printer and ink manufacturers, some experimentation with output settings may be required for optimal results. Please refer to your printer manual for specific recommendations.

Check "Finest Detail." Below output resolution (6 on Figure 6.56).

Make sure you keep these settings throughout the entire test procedure. Different settings will produce different densities of negatives.

6.57 Print Window with More Changes

18. Change Layer > Printer Settings to Color Matching (number 1 in Figure 6.57).

19. Under the words "Color Matching," you will see two buttons. Select Color Sync (number 2). Choose the Save button in the lower right of the same window when you are finished.

20. Make sure you correctly insert your substrate in the printer. If you are using OHP, the notch on your film should be in the upper right corner. If you are using different film, check the manufacturer's instructions. Back to the Photoshop Print settings: click Print on the bottom right of the dialogue box.

PART III: HOW TO USE THE DIGITAL NEGATIVE TO MAKE A PRINT

After you have printed the negative, make a print in the technique you want. We have created a cyanotype as an example. The resulting print will look like the image in Figure 6.58.

THE SECOND NEGATIVE

The cyanotype made with the initial negative will normally lack highlight and shadow details as shown in Figure 6.58. You can see that the actual tonal separation is concentrated in a very narrow area of the original grayscale. That is, the dark tones in steps 70–100 percent do not show up as different blues, and the 0 and 5 percent look the same. This initial print will be used to readjust tone and create a second negative that can expand mid-tones so as to reproduce a full tonal variation. Make sure it is dry before you evaluate.

6.58 A cyanotype from the first negative. ©Young Suk Suh.

There are several different approaches to fixing the contrast of your negative:

1. A simple approach is to change the ink from Photo Black to Matte Black by changing the Media Type back in the Printer Settings dialogue box and selecting a Matte paper. This should make your negative have more contrast as this type of ink absorbs more UV than the regular Photo Black.

2. Another way to deal with contrast in your negative is to change the curve you saved. First look at the step wedge you printed and see if there is any separation in the tones, and at what point in the grayscale tonal separation occurs. For instance, if there is no color in 70–100 percent, you need to darken highlights in the curve of the positive image. Remember: you need to think in reverse, from negative to positive.

6.59 On the left you see the original curve, on the right a corrected curve to render highlight detail.

If on the other hand there is no separation in 0–30 you would lighten the curve in the shadows. Do not change the points in upper right and lower left; add more points in between to separate the tones.

6.60 On the left the original curve, on the right a corrected curve to produce shadow detail.

3. After you analyze and add a new curves adjustment layer, print another negative in the same way as the procedure for the first negative. The only step

6.61 A curve that increases solely shadow and highlights, but not the midtones.

you added to the first negative printing is moving the old curve to the "trash" and putting on a new curves.

4. Make another cyanotype with the new negative. Remember to dry the print before you judge the results.

5. If the print still needs more corrections, go back, readjust the curves, and make another negative and another cyanotype. Repeat this process until you make a satisfactory print. Figure 6.62 is my final print.

6.62 The finished cyanotype. ©Young Suk Suh.

You can use the same process with other printing techniques such as Van Dyke brown and palladium. Figures 6.63 and 6.64 are the final prints of each technique. Young Suk Suh used the same paper and acetate; the exposure time was ten minutes for the Van Dyke brown process. For the Palladium process he used the dilution #3 and a six-minute exposure.

6.63 Finished Van Dyke brown print from a digital negative. ©Young Suk Suh.

6.64 Finished palladium print from a digital negative. ©Young Suk Suh.

Figure 6.65 shows the three-color-gum print Young created. Although making proper color-separated negatives took patience, he found that the resultant print was more satisfactory if he *intensified the color saturation of the scan*. Then, the artist created each cyan, magenta, yellow, and black (CMYK) negative by copying each channel of the CMYK color image into a grayscale file. The watercolors to use for gum printing are described in Chapter 10. The same techniques would be used to make a full-color casein print (Chapter 11).

6.65 Three-color gum print. ©Young Suk Suh.

TIP

InkAID makes a clear semi-gloss precoat that can be applied with a foam brush to any substrate that can go through your printer. It allows the underlying colors or image on the substrate to appear through the coating: http://www.inkaid1.com/inkaid-clear-semi-gloss-precoat.

There are other methods for making digital negatives that use color tints on the film, and you can find them in other books if, for some reason, the instructions above do not meet your requirements.

Part III

Light-Sensitive Methods

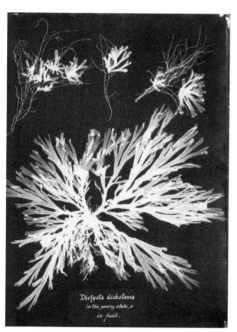

7.1 Anna Atkins. Four pages from her books (see below). Upper left: *Himanthalia lorea*, had been owned by Sir John Herschel (!); Upper right: *Callithamnion tetragonium*; Lower right: *Gigartina compressa*; Lower left: *Dictyota dichotoma, in the young state; and in fruit. Spencer Collection*, The New York Public Library. *The New York Public Library Digital Collections.* 1843-10 1843;1843-1853 http://digitalcollections.nypl.org/items/510d47d9-4b41-a3d9-e040-e00a18064a99; 510d47d9-4ae4-a3d9-e040-e00a18064a99; 510d47d9-4a52-a3d9-e040-e00a18064a99; 510d47d9-4adb-a3d9-e040-e00a18064a99.

Anna Atkins, an accomplished scientific draftsman, botanist, and thought to be the first female photographer, was taught the cyanotype process by her inventor-friend, Sir John Herschel. She recognized photography's potential for book illustration when she lifted cyanotypes out of its previous mathematical sphere with her impressions of algae. Her *Cyanotypes of British and Foreign Flowering Plants and Ferns* is the first book of photographic illustrations and the first to use photos with text (although it was printed in installments from 1843–l854) and the first photographically illustrated science book.

7

Cyanotypes

Cyanotypes, or blueprints, are light- to deep-Prussian blue images that can be inexpensively printed onto paper and fabric. Properly made, cyanotypes are permanent and can be combined with other hand-applied emulsions as well as traditional artists' pigments and pastels. They tend to exhibit less middle tones than other processes described in this book, although there are ways to compensate for its higher contrast emulsion, as explained later in this chapter.

British astronomer and scientist Sir John Herschel (my personal hero, who, in 1819, discovered and freely shared how to "fix" silver-based photos with sodium thiosul-fate—the fixer used to this day with Van Dyke brown prints and, slightly altered, with black and white emulsions) is reputed to have coined the terms "photography," "positive," "negative," and "snapshot". Historians credit Herschel with discovering blueprinting, or heliography with iron salts, in 1842. Calling the process "ferro prussiate," he later used cyanotypes to reproduce his intricate mathematical tables. By 1880, blueprinting was used for duplicating engineering and architectural drawings. At the turn of the twentieth century, Henry LeSecq blueprinted inspired photographic images of Gothic structures in Paris for the French government. Although

many early photographers were prejudiced by its commercial history and appalled at the blue tones we now value, Clarence White, a member of the British Pictorialist photography group called Linked Ring, made superb cyanotypes.

Until the advent of large digital printers and photocopiers, architects and engineers made blueprints or diazo prints on precoated paper, which they exposed through drawings done in pen-and-ink on tissue paper, vellum, or acetate. This precoated paper was not permanent and usually had to be processed in ammonia fumes, which can cause lung problems. However, the user of this book might be inspired by the technique of drawing on transparent or semitransparent materials, like the early practitioners of this process did, as describe on page 105 of Generating Images: Analogue Method.

Mike Ware (see Mike Ware's New Cyanotype Process in Supply Sources), who is the first person to really change the recipe that others and I have used since the invention of cyanotype, notes, "the ability of the Prussian Blue lattice to act as host for relatively large amounts of impurity ions has recently been put to good use by 'locking up' the radioactivity that was deposited on the uplands of North Wales and Cumbria following the Chernobyl disaster. Spreading Prussian Blue on the contaminated soil inhibited the uptake of Caesium 137 by grass; our lamb chops were thus safeguarded from radioactive contamination." Please see the books, listed in the Bibliography, that Ware has written on many of the historic processes; they are thoroughly researched, as well as infused with his subtle sense of humor. In addition, Ware makes a cyanotype kit that can produce more continuous tone blueprints with faster exposure times than the traditional method, although the Ware method does involve more chemical preparation. The kit is carried by many of the suppliers in the back of this book.

SAFETY

If potassium ferricyanide comes in contact with very concentrated acids, such as undiluted acidic acid stop bath, a poisonous hydrogen cyanide gas can be released. In addition, it is an irritant to eyes and skin. Immediately flush the affected area with large amounts of water for at least 15 minutes, removing contact lenses before rinsing eyes.

Both ferric ammonium citrate and potassium ferricyanide are toxic, so wear protective gloves when using these chemicals, and wear a protective mask when handling them in the powder form, so as to avoid inhaling the powder. Remove contaminated clothing and wash affected skin with soap and water.

Never ingest chemicals. (So, don't eat when you are working.)

Disposal of even small amounts of cyanide, found in potassium ferricyanide, should be handled by waste disposal companies or household hazardous waste programs, usually available free or at minimal cost to noncommercial photographers in the United States. Most universities and schools also employ such a service. My city's government warns its residents not to put cyanotyped materials in the recycle bin. We have a hazardous waste day and a center, where such materials can be brought.

John Basye, formerly of Blueprint/Printables, says that local sewage treatment plants want to know when effluent contains cyanide and may wish to test the quantity of cyanide occurring in your household wastewater. Most fire departments also want to know the type and location of chemicals stored in your home/ studio. Even though ferric ammonium citrate itself does not burn, it can produce poisonous gas in a fire.

Do not pour solutions in the ground, into septic tanks, or down a storm drain. If there is more than one cup of blueprint chemistry

to dispose of, evaporate it to a much smaller quantity, which you can label and take to a hazardous waste area.

Clearly label bottles and keep them out of the reach of children and pets.

METHOD OVERVIEW

1. Under subdued light, paper or fabric is coated with liquid yellow cyanotype solution, a combination of two ("A" and "B") iron-based chemicals and water.
2. An enlarged negative or object is placed on top of the coated and dried surface. Ultraviolet light shines through the clearer parts of the negative or around the object and hits the coating, reducing some of the ferric salts of the ferric ammonium citrate to the ferrous state, and then combines with potassium ferricyanide, which turns the coating blue.
3. The negative is removed. The paper or fabric is developed in water, where the unexposed chemicals wash off to reveal the receiver. The exposed areas remain blue.
4. As the emulsion dries, it slowly oxidizes to a deeper blue.

MATERIALS

More detailed descriptions of materials are given in Chapter 4, Creating the Photo-Printmaking Studio.

1. Applicators. Soft house painting brushes or poly-foam brushes 1 in. (2.5 cm) or wider suffice for coating the solution. Personally, I use the hake brush mentioned on page 92 because it is made without any metal that could be corroded, holds up for years when properly maintained, and coats as if it were gliding across the receiver. So that the brush will not pick up too much liquid, I cut approximately ¼ in (6 mm) evenly off the height of the bristles. Sometimes a few bristles will come loose, but you can usually pick them off after the emulsion is dried and before you expose it. Wash and dry brushes between each coating procedure because contaminated or exposed emulsion left on the brushes can produce imperfections in the print. Make sure that the brush, and especially a

foam brush that tends to hold a lot of water, is almost completely dry before you use it again, or the water will dilute the chemistry. Avoid dipping metal brush parts in cyanotype solution. You can protect the metal ferule with clear nail polish.

The *glass* coating rod mentioned on page 268 saves on chemistry and can yield an almost machinelike even coating, or you can float one side of the paper in a tray of cyanotype emulsion or spray it on with an atomizer, spray bottle, or air brush, which also simplifies the application of the solution on large pieces of paper or fabric. Make sure you are wearing a respirator. Flat trays are better because ridges could damage the emulsion.

2. Chemicals. Please note: I have measured all these chemicals on a gram scale, then translated them into common measurements. You will need potassium ferricyanide, available at many photography stores as Farmer's Reducer, and ferric ammonium citrate *green* anhydrous, a special-order item from one of the merchants listed in the Supply Sources. Although you can use brown ferric ammonium citrate, it requires much longer exposure times. You can buy pre-measured or pre-mixed chemicals worldwide at providers listed at http://www.alternativephotography.com/wp/directory-of-suppliers/chemicals-kits. Buying a kit or pre-mixed bottled chemicals, like the ones sold by Photographers' Formulary and Bostick & Sullivan's, is helpful if you want to try the process without buying large quantities of chemicals or if you are making only a few prints. Bostick & Sullivan's cyanotype is costlier and takes a little longer to expose but can make prints with more tonal range. From Silverprint, a store in England, you can buy their Solar Paper, or you will find a similar product on fabric from Blueprints on Fabric in the United States. Silverprint also sells the Fotospeed Cyanotype Kit (liquid sensitizer containing Mike Ware's new formula, mentioned earlier in this chapter, which is available from many sources worldwide), precoated paper and cotton, and raw chemicals.

Although different papers do not absorb the chemistry in the same amount and different coating

methods require different amount of chemistry, generally you will need approximately 1 oz. (29.5 ml) of A and 1 oz. of B for six 8 × 10 in (20 × 25 cm) prints. The peak sensitivity of mixed A and B is two hours, but coated paper can be stored and used with reduced light sensitivity for a month.

A few artists use Vaseline as a resist because it repels the liquid cyanotype solution on paper and you get the color of the paper or fabric where the resist is. You can wash off the Vaseline at the end of your printing process with Woolite and water. I use rubber cement, which can be rolled off a dry cyanotype.

3. Distilled water. Sometimes tap water suffices for making the cyanotype solution, but using distilled water prevents the frustration of mixing up possible bad solutions. Or, use a chlorine filter with tap water. Distilled water is also good for rinsing your brush. A dish tub filled with hot tap water can be used to warm the distilled water (see Item 18).

4. Funnel. Use a glass or plastic funnel to pour dry chemicals when mixing the stock solutions. If mold forms in one of the stock solutions, you can strain it by pouring the liquid through a funnel fitted with a coffee filter, and it will still be good unless it has turned blue.

5. Grayscale and tape (optional). In order to tell if you got as many tones as possible in the developed print, you can employ a transparent Stouffer step tablet or make one digitally (see Chapter 6) next to the image area. Use Step 1 as DMax, the deepest blue with little or no detail. If you are not using a hinged printing frame, use clear removable tape to form a hinge between the edge of one side of the negative/scale and the substrate. The tape ensures that the negative does not move after you have placed it on the coated and dried paper. Do not press the tape down too hard, or it can lift up the emulsion when you try to remove it later. After the exposure, I actually remove only the grayscale and image, leaving the tape on the emulsion because it usually peels off in the wash water, thereby preventing it ripping the paper. Cheap tape is better because it does not hold as strongly!

6. Hair dryer, fan, or plastic clothesline and pins; drying rack. The emulsion has to be completely dried, because if photographic negatives come in contact with wet cyanotype solution, the blacks will bleach out. If inkjet negatives touch liquid, the ink runs. Wear a respirator and use a hair dryer on the *cool* setting or a fan to thoroughly dry the emulsion before laying a negative on top. Do not use electrical appliances near water. I use nylon screening from the hardware store extended over and stapled to painter's canvas stretchers as a drying rack in a dark area. A clothesline and pins can be used to create a drip coating with wet emulsion or to dry finished prints (but make sure the line and pins are clean, a task made easier with plastic items).

7. Image. You will need a negative transparency the same size as the positive print you wish to create. Bear in mind that cyanotype is a contrasty process (there are fewer tones than a black-and-white photograph), and some detail can be lost. So negatives with a wide range of gray and black will reproduce with less separation in the blue shadows and midtones of the print. However, Chapter 6, "Making Negatives: Digital Method," describes a method to tailor negatives for rendering an impressive tonal array. You can also create analogue negatives specifically for cyanotypes without a darkroom, with one of the many methods described in Generating Imagery: Analogue Methods, or with a pinhole camera as on page 110.

8. Laundry bleach or 3 percent hydrogen peroxide (optional). Dilute and use it to intensify the blue of the image, as described in the step-by-step instructions. Hydrogen peroxide solution will degas slowly and lose its potency; do not tightly cap the bottle. Of the two, laundry bleach is more harmful to the environment. In addition, a dilute acid, such as white vinegar from the grocer, can be added, drop by drop, to the mixed sensitizer if you need to increase the highlight range of the print.

Do not allow acid to come in contact with undiluted potassium ferricyanide.

9. Measuring cups or beakers and spoons. Inexpensive cookware, such as 4-cup (946 ml) glass measuring cups and a plastic tablespoon will do. You will need a plastic or glass utensil as a stirring rod for chemicals and water.

10. Neoprene gloves should be worn while you work. A respirator should be put on when you mix raw chemicals and if you are using a hair dryer to dry the emulsion.

11. Newspaper or oil cloth, paper towels or sponge. Cover your work area with layers of newspaper that can easily be removed when contaminated or with oil cloth (available from a hardware store or the Vermont Country Store, listed in Supply Sources) that you frequently wipe clean. Old chemicals can ruin future prints with stains, and after spending a fair deal of money on good paper, why risk damaging it?

12. Printing frame. To achieve good contact between negative or flat object and the cyanotype emulsion, use plate glass with Masonite, another piece of glass, or foam rubber on a stiff backing underneath and heavy glass on top; follow the instructions for building a frame on page 80; or buy a printing frame with a hinged back. You will be ensuring against blurry imagery. Make sure the set-up is larger than the image and that the clean, dry glass is not the kind that blocks ultraviolet light. Foreign particles lodged in the glass can create dimples in the print. If you are using vegetation, such as flowers or leaves, place a sheet of plastic wrap from a grocery store or clear acetate from an art store on top of the cyanotype emulsion. The heat from the exposure causes the vegetation to "sweat," which can produce stains. Dry and press vegetation for better contact and, therefore, better resolution. If you do not use glass, carefully pin in place plants that can blow about or are far from the surface. However, one of the print frame systems is especially effective if you use the sun because a frame prevents the negative from moving on a windy day.

13. Receiver and pencil. For rich blues, use non-buffered or even slightly acidic paper. My favorites are "bright" (this is a relative term) white rag papers such as Arches Acquarelle; Saunder's Waterford, another bright white watercolor paper; and Strathmore 500 Drawing Bristol sheets with plate finish. Others might be Bienfang Rag Layout, kitikata, and rice paper (which you can buy in rolls or sheets and is intended for sumi and calligraphy) on the textured side. Magnani Prescia comes in pale blue and white and other colors; I like working on it, but Prescia is soft enough that sometimes gloved fingerprints show up, so I use paper bigger than the image. I always write on the back of the substrate in pencil or laundry marker on the border of fabric the information that I find useful: name of surface, source of light, exposure time. Writing on the back also helps me remember which is the side to coat because once I divide a large sheet, I can no longer find the water mark (see page 88) on every small piece I have made. Papermaker Michelle Samour has prepared terrific sheets with my students by pulping cotton rag and adding a ketene dimer emulsion as an internal size.

One of my former Museum School @Tufts students, Manon Whittlesey, blue printed over black-and-white silver gelatin fiber photographs, keeping in mind that where the emulsion is coated, it partially bleaches out the black-and-white image. You also can print on the back of fiber photographs, too. Other interesting surfaces include gampi paper, book pages, and cracked waxed paper. Each receiver will yield a different range and hue of blues and will require slightly different exposure times.

Patrick Hilferty printed on doorskin plywood by first preparing the surface with dilute Goldens Fine Pumice Gel. He also was successful with a precoat of acrylic medium mixed with volcanic ash (from ceramic suppliers and not greenware; be careful not to breathe it in) and Golden's Absorbant Ground. Hilferty suggests using sanding sealer if you want to apply cyanotype more directly on wood. Wendy Mukluk states that other unusual surfaces include birch bark and metal, plaster and plastic prepared with a thin, fine layer of matte spray paint. In *Jill Enfield's Guide to Photographic*

Alternative Processes (see Bibliography), the author describes in detail how to print cyanotypes onto ceramics.

14. Sheet of glass or Plexiglas ™ (optional). Angle the glass in a sink, sprinkle the glass or Plexi with a little water to form a suction with the back of the paper, then lay the exposed print, image facing you, onto it while you develop the image with gently running water from a hose. This system allows unexposed chemicals to drain off, preventing them from contaminating the print. Wrap masking tape or duct tape around the edges to prevent glass from cutting you and to cushion the glass from breaking.

15. Siphon washer. This gadget, available on eBay, works well when attached to a tray in a sink to wash prints. A Rapid Washer is a tray connected to a faucet via a hose. Water rushes into the tray, flows over the print and empties by means of holes in the other end of the tray. You can make your own washer by drilling holes up the sides of a dish tub or photo tray and gently running water from a faucet on the back of the print (the pressure of the water can damage the image). These are inexpensive methods of washing and can work effectively if you either wash one print at a time or monitor to make sure the prints get sufficient agitation and do not stick together.

16. Sizing (optional). Rag papers usually are made with sizing, but if you use less expensive paper, some rice papers, hemp, or absorbent papers, you can try ¼ tsp. (1 ½ cc) of liquid gum Arabic from an art store carefully blended into 2 oz. (50 cc) of mixed A and B sensitizer. I use spray starch as described on page 88. If you apply sizing unevenly, your prints may appear blotchy. Apply cyanotype sensitizer on the correct side of the paper on which you will work, as described on page 88.

Barbara Hewitt, formerly of Bluprints/Printables (now known as Blueprints on Fabric, which packages pre-coated paper and fabric, available on their own website and from Freestyle Photographic Supplies), recommends washing out the manufacturer's sizing in hot water before printing on fabric. It is meant to repel spilled liquids but makes the fibers almost impossible to coat.

17. Two dark storage bottles. Recycled brown glass bottles that the chemicals came in or brown glass pint (0.5 L) fruit juice or large vitamin jars are ideal, although increasingly difficult to find. Glass washes out more thoroughly, but plastic bottles might be your only choice. Do not use metal caps, which will corrode from exposure to the chemicals; I have seen it happen. The bottles should be washed every time fresh chemistry is poured in, and one should be labeled Cyanotype A, the other Cyanotype B, with the date each was prepared. Keep liquid in tightly closed brown bottles in a cool, dry area. They will preserve for six to nine months at the least. If the emulsion is not yellow-green when you mix A and B, consider disposing of the liquids and mixing new solutions. If you use such old solution, you will probably get a print that is pale blue, rather than the white of the paper, in the highlights. Eventually, the emulsion will not even yield any separation of tones.

18. Three ridgeless trays or tubs. They must be non-metallic and larger than the print, as one holds the first wash (after the hose wash), another is for the optional intensifying solution, and the third contains the final wash water. A tub can also double as a container of hot water for heating up distilled water while making the stock solutions.

19. Ultraviolet light. Sunlight, rather than artificial light, yields the richest blues. However, outdoor exposures can be over an hour during the New England winter, whereas they may be ten minutes in the summer. A dependable artificial exposure unit is describe on page 83–84; it averages 18–20 minutes to expose a "normal" (not too dense or black and not too thin or clear) negative. Using a dense negative will take longer and, conversely, using a thin negative requires less time but usually renders less tonal separation.

Please see Chapter 4, Creating the Photo-Printmaking Studio, about how I illuminate my coating and developing area.

MAKING ONE OF THE STOCK SOLUTIONS

STOCK SOLUTION A

Stock solutions are the main concentrate of liquid chemistry from which working mixtures are made. This recipe is for exposing the emulsion under artificial light.

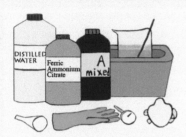

7.2 Equipment You Will Need

EQUIPMENT YOU WILL NEED

Ferric ammonium citrate
Brown bottle
Distilled water
Label
Funnel
Stirring spoon
Thermometer
Measuring cup
Tub

PROCEDURE

1. Adjust water temperature to 75° F (23.8°C).
2. Using a funnel, pour 90 g (124 ml) ferric ammonium citrate into glass beaker.
3. With constant stirring, add enough water *to make* 8 oz. (250 ml).
4. Stir solution until mixed and pour into a labeled brown bottle. Wash utensils in hot water after.

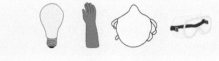

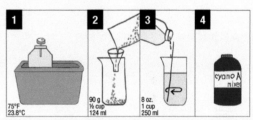

7.3 Procedure

MAKING THE OTHER STOCK SOLUTION

STOCK SOLUTION B

EQUIPMENT YOU WILL NEED

Potassium ferricyanide
Brown bottle
Distilled water
Label
Funnel
Stirring spoon
Thermometer
Measuring cup
Tub

7.4 Equipment You Will Need

PROCEDURE

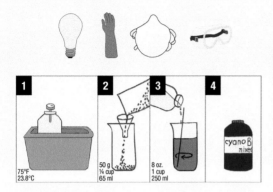

7.5 Procedure

1. Keep water temperature at 75°F (23.8°C).
2. Using a funnel, pour 50 g (65 ml) potassium ferricyanide into a beaker.
3. With constant stirring, add enough water *to make* 8 oz. (250 ml).
4. Stir solution until mixed and pour into a labeled brown bottle. Thoroughly wash all utensils in hot water.

MAKING A CYANOTYPE

7.6 Preparing the Materials

1. Prepare the materials

Shake each bottle of solution, then mix 1 oz. (29 ½ ml) of A and 1 oz. of B together to coat six 8 × 10 in. (20.25 × 25.2 cm) sheets of paper. Use within two hours for maximum sensitivity. Please notice how, on this test print, I have drawn a rectangle for the image's borders and have delineated strips within that rectangle and beyond its edges to represent 5-, 10-, 15-, and 20-minute exposure times. In addition, I have been careful to make sure that each test strip will include highlight, shadow, and midtones.

7.7 Coat the Paper

2. Coat the paper

Dip a brush in the mixture and apply a small amount to the paper, lightly moving the same solution around so as to avoid saturating one area. Coat beyond the image area or coat an extra swatch of test paper so you can watch the change in color during the exposure. It should now appear yellow-green and shiny. Use the cool setting of a hair dryer on both front and back of the substrate, air dry flat, or hang the paper in a darkened room to create drip patterns. The emulsion dries to a matte bright yellow.

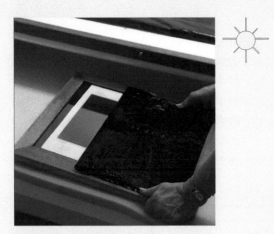

7.8 Expose the Test Print

3. Expose the test print

Place the paper, coated side up, on a backing board or a hinged printing frame, then position the negative, correct-reading (the way you want the image to look) on the emulsion under glass. Place the loaded print frame in direct sunlight or under artificial ultraviolet light for 5–20 minutes. Using opaque cardboard or plastic, expose the print for the times you marked on the paper.

If you are using the digital method in Chapter 6, you need to expose a strip of imageless OHP on top of coated paper for the different minutes and find the deepest blue, which will be your exposure time. (You change the digital negative, not the base exposure time, to make an acceptable print.)

7.9 Judge the Exposure

4. Judge the exposure

As the emulsion is exposed, the cyanotype will turn from yellow-green to blue-green to iridescent blue. You can take the exposure frame into a shady spot or turn off the unit and carefully lift up the hinged negative or frame back. Check to see if the highlights of the print have started to appear.

7.10 Develop the Print

5. Develop the print

Remove the print and prop it on a piece of Plexiglas™ angled in the sink. Outside the image area, hose the paper gently with water, or rock it in a try of water, which you change frequently. No yellow should remain on the paper, and the water eventually should run clear. Then, gently rock the print for two more minutes in a tray of clean running water.

6. Intensify the print (optional)

Rock the print for up to 60 seconds in a tray of one capful of bleach or 3 percent hydrogen peroxide mixed with 32 oz. (1 L) water, until the image turns a deeper blue. (This deepening of the blue would also appear as the print dries and ages.)

7. Wash the print

Use the siphon or tub method to wash the print in constantly changing clean water for 10 minutes. Then blot excess water with a clean, soft sponge and air dry on a rack, hang from a clothesline, or use a hair dryer or fan.

Once the print has dried, choose the exposure you want. If you have used the digital method described in Chapter 6 of this book, make a new exposure that includes the image with the grayscale. Then, as described in that chapter, see that the grayscale shows all the steps necessary, or re-make the negative, which, in the long run, will save you lots of time!

TIPS FOR MAKING A CYANOTYPE

To shorten the exposure time later, add a little extra ferric ammonium citrate to stock solution A. To increase the longevity of the stock solutions and to increase their solubility (good for less porous surfaces), add a pinch (approximately ¼ teaspoon or 1.25 g) of oxalic acid, a crystal purchased through chemical suppliers listed in Supply Sources.

If you will be exposing the emulsion to bright sunlight, cut the stock solution recipe to ¼ cup plus 1 tsp. (50 g or 65ml) ferric ammonium citrate with enough water to make 1 cup solution A and ⅛ cup (35 g or 59 ml) potassium ferricyanide with enough water to make 1 cup of solution B. Not only is this formula less expensive, but also it is kinder to the environment.

I learned the hard way that potassium ferricyanide, even in the dry form, goes bad, albeit slowly. After mixing a fresh batch of cyanotype solutions for a class demonstration, the exposures under my trusty ultraviolet unit were taking an hour and longer to obtain the normal, deep blue usually achieved in 20 minutes. So I did some troubleshooting, eliminating variables one by one. I dismissed the possibility that the emulsion was mixed incorrectly because all my students had watched me carefully measure. I knew I did not use a particularly dense negative for the demonstration. I tried replacing the ultraviolet bulbs, then using a new bottle of distilled water. Next, I rewashed all the mixing utensils to eliminate contaminants and opened a fresh jar of ferric ammonium citrate (which I knew could deteriorate with age or prolonged exposure to light) and mixed fresh solution A. Only when I opened a new bottle of potassium ferricyanide and mixed fresh B solution did the exposures return to normal.

Ferric ammonium citrate (solution A in this book) is readily affected by age and light, so make sure the brown bottle is tightly sealed. Notice, also, that the pre-measured solutions you order from suppliers may be labeled differently; just know that ferric ammonium citrate is a green powder and green-yellow liquid and that potassium ferricyanide is a red crystal and bright yellow liquid.

To enrich the deep blues of the cyanotype print, layer the emulsion twice. That is, let the first (thin) coating almost completely dry, then apply the emulsion a second time. Adjust the exposure, which will be only a little longer than if you were using a single coating. This method is rarely needed on good rag papers.

Rinse and carefully dry the brush as soon as you finish coating the paper. Shield remaining mixed emulsion with an opaque cover, such as the black plastic in which photo paper is wrapped or the opaque plastic used to mulch gardens.

Stir the solution if it has been sitting (even during the brief time you have been working). I teach in a chilly room, so I keep the emulsion warm, not hot, to maintain the chemicals

in solution, rather than precipitate out. Warm solution also makes the emulsion speedier when exposed.

Mixed cyanotype solutions A and B last only one day. Blueprintables (now Blue Prints on Fabric) keeps mixed A and B solution for months in a porcelain tub covered with black plastic. Precoated paper will keep for a few days if stored in a light-tight box and for six months in a light-and air-tight bag. You can tell if the emulsion has started to go bad by observing the coating before exposure; it should be yellow-green. Even so, Blueprintables suggested that "soaking an oxidized dark print with little contrast in very hot water following the rinse out will brighten it significantly."

Be sure the emulsion is completely dry before exposure, or negatives can be damaged and the final finished print will show purple moisture stains.

If you do not use glass, you can lay or pin plants or object on wet emulsion to expose. The articles will pick up blue color, so use ones that are disposable. In 70°F (21°C) to 85°F (20°C) weather, the emulsion also dries during the 5- to 10-minute exposure.

Uneven application of the solutions will cause streaks in the print. However, you might purposely coat cyanotype onto "distressed" wax paper or creased rag paper so that emulsion bleeds into the cracks.

If you hang coated paper or fabric to dry on a clothesline, wash clothespins and line before the next use, or you may stain future pieces with contaminated solution. Use plastic cord and pins because they are easily washed in hot water.

If you use a standard print frame, unhinge a portion of the back and without moving the negative, check highlights of the print for color changes. Exposure is judged visually. For instance, with a thin (more transparent) negative, remove the paper at the blue-green stage, and with a dense (black) negative, the paper should be deep or iridescent blue.

Exposures can be roughly calculated as you would a traditional black-and-white photograph, which is mathematically. That is, if you want the print to look twice as dark, expose it for twice the time, and the converse is true, too. However, when in doubt, overexpose, because you usually can save the print as explained in the next tip.

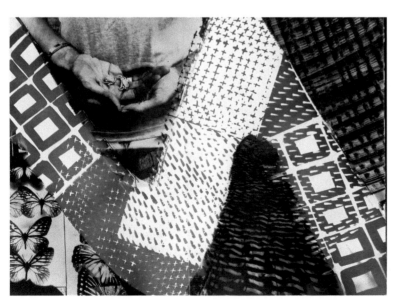

7.11 Laurie Snyder, *Iron and Silver*, cyanotype and Van Dyke brown print (Chapter 8) on Rives BFK from camera negatives and cliché verre negatives (ink drawings made on transparent material, described in Chapter 5). Artist's book: 22 × 15 in. (56 × 38 cm) closed, 22 × 30 in. (56 × 76 cm) open, 1990. © Laurie S. Snyder.

Notice how Snyder uses the bleaching effect of cyanotype on the silver-based brown print emulsion to emphasize the brushed gesture.

7.12 John C. Wood, *Blow Rain Loons*, cyanotype with silver print collage, Polaroid, crayon, stencil type, and graphite on BFK, 1985. ©John C. Wood Estate Trust

John Wood is known for his expressive drawings, as well as his experimental photographic work. He also was a beloved printmaking and photography teacher, concerned with preserving our ecosystem.

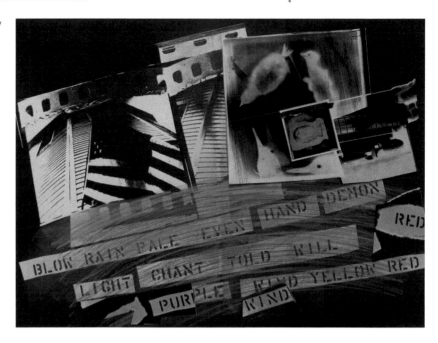

If the print is too blue, it probably was exposed too long, but you might rescue it by leaving it in the intensification bath a little longer or by toning it, as explained later in this chapter, to reduce the overall color (not a specific part). If the print is too pale, it probably was underexposed, so next time increase the exposure time, decrease the intensification time, or further dilute the intensification bath.

Chemical baths applied to the developed cyanotype can turn the image green, violet, black, purple, or red-brown. These toners are described later in this chapter, but they do tend to challenge the permanency of the cyanotype print.

If you are combining cyanotype with brown, casein, or gum printing (processes described in this book), do the cyanotype first or it will alter or obscure the image underneath because potassium ferricyanide is a photographic bleach. If you, being of the experimental nature, still choose to eliminate the under coating and want to blueprint second, dispense with the bleach intensifier. Fixer from the brown print (Chapter 8), additionally, can slightly lighten a blueprint.

Cyanotype works beautifully over dry palladium prints. Make the palladium print (Chapter 12) normally. Cyanotype does not affect palladium underneath, and this combination might be perfect for mixing a photogram with a photographic image separated by the processes, or for split toning a print. You even can develop the cyanotype in water and intensify with hydrogen peroxide without affecting the palladium print underneath. This amalgamation works well on many papers, including strong Japanese rice paper. Use separate brushes for each technique and wash each immediately. In addition, you can coat wet cyanotype and soon after coat wet palladium, dry expose, develop, and clear the combination as you do a palladium print. This wet on wet intentional "contamination" produces greens and yellows.

Other application methods include using a gloved finger, cotton swabs, or sponges to spread the emulsion.

With a brush or cotton swab, carefully put a solution of ¼ oz. (5 g) oxalic acid with 3 ½ oz. (100 ml) water as an after treatment to clear white areas of residual blue. See the Safety section on page 232 for handling oxalic acid.

If you do not wash the print enough, the white areas may turn blue while drying or form a blue puddle because some of the yellow emulsion is left on the paper. However, I have noticed that tap water I had been using for a 15-minute final wash now bleaches the whole print. I suspect that chloramine is being added in larger quantities by the city as a disinfectant, so the water has turned more alkaline. I have cut the final wash back to five minutes, which still rids the print of any residual intensifier or unwashed emulsion. John Barnier, in *Coming into Focus: A Step-by-Step Guide to Alternative Photographic Printing Processes* (see Annotated Bibliography), states that adding ¼ oz. (10 ml) vinegar of 27 percent acetic stop bath to 2.1 qt. (2 L) of water prevents bleaching from alkaline water.

To remove lavender moisture stains, try rewashing the print well and letting it dry. Often the lavender fades. If not, squirt ½ tsp. (2.5 ml) of mild liquid soap, such as Ivory or Woolite, in a clean tray. Add 1 gal. (3.8 L) water. Swish the print for a few minutes. Wash in plain water afterward.

If you notice water spots on the finished print, you probably dripped a liquid on the emulsion before you exposed it. If you find brown streaks, the cause could be drying the print in the sun or impurities in the water.

Store the coated paper or the finished print face up on a clean surface in a dark space. I use nylon screening from the hardware store, stapled to a wooden frame, for racks, and I frequently wash it. Old chemistry accidently picked up on your paper or fabric can stain through to the front. Contaminated blueprint chemistry stains purple.

Do not keep the print in an alkaline or buffered paper box.

You can touch up the blue print with a watercolor pigment such as Prussian Blue.

If a print starts to fade due to the action of ultraviolet light on alkaline paper, you can revivify it by storing it away from light for a few days.

Just as I was about to "go to press," SMFA@ Tufts colleague Jesseca Ferguson (see "Pinhole Photography", pages 110–118, which she co-authored) urged me to look again at the work of Meghann Riepenhoff, whose work hung with ours in an exhibition, "Photography's Blue Period," at the Worcester Art Museum.

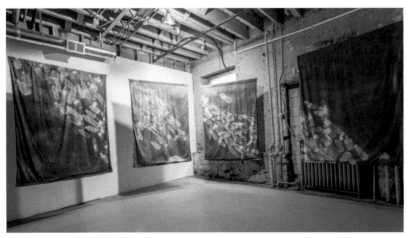

7.13 Jeannie Simms, *Lesbos Cyanotypes*, cyanotype on cotton, ripstop nylon, four 4 × 6 ft. (1.2 × 1.8 m) hanging panels, 2016. ©Jeannie Simms.

The artist (and Museum School faculty) collected bottles and other paraphernalia along the eastern shores of Lesbos, Greece from the same waters where thousands of people crossed from Turkey, with over 800,000 arrivals* in 2015. The bottles and miscellaneous items (toys, shoes, jewelry, sunglasses and even bones) were used to create photogram panels. *UNHCR Statistics, Dec 30, 2015

Riepenhoff's project, "Littoral Drift," employs waves, wind, and sediment that leave physical traces through direct contact with her cyanotype-coated paper. See http://meghannriepenhoff.com/project/littoral-drift/.

CYANOTYPE ON FABRIC

TIPS

In addition to the previous tips given in this chapter, the following tips are useful when printing cyanotypes on fabric.

It is easier to learn the technique on paper before you try fabric.

Certain natural textiles accept cyanotype solution better. More tightly woven fabrics, such as silk charmeuse, print a deeper blue than crepe de chine, which prints darker than pongee. Cotton print cloth provides darker blues than sheeting, which produces a deeper blue than knits or gauze. Cyanotype can be printed on flannel, hemp, duck canvas, chamois leather, cotton velveteen (where the image seems to rest in the fiber's height), linen, and viscose/rayon. I know no one who has had success working on synthetics.

You can simply create visual variables if you use colored, rather than white, fabric, but do not use fabric that has been treated with liquid repellants; use ones that have been prepared for dying.

Fabric should be stretched to pull out wrinkles during coating. As described below, I use painter's canvas stretchers from an art store or plastic embroidery hoops to pull the material tightly before coating. Some fabric artists use a batik frame or even an old picture frame.

I use a staple gun to attach and leave the fabric on the frame through the coating, exposing, washing, and drying in order to make up for it stretching when wet and possibly shrinking when dry. A frame, rather than coating a piece of cloth on top of scrap paper, also conserves the amount of chemistry you need. However, if you are going to coat a few pieces of cloth, stack them on top of each other so that the excess from the top piece goes through to the piece below it.

It helps maintain the fabric's shape if the threads run parallel to the frame.

Use a laundry or permanent marker outside the image area to remind yourself of the type of fabric, exposure, etc. If the fabric is thick enough, mark on the back, so that you will know the correct side to coat. If it isn't thick, mark the information on masking tape on the back, so you will know which side you coated because that is the side you will thoroughly dry before laying your negative on top.

Like paper, fabric can be coated lightly with a brush (foam brushes are superb), sprayed, or dipped into a tray of solution, but thorough drying will take longer because the fabric might seem dry when it isn't. Another advantage of stretching the fabric is that it dries more quickly and without flapping in the breeze as shown in the illustrations in Figures 7.14 through 7.18.

7.14 Staple the fabric onto painter's canvas stretchers but with the "bad" side out and "good" side in. Make sure that the stretchers are at least 2 in. (5 cm) larger all around than the glass and image.

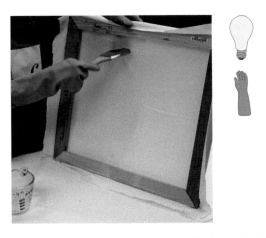

7.15 Coat the stretched fabric on the good side. Do not drench the fabric, but use a foam brush for a smooth border and bristle brush if you want the strokes to show. Move the same emulsion around in different directions.

7.17 In this picture, you can see that the negative and glass are placed inside the depth of the frame, facing towards the light source. Then, the whole set-up is placed in the UV unit.

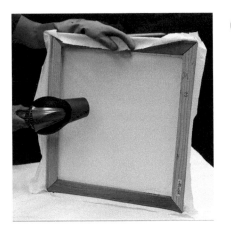

7.16 Notice that the correct side of the fabric is facing inside the basin of the frame so that negative and glass can be placed there. Dry both sides thoroughly with a hair dryer on a cool setting or with a fan.

7.18 The exposed fabric is developed with water and dried on the frame. Try to avoid spraying water too hard on the image. Image ©LBlacklow.

MORE TIPS FOR CYANOTYPE ON FABRIC

Fabric artist Eliza Proctor advised not to air dry the freshly coated emulsion on humid days and nights, or you may get a mottled print.

For more detail in the finished piece, use a warm, not hot, and dry, not steam, iron on the back of the coated and dried fabric before exposure, and use plate glass that does not block UV light during the exposure. In this way, your negative will be in closer contact with the sensitized surface and result in more detail.

Sandra Sider, in an article entitled "Blues in the Light: Cyanotype on Fabric," in *Fiber Arts* (Sept/Oct 1986), suggests that cyanotypes impart an iron stain to the fabric that is permanent: "Even though cyanotypes might fade somewhat in ultraviolet light, the intensity of the blue can be revivified by storing the piece away from light for a short period of time" (a couple of days to a couple of weeks). Richard Farber explains in *Historic Photographic Processes* (see Annotated Bibliography) that a

partial reduction of the Prussian blue to the white ferrous ferrocyanide occurs; this regenerative ability is unique in photography to the cyanotype.

Blueprinted fabric pieces can be washed in cool water with a mild liquid soap. Avoid detergents and soaps with chlorine bleach, phosphates, or borax. Baking soda by itself and baking soda in washing products or underarm deodorants will cause the blue to turn yellow. Powdered soap does not dissolve properly, creating spots on the fabric wherever granules touch the wet blueprint. Residue in and on washing machines where powdered soap is used also will affect the blueprint. Dry cleaning is not recommended.

Sometimes you can remove purple moisture stains in fabric by washing it in ½ tsp. (2.5 ml) liquid soap such as Ivory or Woolite mixed with 1 gal. (3.8 L) water. Carefully swish the cloth without creasing it for a few minutes. Wash in plain water. Rinse well afterwards, but do not wring dry. Washing blueprinted fabric will restore the blue color, but it is usually less intense. Powered and biodegradable soaps are not recommended. Use Spray 'n' Wash, K2R (available at hardware stores and the Vermont Country store listed in Supply sources), or Rit Grease, Stain, and Soil remover #90.

Never—in the coating, drying, or washing—wring the fabric, or you can create permanent marks.

Blueprints on Fabric (listed in Supply Sources) stocks precoated T-shirts, cotton, organza, and silk by the yard, and 6 in. (15 ¼ cm) square and larger cotton pieces. You can send them your fabric to coat, too.

TONING CYANOTYPES

Cyanotypes can be toned to other colors, but John Barnier, in *Coming into Focus* (see Annotated Bibliography) states that most toners, except the one with highly toxic lead acetate, which I do not recommend or write about due to health and environmental concerns, or the one with sodium borate, are not stable.

1. Make a few dark (overexposed) prints and let them dry for a day. Later, presoak them in water and sponge excess liquid off. Either pour the toning mixture into trays and bathe the print until you get the color you want, or apply the solution with a brush to selected areas. Keeping an untoned, wet print nearby will help you decide how long to tone.

2. For a gray to reddish tone, dissolve ⅟₁₆ oz. (4.8 g) copper nitrate in 3.3 oz. (96 ml) distilled water, then add 5–7 drops household ammonia.

3. For brown to black tones, add ⅓ oz. (10 ml) ammonia hydroxide to 3.3 oz. (96ml) distilled water in one tray. (Alternately, you can use the yellow-tone recipe below to bleach the color out.) In another tray, combine a little more than ⅓ oz. (9.4 g) tannic acid, available at a pharmacy or wine-making store, with 17 oz. (500 ml) warm distilled water. You can also obtain tannic acid by seeping 10 pekoe tea bags in 2 cups (0.24 L) water. Immerse the cyanotype in the first solution until it practically disappears, wash it carefully for a few minutes, then wash it and put it in the second bath until you achieve the desired color. If the paper base and highlights look stained, you might not have washed the print long enough between the two baths. Black teas bags seeped in a similar way will impart dark tones, and you needn't worry about bleaching.

Judy Seigel, long term editor of the World Journal of Post-Factory Photography, recommended this alternative formula for brown or black tones: add

1 teaspoon of tannic acid to 1 qt. (0.95 L) distilled water in a tray. In another tray, add 2 teaspoons sodium carbonate to 1 qt. (950 ml) water. Immerse the cyanotype in the first bath for 2 minutes, then rinse it and put it in the second bath. Rinse it again and put the print back in the first bath. Continue in this manner until you achieve the desired tone.

4. For yellow tones, Barbara Hewitt, formerly of Blueprint/Printable, recommends dissolving 1 tablespoon trisodium phosphate from a hardware store in 1 qt. (0.95 L) warm water. I have also used a weak solution of chlorine bleach from a grocery store to achieve the same effect.

TIPS FOR TONING CYANOTYPES

Once the mixture becomes exhausted and no longer affects the print, discard it and mix fresh toner. Wash the print carefully after toning.

Most of the necessary chemicals are available through Photographers' Formulary, listed in Supply Sources.

Wear protective gloves and goggles when toning prints. Pour the toners into trays larger than your print.

Search for more formulae online at https://mpaulphotography.wordpress.com/2011/04/01/cyanotype-toning-the-basics/. Filipe Alves explains how to make blue and sepia split-toned pictures on www.alternativephotography.com. Or consult the directions in *The Keepers of Light and Photo-Imaging: A Complete Guide to Alternative Process* (see Annotated Bibliography).

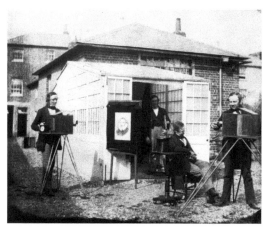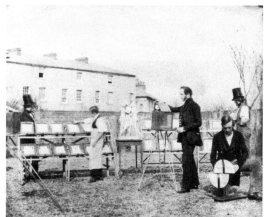

Figures 8.1 and 8.2 Attributed to William Henry Fox Talbot and Nicolaas Henneman, *Panorama of William Henry Fox Talbot's Reading Establishment*, salted paper prints from paper negatives, Left image: 18.6 × 22.4 cm (7 ⁵⁄₁₆ × 8 ¹³⁄₁₆ in.), Right image: 18.1 × 22 cm (7 ⅛ × 8 ¹¹⁄₁₆ in.), Overall sheet: 19.9 × 49.1 cm (7/¹³⁄₁₆ × 19 ⁵⁄₁₆ in.), 1846. Gilman Collection, Gift of The Howard Gilman Foundation 2005. Courtesy The Metropolitan Museum of Art, New York.

Talbot was buttressed by the dedication of Henneman, his former valet, in the creation of the first commercial photo-printing company, actually set up by Henneman. The two pictures above advertise the capabilities of the studio, which apparently was not actually called The Reading Establishment and was not owned by Talbot: copying paintings, photographic portraiture, contact printing negatives into positives, and (Henneman) photographing sculpture. Talbot is in the middle removing the lens cap from a large-format camera because there were no shutters on cameras at that time. (He was one of the inventors of cameras as we know them.) The process he probably is using, which he devised a few years before in, 1841, is calotype, also known as Talbotype: "Fine-quality writing paper was sensitized with potassium iodide and silver nitrate solutions and exposed in the camera, typically from ten to sixty seconds in sunlight. The negative was then developed in a solution of gallic acid and silver nitrate and fixed. The paper was generally waxed after processing to make it translucent [author's note: an idea you can use, too!] and was printed in sunlight onto salted paper [author's note: to make the positive print]".[1] See Chapter 9 to learn how to make a salt print.

Notice the chair and armrest for the sitter, provided so that he would not move during the long exposure (but short for its era), and see that behind Talbot there are printing frames, similar to what we now use. The man on the far right might be in charge of a focusing device.

I have thought it almost comical, in a way, that repeatable photographs should have begun in England, where the weather is not known to be especially sunny all year. And so, I would imagine that the glass structure, like a greenhouse, behind the sitter, was used not only to coat paper, but also to accommodate rainy and cold days, while letting in the most light possible. I am also fascinated by the fact that Talbot's home, Lacock Abbey, which he often photographed, is not far from Stonehenge. Yet Talbot, who was a sophisticated amateur archeologist, seems not to have ventured there with his camera, although he did take pictures in France and Spain.

8

Van Dyke Brown Prints

Van Dyke brown printing, this chapter's subject, is related to salt printing (Chapter 9), the basis for which was invented in 1842 by Sir John Herschel, mathematician, astronomer, chemist, inventor, botanist, and experimental photographer. It utilizes the transformation of ferric (indicates an iron component) ammonium citrate into the ferrous (another word that points to iron) state, which then could be combined with silver and other metals. In addition, salt prints, calotypes, and Van Dyke brown prints employ silver nitrate as one of their light-sensitive components.

A brown print can be made on paper, leather, or fabric and can yield permanent images rich in detail with subtle separations in the middle tones and shadow, ranging from pale to deep Van Dyke brown. A photographic negative, when placed in contact with the silver-based emulsion, produces a positive picture after relatively short exposure to daylight or ultraviolet light. The longer the exposure, the darker the tone of the print. A brown print also reacts positively to such toners as polytoner, gold, selenium sepia, copper, and blue (see Chapter 3, Toning) to produce glistening browns, purples, pinks, and blues. Brown printing, which is costlier than cyanotype due to the price of silver nitrate, one of its component chemicals, can be combined with some other techniques describe in this book—I often mix a layer of brown with a different layer of cyanotype—and with traditional artists' materials such as paint and pastels. Gum (Chapter 10) over an underexposed, pale brown print can be effective, too.

William Henry Fox Talbot, basing his experiments on the work of earlier pioneers in photography, is considered the originator of photographic printmaking[2] on paper.

In 1834 Talbot had made semi-permanent negative photographs on paper soaked in silver chloride and fixed in salt solutions, then he made positives by contact printing the images onto another sheet of paper treated in the same way. He kept this discovery secret until he heard about Daguerre, across the English Channel, announcing his direct positive process on metal. Talbot's 1839 public proclamation of the "process by which natural objects may be made to delineate themselves without the aid of the artist's pencil" (Talbot's words), i.e., salt printing (Chapter 9) and, later, patented as the Talbotype, is, as previously mentioned, related to Van Dyke brown printing. Talbot devoted himself to photography and struggled with the art for years. He worked hard to perfect his process so that by 1840, he patented—which kept it from being widely used—the calotype process in hopes that it would rival the Daguerreotype for short exposures and rendering detail in portraiture. Talbot made the images permanent by fixing them in a bath of sodium thiosulfate (still a component in today's fixer), suggested by my hero, Sir John Hershel, inventor of the cyanotype process (see Chapter 7) and credited with coining words such as "snapshot," "positive," and "negative." Many historians consider Talbot the creator of modern photography because he formulated a technique that allowed the practitioner to make one negative and print it as repeatable, rather than one-of-a-kind, positives on paper. He eventually discovered how to strengthen these prints chemically from indistinct images to clear and subtle renderings. Very soon after, photographers used his process to travel the colonized world, taking pictures of remote places and people. I try to imagine having seen only painted and drawn renditions of faraway loca-

tions, then witnessing my first photograph of the Pyramids! It must have been an extraordinary experience with profound repercussions, perhaps akin to watching television for the first time in the 1950s or using a computer for the first time in the 1980s.

In addition, Fox Talbot patented a photo-engraving method and is also credited with the idea of breaking up a black-and-white image into small dots for reproduction on a lithography plate, which is physically the basis for halftone offset printing and visually, dots per square inch in digital imaging. He may have been frustrated that his "photogenic" prints had faded (the earliest prints were only partially stabilized with salt, and he did not know to thoroughly wash out the sodium thiosulfate, then known as hyposulphite of soda fixer that he eventually used, at the advice of Sir John Herschel), so his photolithography method employed more stable printer's ink. Talbot's Reading Establishment, pictured at the start of this chapter, was the first commercial photo studio in the world and bears witness to his success at building a camera and inserting a lens in it.

In 2006, Talbot's family gave his photos, notebooks, manuscripts, and correspondence with other key scientists to the British Library. In addition, his home, Lacock Abbey, is open to the public.

SAFETY

Silver nitrate in crystal or solution form is destructive to the skin, mucous membranes, and eyes, so wear neoprene glove, safety goggles, and mask, and handle the chemical with care. It is poisonous and can cause burns and blisters; in case of skin contact, flush the area with water, followed by soap and water. If it gets in the eyes or mouth, flush with water, then seek medical attention immediately.

Do not inhale silver nitrate dust, which can cause sore throat, labored breathing, confusion,

nausea, and even unconsciousness. Wear a mask with a dust filter both when mixing and when hair-drying Van Dyke brown emulsion.

If you do get brown stains on your skin, wash the areas, then let them wear off. Silver nitrate can supply oxygen to a fire. Clean up spilled silver nitrate with water and dispose of excess down a drain, not in a wastepaper basket and not directly into an aquatic environment because it is dangerous for marine organisms. Or, cover the spill with dry sand or dry ground vermiculite, which you enclose tightly in a container for proper disposal.

Tartaric acid is moderately hazardous if inhaled or touched. Wear protective gloves and mask.

Oxalic acid can be harmful. See page 232 for hazards and prevention.

Direct contact with ferric ammonium citrate can irritate the nose, throat, lungs, and skin. Remove contact lenses if worn, flush the irritated area with water, and wash contaminated skin with soap and water. Wear protective gloves and mask.

Never mix ammonia products with bleach, since the combination produces lethal fumes.

Most fire departments want to know the location and types of chemicals stored in your home. I keep many of mine in a fireproof cabinet.

Never ingest chemicals, eat, or smoke (but then, why smoke?) in your work area.

Clearly label bottles and keep them out of the reach of children and pets. Brown print solution can be fatal if swallowed and can severely damage the eyes if splashed into them.

Dispose of excess chemicals by washing them with large volumes of water down a drain connected to a decent sewage treatment system.

Old fixer, aka "hypo" solution, can produce highly toxic sulfur dioxide gas, so discard fixer that no longer is clear in color. With the right fixture, you can also reclaim the silver in fixer.

In addition, repeated exposure to sodium thiosulfate or powdered fixer can cause eye irritation and skin dermatitis; wear protective gear when using it.

Do not store chemicals near food and keep them away from children or pets.

Once mixed, the solution should remain stable for at least one year at room temperature in an opaque bottle.

METHOD OVERVIEW

1. Brown print solution, containing silver nitrate and ferric salts, is mixed and coated onto paper or fabric, and dried in subdued light.

2. An enlarged negative or object is placed on top of the coated surface. Ultraviolet light shines through clearer parts of the negative or around the object and hits the coating, reducing some of the ferric salts to the ferrous state.

3. The negative is removed, and the exposed paper or fabric is washed in water, where the ferrous salts reduce the silver nitrate to metallic silver, visible as a brown image. The print is fixed in a chemical bath and washed again to produce a Van Dyke brown print that is the reverse of, for instance, the negative.

MATERIALS

More detailed descriptions of materials are given in Chapter 4, Creating the Photo-Printmaking Studio and Chapter 7, Cyanotypes.

1. Applicators. A labeled soft house painting brush, hake brush, and Blanchard brush (page 91) are useful tools for coating the solution. You can dip paper into the emulsion by pouring a small amount in a glass of porcelain baking ban, which you tilt at a 45° angle. If you use an applicator with metal parts, keep the metal out of the solution, or coat it with clear nail polish. Make sure you do not take up too much emulsion with the brush, because a soaking, rather than a thin coating, can puddle in spots and take seemingly forever to expose.

Wash and carefully dry brushes between each coating procedure; contaminated brushes can produce imperfections in the print. If you leave

a brush with emulsion in light, for instance, the liquid still on the bristles can be exposed, thus tainting the next coating with dark streaks. Make sure the brush is almost completely dry before you use it again, or the wash water will dilute the chemistry. Carefully wash the brush after a studio session, and do not use it with other processes.

The glass coating rod, mentioned on page 268, saves on chemistry and can yield an almost machine-like layer on smooth paper; it can be used with other processes if it is carefully cleaned. Or, spray emulsion on with an atomizer or air brush while wearing proper protective gear.

2. Chemicals. Please note: I have measured all these chemicals on a gram scale, then translated them into common measurements. You will need 1 oz. (30 g) silver nitrate crystal, ½ cup (90 g) ferric ammonium citrate *green* anhydrous, and 1 tablespoon (15 g) tartaric acid to make approximately 32 oz. (946.3 ml) working Van Dyke solution; all are special-order items from one of the merchants listed in Supply Sources. Fixer (hypo) is available at photography stores, but do not use rapid fixer because it seems to bleach a brown print. I buy 250 g (8 oz. or 1 cup) at a time of crystal sodium thiosulfate, which I prepare by thoroughly dissolving 1 oz. (30 grams) to 32 oz. (946.3 ml) water and mix afresh after processing six 8 × 10 in. (20.32 × 25.4 cm). Jesseca Ferguson, who co-authored the section of this book on pinhole photography (see page 110), suggested that I try a generous 1 tablespoon (20 g) sodium sulfite and 1,000 ml water as a clearing bath, and I remember that the old Polaroid black and white film employed the same method to clear its self-developing negatives. The much more toxic hypo eliminator is unnecessary. Or, to reduce wash time, I use hypo clear, available at photography stores and mixed at one-half the manufacturer's directions for double weight photos. Save chemicals in tightly capped bottles in a cool, dry place.

Bostick & Sullivan (see Supply Sources) makes premixed, liquid brown print solution, which I now use, after decades of mixing from scratch, because I would rather spend the extra money

and not risk my well-being from possibly breathing in unhealthy particles. Photographer's' Formulary (see Supply Sources) packages a more economical kit with all the pre-measured components, and it is helpful in case you want to try this method without investing in quantities of chemicals of if you need to make only a few prints. Fotospeed makes the closely related Argytotype process kit that can be purchased world-wide; it comes with instructions, sensitizer and fixer, good quality paper, digital contact film, coating rod, gloves, and syringe.

Some printers use no more than one or two drops of 10 percent potassium dichromate—that would be 2 teaspoons (8 ml) dichromate—to 9.5 oz. (100 ml) distilled water for the stock solution—in the first wash of 1 pt. (473 ml) distilled water for rendering more contrast. The dichromate solution also can help clear highlights if you have used emulsion that has started to go bad and appears a pale brown, rather than pale yellow, when still wet and coated. Dichromate or bichromate is a carcinogen; it must be carefully handled with gloves, goggle, and respirator. In addition, it is terribly toxic for the environment, so I try to stay away from dichromate, and its effect is limited anyway. Making proper negatives (Chapter 6) is the answer. Liam Lawless, a great experimenter with formulae, recommends substituting 3–6 g ferric citrate for the same amount of ferric ammonium citrate. Mix it into hot water, then allow it to cool before adding it to the Van Dyke solution to see a noticeable difference in contrast.

If you use a hose and tap water, you may find that the excess emulsion is not washing out. Carmen Lizardo, a contributor to the classic "Post Factory Photography," recommends a pinch of citric acid or lemon juice to the first bath so that you change the water from alkaline to slightly acidic. In addition, gold toning (Item 18, below) can help with longevity of a Van Dyke brown print.

3. Distilled water. Sometimes you can get by with tap water for making the brown print solution, but the use of distilled water prevents the frustration of

possibly mixing bad solution. A dish tub filled with hot tap water can be used to warm up the distilled water (see Item 4, below).

4. Four nonmetallic trays or tubs. You will need labeled photo trays—I find ones without ridges are better for evenly distributing liquid on the print's surface if you gently rock the tray—or dish tubs larger than the print when you first wash the exposed paper, fix the image, remove the fixer, and do the final wash of the image. You may need more trays if you will gold-tone the Van Dyke. One tray or deeper tub can double as a container for hot water to heat up the distilled water while making the stock solution.

5. Hair dryer, fan, clothesline, and pins. The emulsion has to be completely dry, because if photographic negatives come in contact with wet emulsion, a permanent brown stain is created. If inkjet negatives touch liquid, the ink runs. Use a hair dryer only on the cool setting or a fan to thoroughly dry the coating before laying a negative on top. Do not use electrical appliances near water. I use nylon screening from the hardware store extended over and stapled to canvas stretchers from an art store as a drying rack in a dark area. A plastic clothesline with plastic clothes pins, which are easier to clean, can be used to air dry finished prints.

6. Image. To make a positive print, rich in detail, either use a negative transparency the same size as the positive you wish to create, or use real objects as one of the many ideas in Generating Imagery: Analogue Methods, page 100. Even semitransparent objects, such as leaves, show the veins after proper exposure. Or, generate film images with a pinhole camera, also in Chapter 5. Brown printing will pick up and render a broad gradation of tones, but I prefer a slightly contrasty negative that would print with a #1 or 2 filter on polycontrast black-and-white paper. We have carefully worked out a wide tonal range digital profile (see Chapter 6, Making Negatives: Digital Method) for brown printing on Platine paper.

Because the emulsion is a bit expensive, I use a pencil to lightly draw around the edge of the image, and that outline provides a template for where I will coat. In addition, I use pencil on the back of the paper to write information such as paper brand, sizing if there is any, date, exposure source, and exposure time.

If you are using vegetation, such as flowers or leaves, place a sheet of plastic wrap from a grocery store or clear acetate from an art store above the dry Van Dyke emulsion and below the plant life. The heat from the exposure causes the vegetation to "sweat," which can cause stains. Dry and press plants for better contact and, therefore, better resolution. If you do not use glass, carefully pin in place cuttings that can blow about or are far from the surface. You also can catch shadows on the emulsion.

7. Light. If you have built an ultraviolet light exposure unit as described in this book (Chapter 4), you probably will need ten minutes to expose a "normal" (not too dense or black and not too thin or clear) negative. Sunlight is also suitable and yields even deeper tones in less time on a sunny day. I find Van Dyke emulsion needs almost half the exposure that a cyanotype requires. Using a dense negative will take longer and, conversely, using a thin negative requires less time, but too thin a negative eliminates much of the detail that brown prints can render. Thick fabric will take longer to expose.

Mix and coat the chemicals in subdued light or under a safelight. I illuminate the coating area with an ordinary 40-watt tungsten bulb because I want to see where I have coated, and a yellow safelight, which is near in color to the emulsion, makes observation difficult. However, if you repeatedly get a silvery gray as streaks in the image or in the highlight areas of the finished print, the emulsion or brush might have fogged from being left under tungsten too long, and you might try a bright red safelight. The other cause could be that the emulsion was overheated when you dried it. At all times, protect with an opaque cover, such as a black plastic wrapper sheet film and photo paper are enclosed in, or garden mulching plastic, the

emulsion you have poured from the bottle of mixed solution.

8. Neoprene gloves, respirator with toxic dust filter. The gloves should be worn while you work, and the respirator should be added when you are mixing raw chemicals and if you use a hair dryer to dry the emulsion. Gloves can pick up chemicals; clean them before you touch paper so that you do not leave gloved finger prints.

9. Newspaper, oilcloth or blotter paper, paper towels/sponge. Because Van Dyke brown print solution stains and can contaminate other sheets of paper and other surfaces, cover your worktable, which should be stable, hard, and smooth, with layers of newspaper that can easily be removed when dirtied. Oil cloth, available from the vermontcountrystore.com, oilclothbytheyard.com, and scandinaviandesigncenter.com, is just like the stuff from the 1950s and has a liquid-repellant surface. Frequently wipe it clean.

10. Printing frame. To achieve good contact between negative or flat object and emulsion, use a printing frame bought from one of the makers listed in Supply Sources; plate glass with other sheet of glass, Masonite, or foam core underneath; or follow the instructions for building a frame on page 80. In one of these aforementioned ways, you will be ensuring against blurry imagery by weighting down the negative, and if you have a split-back frame, you can inspect the image without moving the negative. Make sure glass is larger than the image, not the kind that protects against ultraviolet rays, and is clean and dry before each use. Foreign particles lodged in the glass can create dimples in the print. If I am using a printing frame without a hinged back, I create a hinge with the substrate by using clear tape on one edge of the negative, as described in Item 16 below.

11. Receiver. Use paper larger than the image for ease of coating it. Finished prints can be made on *un*buffered, 100 percent rag paper of medium absorbency, while practice prints can be crafted on less-expensive paper that does not delaminate in water. Many stationery stores sell cotton-based

Crane's Kid Finish AS811, but it can be a little tricky to prevent from ripping if you use sheets larger than 8×10 in. (20.32 cm × 25.4 cm). I describe a simple method for protecting the paper while putting it through liquids in Chapter 4, Item 12. On the other hand, Crane's is a perfect weight for using in a laser printer after brown printing on it, or as pages in an artist's book. Photographer's Formulary carries Crane's 90 lb. cover wove paper from sheet size to rolls. Bostick & Sullivan sells the smooth Kozo, made in Japan from mulberry bark and cotton abaca. I often use an off-white or tan paper, so visually the print appears more continuous-tone. The brightest white without artificial whiteners can be obtained in the deliciously tactile, perfectly sized, but more expensive, Arches Platine, now available in two weights from Bostick & Sulivan. Keep in mind that the print might appear more contrasty due to the deviation between the deep browns of the image and white of the paper. My students have also used recycled book pages, handmade papers from India, and Rising Stonehenge.

I have printed Van Dyke brown on Tyvek™ (spun plastic that looks a bit like rice paper but is impressively durable and is used in sheets to make water-proof envelopes and in rolls to wrap houses during construction) by coating lightly with a sponge brush, working the emulsion in evenly with a dry sponge brush, and vastly over-exposing it.

You may be inspired by Talbot's waxing of prints (see caption under the Reading Establishment photos that opened this chapter). He used this technique to make thin paper transparent enough to employ as a negative, yet the transparentizing of paper might be an aesthetic you are interested in because often you can see the fibers in the paper. In addition to wax, another method for accomplishing this appearance is described near the end of Chapter 4: Transparentizing Office Copies.

Natural fabrics, such as a close weave cotton and muslin, accept the brown print solution best and

yield the deepest tones, but brown printing also can be done on painter's cotton duck canvas and synthetic fabrics, such as bridal or slipper satin. Avoid permanent-press cloth, which repels the solution. It is easier to learn the technique on paper before you apply it to fabric. The Tips section of this chapter describes more about using fabric, and see Chapter 7, Cyanotypes, both the Materials and the Cyanotype on Fabric sections, for more details (page 159 and 166).

I always mark on the back edge of the substrate in pencil, or laundry pen with fabric, the information I find useful: name of surface, source of light, and exposure time and date. Writing on the back also helps me remember which is the side to coat, because once I divide a large sheet, I no longer can find the water mark (page 88) on every smaller piece I have made.

12. Sheet of glass or Plexiglas™ (optional). Angle the plexi in a sink, sprinkle it with a little water to form a suction with the back of your print, then lay the exposed print onto it while you gently hose running water on it. This system, which I learned from Bea Nettles, allows unexposed chemicals to drain off, preventing them from contaminating the print. Wrap cloth tape or duct table around the edges of glass to prevent it from cutting you and to cushion the glass from breaking.

13. Siphon washer. This gadget, available on eBay, works well when attached to a spigot and then to a photo tray in a sink for washing prints. Or, you can drill small holes up the sides of a dish tub or photo tray and gently run water directly from a faucet onto the back of the print. Both methods allow clean water to enter while contaminated water drains. If you do not have running water, fill the wash tray with water, agitate the print for 20 seconds, then dump the water and refill the tray. Keep repeating for 3–5 minutes for a first wash and 30 minutes for a final wash if you do not use hypo clear. Blot the print with a clean sponge afterward.

14. Sizing. Good rag papers tend not to need more sizing than the manufacturer has put in. With hemp, often with Rives BFK, and with absorbent surfaces, sizing is essential. Different sizings can affect the color of the final print, so experiment with methods described in Chapter 4 of the section Preparation for Light-Sensitive Methods. The gelatin sizing described in that chapter tends to darken the deep browns while keeping the whites pristine. If you do treat the paper, definitely size it evenly and thinly, as described in that chapter. Uneven and thick sizing can cause patchy stains on your print. Often, sizing improves the appearance of details in the image.

With fabric, use hot water and wash out the manufacturer's sizing before printing. Hot water will preshrink the fabric, which is useful if you are going to employ another technique on top of Van Dyke. In Chapter 4 and the end of Chapter 7 on cyanotypes, I describe my method for stretching fabric before coating, exposing, and processing.

15. Storage bottle. A glass quart (1 L) fruit juice, recycled chemical, or vitamin bottle, or a brown plastic jar sold in photography shops, thoroughly washed and labeled as to contents and date mixed, is fine for storing the emulsion. You can even use a clear glass bottle if you carefully enclose it in an opaque bag, such as the plastic ones in which photographic paper and sheet film are wrapped. Store liquid chemicals in tightly capped containers in a cool, dry area. Be careful to stir, not shake the bottle, because if it has a metal top, the cap will eventually corrode from the chemicals and contaminate the emulsion. It has happened to me! I have a refrigerator in my studio, where I put solution in order to extend its life for over a year, but I use the emulsion at room temperature. The mixture should neither freeze nor heat up; children and pets should not have access to it; and the refrigerator where you might store chemicals should not be the one in which you store food.

16. Tape. If you are not using a hinged printing frame, use clear removable tape to form a fulcrum between the edge of one side of the negative and the substrate. The tape ensures that the negative does not move if, after you have placed it on the coated and dried paper, you want to check

on the emulsion color as it is exposed. Do not press the tape down too hard, or it will lift up the emulsion when you try to remove it later. I tap the tape against my clothes to pick up a little lint and, therefore, help ensure that the tape will not be as sticky and will not remove the Van Dyke coating later. Cheap tape is better because it does not hold as strongly!

Some of my Museum School student have used a few pushpins, rather than tape, through the border on two corners of the negative and through the emulsion and paper and abutted glass up to the tacks. After processing the paper, damp pin pricks can be gently rubbed on the back so that the paper fibers close up and the holes are invisible. Or, you can save the tack holes if you want to line up the negative later to print a different technique on top of the brown print.

17. 32 oz. (1L) measuring cup or beaker, stirring rod, funnel, thermometer, soft and clean sponge. You will need nonmetallic implements. It is easier to see if the chemicals have gone into solution if you use clear plastic or glass. In addition, printed black numbers, rather than clear measurements, are easier to read once you put brown solution in it. If you notice sediment at the bottom of the bottle, pour the emulsion through a coffee filter in a funnel or you can get black spots in your print.

18. Toner (optional). I was surprised to discover that some prints fellow graduate students and I made 40 years ago had faded, while others of the same age had remained the original brown. Since I used the same paper and stored them in the same way for both sets of Van Dykes, I concluded that I had not been careful enough when processing the exposed emulsion. Perhaps I had not properly washed the print in the first bath and, therefore, had not removed the excess iron? Maybe I had not removed all the fixer? If you want to be more certain about permanency, you can use gold toner, which does alter the color from deep brown to warm brown: With gentle agitation, rock one exposed print at a time in a non-metallic tray of Carmen Lizardo's acidifying bath, explained under "Chemicals," Item 2, above, for two minutes. The liquid may look milky due to the unused silver that has been removed. Transfer the print to another tray of acidified water for two minutes. This tray's contents should appear clearer. (If you are going to tone a second print, then beforehand, dump the first try, move the second try to be the first, and mix fresh acidifying bath for the second tray.) Wash the print in a third tray of regular running water, or change the tray's water ten times for one minute. Carefully immerse the print into a ribless tray of diluted gold toner for five minutes, while gently rocking the tray. Gold toner kits, which you further dilute to a 5 percent solution as you use it, can be purchased from Bostick & Sullivan and Photographer's Formulary Gold 231 Toner at half strength; mix fresh toner for each print. Or purchase pre-diluted gold toner from Silverprint in the U.K. Fix as described in this chapter. Clear in 1 percent sodium sulfite, hypo clear, or Permawash™. Wash again for five to ten minutes. What you have done is replace silver with more stable gold. Chapter 3, Toning, describes other methods, such as selenium (very toxic) and Berg toners (the blue is really diluted cyanotype plus 28 percent acetic acid stop bath and the Berg copper toner brings the print back to the color before it was fixed).

MAKING THE SOLUTION

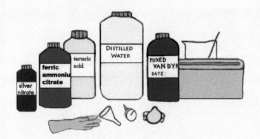

8.3 Equipment You Will Need

EQUIPMENT YOU WILL NEED

Silver nitrate

Ferric ammonium citrate

Tartaric acid

Distilled water

Label and permanent marker

Brown bottle

Beaker

Funnel

Stirring rod

Thermometer

Tub

PROCEDURE

1. Adjust water temperature to 75° F (23.8°C).
2. Using a funnel, pour 90 g (124 ml) ferric ammonium citrate into a beaker.
3. With constant stirring, add water *to make* 8 fl. oz. (250 ml).
4. Pour the solution into a labeled brown bottle.

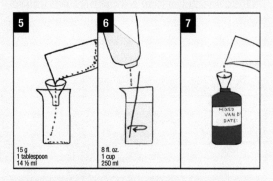

8.5 Procedure

5. Pour 15 g (14 ½ ml) tartaric acid into a beaker.
6. With constant stirring, add water *to make* 8 fl. oz. (250 ml).
7. Add this mixture to the brown bottle containing the ferric ammonium citrate solution.
8. Pour 30 g (29 ½ ml) silver nitrate into beaker.
9. With constant stirring, add water *to make* 8 fl. oz. (250 ml).
10. Slowly pour the mixture from the bottle containing the ferric ammonium citrate and tartaric acid solution into the beaker with the silver nitrate.
11. Add enough water *to make* 30 fl. oz. (887 ml) for artificial light or 32 fl. oz. (1 L) for bright sunlight.
12. Pour the contents of the beaker into the brown bottle. Cover the bottle and shake the solution to ensure thorough mixing of chemicals.

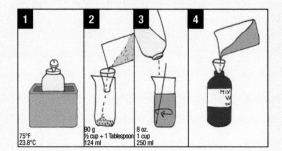

8.4 Procedure

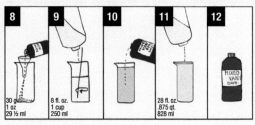

8.6 Procedure

MAKING A BROWN PRINT

Please check the Making Negatives: Digital Method chapter, where a more precise method using the first test print to find the time for DMax (darkest brown) is described.

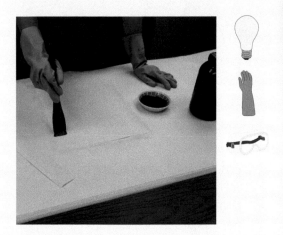

8.7 Coat the Paper

8.8 Expose the Print

Some printers partially dry the first coating with a hair dryer and then apply a second coat and dry that before exposure, to darken the shadow areas of the print.

1. Coat the paper

Shake the bottle of room-temperature solution and pour 1 oz. (29 ml) into a glass or porcelain cup. To ensure that the solution does not draw up into the bristles, wet your brush in a little distilled water, then wipe it almost dry on a clean towel. Dip only the end of the brush into the emulsion and apply it to the paper, quickly and lightly moving the same solution around so as to avoid saturating one area. Coat beyond the image or coat an additional small piece of the same paper for watching the color change during the exposure. Let the paper sit in a dark place for a few minutes before you fan or hair dry on a cool setting.

Or, dry the emulsion flat or hang from a clothesline, in a dark and clean area. Make sure the coating is yellow, because if it appears brown, it has gone bad.

2. Expose the print

Make a sandwich with backing board on bottom, paper facing emulsion side up, negative touching the emulsion and not reversed (aka "right reading"), heavy glass on top of the unit. Place the loaded print frame so that the emulsion faces the light source, in direct sunlight for 3–10 minutes, or under artificial ultraviolet light 6 in. (15.25 cm) away for 5–15 minutes. Either watch for a little more detail than you desire in the middle tones and the beginning of detail in the yellow-brown of the highlights, or watch the scrap paper turn from yellow to tan to brown to silver brown. Always turn off the UV light before you judge the color and never look at the bulbs without protective goggles.

Another method is described in the step-by-step photos of the Cyanotype chapter, page 153.

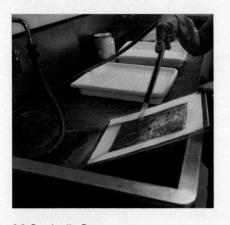

8.9 Develop the Paper

4. Fix the print

Mix fixer according to the manufacturer's recommendations, then dilute it further by combining in a tray 2 oz. (59 ml) of the stock solution with 32 oz. (1 L) of water or use the thiosulfate recipe described in Item 2 of Materials. Immerse the print for five minutes while gently rocking the tray. Fixer will darken the image and make it permanent, but too long in the fixer can bleach the print. Since it is weak, fixer should be regularly changed when it no long darkens the image.

3. Develop the paper

Remove the negative from the print frame and set it aside in a clean place. Then, take the paper out from the print frame and wash it thoroughly with a gentle water spray followed by a tray wash until the cool, running water is clear (approximately 2–5 minutes for thick paper). If you instead use warm—not hot—water, wash for three minutes. An option at this point is to increase the contrast with a dichromate bath or to gold tone the print, as described in Toning, Chapter 3, and in Item 18 above.

8.11 Inspect the Print

5. Inspect the print

Before the print enters the fixer, it will be a yellow-brown. As it fixes, it turns a true brown (this color change is one way to know if your fixer is good or needs replacing) and continues to darken as it dries.

8.10 Fix the Print

8.12 Remove the Fixer

6. Remove the fixer

Dilute the fixer remover according to manufacturer's recommendation for photo paper (or sodium sulfite as described above, Item 2), pour it into a try, and immerse the paper for the suggested amount of time, usually three minutes. Gently rock the tray for the full time because fixer left in the print can ruin the paper and image over time! This is not an optional step.

7. Finish the print

Water wash the print for 10–15 minutes in a tray fitted with a syphon, or frequently change water in a clean tray, then lift the print by one corner and let leftover liquid drain off. On a clean surface, blot excess water with a soft, uncontaminated sponge and dry in a clean area on a rack or a clothesline. The image continues to darken as it dries and oxidizes, so hold back judgment for 48 hours.

Once you have figured out a good exposure time, you can print the whole image with the grayscale if you are using the digital method described in Chapter 6.

TIPS

Store brown print solution in a cool, dry place, such as a refrigerator, and the solution should last for months, even years, if the container is tightly capped. Do not store solution with food.

Cut the recipe in half if you are not doing a great deal of printing.

Wet emulsion shimmers, while dry emulsion is dull.

Silver nitrate has a tendency to precipitate to the bottom of the stock solution, if it has been sitting (even during the brief time you are working), so regularly stir the solution gently before using.

When applying the emulsion do not brush too hard or you can abrade the paper. Do not go back after the emulsion has started to dry in order to "touch up" the coating. The spot you coated will show up in the final print where the emulsion is doubled. It becomes darker, and a ring around the edge is obvious. Instead, every so often, hold the coated paper at an angle as you apply emulsion. You can observe wet areas, which glisten, and dry or uncoated areas, which are either matte or the color of the substrate.

If you mix blue or gum on top of a brown print, the bleach or peroxide you use as an optional intensifier for blueprinting and the dichromate sensitizer in gum printing will fade the brown print. So, start with a very dark (overexposed) brown print or do the brown printing last (although its dark color tends to obscure other colors).

Former Museum School student and artist Bill Durgin purposely underexposes a cyanotype then prints the same negative in Van Dyke over it, resulting in brown prints that are almost black. (Rembrandt often used ultramarine blue and umber pigments, rather than black, in the shadows of this paintings.) A different, two-toned effect can be created

8.13a and 8.13b Lynn Silverman, *A Grove of Four Trees*, 19 ½ × 14 in. (49.5 × 35.56 cm) each, Van Dyke on Fabriano paper, 1987. Silverman made a series of brown prints with the subject matter of four trees growing together to form one large leafy mass. Inspired by imaginary relationships between the individual tree and the canopy, she employed masks (see Chapter 4, Creating the Photo-Printmaking Studio) and "sawing" the four trunks into strips, thereby transforming the grove into architectural or iconic significance. You also could selectively coat the paper, rather than brush on emulsion from corner to corner, in order to obtain a similar effect.

when you use a negative for one process and a positive for the other process.

Blue usually will erase brown under it, so you can achieve an effect that preserves the cyanotype's brush stroke. Or, you can use an overexposed brown under a diluted solution of blue so as to minimize the erasure.

Do not use tools and utensils from other processes with brown printing, or you can contaminate the emulsion. This rule holds true for all techniques.

A little sensitizer solution goes a long way: 1 teaspoon (3 ml) will coat an 8 x 10 in. (20 x 25 cm)

sheet of smooth paper. Beware of overly saturated paper, which makes for longer exposures and can cause stains.

Be sure the emulsion is completely dry before exposure, or negatives can stick to it or be damaged, and the finished print will show black stains.

Rinse and dry your brush as soon as you finish coating the paper; do not wait until the end of a session, when the leftover emulsion on a brush might be accidentally exposed too long, even to a safelight.

8.14 Laura Blacklow, *Untitled, from Backyard Botanicals*, 19 × 26 in. (48.26 × 66 cm), combination cyanotype and Van Dyke brown print on Rives BFK paper. ©2011 LBlacklow. Collection of Ania and Gerry Gilmore.

My students and I have used blue and brown wet, or I have coated and exposed and developed an image with one process, then coated, exposed, and developed the same print with the other process, and sometimes even more of the same procedures. The cover of this book was done in this manner of repeated coatings. The combination yields unpredictably exciting colors, like greens and pinks. I do not use intensifier (for cyanotypes) because it wipes out the brown print underneath, and I do not use fixer remover/hypo clear (for brown prints) because it removes the unusual colors. But you have to use Van Dyke's fixer, and I have found that the most important step for the brown print's survival is to wash very carefully. Displaying the combination print under UV protective glass is imperative, too. As back up, I take excellent quality digital shots so I can make inkjet prints, also.

If you hang coated paper or fabric to dry on a clothesline, wash the clothespins and line before the next use or you can stain future pieces with contaminated solution.

If you use a standard print frame, unhinge a portion of the back and check one half of the print for color changes without moving the negative. Exposure is judged visually. With a thin (more transparent) negative, remove the paper at the tan-brown stage, and with a dense (black) negative, remove the paper when it turns deep silvery brown. Still, the best results occur with a properly made negative.

Photographers' Formulary sells potassium dichromate for contrast control, which decreases the middle tones. Approximately 9–10 drops of a 10 percent dichromate solution is added to a 16 fl. oz. (500 ml) water first wash. A 10 percent solution is made by taking 1 oz. (29.5 ml) of water and slowly stirring in the dichromate until no more can be absorbed

and the crystal begins to precipitate out. That is a 100 percent solution, so then add 9 oz. (266 ml) more water. Because dichromate is toxic, it is recommended that you mix the solution in a sink—not your kitchen sink—and wash all the utensils immediately after use. I recommend wearing neoprene gloves. Dispose of excess dichromate with copious amounts of water down a drain, not in a wastepaper basket. If you want to get rid of any quantity of dichromate, take it to a hazardous waste center. It is one of the worst polluting chemicals in this book!

If the print is too pale, increase the exposure or use a more transparent negative.

If the print is overexposed, so that the highlights are blocked and the brown is too dark, leave the print in the fixer longer than recommended until it comes back to the color you want. Make sure you remove the fixer afterward and thoroughly wash the print. If this

procedure does not work, make another print with less exposure or make a denser negative.

To remove wrinkles, dampen the back of your dry print with a slightly wet, clean sponge, place the print face down in a hot (375°F or 191°C) dry mount press for 12–20 seconds, or press the back of the print with an iron on the cotton/linen setting. This procedure will darken the print, too.

See Chapter 3 for examples and instructions on toning brown prints to blue, yellow, cop-

per, and silver after you fix the print. Consider extremely weak selenium toner to darken the brown color, before you fix the Van Dyke print (also described in Chapter 3). The toning chapter is written by Elaine O'Neil, whose quilt appears in Figure 8.15.

In *Primitive Photography* (listed in the Annotated Bibliography) Alan Greene describes a related process, the calotype, and his own salt printing method.

TIPS FOR BROWN PRINTING ON FABRIC

See the section Cyanotype on Fabric in Chapter 7, page 166, for lots more information.

Like paper, the fabric can be coated lightly with a brush or dipped in a tray of solution,

but do not wring the cloth or you might find permanent lines in the coating. Be watchful, because thorough drying will take longer.

8.15 Elaine O'Neil, *Night Visits*, 72 × 92 in. (1.8 × 2.3 m), Selenium Toned Van Dyke brown print on cotton. ©1985 Elaine O'Neil.

A bat that made its final resting place in O'Neil's attic became the subject for this comforter, based on a traditional quilt pattern. The artist photographed the deceased animal and used the negatives to print on pieces of cotton, which she exposed in sunlight and arranged and sewed into a complex pattern of light and dark, obtained by lesser or more exposure.

Do not air dry the freshly coated emulsion on humid days and nights or you may get a mottled print.

Here is a sad story that might help you remember always to fix, then remove the fixer from fabric and carefully final wash it. When I was learning these processes in graduate school—there were few modern instructions to refer to—at the Visual Studies Workshop, I labored many hours creating a brown print quilt from antique negatives, sewing the pieces together and embroidering details by hand. I did not fix the image pieces long enough nor did I bother using hypo clear because I did not know. I gave the quilt to my parents, who proudly displayed it near their living room window. Six months later, all that was left of the quilt was the stitchery and some cotton!

For more detail in the finished piece, use a warm, not hot, iron on the back of the coated fabric before exposure; in this way, your negative will be in in closer contact with the emulsion. Even better, you can stretch the fabric to eliminate wrinkles, as described in Cyanotypes on Fabric, page 166. Use plate glass during the exposure.

Brown printed fabric can be washed in cool water with mild liquid soap, such as Ivory or Woolite. Avoid detergents and soaps with chlorine, bleach, borax, or phosphates.

Brown prints can be dry cleaned.

NOTES

1 Coe, Brian, and Mark Haworth-Booth. *A Guide to Early Photographic Processes*. London: Victoria and Albert Museum, 1983, p. 17.

2 Crawford, William. *The Keepers of Light: A History and Working Guide to Early Photographic Processes*. Dobbs Ferry, NY: Morgan & Morgan, Inc., 1979, p. 16.

9.1 France Scully Osterman, *Light Pours In*, from the Sleep series, waxed salt print on Strathmore paper, 8 × 10 in. (20.32 × 25.4 cm), 2002. ©France Scully Osterman.

The Sleep images offer contradictions: a sense of voyeurism juxtaposed with a moment of innocence; a reminiscence of death (or post-mortem), yet full of movement and energy.

9

Salted Paper Prints

By France Scully Osterman

The earliest salted paper prints were made in the 1840s and 1850s from calotype paper negatives, waxed paper, and albumen-on-glass negatives. Salt prints were also sometimes called "Crystalotypes." The term was used by John A. Whipple of Boston specifically for salt prints exclusively produced from glass negatives including albumen-on-glass, and wet-plate collodion negatives.

The wet collodion negative process was published by Frederick Scott Archer in 1851 and quickly adopted by photographers all over the world because, unlike the daguerreotype process, it was less expensive to produce. Salted paper and albumen prints were used by wet collodion photographers throughout the collodion era (1851–1880). After the albumen print became popular, salt prints were often referred to as "plain" prints. This may have been because the albumen print had a glossy appearance, a much desired aesthetic of the period.

Salted paper prints were also used as a base for over-painted solar enlargements from around 1859–1870. These required an exposure of at least an hour for the solar projected image to be printed deep enough as a reference for the application of chalk, charcoal, or pastel.

SAFETY

Always wear disposable gloves when working with the silver nitrate solution, as it will stain hands and permanently stain clothing.

Silver nitrate is a corrosive and should be handled with care by wearing protective gloves. Avoid contact with eyes.

Dispose of solutions responsibly. If your town has a hazardous waste area, use it.

Do not use any photo equipment, such as Pyrex ™ baking dishes, for any other purpose.

METHOD OVERVIEW

9.2 Method Overview

1. A piece of paper, slightly larger than the negative, is carefully floated on, submerged in, or brushed with a solution of ammonium or sodium chloride and water.

2. The salt solution may also include a small amount of sizing such as gelatin or one of many starches, such as arrowroot or tapioca. The sizing step is optional, but is sometimes added to prevent the silver chloride from going deep into the paper fibers. This not only enhances the detail of the image but also alters the final image color.

3. After coating with the salt solution, the paper is either dried with a hair dryer or hung up to dry. Once perfectly dry, the paper is then coated with silver nitrate solution (by either brushing or floating) and dried again. The paper is now covered with the compound of silver chloride and an excess of silver nitrate and is sensitive to light.

4. The sensitive paper is placed in contact with a negative in a contact printing frame and exposed to sunlight or an ultraviolet light source. Exposure to light converts the silver chloride to metallic silver. The longer the exposure to light, the darker the metallic silver deposit will become. Areas not exposed to light remain the color of the paper. This action of photolysis is continued until the image is intentionally printed darker than what looks right for the final image.

5. The fully formed print is then washed in slightly chlorinated water to remove excess silver nitrate. It is then toned with gold chloride (toning is optional) and fixed in sodium thiosulfate (aka hypo) to remove the deposits of unexposed silver chloride, and hypo cleared. The print is subsequently washed and dried.

6. Once completely dry, a protective finish maybe be added to protect the metallic silver in the print from harmful atmospheric sulfides. This chapter discusses how to coat the print with bees wax. Coating the print with wax also increases contrast, making the DMax darker, while lending a satin finish.

MATERIALS

1. Paper. One hundred percent cotton or acid free paper, strong enough to withstand extended washing, such as Fabriano Bristol.

2. Chemicals and equipment.

a. Salt Solution:

Pyrex beaker (large enough for the amount of salting solution you plan to mix)

Stirring rod or spoon

Hot plate or stove top (if using gelatin sizing)

1.5 grams ammonium chloride or sodium chloride (no iodine added; Kosher salt is perfect)

1.5 to 2 grams food-grade gelatin, like Knox (gelatin for sizing is optional)

100 ml (3.38 oz.) distilled water

b. Silver Solution:

15 grams crystal silver nitrate

100 ml (3.38 oz.) distilled water

Glacial acetic acid (if needed)

Pyrex beaker (large enough for the amount of salting solution you plan to mix)

pH strips

Disposable gloves

Rubylith (see Creating the Photo-Printmaking Studio, page 102) or a piece of red glass large enough to cover light unit (optional; needed if floating paper on silver solution)

Light unit (optional; needed if floating paper on salt or silver solution)

c. Toner: Gold Chloride *Stock* Solution:

1 gram pure gold chloride

Distilled water

Brown glass bottle that will hold 200 ml (6.76 oz.)

Gold Chloride *Working* Solution:

700 ml (23.7 oz.) distilled water

10 ml (1 grain) gold stock solution

Pyrex glass beaker large enough to hold a minimum 700 ml (23.7 oz.)

Very small graduated cylinder (20 ml or less than 1 oz. capacity)

Glass stirring rod

pH test strips

Sodium bicarbonate (baking soda)

d. Fixer:

1000 ml (33.8 oz.) warm water

150 grams (5.25 oz.) sodium thiosulfate ("hypo")

2 grams (slightly less than ½ teaspoon) sodium bicarbonate

e. Hypo Clearing Solution:

30 grams (1 oz.) sodium sulfite

3000 ml (101.4 oz. or 3.17 qt.) water

f. Waxing (optional):

Beeswax, lavender oil

Removable masking tape

Microwave or hot plate

3. Ultraviolet light source or direct sunlight, contact printing frame with a hinged back.

4. Other items. Shallow glass bowl or saucer; cotton wadding; flannel cloth (used for baby clothes and winter sheets); smooth, flat worktop (smooth counter, sheet of plexi-glass or glass), timer or watch. (Osterman advises that accurate gram scales can by purchased in kitchen and sporting shops. L.B.)

5. Materials for contrast control (optional): Tissue or tracing paper; household ammonia; large plastic storage box with lid; rolled cotton wadding (can be found in some pharmacies).

6. Materials for coating the paper. If you choose to brush on the emulsion, you will need rolled cotton wadding; small bowl; a smooth board for coating 2 in. (5 cm) larger on all sides than your paper; blotting paper; clear packing tape; removable "painter's" masking tape; hair dryer or a clothesline and spring-type clothes pins.

If you prefer to float the paper on the solution, you will need a Pyrex™ baking dish, clear glass tray, or dedicated plastic tray; clothesline and spring-type clothes pins; steamer, humidifier, or tea pot (only needed as an option for working in a dry climate); toothpick or small brush.

7. Table light unit large enough to hold Pyrex™ baking dish (optional).

MAKING A SALT PRINT

The sizing and salt solutions are not light sensitive and applied under any type of light.

1. SIZE THE PAPER

If using gelatin sizing: add gelatin to cold water and let sit for 15 minutes until gelatin softens. Then heat the water and softened gelatin on a hot plate and stir until dissolved.

Add the ammonium chloride to the warmed solution and stir until dissolved. Let the solution cool to room temperature before using.

(If not adding gelatin, salt will dissolve easily in room temperature water.) It may be used slightly warm or cool, but should not be used hot. However, if the solution with gelatin gets cold, it will gel and will have to be re-warmed. Temperatures in the 70–78°F (21–25.5°C) range work best.

2. SALT THE PAPER

METHOD I: BRUSHING

It is more difficult to make even coatings by brushing than by floating, but brushing does not require as much solution as using a tray and floating the paper. Once mastered, it is a very economical way to prepare the paper (especially when sensitizing). It's the perfect technique when you only want to make a print or two, and easier to do if you don't use the gelatin sizing in the salt solution.

To prepare the coating board, cut the blotter to slightly smaller than the board. Tape the entire perimeter of the blotting paper onto the board. Tape the four corners of the paper to the center of blotting paper. After the blotting paper has been used extensively and is contaminated with silver, it can be replaced with a fresh piece. Another option is to cover the board with clear packing tape, which can then be wiped clean between coatings.

Pour some of the salting solution into the small bowl. Ball up cotton by pulling the loose strands to the back and, wearing gloves, dip the cotton into the salt solution so that it is thoroughly wet, but not dripping. Apply to the paper in slightly overlapping lines, in one direction only. Allow an extra margin beyond what you will need for your print. After coating the whole sheet, quickly turn the paper 90 degrees, and go over the paper again with the same piece of cotton. *Do not apply more solution, unless the cotton "shreds" which means you did not apply enough.* Turn the paper 90 degrees once more and brush the paper with the same cotton ball a third time.

These repeated steps are meant to help distribute the solution evenly, without puddles or streaking. A cheap turntable, also called a Lazy Susan (available at a kitchen store), under the coating board makes this process faster and easier. The solution on the paper should be a satin, even wet finish. Allow the

solution to spread for a minute before drying. Dry thoroughly with a hair dryer.

METHOD II: FLOATING

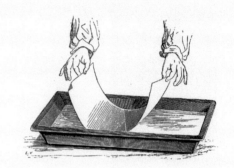

9.3 Floating Paper on Salt Solution

This method is recommended if you are using gelatin sizing and if you are coating many sheets of paper. Once dry, coated paper can be stored indefinitely as long as it is stored in a clean, dry environment.

The salt solution must be in a tray slightly bigger than the paper. The author uses Pyrex trays for prints 8 × 10 and smaller, but any glass, ceramic, or dedicated plastic tray may be used. Enamel trays are appropriate, too, unless they are chipped. Avoid bubbles when pouring salt solution into tray. Mark one side of the paper on a corner with a pencil before floating so that you will know later which side is salted.

To completely avoid bubbles, the author suggests using a clear Pyrex™ tray for the solution, which is placed on top of a light table. This makes it possible to see through the paper, and check for bubbles once the paper makes contact with the solution. (For the *silver* solution, first cover the light unit with rubylith or a piece of red glass which covers the light unit completely.)

Fold the two opposite ends of the paper about 1 cm (less than ½ in.) to use as handles. Hold the paper by these two ends and

allow the center of the paper to curve gently downwards. (See Figure 9.3, Floating Paper on Salt Solution.) If the room is very dry, first humidify paper with a sick room humidifier or teapot before floating. Floating is also easier with thinner papers, such as Crob'art or Universal Sketch.

Set the lowest part of curved paper onto bath so that only the very end of the curve nearest you makes contact with the solution. Then, gently lower the rest of the center section onto the solution. Now, lower one side of the paper onto the solution and then the other side until all the paper is floating upon the surface except for the handles on the ends.

Once the paper is floating, it may begin to curl upward on the ends. If so, gently hold down the ends with the tips of your gloved fingers until the front of the paper absorbs enough solution to make it lay flat. Make sure that you don't push the paper too hard or the back of the paper will go under the solution. Once the paper lays flat on the solution you should lift up one side of the paper and inspect for bubbles. If discovered, they should be popped with a toothpick, small brush, or the tip of a piece of paper. Check the other side as well. (If you are using a light table under the glass tray, then you can see any bubbles through the paper.)

Float the paper on the salting solution for a total of two minutes, counting from the time the paper lays flat. After two minutes, slowly pull the paper up from the solution by one corner, and hang the paper by two corners with spring type clothespins on a line to dry. Blot any droplets on the bottom edge of the paper with a disposable paper towel. The salting solution is not light sensitive so this operation can be done in daylight. Once the paper is dry it can be kept indefinitely. Flattening the paper in a book or with dry mounting press makes subsequent floating on the silver solution much easier.

When needed, the "salted paper" is taken to a darkroom illuminated by red or yellow light. After the paper is brushed with, or floated on the surface of, silver nitrate solution, it is then removed and hung in the dark to dry. It should be used as soon as possible after it is dry, preferably within an hour or two.

If gelatin or other organics were included in the formula, throw away the salting solution when done. If gelatin is not added, you can filter it and reuse it. (The author uses a funnel with cotton balls to filter).

3. SENSITIZE THE SALTED PAPER

While the silver solution is not affected by light when first mixed, once it has been in contact with organic matter, like paper, salt, and/or gelatin, it's important not to expose it to strong light. Coating the paper can be done in a room with a dim white light, but the coated paper should be dried in a darkroom or room illuminated only by red, amber, or orange light. You will be handling the sensitive paper and exposed print in subdued white light during processing, but it's best to limit exposure whenever you can to prevent fogging.

First, you need to make the silver solution. Dissolve silver nitrate in distilled water. Measure the acidity with pH strips. (If printing in hot weather, add small amounts of glacial acetic acid until you make the pH = 2.5 to 3.5. Pour the solution into a small bowl for dipping cotton and brushing. (Floating requires a greater volume of solution, and depends on the size paper and tray you are using.)

Instructions for brush coating and floating paper on the silver solution are the same as for applying salt, except that the procedure is done in subdued or safe light conditions. It's possible to use a 60 watt tungsten bulb six feet (1.8 m) away from the coating area for sensitizing, though a bright yellow or red light is safer.

Once coated with silver solution, the paper may be hung on a line with clothespins in a darkened room or dried quickly with a hair dryer. It is very important to make sure the paper is as dry as possible before using it for printing. Failure to pay attention to this step can result in blotchy prints and also damage to the negative.

4. EXPOSE THE PRINT

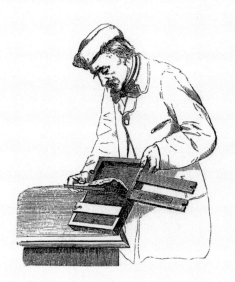

9.4 Opening the Printing Frame to Check Print Exposure

Once dry, the sensitized paper and negative are placed in contact with the sensitive side facing the image or emulsion side of the negative. This is done by first placing the negative into a contact printing frame image or emulsion side up. Then the paper is placed on top of the negative, coated side down. The back of the printing frame is closed and the frame placed in the sun or under a UV light unit.

Photographic printing frames are fitted with a hinged back to allow inspection of the print, without changing the registration of the paper to the negative. After the frame has been exposed to light for a few minutes, take it to an area where the light is subdued and open one half of the printing frame to inspect the progress of printing out. See Figure 9.4,

Opening the Printing Frame to Check Print Exposure.

The print should be exposed to look two shades darker than what would be considered normal for the finished image. If the image is too light or even looks perfect, close the back and continue to expose the print until the areas of maximum density are a shade or two darker than the desired finished print. The print will lighten considerably when fixed.

5. PROCESS THE EXPOSED PRINT

Pyrex™ glass baking dishes are perfect trays for all of these operations. They should be well cleaned with rottenstone or kitchen cleanser and tap water, given a final rinse with distilled water, and allowed to dry upside down before using for photography.

The print is given an initial "precipitation" wash (see below for more details) in tap water to remove the excess silver nitrate. Once the excess silver is completely removed, the print can be toned with gold or go directly into the fixing bath. The print is fixed in sodium thiosulfate, aka "hypo." An optional sodium sulfite bath helps to make the print easier to wash. The print is washed in running water or several changes of clean tap water and dried between blotters or with a hair dryer.

The "Precipitation" Bath (First wash)

The print is first placed in a tray of clean tap water. Municipal tap water in the United States often contains chlorine salts (sodium chloride). The excess silver will react with the chlorine in the tap water, precipitating the extra silver chloride on the paper. This will appear as a milky white haze in the water. When using tap water without chlorine, you must add a pinch of table salt to this bath. A dark tray makes observing the silver chloride much easier. The water from this first precipitation bath should be changed about three times. When there is no longer any milky

white silver chloride, and the water remains clear, then wash the print with one more change of clean water. The print is now ready for toning (optional) and fixing.

6. TONING THE PRINT (OPTIONAL)

To Tone or Not to Tone

The print must be fixed to remove the unexposed silver chloride. Failure to thoroughly fix and wash the print will cause it to fade in time. Toning is done in order to apply gold to the silver image. In theory, this helps to preserve the print, though if the print is not fixed or washed well, no amount of gold will help; it will fade to a greenish yellow color. For the most part, toning is really done for aesthetic reasons; to modify the final image color. The more you tone a salt print with gold, the cooler the final image color. If you like warm or cool brown hues, pass over the following toning section and go right to the fixing instructions. If you wish to tone the print keep reading the next paragraphs on gold toning.

Gold Toning

Gold toning is usually done before fixing. There are many different chemicals that can be added to change the pH of the gold solution. The following formula works well to produce purple brown tones and can be used immediately after mixing. More gold can be added during the printing session if it seems to slow down, but the working solution should be discarded at the end of the day.

Gold Chloride (Stock Solution)

Gold chloride is always sold in small glass ampules containing 1 gram. Remove the top (or break the sealed ampule) and place the entire container into a 200 ml brown (6.7 oz.) glass bottle containing 154 ml (5.2 oz.) distilled water. Because 1 gram is equal to 15.4 grains, every time you need a single grain of gold for a toning formula measure 10 ml (.33 oz.) of this stock solution.

Basic Bicarbonate Gold Toner (Working Solution)

Measure out 1 ml (.03 oz.) stock gold solution and add this to 700 ml (23.6 oz.) distilled water. Add a half teaspoon of sodium bicarbonate and stir the solution. Check the pH with test strips. Add more bicarb as needed until the pH is 8.0. Pour into a clean glass tray.

Place the washed print into the gold toning solution and rock the tray gently. Observe the tonal change. If the print tones very quickly, add more distilled water to the solution. It should take at least two minutes to change the print color from a red hue towards a purple brown. When you like the color, place the print into the fixing solution.

7. FIXING THE PRINT

Fixing will always lighten the hue and reduce the density of a print. If a toned print is placed into the fixer and you observe a considerable loss, it means that the print was not toned enough. Deep toning can only be done to deeply printed prints, and deeply printed prints can only be made with strong negatives.

After the first "precipitation" wash, the print is placed in toner. If not toning, the print is placed directly into the fixer (formula above) for at least five minutes with agitation. The tray should be agitated continuously. During this fixing stage the tones of the print will shift from purple brown to a warmer milk chocolate or even yellow depending on the sizing of the paper, the amount of gelatin or starch mixed with the chloride, and how deeply the image was printed.

8. CLEARING THE PRINT

Using a hypo clearing agent, such as sodium sulfite, allows washing the fixer to be more

effective. This means that the washing time can be reduced. You do not need to use a clearing bath, but it's handy when you're short on time or just want to do the best possible processing: Add 30 grams (1.05 oz.) sodium sulfite to 3000 ml (3.17 qt.) water and mix until dissolved. The print is placed into a bath of sodium sulfite for three minutes, agitating continuously. Sodium sulfite acts as a hypo clearing agent to aid in removing excess hypo and make the final water wash more effective.

9. FINAL WASHING AND DRYING

The final wash for prints not cleared in sodium sulfite should be at least 30 minutes in running water, or wash the prints in a tray of water with constant agitation. Change the water at least four times over a 30-minute period. If the print was cleared in sodium sulfite, wash for 15–20 minutes in running water, or wash the prints in a tray of water with constant agitation, and change the water at least four times over a 20 minute period.

The washed print can then be removed from the water, placed on a blotter and covered with a second blotter. Apply gentle pressure to the top blotter to absorb water from the print. Then place the print on a clean blotter and allow to dry, or dry with a blow dryer.

10. PROTECTIVE COATINGS (OPTIONAL)

The metallic silver in printed out images is very fine and as such, susceptible to atmospheric conditions. Such prints are especially vulnerable to sulfides in the air which may cause deterioration, loss of density, and migration of silver particles. In the nineteenth century coatings were applied to salted paper prints to protect them from the sulfurous atmosphere. These coatings included albumen, varnishes, gelatin, and various starches.

The most effective way to protect a salt print is to coat the surface with wax, thereby protecting the silver from harmful atmospheric effects. Waxing adds also depth to the tonality of the print and imparts a beautiful satin finish.

Waxing

Beeswax is usually sold in the form of candles or cast shapes for craft purposes. To use this wax for coating prints you must first change it to a usable form. Place some beeswax in small saucepan and melt under medium high heat. Be careful, wax is very flammable! Spread a large sheet of tinfoil onto a counter top and bend the edges up to form a tray. When the wax is completely melted, pour the hot wax out onto a sheet of aluminum foil. When cool, the foil can be flexed to release the wax in thin chips. If it sticks to the foil, place the wax-covered foil in the freezer for a few minutes and try again. Put the chips in a zip lock plastic bag for storage.

Put a few wax chips in a shallow glass bowl and place this in a microwave or on a hot plate on high heat until the wax melts. Carefully remove from heat and allow the wax to cool and solidify completely. Make a rubbing tool by placing a 2½ in. ball of cotton wadding in the middle of a piece of 7 × 7 in. cotton flannel. Draw up the edges and form a door knob-shaped rubbing pad. This will be used to apply the wax to your print.

Tape the entire perimeter of the print onto a smooth counter top or piece of glass taped to a table top. Make it as flat as possible. Add about 15 drops lavender oil on the wax and use the rubber pad to work it into the wax. It will take some time with a new rubber. You are looking for a very even consistency of wax on the bottom of the rubber that is about the viscosity of thin lip balm. Continue to add lavender oil to maintain the viscosity of a thin paste.

Apply the wax to the surface of the print by rubbing in only one direction. Do not go back and forth! This could cause the rubber to grab the print and tear it in half. The wax should go on smoothly with little effort. If the wax seems stiff, add more lavender oil to soften it so that the wax goes on evenly. Remember that you want to wax the print, not oil the print. Be sure the oil is well mixed with the wax.

Once you have covered the entire print, wax from one of the sides to be sure the wax is embedded in the fibers of the print. After waxing from one side, use your fingertips to continue to work the wax deeply into the paper.

Allow the wax to rest on the print for a few minutes and then remove excess by gently rubbing with a clean piece of flannel cloth. Once the excess is removed, you may now lightly buff the finish with a clean piece of flannel to a satin sheen. Tape should be removed slowly. To avoid tearing, slowly and carefully pull tape away at a 90 degree angle while holding down the edge of print with clean fingertips.

9.5 Printing in Direct or Filtered Sunlight

CONTRAST AND NEGATIVE MANIPULATION (AS NEEDED)

The salt and silver ratio in this manual is formulated for the typical calotype or collodion negative of the nineteenth century. Salt printing was not generally done with gelatin dry plates or flexible films. If you try to use a film negative that works well for modern developing out papers, it will not have the potential to make a good print using the salt printing technique. Digital negatives can be tweaked to print as a warmer image color, producing "spectral density." This additional spectral density can be made to print excellent salt prints.

You can manipulate the contrast of a salt print by controlling how fast the light converts silver chloride to metallic silver. This can be done by either printing with a weaker light (e.g., on a cloudy day) or the use of tissue overlays.

Tissue Overlays

The most important factor in the quality of the final print is the character of the negative. It is very difficult to make a great print from a weak or thin negative. Slowing down the printing process, however, will increase the contrast. The easiest way to do this is to tape one to three layers of tracing paper over the top window of the printing frame. Frosted white or ground glass can also be used. An alternative is to print on a cloudy bright day or in diffused light. See Figure 9.5, Printing in Direct or Filtered Sunlight.

Fuming

Raising the pH of sensitized paper with ammonia is an effective means to make the paper more sensitive and increase contrast. This is done by taping the corners of the paper, emulsion side out, on the underside of a lid from a large plastic storage box. Place a layer of cotton wadding in the bottom of the box and drizzle an ounce or two of household ammonia upon the cotton. Secure the lid and fume the paper from 1–4 minutes as a test. Remove the paper and allow it to out-gas for a minute before placing it in the printing frame. Fuming should not be done in the same room you are processing the prints.

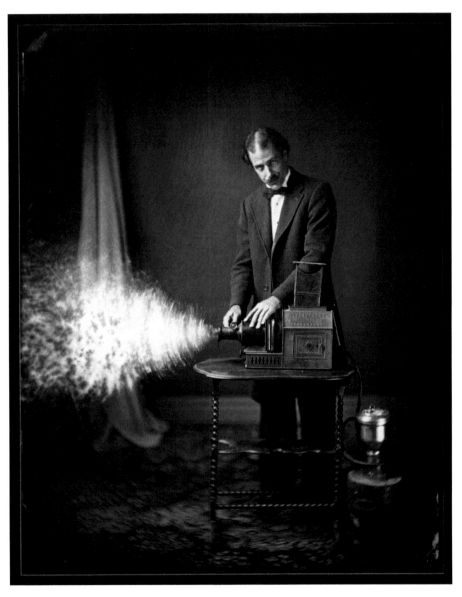

9.6 Mark Osterman, *The Rhoads Incident*, from *the Amnesia Curiosa series*, gold-toned salt print on Arches Platine paper, from an 8 × 10 in. (20.32 × 25.4 cm) collodion glass negative, 2006. ©Mark Osterman.

Based on a tragic fire in the Rhoads Opera House (1908, Boyertown, Pennsylvania) that was started by the magic lantern projectionist.

10.1 Starting on upper left:

Edward Steichen, *J. Pierpont Morgan, Esq.*, 51.6 × 41.1 cm (20 5/16 × 16 3/16 in.), Gum bichromate over platinum print, 1903, printed 1909–10 (1903 version was carbon print), Alfred Stieglitz Collection, 1949, 49.55.167, © 2016 Artists Rights Society (ARS), New York; *Untitled* (Experiment in Multiple Gum), 47.8 × 38.4 cm (18 13/16 × 15 1/8 in.), Gum bichromate print, 1904. Alfred Stieglitz Collection, 1933, 33.43.39, © 2016 Artists Rights Society (ARS), New York; Balzac, *the Silhouette—4 A.M.*, 37.9 × 46 cm (14 15/16 × 18 1/8 in.), Gum bichromate print, 1908, Alfred Steiglitz Collection, 1933, 33.43.36 ©Artists Rights Society (ARS), New York; *Rodin—The Thinker*, 39.6 × 48.3 cm (15 9/16 × 19 in.) Frame: 79.4 × 87.6 cm (31 1/4 × 34 1/2 in.), Gum bichromate print, 1902. Gilman Collection, Purchase, Harriette and Noel Levine Gift, 2005, 2005.100.289, © Permission of Joanna T. Steichen. All images courtesy of The Metropolitan Museum of Art.

Steichen is one of my favorite gum printers because his pictures are not sentimental but offer a psychological encounter with the viewer. His background as a lithographer's apprentice at 15 years of age, training as a painter at the Milwaukee Art Students League, and time living in Europe must have opened him to new ideas, because he introduced Alfred Steiglitz in New York to the then avant-garde work of Picasso, Matisse, and Cezanne. His gum prints of Rodin contemplating his own sculpture, "The Thinker," shows an old man stooped over in meditation. Steichen returned to the United States and, after a successful career as a "straight" commercial photographer (his portrait of Greta Garbo is well-known), eventually became the first director of a museum photography department, at the Museum of Modern Art in New York, where he curated the influential and controversial *Family of Man* exhibit and was the first photographer to be awarded the U.S. Presidential Medal of Freedom by John F. Kennedy.

10

Gum Bichromate Prints

Gum printing makes water-soluble pigments, such as gouache and watercolors, photographic, producing prints of subtle and wide-ranging colors on paper, ceramics, or fabric. Mixing gum arabic, paint, and a solution of ammonium or potassium bichromate as the light sensitizer, you can create a single or multicolored image ranging from continuous-tone to high-contrast. Gum printing also can be combined with traditional printmaking processes such as etching and drypoint, or with other photo-printmaking techniques from this book. Unlike Van Dyke, cyanotype, and palladium, gum printing creates an actual physical buildup on top of, rather than an absorption into, the substrate. Because the emulsion is delicate, your patience and a willingness to experiment are essential.

One of the earliest photographic processes to be used as a personally expressive medium, *gum bichromate*—also known as *dichromate*—printing is usually credited to a Frenchman, Alphonse Louis Poitevin, whose 1855 patent, based on experiments using carbon, were founded on tests with the light sensitivity of dichromates by earlier inventors. The English photographer John Pouncy temporarily patented the technique in 1858, for a gum-pigment-dichromate sensitizer, which, when coated on paper and exposed to ultraviolet light under a negative, selectively hardened in relationship to the amount of light allowed through the different density areas of a single negative. The other parts of the sensitizer were not affected by light due to the impenetrability of the negative in those (highlight) areas, and

they washed off, showing the paper. Some historians say that the process was introduced to the art world by A. Rouille-Ladeveze, who wrote the first book on gum and exhibited "photo-aquatint" prints in Paris and London in 1894. But the method was recognized as a workable artists' medium through the showing of gum prints by Robert Demachy. In 1897, Demachy and Alfred Maskell published *Photo-Aquatint, or the Gum Bichromate Process*, a book that helped spread its popularity and was founder of the influential Paris Photo Club. Simultaneously the European-born American photographer, Edward Steichen, made multi-color gum prints that he often combined with other photo-printmaking techniques (see illustration at the beginning of this chapter). Two groups devoted to admitting photography into the fine-art world, the Linked Ring in London and Photo Secessionists in New York, exhibited in a few galleries and camera clubs. Demachy, Steichen, Alfred Steiglitz, Clarence White, Heinrich Kuehn, and Gertrude Kasebïer also published photogravure reproductions of gum prints in Steiglitz's *Camera Work*. These photographers preferred gum printing because it resembled a painting with its thick, malleable coating, rather than the thin, hard, smooth emulsion of the standard photographic papers, and they turned to the current vogue in painting as their inspiration. Clarence White, for instance, was known to purposely remove gum print details that might detract from a picture in the style of Japanese-influenced images made popular by painters, especially Whistler, and also Corot and the French Barbizon School.[1] The process lost its popularity after the First World War, usurped by speedier methods and abandoned by Demachy, but many artists still find it a pliable and rewarding process.

SAFETY

Bichromates (aka dichromates) can cause skin inflammation, similar to an allergic reaction,

upon repeated exposure. Wear protective gloves and goggles at all times when mixing and coating bichromate as well as when washing a bichromate-sensitized print. Wear a respirator with a toxic dust filter when handling bichromate crystals.

In the European Union, the dichromates (sodium and potassium) are classified as SVHC (substance of very high concern), and the use of it will be forbidden or strongly regulated and only approved after authorization from ECHA (European Chemicals Agency) after September 21, 2017. After this date "the placing on the market and the use of the substance shall be prohibited unless an authorisation is granted."

Store ammonium dichromate away from heat and combustible materials. Bichromates are not combustible but can add to the intensity of a fire. Do not smoke in your work space.

Bichromates can be poisonous when ingested, even in small quantities. Keep chemicals and chemically contaminated materials away from your mouth and out of the reach of children and pets. They are suspected carcinogens.

Dispose of excess solution or chemical by flushing it down the drain with a large volume of water, not in a wastepaper basket. Better yet, evaporate the excess, then take this much smaller quantity to a hazardous waste center. Here is what Bostick & Sullivan (see Supply Sources) recommend:

- Collecting the Nasty Stuff. This step is particularly important if you are on a well and a septic system! That is not to say you should be dumping it into your municipal system, however. The first step is to collect your gum-developing run off. You may wish to collect this in a large tank or plastic garbage can.
- Converting to Trivalent. Add sodium bisulfite, sodium sulfite, plain old spent fix, or sodium thiosulfate to the solution. The solution will turn from orange to green. Keep adding until there is no more green color and add a bunch more to ensure all is converted. It is now a much safer trivalent chromium compound.

- Making a Precipitate of the Chromium. You want to go a step further. Now add an alkali to the solution in the tank or garbage can. You can use sodium hydroxide (plain old Draino works fine) or sodium carbonate or potassium carbonate. After the alkali is added the chromium now is converted to chromium hydroxide which can be filtered out.
- Building the Filter Thingy. I have not attempted the filtering step on a large scale as I have not gum printed in several decades. I have however filtered tanks of solution many times before with this system. Here's how I would approach the problem: I'd start with a small pond pump. Not a real tiny one but one that costs about $50 would be large enough to handle a 50-gallon plastic garbage can.

Now buy a house size water filter. They are available in any hardware store and are usually blue plastic and are about the size of a 1 liter Pepsi Bottle and cost about $15. Next buy the fittings necessary to attach the blue plastic house water line filter to the outlet of the pond pump directly. Install a cheap paper filter into the housing ($3–$5). Do not use the expensive charcoal filter cartridges, as they are a waste of money in this case.

- Filtering the Tank. Dunk the pond pump with the filter directly attached into the tank. Plug it in and let it run overnight. It will intake and discharge into the tank. This is less efficient than filtering from one tank to the next, but the plumbing is far simpler. I've used this system to filter stuff in tanks in the past. You may have to change the filter two or three times depending on the amount to filter out.
- Disposing of the Wet Nasties. When finished, put the filters in a 1 gallon Ziploc bag and label the bag "Chromium Oxide Waste." Take the bag to your hazardous waste disposal center.

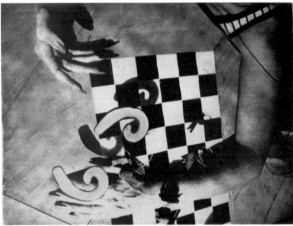

10.2a and 10.2b Left (A): Todd Walker, *Untitled*, approximately 5 × 8 in. (12.7 × 20.32 cm), gum print on paper, circa 1987. Courtesy of the Walker Image Trust.

Right (B): Melanie Walker, *Cucumber*, 16 × 20 in. (40.64 × 50.8 cm), gum print on Somerset Satin using traditional size with formaldehyde, 1985. Courtesy of the artist.

Todd Walker and Melanie Walker are father and daughter. Although both artists may share some similar visual issues, such as photographically manipulated space, each responds in a manner that reflects his or her concerns. Todd Walker was an important teacher and artist in the resurgence of non-traditional photographic methods. For the illustration in Figure 10.2, he took photos of a person inside a fabric tube and used a positive transparency, sensitizing the paper repeatedly to build up a rich black. He then used pigments with white and, at times, mica mixed into them. Todd died in 1988.

Born with a visual impairment that left her with constant double vision, much of Melanie Walker's work addresses living with a double reality that is in a constant state of being negotiated. With this particular work, layers of glass were incorporated into the making of the image so that some of the objects seem to float on a different plane. The initial picture was from a black and white negative and additive, selective color was incorporated through the gum printing process, as described in the instructions below.

Inhalation of gum arabic solution or powder can cause asthma, so if you spray rather than brush on gum bichromate emulsion, use a respirator over your nose and mouth.

Certain paint pigments, such as emerald green, cobalt violet, true Naples yellow, all cadmium pigments, flake white, chrome yellow, manganese blue and violet, Verona brown or burnt umber, raw umber, Mars brown, lamp or carbon black, and vermillion/sindoor, can lead to poisoning and other complications if they are ingested or inhaled frequently. Wearing a respirator, working in a ventilated area, and carefully washing your hands and cleaning your fingernails after using these pigments can prevent accidentally carrying them to the mouth and ingesting them.

METHOD OVERVIEW

1. Paper or fabric is heavily sized and dried.
2. Under subdued light, the substructure is sensitized with the gum bichromate mixture containing gum arabic as a colloidal binder, light-sensitive dichromate and water, and any color pigment, and then dried.
3. The coated and dried surface is immediately placed in contact with an object or negative, and ultraviolet light is shone through the negative. The emulsion hardens and becomes an insoluble colloid in correspondence to the time between coating and using the emulsion and in proportion to the "positive" areas where light reaches it.
4. The negative is removed. The paper or fabric is developed in water, where unexposed and, therefore, soluble, areas of color are dissolved and wash off, leaving a reversed image to dry and further harden. The image can be manipulated, removing select areas of colored gum-pigment, while wet.
5. One coating must dry before a new layer of the same (for deeper color) or different (to alter the color) gum arabic-bichromate-pigment blend may be applied to the whole or part of the image, exposed under the same or new negative, and processed.

MATERIALS

More detailed descriptions of materials are given in Chapter 4, Creating the Photo-Printmaking Studio.

1. Applicators. You will need two brushes: one to coat the paper and one to blend the layer. In my studio I have at least one labeled hake brush for each technique I pursue, but I especially like the hake brush for chromated solutions because the bristles are stitched and not connected to the flat wooden handle by any metal that could corrode. Even though a few hairs might shed when you first break in a hake brush, they are easy to pick off after you dry and before you expose the emulsion. Other choices include watercolor brushes, fine flat bristle brushes, and nylon paint brushes. I keep an array of widths, from 1 in. (2.5 cm) for an 8 × 10 in. (20 × 25 cm) image to wider brushes for larger prints. A foam paint roller from the hardware store is a good alternative; you need to get used to it by rolling back and forth and in cross directions to get rid of roller marks until the coating is as smooth as you want. If you use an atomizer or airbrush to apply the emulsion, be sure to wear a respirator and work in a well-ventilated area. A dry Blanchard brush (see page 91), a soft but relatively expensive badger paint brush, or a clean foam paintbrush helps blend in and buff the strokes made by the coating brush. The area you want to coat will determine the width of the brush. A small, soft, round traditional watercolor brush comes in handy for coaxing the development of the print in water. Keep the metal part of the brushes away from the bichromate, or coat the ferrule with clear nail polish.
2. Brown bottle, opaque 35mm film canister if you still use film, or pill containers. A clean, recycled fruit juice jar or dense plastic jar is optional, in case the recipe is doubled or tripled. Are you glad to finally find a use for those empty pill containers? They are perfect for storing the mixed gum bichromate solution because they are light tight and spill-proof.
3. Chemicals and funnel. You will need premixed gum arabic 14° Baume ("baume" refers to the density

of the liquid), available usually in one-gallon (3.8 L) jugs from offset lithography/commercial printing suppliers. In addition, smaller quantities—enough to last for quite a few print sessions—are sold in art stores under the names Winsor & Newton or Grumbacher gum arabic for oil painting and from Photographers' Formulary. These commercial brands last a long time, although I have found that if the gum ages to a very dark brown, it greatly lengthens the exposure time. Even if pure gum arabic is available and less expensive as a powder, it is time-consuming to mix and strain at the proportions of 1 oz. (30 g) to 3 oz. (90 ml) distilled water plus a preservative. Do not heat gum arabic solution, so use it and store it away from heat and strong light. You can also use plain gum arabic around the borders before you start printing, and it will act as a mask to keep pigments and dichromate from staining that area.

I have read of a 20 percent solution of 88 percent hydrolized PVA (polyvinyl alcohol without vinyl acetate) and water being used instead of gum arabic. After letting the mixture stand for 20 minutes, it is heated to no higher than 122°F (50°C) with continuous stirring, at which point the PVA should appear clear. Any undissolved grains can be strained through a double layer of cheesecloth in a funnel. Incidentally, a form of this PVA method with ammonium dichromate is used as a photo ceramic technique on bisque ware and as an emulsion for photo silkscreen. Any user of these components should check the health hazards associated with them, and the Annotated Bibliography of this book lists appropriate organizations and books.

You will also need either potassium or ammonium bichromate, which can be purchased as a dry crystal in 1-pound (0.5 kg) or smaller bottles from suppliers listed in Supply Sources. I prefer ammonium bichromate for its greater sensitivity to ultraviolet light—it is nearly twice as fast as potassium bichromate—but using it means you have to be more careful about fogging the emulsion through accidental light exposure or letting the sensitized layer sit too long or become too hot (gum prints grow to be more sensitive the minute the coating is dried or heated).

Proper mixture, exposure, and development should avoid staining problems in the finished print, but a bath of 5 percent potassium alum and distilled water may help clear it. This bath also hardens the gum emulsion, a result especially useful with multiple coatings. Some gum printers use a 10 percent solution of potassium metabisulphite or sodium bisulfite for five minutes to clear the prints individually, as the emulsion is quite delicate and you will want to watch the action on each one and prevent one print from damaging another.

4. Contact printing frame. On top, use plate glass that does not block ultraviolet light with Masonite underneath, another piece of glass as a backing, or follow the instructions on pages 80 for building a frame; one with a hinged back is not needed because during exposure you cannot really see when the exposure is right. However, if you are going to continue with other processes or if you are going to combine gum over other emulsions, I think you will find that investing in a good print frame will be worth it. You can find, in the Supply Sources, companies that sell them. I no longer trust pine board, foam, or foam core because they change shape after a little use.

5. Distilled water. Sometimes tap water is fine for making the bichromate solution, but distilled water eliminates the frustration of possibly mixing bad solution. A tub filled with hot tap water can be used for warming the distilled water.

6. Hair dryer with warm and cool settings.

7. Household bleach (optional). Severe overexposure causes pigment stains that can be removed by adding a few drops of laundry bleach to the first water bath. You can also use this bleach and water mixture with Webril Wipes (see Philben, a lithography merchant, in Supply Sources) or cotton swabs to gently clean up borders after you finish printing. Selective areas can be lightened with a sharp typewriter eraser applied gently on a dry print. With both methods, you have to be careful not to abrade the paper.

8. Image. Low-density (no heavy black) and low-contrast negatives the size of your intended print offer the possibility of as full a tonal range as possible (about 4–6 tones) in a single color after one exposure to gum bichromate emulsion. More often, though, the density of the negative exceeds the range of the emulsion, thus requiring multiple exposures to build up highlights, middle tones, and shadows. Posterized and color separation negatives, explained in both the Making Negatives: Digital Method, Chapter 6, and in Phil Zimmerman's *Options for Color Separations* listed in the Bibliography, offer versatility, because you can create a multiplicity of colors from only three pigments. In addition, high-contrast negatives work quite well. I tried printing a low-contrast negative in alizarin crimson over a print in a dark green from a high-contrast negative of the same image. The results yielded a range of colors from deep brown to pink after just two exposures. The most trustworthy and fastest way to make a set of negatives is digitally (see pages 120–149). Remember: you have to keep inkjet negatives absolutely dry, or the negative's image washes off. You can make color separations with a large-format camera negatives or with a pinhole camera (page 110), either with the proper filters and black-and-white sheet film or by scanning a color negative and separating it into its component colors (see Making Color Separations in Chapter 6, page 121). Even with color separations, you will find that compressing the scale (not 0 to 255, but perhaps 25 to 225 steps in the Curves Layer of Photoshop®) is about all the gum process can render. The end of this chapter shows step-by-step photos for making a full color gum print.

In addition, try stencils, found objects, torn paper, lace, and drawings on acetate. To get more than one layer of color, register negatives as described later in this chapter or in Chapter 4. Negatives made on the proper acetate (the manufacturer usually specifies what materials to use) put through a photocopy machine and photogram objects will work, too. Please look at Christian Marclay's work on page 98 for an unusual cyanotype photogram,

a method that could be used with any of the hand-coated processes.

9. Measuring cup (4 oz. or 114 cc) and measuring spoons, clear plastic cups with white paper placed under them or shallow glass bowl or saucer, stirring rod. The small, clear-plastic 1 oz. (30 ml) medicine measuring cups available at a pharmacy are also helpful. A shallow glass bowl, such as a pudding dish found in a grocery store, or a glass saucer from the next-to-new shop, is helpful because you can place it on top of a ruler in order to measure the length of the link of pigment. And, both glass and plastic can be used atop white paper to facilitate seeing the color of the pigment more clearly. White, rather than colored, ceramics also serves the same purpose.

Avoid stirring rods that can break or chip and thoroughly wash and dry all equipment, including brushes, in water after each layer.

10. Newspaper, paper towels, and kneaded eraser. Cover the work area with newspaper. Discard sheets as they become soiled. Blot the coating brush with paper towels. Use a kneaded eraser to pick up debris from the dried and unexposed emulsion layer.

11. Pencil, notebook, and timer, watch, or clock. Keep copious notes with *pencil* on the back and outside the image area of the print. Include information about the density of the negative, type of sizing and paper, pigment color and proportions of sensitizer, and exposure method and time. In addition, I urge you to start a three-ring binder with test prints that contain the necessary data. You can also use a pencil to mark the image area before you coat the paper.

12. Pigments. Please see the end of this chapter for detailed instructions on making a full color gum print. Professional or artist-grade watercolors or gouache in small tubes work best. Be forewarned that different manufacturers may label the same color with different names, so ask at a good art store if you cannot figure out what tube from one company is the equivalent to that color made by another company and which colors are more

permanent. The quality of the pigment, as well as the color, can make a difference if you want to avoid staining on your paper. I advise students what took me some time to learn: art is what you love, so don't scrimp by buying inferior grade supplies. Instead, save money by packing your lunch and eating dinner at home! Watercolors produce more transparent coatings and can create a variety of colors with just a few pigments, whereas gouache renders a more opaque deposit and, therefore, tends to cover the layer underneath, but gouache could be more suitable for the base or for a print that requires solely a single coating. Liquid tempera colors have been used with success, but they tend to separate into fine particles, producing a grainier look to the gum bichromate print. However, Peter Fredrick wrote about his Frederick TemperaPrint Process in *Creative Sunprinting*, listed in the Bibliography but difficult to find and, with Alex Chater, created step-by-step instructions on www.AlternativePhotography.com. Frederick used eggs, ammonium dichromate, and acrylic pigments. Pigments tend to be more permanent than dyes, but some colors innately last longer than others, and a good art store employee should be able to inform you about stability. I have experienced problems with Cerulean blue.

For a full-color print, I use cadmium yellow medium, thalo or ultramarine blue, and alizarin crimson or permanent rose. I do not use black but prefer Payne's gray.

13. Plastic clothesline and pins or drying rack that you keep clean.

14. Protective gloves, respirator mask. In the beginning of this book, you will notice that I recommend heavy Neoprene, but Nitrile also will work with most chemicals.

15. Registration pins, light table, masking sheets, masking tape, ½ in. (1¼ cm) heavy black tape, ruler, hole punch, scissors, stencil knife (optional). Gum bichromate printing yields subtle colors, and usually one coating with one exposure is not enough. Remember: you will probably use the negative emulsion side down so that it looks correct on top of the paper. If you are using more than one negative with multiple coatings and exposures, see Chapter 4, Creating the Photo-Printmaking Studio, which describes a tried and true registration system (see page 85) using two registration pins and a hole punch of the same diameter, whether you are using different negatives or the same one more than once. Another option that ensures image alignment when using one negative with multiple coatings and exposures requires cutting four strips of heavy black tape 1 in. (2.5 cm) long. Affix a tape strip to the center of each of the four edges of the same negative, beyond the image area. Trim the excess so that the tape is flush with the film, and with a sharp hole punch make a half-circle notch in each of the taped edges. If you coat the paper with gum bichromate emulsion beyond the image area, the hole punch method will provide a dark half-circle on every side of the print after exposure. You can line up the notches in your negative with these half-circles for subsequent exposures. In addition, at the end of this chapter, you will find directions for using push pins and cardboard for registration. A light table helps you align many negatives before you punch and arrange them.

A method that Richard Sullivan, of Bostick & Sullivan (see Supply Sources), recommends requires cutting a piece of Formica several inches larger than the paper, obtaining registration pins, Berkeley or other company registration tabs (self-sticking 1 in. square Mylar with hole punched in one end), and double-backed carpet tape. He suggests taking your paper and dry mounting it to the center of the Formica or heat-resistant plastic. Degrease one edge of the board next to the paper with isopropyl alcohol. Cut a piece of carpet tape a little larger than the registration pin and first stick it to the pin then stick the unit onto the degreased Formica next to the paper. Repeat this process with the other pin and stick it a few inches from the first pin on the degreased margin of the board. Next take each of the tabs and put them onto the registration pins with the sticky side up. Carefully attach the negative, emulsion side up, to the sticky part of the tabs. Coat the paper with the

gum bichromate solution, Sullivan advises, light on pigment and underexpose it beneath the negative, which has been inserted onto the pins. Remove the negative. Process the paper still attached to the Formica, and build up layers, sizing and drying in between. When you are finished, stick the board and print in a hot dry-mount press, quickly peel up one corner of the paper, and strip it off the Formica. You can reuse the board and pins.

Tips for Making Gum Prints, below, has more detailed instructions and step-by-step illustrations.

16. Receiver and sizing. Finished prints should be rendered on rag paper with a slightly toothy texture for the mixture to cling to, medium absorbency, and resiliency in repeated water baths, such as Fabriano Artistico Extra White Hot Press, Strathmore Artists Print paper, Arches and Lana Aquarelle 300 grams—not pounds—per square meter (gsm) watercolor block, or Lana or Cotman Watercolor pads. I am such a fan of Platine that I even use the back of it (a slightly rougher surface) because Platine is the brightest white you can find without optical brighteners, and it is both internally and externally sized the way I like. Other printers swear by Bergger Cotton 320. The backs of more textured papers (even the backs of reject prints) can be used for higher contrast work. Practice prints can be made on less expensive paper. Yupo works well with multiple coatings because it is a plastic sheet and dimensionally stable, although I am not fond of its texture.

Other surfaces that work are those with a tooth, such as the dull side of aluminum lithography plates (I "recycle" them from the printmaking department at the Museum School, where I teach), the matte side of frosted acetate, sand-blasted glass and plastic, and roughed up metals. Tyvek™, which is spun plastic that looks like rice paper, works well. It is sold at home-improvement stores as an insulating barrier against water or you can take apart a waterproof Tyvek™ envelope purchased from a stationer.

Some gum printers use white or other pigments lightened with white on dark paper. Arches Cover, Rising Stonehenge, and Rives BFK, which comes in black and dark brown, is particularly suited to this dramatic approach. Or you can brush cyanotype, palladium, or brown print solution on paper, expose it to ultraviolet light without a negative, process the paper, and get a sheet of solid deep blue or brown paper with a long exposure and a sheet of pale colored paper with a short exposure.

Sizing fills the pores of the paper so that the color stays on top, rather than sinks in, but sizing can also affect the color of the finished gum print. Unless you use the diluted acrylic polymer size by itself, all paper should be sized (see page 89) with a method that uses hot water because you will also be preshrinking the paper, an important preparation for more than one gum print coating. Otherwise, you need to preshrink paper by floating it for 20 minutes in 104°F (40°C) water, then hanging it without weighting it to dry, or drying it flat on clean screens. In an article entitled "The Gum Print," in *Darkroom Photography* (Oct. 1986), James Collins suggests the following method, which I have successfully used: size the paper, then air dry it. Apply the gum bichromate emulsion to an area about 1 in. (2.5 cm) larger on all sides than the image, and hang the paper in front of a cold-air fan to dry. When the emulsion is just barely tacky to the touch, put two pencil dots 12 in. (30.5 cm) apart and about $1/8$ in. (5 mm) inside the emulsion edge. Hold a hair dryer about a foot (30½ cm) from the paper (I hold it closer), and evenly blow warm air (I use hot air) over the paper until it has shrunk the paper by $1/8$ in. (5 mm) and the pencil dots measure $11^7/8$ in. (30.25 cm) apart. Make the exposure, develop the image, and repeat this coating and preshrinking procedure with each application of emulsion.

My personal routine is always to use a sheet larger than the image so I can take notes and register negatives outside the picture. First I use the alum and spray starch method described on page 90, then I use one layer of acrylic matte medium diluted with six parts water between each color to prevent light areas from staining. You can even tint the first layer of this diluted sizing with

acrylic paint if you want a pale color to work on. You can finish a print with gloss medium over the last color to make an even more lustrous appearance than the gum arabic in the formula already provides. When I use the back of Platine, I need only use spray starch by itself; I spray and then lightly sponge brush two coats in opposite directions, letting each coat dry before I apply the next. I employ this simple procedure before each layer of color, measuring for shrinkage as described in the previous paragraph.

The other sizing methods (see pages 90) work for numerous coatings, but be aware that the highlights become tinted with pigment. With the acrylic polymer matte medium method (page 91) by mixing 1 part polymer medium with 8 parts water, you can build up more layers and keep the highlight areas bright, but the paper eventually becomes stiff. Therefore, rather than use sizing, try using white gouache, which is more opaque than watercolors, for the first coating, exposing, and processing it without a transparency. Then proceed with normal gum printing. The traditional sizing, from a time before there were plastics as found in polymer medium, is the gelatin method described on page 90.

Because sizing paper and fabric is necessary, messy, and time-consuming, you will find it more practical to size several pieces of paper or fabric at once. Keep all implements and surfaces clean and size the substrate's side to which you will apply the emulsion. If the surface you size on is either a tray or a table, make sure it is horizontal. Using a puddle pusher, available at Photographers' Formulary, helps ensure a flat, smooth coating.

I find that, no matter what paper or type of gum print technique I try, there is a limit to the number (for me, it is 5–6 layers) of gum-pigment-bichromate coatings that will sit on the surface. I recommend that you look at Marco Breuer's work reproduced on page 109 of Generating Imagery: Analogue Methods for a more robust attitude about layering color.

Natural fabrics, such as cotton, canvas, and linen preshrunk (in hot water, which will also remove the manufacturer's sizing and is counterproductive for our purposes) and surface sized, as described in Chapter 4, can be used with gum bichromate printing. I have used gessoed painters' canvas, which eliminates the need to surface size. Practice first on paper, since imaging on cloth is a technically challenging way to work.

17. Trays or tubs. You will need two glass, plastic, or porcelain trays larger than the print and without ridges that could damage the delicate wet gum print when you develop the image and fix it. You may also want a third tray for a stain-remover bath and a fourth tub from a grocery store for hot water to keep the bichromate solution warm so that the chemicals do not precipitate out. If you do not use protective gloves, you will need non-metallic tongs to pick up the print, and I use the wishbone-shaped plastic ones with rubber tips because they stay in one piece and last longer.

18. Ultraviolet light and studio light. You cannot see a great color change after exposure and before development, unlike with cyanotype or Van Dyke brown printing. Artificial light such as sunlamps, photofloods, or fluorescent ultraviolet tubes (how to build an exposure unit is detailed in Chapter 4) allows the exposure to be exactly timed and is not affected by the weather, the time of year, or the time of day. A typical exposure in my studio is six minutes. However, indirect sunlight can be used; avoid direct sunlight, where bright radiant heat output can cause the emulsion to fog with exposures over five minutes.

I illuminate my studio with a 60-watt tungsten bulb 4 ft. (1.22 m) away, and I have never noticed a problem. However, in 2007 the United States Congress passed a regulation requiring new energy-efficient standards for basic light bulbs so that standard incandescent bulbs are being phased out and will no longer be produced, although standard bulbs will still be available to purchase while supplies last. A number of specialty incandescent bulbs, such as chandelier, and

65 watt incandescent flood light and ceiling fan bulbs, will remain available, and I would suggest them because some models can be screwed into a regular socket. You should run a test to make sure your paper does not fog with your studio lights on: coat and dry a sheet of paper with the emulsion, let it sit on your work table for at least 15 minutes, then develop it to see if the emulsion has been exposed or hardened. Another bulb that works is a bug light, but the problem with this light source and a traditional red darkroom safe light is that seeing the coating is more difficult. Do not be tempted to use Compact Fluorescent (CFL) or other fluorescent sources, which give off ultraviolet. In the United States, some manufacturers are already phasing CFL bulbs out and are only going to produce Light Emitting Diode (LEDs), which also emit ultraviolet. But the easiest solution of all is to do the mixing and coating—not air drying—in a room where you can cover the windows or pull the shades.

MAKING THE BICHROMATE SOLUTION

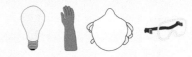

EQUIPMENT YOU WILL NEED

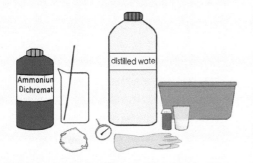

10.3 Equipment You Will Need

Ammonium bichromate crystals
Measuring cup
Stirring rod
Distilled water
Plastic film container or pill container
Plastic cup or saucer
Thermometer
Tub of hot water
Neoprene gloves
Respirator mask with toxic dust filter

PROCEDURE

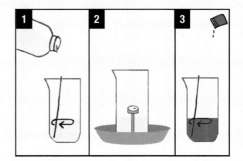

10.4 Procedure

1. Pour ¾ fl. oz. (20 ml) water into measuring cup.
2. Adjust water temperature to 90°F (32°C).
3. Measure, then pour ⅙ fl. oz. (5 ml) ammonium bichromate crystals into the measuring cup, stirring constantly.
4. Pour the bichromate solution into a pill bottle. Allow it to cool to room temperature.

TIPS FOR MAKING THE BICHROMATE SOLUTION

You can double or triple the following recipe if you plan on doing a lot of printing, because the bichromate stock solution has an indefinite shelf life when stored in a cool, dark place. Should the crystals separate from the water, they will reblend when warmed to 90°F and stirred.

Please note: Making Negatives: Digital Method, Chapter 6, describes a method for finding DMax, or the deepest tone a process will make with solely the imageless film, which does have a light-blocking effect. You may find that different hues require different exposure times for rendering DMax.

MAKING A GUM PRINT

1. Preshrink and size the paper

For all gum printing, whether a single color or multi-coated, apply one of the sizing methods described above in the materials list: Receiver and Sizing, or in Chapter 4, Preparation of Light-Sensitive Methods, to make the surface of your paper ready to accept the emulsion.

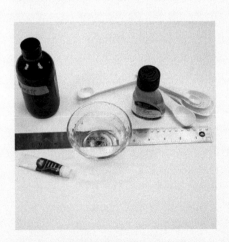

10.5 Mix the Emulsion

2. Mix the emulsion

Squeeze a ½ in. (1.25 cm) link or worm of watercolor pigment, or mix two colors to make a new hue, into a clear cup or bowl big enough to fit your brush. Add ½ tsp. (2.5 ml) of gum arabic, and thoroughly mix the two. Stir in ½ teaspoon of bichromate solution. The color of the mixture will change to a

dreadful yellow, but your pigment color is still there! Dampen the coating brush, then blot it on paper towels until damp but not wet.

10.6 Coat the Paper

3. Coat the paper

Use the emulsion to coat an 8 × 10 in. (20 × 25 cm) piece of paper by pouring it from the cup onto the middle of the sized paper. With a brush, quickly work that emulsion on evenly and lightly in a horizontal direction to an area beyond the image. The emulsion will not look like the watercolor pigment at this point but will have a sort of unpleasant yellow-orange tint to it. Using the same brush and pigment, work the emulsion in vertically. Allow it to air dry for a minute, and when the emulsion

looks tacky, gently smooth the coating with a clean, dry, soft brush. Pick up brush hairs with a kneaded eraser.

Air dry in the dark for approximately 20 minutes or use a hair dryer on the cool setting. Immediately after the emulsion is dry, carefully pick off any more brush hairs and *immediately* make a sandwich with the exposure frame or backing board on the bottom, the paper with the emulsion facing up next, the negative reading correctly on the paper, and clean glass on top.

10.8 Develop the Paper

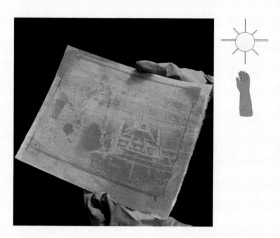

10.7 Expose the Print

4. Expose the print

Place the loaded print frame in the shade for 10–30 minutes, under a sunlamp or photoflood bulb 3 ft. (1 m) away for 3–12 minutes, or under ultraviolet fluorescent bulbs 6 in. (15.25 cm) away for 6–15 minutes. Exposure times vary according to the light source, pigment color, and pigment density. You will have to experiment and keep detailed notes.

When you remove the coated sheet from ultraviolet light, it still will not look like the pigment you used.

5. Develop the paper

Because the reaction that occurred during exposure continues after the emulsion has been removed from light, immediately place the paper face up in a tray of warm—near 90°F (32.2°C)—water that you gently rock. After 30 seconds, turn the paper over so that it is face down and the used chemicals precipitate off, rather then sitting on the image. Development, a delicate process, takes from 10 minutes to overnight and consists of floating the paper in warm water that you change often. While the print is developing, you can lighten areas of it by rubbing very gently with a soft brush or cotton swab, but be careful, because the emulsion is fragile and severe agitation can remove the image altogether. If the water becomes tainted, gently move the print to a tray or 80°F (26.67° C) water.

10.9 Fix the Print

6. Fix the print

When development is complete, the unexposed areas of the emulsion dissolve and float off the paper, leaving the exposed areas the same color as the pigment you used. Transfer the print to a tray of cool water for 15 minutes then air dry flat or use a hair dryer as described above or fan dry. With the polymer medium method, resize the dry print before adding a new coating of emulsion. With the alum/spray starch method alone, resize with a new layer of starch.

TIPS FOR MAKING A GUM PRINT

Before you mix the gum bichromate solution, you can get a sense of how the colors will combine after you print different layers. Take a piece of paper the same color as you will be printing on and a brush, mix a dab of each color with water, and layer the liquid colors in the order you were planning to use them. Be sure to let each color dry before you add the next.

Write down every detail of your printing method so that you can be consistent when you work, because precision is not easy. After all, a 1 in. link from a small tube of watercolors will not be exactly the same as a 1 in. link from a large tube, and the density of the earth colors tends to be thicker than that of other colors, but the recipes still work. In addition, write "top" outside the image area because sometimes, after you coat a dark color, you cannot see the underlying picture.

This following, a slight departure from the method described earlier in Item 16, is a system that I find useful for making sure that after each soaking, when the rag (cloth) paper changes size, I bring the sheet back to its original dimensions so that the negatives can be registered: I make a mark on the front of the paper with a sharp pencil point at 1 in. (2.5 cm) and 8 in. (20 cm). The marks are outside the image area but within the coating area. I always use a hair dryer to dry the paper. First I use heat, and I keep re-measuring with a ruler until the pencil marks are back to their original length. Then, I change the hair dryer setting to cold.

You must thoroughly mix the pigment with the gum arabic and bichromate solution (see Step 2), or the emulsion will be streaked. Improper sizing, such as the gelatin method without a hardener, or too much pigment can cause stains in the developed printing paper. Remember, a dichromated solution will continue to lose sensitivity over time or when stored in heat or humidity, so you must use the mixed and/or coated emulsion as soon as you can.

The recipe described in Step 2 on page 214 works better for one-, two-, or three-coating prints, as it renders relatively strong shadows, good middle tones, and clear highlights (although gum prints are pale after just one exposure). An emulsion of a ½ in. link of pigment and ½ teaspoon gum arabic with 1 teaspoon bichromate solution shortens the exposure time and is better for halftone negatives, more than three coatings, and printing on fabric.

If you are going to use the same negative repeatedly, build up your image by making exposures for highlight, middle tone, and shadow areas. A good working method is to divide your gum-pigment solution into three densities:

Light: 1 in. (25 mm) link pigment to 1 teaspoon gum arabic and ½ oz bichromate solution.

Medium: 2 in. (51 mm) link of pigment to 1 teaspoon gum arabic and ½ oz bichromate solution.

Dark: 4 in. (102 mm) link of pigment to 1 teaspoon gum arabic and ½ oz bichromate solution.

Use the lightest solution for the first and longest exposure—this will give you highlights.

For the middle tones, lessen the exposure by 1–2 minutes and use the medium solution. For the shadows, reduce the exposure again by 1–2 minutes and use the dark solution.

MAKING A FULL-COLOR GUM PRINT

Please note: gum printers can employ different pigments and another order of colors resulting in a different appearance in the finished print. At some point, if you are not trying to emulate a color photograph, these choices become subjective.

A traditional in-camera method, using filters and black and white film, is available through my website, where my contact information is accessible.

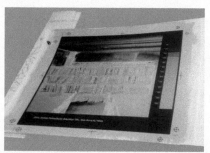

10.10 Size the Paper and Register the Negative

1. Size the paper and register the negative

First, pre-shrink the paper as described above. Then size it. Between each color, I use diluted Acrylic Polymer medium, as described in Item 16. Start with a set of color separations (see Making Negatives: Digital Method, pages 120–149). A less exact, but easier, method for registering negatives is to use pushpins through the four black borders of the negatives after you have aligned them on a light table. First, fasten the one negative to the light tabletop with transparent tape. Then, align and tape the next negative on top. Continue in this way until all the negatives are in position, then

push the pin through all negatives at once. You can use a paper towel behind the negative so that you do not mar the light table's top. As you print, push the pin through the previously made holes in each negative, through the paper, and into a backing board. With this method, you use the same small hole in the paper made by the pushpin and use glass only as large as the edge of the image. In addition, you can line up the negative and the paper with a pushpin, lightly tape the two together beyond the image area, remove the pushpins, and put the unit in a print frame. Notice that when the negative was made, a border was allowed so that information, such as the color to be used with that specific negative, is printed on its edge, outside of the image area.

2. Print a pale first color

Print the first color light for placement. You can begin with the blue-filtered negative to create a pale Payne's gray first coating so that you can see the image before you start registering and exposing negatives and prints on top of each other. Expose, develop, and dry.

10.11 Print a Yellow Layer

3. Print a yellow layer

Again use the blue channel negative on each yellow layer. Since yellow naturally is such a pale color, you may need more than one thin coating and one exposure, and because gum bichromate colors are translucent, better tonal separation and color subtlety can be achieved by multiple printings of the same color. Also, one printing usually produces weak color. Try cadmium yellow light mixed into the gum and dichromate mixture. Either run tests of two minute strips or try an exposure for approximately six minutes under an artificial UV unit where the bulbs are 6 inches (15 ¼ cm) away, develop, dry.

10.12 Print the Magenta Layer

4. Print the magenta layer

In Figure 10.12 on the left, you see the result of one coating with alizarin crimson pigment mixed into the gum-dichromate solution to make a thin layer, which was exposed with the green filtered negative, then developed and dried. On the right, you see two coatings, exposures, and wash-ups of alizarin. Using a soft brush, you may need to coax the red pigment off a bit in the deep shadow areas during development so the print does not end up too magenta.

10.13 Print the Blue Layer

5. Print the blue layer

Last, mix ultramarine or thalo blue into gum-bichromate solution and expose that thin layer with the red-separated negative, develop, dry. During development, you may possibly need to brush off any blue that printed in the highlights. The writing on the right side of the print, outside the image area, is notes on each layer's color and exposure time, whereas the printing on the bottom was done at the time of making the digital negative and contains information about the paper and the digital procedures.

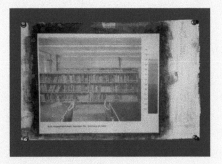

10.14 Print the Last Layer
Image © Young Suk Suh

6. Print the last layer (optional)

Use the negative for the blue layer, and you can add a last layer of gray to deepen the shadows. Many gum printers find that black is too strong and hides the colors underneath.

TIPS

Avoid working in extremely humid conditions, because the bichromate solution soaks up moisture from the air and becomes less sensitive and produces less contrast in the developed coating.

Make sure the polymer medium sizing is not thick or uneven when you apply it, or you can end up with large light spots after development. On the other hand, if you do not apply enough sizing, you might find that the color permanently stains the paper.

If a cap on a tube of paint sticks, you can loosen it by holding a lighted match under or running hot water over the cap for a few seconds. Clean the threads with a tissue, then apply a little petroleum jelly to the ridges to avoid this problem again. If the paint has dried up, just remove a hunk of it by cutting the bottom of the tube, then soak the dried chunks in a little distilled water until it softens. These are old art school tricks that I was reminded of by Judy Seigel.

Mix your own colors rather than depending on the manufacturer's colors straight out of the tube.

The emulsion (see page 211) may be applied to the entire sheet of paper or only to specific areas. To make a smooth and light coating, use a foam brush and apply in quick, even strokes; for texture, use uneven strokes and a bristly brush. A foam roller can give either a pointillist effect or a very smooth surface, depending on how much pressure you exert. You can use quite a bit of "muscle" to make sure that the gum-pigment-dichromate emulsion is applied so evenly that no brush marks or air bubbles remain. However, you must work quickly or the emulsion starts drying, and you cannot move the emulsion much. Do not worry if a few hairs come off as you coat the emulsion; you can pick them off a dry print after each coating, and they will not leave a mark.

Do not apply too thick a layer of emulsion, because a heavy coating obstructs the exposure (meanwhile, a thinner coating gives better detail). A slight tooth to the paper helps prevent the solution from slipping off later, when you develop the paper but are sure you exposed long enough.

Rinse and dry your brush as soon as you finish coating the paper.

When drying the emulsion, remember that too much heat from a hair dryer will cause the bichromate to harden and become insoluble in water.

Be careful measuring the components of the emulsion because too much dichromate or too little pigment can lower the image's contrast.

Because the emulsion becomes more sensitive to both light and heat as it dries, coated papers do not store well, and the emulsion will harden with time. Coat only as many sheets as you plan to use at one printing session. The three-part emulsion will not store well, either; so mix just enough emulsion to use, coat it immediately, and discard the rest.

You can, however, mix and indefinitely store the gum and pigment mixture without the dichromate.

Exposure times for gum printing must be determined by testing, so before you start to work on an actual print, you can reduce future frustration by running the following test: coat with emulsion and dry a sheet of paper. Cut this sheet into 2½ in. (6 cm) strips, marking each strip to indicate the emulsion used. Using a different strip but the same part of the negative, make separate exposures of different lengths of time, being sure to mark the exposure time and light source on the strip. Develop, dry, and evaluate each test for each emulsion used. Keep a notebook with these test strips for future reference, because you will notice that different colors may need

different exposure times. When I use the fluorescent exposure unit described in Chapter 4, I find a 6-minute exposure to be a good starting point with "normal" negatives.

Do not worry if you cannot see a latent image on the coated paper after exposure and before development. Sometimes you can see one, but either case is not a sign of a correct or incorrect exposure.

If the image was overexposed or the light source was too hot, the emulsion will harden and will not wash off. If the image was underexposed, the emulsion will float off. If you used too thick a coating or too much pigment when applying the emulsion, the image will flake off. This problem is exacerbated with multiple coatings.

Make sure the developing tray is full of water—if the gum print scrapes the bottom of the tray, the image will rub off.

You can remove some stains by floating the print in very hot water for 5–10 minutes, but be sure to place the print in cold water immediately afterward for the final rinse. Do not be confused if you are using more than one color per coating: you should wash the yellow dichromate stain after each coating, but the highlights with detail may have yellow pigment in them, if you used that color.

If the shadows are blocked, try gently coaxing the pigment off with a soft brush in the water. Or, remake your negative with a new, flatter curve adjustment.

If you find little white bubbles on the finished print, try developing the print face-up while you watch to make sure that no run-off pools on the image.

Gum works beautifully under liquid enlargement emulsions (see Chapter 13) and over brown or platinum/palladium prints. My personal favorite is gum over cyanotype, but the dichromate in the gum tends to bleach the blue, especially with six or more coatings. Therefore, start with a slightly overexposed blueprint and size with the polymer method— which also deepens the blue print—before you coat the gum bichromate solution.

Rockland's (Rockaloid.com) SelectaColor for paper, wood, metal, and plastics can be used in a similar way to gum printing because they are composed of a more permanent pigment base, which you coat on a receiver and expose under a contact-size negative, then sponge develop.

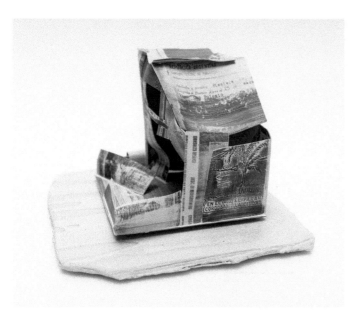

10.15 Graciela Olio, *Casa Refugio*, 25 × 20 × 20 cm (9.8 × 7.9 × 7.9 in.), porcelain (Keraflex) and gum bichromate, white stoneware, firing 1270°C, (2318°F), Oxidant, 2016. Photo Credit: Escuela de Arte de Talavera.

Created during the program of International Artistic Residencies of the School of Art of Talavera. Talavera de la Reina, Spain, Argentinian artist, Graciela Olio, grounds her work in a cultural mix of Pre-Columbian, Hispanic-American, and European ancestry. She is aware of and consciously wants to break down the traditional divide between art and craft. For more information on how to apply photo images to ceramics, see *Jill Enfield's Guide to Photographic Alternative Processes* (second edition, forthcoming, 2018).

Pébéo's Setacolor transparent fabric paints are light-sensitive when mixed with water and can be applied to either natural or synthetic fabric and used wet. You contact print objects (e.g., leaves, shells, cheesecloth) directly on top of the paints after they have been coated on cloth and put the setup in the sun or under heat lamps. When the fabric dries, you have a print without any further processing. Once the fabric is heat cured, it is wash-fast and color-fast and can be dry cleaned. Made in France, the dyes and instructions for their use also are available in the United States.

You can use the plain pigment to spot the print and lessen visible imperfections. Always start lighter than you want by adding more water to the paint.

NOTE

1 Doty, Robert, ed. *Photography in America*. New York: Random House, 1974.

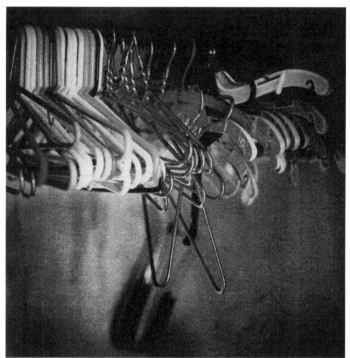

11.1a and 11.1b Christina Z. Anderson, two images from the series, *Past Lives*, 2012, each picture: Tricolor Casein Print. Left: *Ditchley Window*, 5.5 × 7 in. (14 × 17.8 cm). ©Christina Z. Anderson. Right: *Mother's Closet*, 7.25 × 7.25 in. (18.4 cm). © Christina Z. Anderson Anderson authored *The Experimental Photography Workbook*; *Gum Printing and Other Amazing Contact Printing Process*; *Handcrafted: The Art and Practice of the Handmade Print*; and *Gum Printing, A Step by Step Manual Highlighting Artists and Their Creative Practice* (Focal Press, 2017). This casein series *Past Lives* is a visual reconciliation of place, being, memory, and loss. All prints were created, layer by layer, in milk protein (casein), a fitting metaphor for childhood memories of shelters the artist had known. Anderson used pigment powders in the historic colors that were common at the time of the oldest home in the project (1752). They are raw sienna, red iron oxide, and ultramarine blue mixed with cottage cheese casein and coated on PVA-sized Fabriano paper.

11

Casein Pigment Prints

This method, also known as the casein bichromate printing process, utilizes curdled milk dissolved in ammonia to bind the component materials and was patented in various forms starting in the 1870s, as a technique to use with other photo-printmaking methods, such as over Van Dyke brown printing (see Chapter 8) and cyanotype (Chapter 7). Used by itself, however, casein printing can yield nuanced, colorful results similar to the watercolor or gouache paints that make up part of the emulsion. The translucency of each color coating permits a new hue in a new layer of emulsion to combine and change the pigment color in the developed coating underneath. One of the least expensive of the hand-applied emulsions, casein printing is closely related to gum bichromate printing (see Chapter 10),

and a reading of that chapter is highly recommended. Casein usually requires much less ultraviolet exposure to yield stronger and slightly more distinct colors than the gum bichromate process.

SAFETY

Bichromate (also called *dichromate*) can cause skin and eye irritations and even burns upon repeated exposure. Wear protective gloves and goggles at all times when mixing and coating, as well as when washing a bichromate-sensitized print. Wear a respirator with toxic dust filters when handling bichromate powder or crystals to avoid sore throat, cough, labored breathing, and more serious difficulties. Once dry, the print should not be a problem to your

health if the unused bichromate is washed thoroughly during the development step.

Bichromates can be poisonous when ingested, even in small quantities, so keep containers labeled, and store chemically contaminated materials away from your mouth and out of the reach of children and pets. Do not eat, drink, or smoke during work. Wash hands and skin that might have come in contact with chemicals, especially before eating, even if you wore gloves.

In the European Union, the dichromates (sodium and potassium) are classified as SVHC (substance of very high concern), and the use of it will be forbidden or strongly regulated and only approved with authorization from ECHA (European Chemicals Agency) after September 9, 2017. After this date "the placing on the market and the use of the substance shall be prohibited unless an authorisation is granted."

Wear an apron or lab coat, which stays in your studio. Wash it separately from your regular laundry.

Make sure your workspace is properly ventilated. Ilfordphoto.com states: "Ensure darkroom areas are adequately ventilated: there is no hard and fast rule as the required ventilation depends on the duration and type of work, but an extraction fan mounted on an external wall to provide 10—15 changes of air per hour will normally produce a safe working environment."

Dispose of excess solution or chemicals by flushing it down the drain with a large volume of water, not in a wastepaper basket. Bichromates are not combustible but do enhance combustion of flammable and combustible substances. Store both dry and diluted bichromate in their own fireproof cabinet. (See Chapter 10 for more suggestions on how to neutralize bichromate.)

Certain pigments, such as emerald green, cobalt violet, true Naples yellow, all cadmium

pigments, flake white, chrome yellow, manganese blue and violet, Verona brown and burnt umber, raw umber, Mars brown, lamp black, and vermillion, can lead to poisoning and other complications if they are ingested or inhaled frequently. Wearing a respirator and gloves, working in a ventilated area, and carefully washing hands and cleaning fingernails after using these pigments can prevent accidentally carrying them to the mouth and swallowing them.

Bichromate is carcinogenic to humans after long-term or repeated exposure, and it may cause asthma. Carefully respecting precautions and prevention methods and, depending on the degree of exposure, periodic medical examination, is suggested.

METHOD OVERVIEW

1. Paper or fabric is preshrunk, sized, and dried.
2. Under subdued light, the paper or fabric is coated with casein pigment emulsion and allowed to dry.
3. The coated surface is placed in contact with a negative or object, and ultraviolet light is shone through the negative.
4. The negative is removed. The paper or fabric is developed in water, where unexposed areas of the color are dissolved, leaving a reversed image to dry and harden.
5. One coating must dry before a new layer may be applied, exposed, and processed.

MATERIALS

More detailed descriptions of materials are given in Chapter 4, Creating the Photo-Printmaking Studio. In addition, please read Chapter 10, Gum Bichromate Printing, as the two techniques have similar requirements and a method for making color separated negatives is explained.

1. Applicators. Try fine flat-bristle brushes or nylon paint brushes about 1 in. (2.5 cm) or more wide, a sponge brush (better for "buffing" the coating after

it is applied with a bristle brush because sponge brushes have a tendency to take up too much wet emulsion), or a foam print roller from the hardware store. A small, soft brush for coaxing the development of the print in water can be handy. Keep the metal part of the brush out of the bichromate solution and protect it from corroding by coating with clear finger nail polish. If you use an atomizer or airbrush, be sure to wear a respirator and to work in a well-ventilated area.

2. Brown or opaque bottle. Since one of the emulsion's components, diluted potassium dichromate, is light sensitive, it should be stored in a dark bottle, such as a clean, used fruit juice, mouth wash, or vitamin pill jar.

3. Cheese cloth and mesh food strainer or nylon stocking and large plastic drinking cup. Inexpensive cheesecloth, purchased at a hardware or grocery store, is used to line a good strainer when cleaning the casein base. Do not use these materials to cook with later.

4. Chemicals. You will need either potassium or ammonium bichromate, which can be purchased in 1 lb. (0.5 kg) or smaller quantities from merchants listed in Supply Sources at the end of this book. I used to use ammonium bichromate, but I found that the exposures were too fast, so I changed to the less light-sensitive potassium bichromate, which offered more control over making tests for the accurate exposure time. Meanwhile, overexposure can be difficult to correct because the emulsion is so completely hardened that even development in hot water and scrubbing only slightly affect the image. Photographers' Formulary, listed in Supply Sources at the back of this book, sells a casein printing kit with potassium dichromate, ammonium caseinate, and sodium benzoate along with red, yellow, and blue watercolors to make approximately 20 8 × 10 in. (20.3 × 25.4 cm) tri-color gum prints.

Either instant powdered non-fat milk or fat-free cottage cheese, both of which are available at a grocery store, are combined with a few drops of thymol (optional), a preservative available at health food grocery stores, to provide the casein binder.

Undiluted lemon juice or 28 percent acetic acid, sold as stop bath in photo stores, curdles the milk.

A bath of clear, non-sudsy ammonia from a grocery store (usually 3 percent), stronger janitorial ammonia, or ammonium hydroxide diluted with water to a 10 percent strength, helps clear a muddy print and also is one of the elements in the emulsion. Ammonia fumes are particularly strong and unpleasant, so make sure you wear a fumes mask and use the product in a well-ventilated area.

Steve Salniker e-mailed me with good advice: casein should look like a semi-transparent glue, similar to gum arabic solution. His recipe is 400 ml (13 ½ oz.) distilled water to 60 grams (2 oz.) non-fat dried milk. He mixes this combination together and heats it in a double boiler until it begins to steam. He then adds 6 oz. (177 ml) of white vinegar to curdle it. Strained curds are put into cheesecloth to squeeze out remaining moisture, then the ball of curd is torn into bits and put into a wide-mouthed jar (about 59 grams or 2 oz. of curd is yielded this way). Afterwards, Steve heats 4 oz. (118 ml) of distilled water in the microwave for about 25 seconds, then stirs in 8 grams (¼ oz.) of borax. This solution is poured into the curd jar. Within a few hours the curds dissolve and begin making a cloudy emulsion—by 8 hours you›re left with casein glue. There's still some goopy stuff on the bottom that can be mixed further into the solution, and then strained. You make about 100 ml (3 ¼ oz.) of casein through this method—maybe way more than the beginner needs. He has noticed no odor or spoilage if the solution is left out at room temperature for a week—though now he refrigerates it at my suggestion. He slightly thins the emulsion and uses the same proportions of pigment, dichromate solution, and casein as suggested in gum printing. Steve got the formula from D. B. Clemmons and upped the amounts of the basic ingredients proportionally to get more casein. See his work at http://www.seacoastnh.com/arts/photossalniker/.

5. Distilled water. Sometimes tap water is fine for making the bichromate solution, but the use of

distilled water eliminates the frustration of possibly mixing bad solution.

6. Image. Black and white negatives, described in Chapters 5 and 6, of low density, low contrast, and the same size as the print you wish to make, offer the possibility of full tonal range after one exposure to casein pigment emulsion. More often, though, the density of the negative exceeds the range of the emulsion, requiring multiple exposures to build up highlights, middle tones, and shadows. Posterized negatives, described on page 86 or color separation negatives explained in depth in Chapter 6, Making Negatives: Digital Method, and Chapter 10, Gum Bichromate Prints, offer versatility. Or use a pinhole camera as in Chapter 5, which also offers a variety of other creative ideas. High contrast negatives also work quite well. If more than one printing is desired, negatives will need to be registered as described later in this chapter and in Preparation for Light-Sensitive Methods section, and Chapter 10 on gum printing.

Try stencils, found objects and old black and white transparencies, torn paper, lace, drawings, and photocopies on acetate. Remember: these items usually are positives, not negatives, and photo processes reverse the highlights and shadows.

7. Measuring cup or beaker and stirring rod. You will need a cup or beaker that measures 16 oz. (455 cc) in ½ oz. (14 cc) increments. Glass is easier to keep clean.

8. Measuring spoons. Cooking utensils, never reused in the kitchen, are fine. Small, clear 4 oz. (102 ml) medicine measuring cups, available at pharmacies and sometimes packaged in cough syrup, are useful.

9. Newspaper or newsprint paper to protect your work surface; hair dryer with cool setting.

10. Pigments. Professional-grade watercolors or gouache in tubes work well. Liquid casein color have been used with some success, as has powdered pigments (mixed with a few drops of photographic wetting agent, such as Photo-Flo, to the powder and water mixture). Make sure that the pigment you use is not metallic, such as nickel azo (brownish yellow) or chromium yellow, because the metal will eventually react negatively with the bichromate.

11. Printing frame. Use a new or antique printing frame, glass with Masonite underneath, plate glass on top or another sheet of glass or follow the instructions for building a frame on page 80.

12. Protective gloves and respirator.

13. Receiver. Practice prints can be made on lighter weight and less-expensive printmaking paper, but finished prints should be produced on rag paper of medium absorbency for longevity, such as 145 GSM (grams per square meter) medium weight Arches Platine, 140 lb. (pounds) Fabriano Artistico, 140 lb. Lana Aquarelle Hot Press, or 250 GSM/110 lb. Stonehenge in cream white, fawn (pale tan), pale blue, pearl gray, and warm white. Heavier papers include Arches Aquarelle, Magnani Prescia (which is deliciously soft, comes in both soft white and what I call "regular" white, cream, light blue, and gray, but shows finger and tongs prints, so use a piece larger than your coating!), 310 GSM Arches Platine (the whitest white without artificial buffering agents) and Bergger Cot320. All paper should be sized (page 89) and preshrunk for more than one coating. In addition, if you are doing this process on top of cyanotype or Van Dyke brown, those prints should be sized beforehand. Once the paper is dry, use a pencil to outline the borders of the image. James R. Collins, author of "The Gum Print" in *Darkroom Photography* (Oct. 1986), suggests the following method, which I often use: size the paper, then air dry it, apply the emulsion to an area about 1 in. (2.5 cm) larger on all sides than the image, and hang the paper in front of a cold-air fan to dry. When the emulsion is just barely tacky to the touch, put two pencil dots 12 in. (30.5 cm) apart and about ⅛ in. (5 mm) inside the emulsion edge. Hold a hair dryer about a foot (30.5 cm) from the paper and evenly blow warm air over the paper until it has shrunk the paper by ⅛ in. (5 mm) and the pencil dots measure 11 ⅞ in. (30.25 cm) apart. Make the exposure, develop the image, and repeat this preshrinking (without resizing) procedure with each coating.

Preshrink synthetic or natural fabrics as described above. Practice making prints on paper first, because working on fabric is more difficult. A good method is described at the end of the Cyanotypes, Chapter 7, page 166.

14. A small glass bowl atop a piece of white paper or a white china bowl or plate becomes the palette for mixing the emulsion. You can either build up layers of different colors in order to make new hues, or you can pre-mix two colors to make a coating of a specific hue.

15. Sizing. Because sizing paper and fabric is necessary, messy, and time-consuming, you will find it more practical to size several pieces at once. The acrylic-polymer medium method (page 91) works well. It is easy, but it stiffens the paper and yet will not allow for shrinkage described in Item 13 above. Todd Walker's alum sizing also is appropriate and is also explained in Chapter 4, Creating a Photo-Printmaking Studio, Item 4, sizing, page 89.

16. Spray nozzle for sink hose and kitchen blender (optional). The spray helps with development of a print that is not clearing in the highlights while the blender makes the job of mixing the casein and dichromate easier. Do not use the blender for preparing food afterwards.

17. Timer, watch, or clock.

18. Two registration pins and punch or push pins, masking sheets, masking tape, ½ in. (1 ¼ cm) heavy black tape, ruler, scissors, stencil knife (optional). If you are using more than one negative or more than one coating, and you want the layers of the image to line up repeatedly, follow the instruction in Chapter 10 and/or Chapter 4.

19. Two trays or tubs. You will need trays larger than the print when you develop the image and fix it. I use a glass baking dish because it more easily washes clean.

20. Ultraviolet light. The exposure does not cause a color change, as with cyanotype or Van Dyke brown printing, so artificial lights, such as sunlamps, photofloods, or black light fluorescents (see detailed explanation, page 82) are recommended because the exposure can be exactly timed. However, indirect sunlight can be used; avoid direct sunlight, where bright radiant heat output can cause the emulsion to fog with exposure.

MAKING THE BICHROMATE SOLUTION

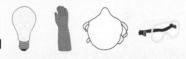

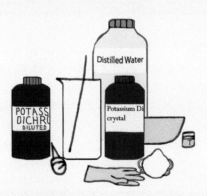

11.2 Equipment You Will Need

EQUIPMENT YOU WILL NEED

Ammonium or potassium bichromate crystal
Measuring cup or beaker
Bowl or tub
Stirring rod
1 oz. (30 ml) measuring cup
Distilled water
Label and permanent marker
16 oz. (473 ml) Brown Bottle
Thermometer

PROCEDURE

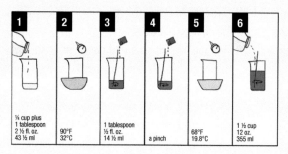

1	2	3	4	5	6
¼ cup plus 1 tablespoon 2 ½ fl. oz. 43 ½ ml	90°F 32°C	1 tablespoon ½ fl. oz. 14 ½ ml	a pinch	68°F 19.8°C	1 ½ cup 12 oz. 355 ml

11.3 Procedure

1. Pour water into measuring cup to make ¼ cup plus 1 tablespoon (43.5 ml, 2 ½ fl. oz.).
2. Adjust water temperature to 90°F (32°C).
3. With constant stirring, add 1 tablespoon (14.5 ml, 0.5 fl. oz.) bichromate crystals.
4. Add more bichromate until crystals will not mix in but precipitate to the bottom of the liquid.
5. Adjust water temperature to 68°F (20°C).
6. Stirring constantly, add water to make 1½ cups (355 ml, 12 oz).
7. Pour the bichromate solution into a labeled brown bottle.

TIPS FOR MAKING THE BICHROMATE SOLUTION

Should the crystals separate from the water, they will reblend when warmed to 90°F (32.2°C) and stirred.

You must thoroughly mix the pigment with the casein and bichromate solution, or the emulsion coating will be streaked.

Because the casein curd will dissolve three hours after adding the other chemicals to it, plan on doing multiple coatings during one print session.

The pure casein can be refrigerated and preserved for a few days.

Numerous other recipes for casein emulsions are detailed in Christina Z. Anderson's *Gum Printing and Other Amazing Contact Printing Processes* (christinaZanderson.com).

MAKING A CASEIN PRINT

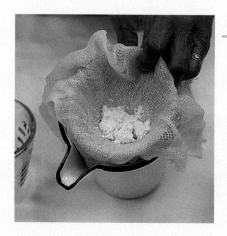

11.4 Curdle the Milk

1. Curdle the milk

In a measuring cup, thoroughly mix 1 oz. (30 ml) instant powdered non-fat milk with 7 oz. (199 cc) hot water. By adding a few drops of 28 percent acetic acid or lemon juice to the mixture, patiently curdle the milk. Arrange two layers of the cheesecloth in a strainer, pour the curdled milk through it, catching the curd in the cheesecloth, and rinse the curd with cold water. Squeeze the cheesecloth and curd, getting out excess liquid.

Or, place 2 oz. (59 ml) fat-free cottage cheese in a strainer, rinse in cold water, and press off extra liquid.

11.5 Mix the Emulsion

2. Mix the emulsion

Crumble the curd or cottage cheese into a measuring cup, add 2 oz. (50 cc) of 1 percent ammonia, and mix well with a fork or electric blender. Thoroughly mix ½ teaspoon (2.5 ml) of the casein or curd mixture with ½ teaspoon of the dichromate solution and ¼ teaspoon (1.25 ml) watercolor pigment.

11.6 Coat the Paper

3. Coat the paper

Use the emulsion to coat one 8 × 10 in. (20.25 × 25.5. cm) piece of paper by pouring it from the cup onto the sized paper and quickly working the emulsion on evenly with a brush to an area beyond the image area. The emulsion will not look like the water-color pigment at this point but may have a yellow-orange tint to it. Lightly buff the coating with a clean, dry foam brush.

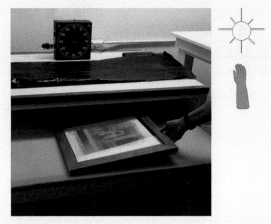

11.7 Expose the Print

4. Expose the print

Use a hair dryer on the cool setting, and when the emulsion is dry, make a sandwich with the backing board on bottom, paper with emulsion facing up next, negative reading correctly on the paper, and clean glass on top.

Place the loaded print frame in shade for 5–15 minutes, under a sunlamp for 2–30 minutes, or photoflood bulb 3 ft. (1 m) away for 3–12 minutes, or under ultraviolet fluorescent bulbs 6 in. (15.25 cm) away for ½–10 minutes. Exposure times vary according to the light source, pigment color (blue requires the shortest exposures, while yellow and black take the longest, and violet and green are in-between with similar exposure times and red and orange a little more, but similar times) and density, and emulsion thickness. You will have to experiment and keep notes.

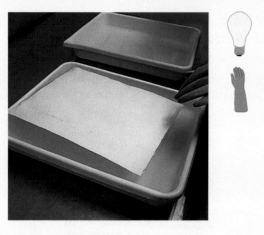

11.8 Develop the Paper

5. Develop the paper

The reaction that occurred during exposure continues after the emulsion has been removed from light. Therefore, immediately place the paper face down in a tray of warm water for 2–5 minutes. Move the print face up to a tray of warm water. If the image is not clearing where you want, place it face up in a tray containing 2 oz. (59 ml) of 3 percent ammonia or a little baking soda and 32 oz. (946 ml) room temperature water for 2–5 minutes. Development may take several dips back and forth; it is complete when the unexposed areas (highlight) of the emulsion dissolve and float off the paper, the exposed areas (shadows, middle tones, and highlights with detail) are the same color as the pigment you used, and no orange dichromate stain is visible. When I am using more than one coating, I often start with a slightly underexposed (pale) Paine's gray image so that it is easier to line up negatives later for other colors.

6. Fix the print

Transfer the print, face down, to a final tray of gently running cool water for 15 minutes, remove the print, and air dry it face-up and flat or use a hair dryer. Resize the print if you want to add another layer of emulsion.

TIPS FOR MAKING A CASEIN PRINT

If the emulsion seems not to be going on smoothly, brush many times and in different directions. Next time, make sure that all the ingredients are thoroughly blended.

After coating the emulsion, be sure to immediately wash your brush or temporarily leave it in water while you work. Then, wipe off fluids before you use the brush again.

Exposure times for casein printing must be determined by testing, so before you start on an actual print, you can lower the frustration level by running the following test: Coat with emulsion and dry a sheet of sized 8 × 10 in. (20 × 25 cm) paper. Cut the sheet into 4 × 5 in. (10 × 12 ½ cm) strips, marking each strip with a pencil to indicate the emulsion color and formula used. Using a different strip for each exposure, make tests of different lengths of time, being sure to note the exposure time and light source on the strip. Make sure the same part of the negative and grayscale are used for each test. Develop, dry, and evaluate each test for each emulsion used, and keep a notebook with these test strips for future reference.

If the negative is too thin, the image is overexposed, or the light source is too hot, the emulsion will harden and will not wash off where you want.

If the negative is too dense or the image is underexposed, the emulsion will float off, and if you use too much pigment when mixing the emulsion or the emulsion is too thick, the color will flake off.

While the print is developing, you can lighten areas by rubbing gently with a soft brush or cotton swab, but be careful, because the

emulsion is fragile and severe agitation can remove the image all together unless you have greatly overexposed. A bath of hot water also will speed up development. A gentle spray of warm water in a specific area can coax the pigment off.

In the Jan./Feb. 2000 issue of *Photo Techniques Magazine,* Bob Whitefield describes "a new process: gelatin acrylic." He uses posterized high-contrast positives with semi gloss house paint on paper sized with gelatin and coated with bichromate.

See Tips, page 216, in the Gum Bichromate Printing chapter for more trouble-shooting advice.

11.9 Laura Blacklow, *Untitled,* from *Territories,* casein print and pencils, 6 ¾ × 4 ⅝ in. (17.145 × 11.75 cm), © 1978.

I chose casein printing for this image because it is an inexpensive process, which creates subtle colors and forces me to slow down as I work. Some of the colors have been made by building up casein coatings of different hues, each of which was printed with the same negative. Some of the color has been achieved with casein coatings and no negative, while other hues come from colored pencils applied to the dry print.

12.1 Craig J. Barber, *We Moved Across the Paddy, from Ghosts in the Landscape*, 10 × 24 in. (25.4 × 61 cm), Platinum/Palladium print from pinhole negative on Crane's paper, 1998. © Craig J. Barber.

For over twenty years Barber has worked with pinhole cameras (see pages 110–118). The simplicity of a cardboard box with a small hole and its ability to re-imagine the world inspired the photographer to continue using the device. In addition to the odd vision that matches the artist's way of seeing, and the long exposures—from 40 seconds to more than one hour—that allow him to set up a different kind of relationship with a location, Barber enjoys the fact that chance, mystery, and surprise play rolls in pinhole technique. Lastly, the artist states that his photographs tend to be about memory, and the long exposures resonate as time passes in front of his "lens." Poignantly, Barber was a marine during the U.S. involvement in the Viet Nam War, and 28 years later, he re-visited places that he remembered. You can see more of this series in his book, *Ghosts in the Landscape: Vietnam Revisited* (Umbrage Editions, New York: 2006).

12

Platinum and Palladium Prints

Historically considered the premier, treasured, hand-coated emulsion among photographers, platinum (aka platinotype) and the closely related palladium printing processes are two of the tonally richest—that is, they can render nine shades plus D-max—and most permanent emulsions available. Depending on the paper and processing procedures used, the more expensive platinum can yield cool velvety blacks, while palladium renders warmer blacks and sepia browns. Although both processes are probably the most costly hand-coated techniques covered in this book, they rarely are used alone but usually are combined with each other, as well as used under gum bichromate (Chapter 10), cyanotypes (Chapter 7), and other techniques. The advantage of combining platinum/palladium

with gum printing is that if you do not like what you created, you can remove it, whereas cyanotype is permanent when joined with platinum/palladium.

My hero, Sir John Herschel, was the brilliant British scientist and generous (he was the one who finally figured out how to fix a silver-based print and advised Talbot to try his method) gentleman who originated the formula for cyanotypes. In 1832, he also announced publicly that platinum, when mixed with other chemicals, becomes sensitive to light. Forty years later, in 1873, William Willis refined, patented, and, in 1879, manufactured kits including pre-coated paper and requisite chemicals for the platinum printing process. He called his venture the Platinotype Company, and he later manufactured less

expensive palladium kits. Within three years, devotees began coating their own paper when the formulae were made public. Other manufacturers, such as Ilford, (Agfa) Geveart, Ansco, and Kodak eventually entered the market. Because of the emulsions' stability and impressive permanence, relative ease to procure and use, and sensuous results, at the turn of the century platinum and palladium were used by diverse and influential artists of both the Pictorialist and Photo-Secessionist movements, such as Frederick Evans, Alfred Steiglitz, Paul Strand, Edward Steichen, Gertrude Käsebier, and Francis Benjamin Johnston. When the cost of platinum increased during World War I (partly due to the discovery that this "noble metal" could be used to make explosives), it became so expensive that most manufacturers eventually stopped making platinum-coated papers, substituting palladium instead. Steiglitz wrote of his struggles to make palladium produce the kind of prints he wanted: "I do nothing according to instructions," and "If I follow them I might as well throw cans of paper into our blazing fire." He "made all sorts of experiments" with palladium paper, trying, as he told Strand, to determine its "elasticity." Often he made 100 attempts before he achieved even one that met his standards. He worked with different hues of paper, varied the temperature of developing baths, and explored the effects of wax and varnishes on the print.[1] Still, Laura Gilpin and Imogen Cunningham, among a group of platinum/palladium aficionados, coated their own papers and continued the tradition for decades. More recently, Irving Penn, Robert Mapplethorpe, and Wendy Snyder MacNeil have been part of the resurgence of platinum and palladium printers who have shown their work at prestigious galleries and used the processes in the commercial world.

SAFETY

Because of the health hazards and the number of chemicals employed to make the solutions, I advise the use of premixed sensitizers as described later in this chapter. All chemicals should be clearly labeled and kept out of reach of children and pets. If you have access to a fume hood, please use it. Make sure your work space is ventilated, as described on page xv.

Ferric oxalate (No. 1 and No. 2 solutions) is corrosive to skin, eyes, nose, and throat and causes severe damage internally—even death—if swallowed. So wear protective gloves and goggles. When mixing from the powder, use a respirator with a toxic dust filter and protective goggles. If it should spill on your skin, wash immediately with soap or pHisoderm™ and water. Keep the top of the dropper bottles and the screw thread free of dried ferric oxalate by wiping them frequently with a damp paper towel.

Potassium chlorate (No. 2 solution) is added to increase contrast. Because it is moderately toxic upon skin contact, protective gloves should be used. If you are using the powder form to mix your own sensitizer, be aware that it is highly flammable and explosive. If it spills or is contaminated with impurities such as flammable or organic materials, it should be removed immediately with water. Care should be taken to avoid dropping, friction, and heat. Potassium chlorate should be stored away from heat and combustible materials, and a fume hood or acid gas respirator should be used to avoid the fumes, which are toxic.

When mixing from scratch, oxalic acid is sometimes used to make the solution more light-sensitive. It is toxic upon skin contact, ingestion (it can be fatal if swallowed), and inhalation. Wear protective gloves, goggles, and an acid mask. In case of eye contact, flush with water for 15 minutes and seek medical attention. If swallowed, call your local poison center. Do not induce vomiting.

Palladium chloride (#3 palladium solution) is slightly toxic upon skin contact and inhalation, so handle it with care and use a skin barrier cream. Palladium also can cause damage and degradation of DNA.

Platinum chloride (No. 3 platinum solution) is moderately toxic by skin contact and may cause allergic reactions. It is much more dangerous to breathe and can cause problems such as nasal irritation, asthma, or lung scarring and emphysema from repeated inhalation. Wear protective gloves and goggles when using platinum chloride and a respirator with toxic dust filter when mixing from powder.

Potassium oxalate is used in some formulas for developer. Because it prevents blood from clotting, it is toxic upon inhalation and ingestion. It is also corrosive to skin, eyes, nose, and throat, and can cause internal damage or death. I urge you to use ammonium citrate developer instead.

EDTA clearing agent is only slightly toxic, so handle it with care and use a barrier cream. Do not inhale the powder. I combine it with sodium sulfite, which is moderately toxic by inhalation and ingestion. Heating and treating sodium sulfite with acid causes the formation of highly toxic sulfur dioxide gas. Additionally, store it away from acids.

Some formulas call for hydrochloric acid (aka muriatic acid at the hardware store) in the clearing bath or in the developer. The concentrated form is highly toxic upon skin contact, inhalation, and ingestion. It should never be used near ammonia products, and the gas from the acid is dangerous. Always add acid to water and not the other way around. Potassium dichromate, which can be added to hydrochloric acid to increase sensitivity, is moderately toxic upon skin contact and ingestion, but highly toxic upon inhalation and affects marine animals when flushed into bodies of water. For these reasons, I recommend the use of EDTA mixed with sodium sulfite instead.

Gold chloride solution can be added to palladium sensitizer, a few drops at a time, to warm the color or even turn it pink. It is moderately toxic, but wear gloves and a mask when repeatedly handling the powder because it can cause respiratory, kidney, and nervous system disorders.

Richard Sullivan and Carl Weese state in *The New Platinum Print* that platinum and palladium are a potential environmental hazard when you dispose of used developer. They assert these metals "may be removed by adding a small quantity of steel wool to the developer: about 1 pad per gallon of solution. Metallic iron will reduce out any noble metals into their pure state. After sitting overnight, there might be a small residue of platinum or palladium metal in the bottom. Pour off the developer and save the black metal in the bottom. The steel wool may also be shiny, which means it's been plated by the noble metals in the developer." Then dispose of it according to local regulations.

METHOD OVERVIEW

1. The solution is prepared by mixing together drops of sensitizer customized to work with your transparency.

2. Paper or fabric is sized and coated with a sensitizer of platinum or palladium salts and light-sensitive ferric oxalate, an iron salt.

3. An enlarged negative or object is placed on top of the coated surface. Light shines through the clearer parts of the negative or around the object, reducing the ferric oxalate to the ferrous state. At the same time, the coating prints out partially, creating a self-masking effect.

4. The exposed paper or fabric is developed. The ferrous oxalate dissolves and further reduces the platinum or palladium salts to dark pure metal in the exposed areas and a slight neutral tone in the highlights.

5. The paper or fabric is washed, then placed in three successive clearing baths to eliminate background tinge. It is water washed again and dried. The print dries down a little darker than when it is wet, and more details become apparent as it dries.

MATERIALS

More detailed descriptions of materials are given in Chapter 4, Creating the Photo-Printmaking Studio.

1. Image. You will need a negative transparency the same size as the positive print you wish to create. Both palladium and platinum emulsions render a seemingly limitless array of tones, so whatever values are clearly separated on the negative should appear in the print. In addition, the emulsions can be mixed to suit your negative and desired result, so there is great latitude in the appearance of the transparency, except that it cannot be especially thin or extremely dense. Because of the self-masking effect mentioned in the Method Overview above, shadows are created early in the exposure, and that progression holds back the rate at which shadows and low print tones darken, thereby allowing highlights to receive more exposure than is possible in a printing-out process, commonly thought of as salted paper (Chapter 9), silver choloride black and white photography, the printing out process, and albumin printing. Therefore, negatives that have long tonal scales are advantageous. (You can see why many printers prefer slightly high-contrast negatives with a lot of separation in the shadow details and information in the midtones.)

If you follow the in-depth instructions in Chapter 6, Making Negatives: Digital Method, you can use a curve in Photoshop™. Once you find the curve that prints with your type of negative, combination of component solutions, and paper, you can save it in Photoshop® and apply it to other negatives. All you need to do is: after you have finished making the curve, select and hold your cursor over the small box with parallel lines in the upper right side of the curve layer, next the word "Properties."

Select "Save Preset" and a bigger window will appear. Enter a name and click "Save." To apply the curve to a different negative, select a curves layer but then go to that same small box but this time select "Load Curves Preset." Again, a larger window will appear, and you will see the name of the preset, which you select by clicking on and highlighting it, then choose "Open" at the bottom of that window. When you go to print the image on Pictorico film, just make sure that the negative is reverse or inverse of the positive, displays plenty of blacks, and flipped horizontally. The Digital Negatives chapter explains these options in detail. If you will be combining platinum/palladium with gum printing, use less contrast in the curve of the latter process.

If you are using orthochromatic film, try overexposure and underdevelopment with a dilute film developer, such as stock D-76 made from powder and diluted 1:3 parts water, and focus on capturing the most detail when making the positive, before you contact it to another sheet of film to make a negative. When you make the negative, do the opposite: expose for the shadow detail and overdevelop by 25–50 percent with a paper developer such as stock Dektol® made from powder or Solutek D-72 which comes as a healthier-to-use liquid stock solution, then dilute it with 6 to 8 parts water. (See www.laurablacklow.com, where information on contacting me is given. I will send you scans of that chapter from the 4th edition of this book.). Photographers' Formulary, listed in supply sources, sells numerous film and paper developers, including the prized Pyro developer, which, due to its staining effect, reduces grain and promotes precise tonal separation in the highlights, while providing a superior density scale. Because Pyro is toxic if breathed in or if it is absorbed by skin, precautions such as wearing a protective mask and gloves are vital. Moreover, with all liquid chemicals, put on gloves.

If you use a view camera, try loading it with a panchromatic film, such as Ilford HP5, and overdeveloping by 15–30 percent in HC110, dilution B, or with Pyro Developer described above. These

methods are not explained in detail in this book, so look in the Annotated Bibliography for one of the platinum printing books that does describe more specifics.

2. Chemicals. In all techniques, if I can acquire what I need already mixed without sacrificing quality, I do so because of the health hazards involved in mixing dry chemicals. I don't even like the possibility that some excess chemical powder might have settled on a surface. I recommend that you purchase the Standard Platinum and the Standard Palladium Kits premixed from Bostick & Sullivan or (next best) pre-measured dry chemicals from Photographers' Formulary who send a catalogue and instructions. Both companies are listed in Supply Sources at the end of this book. Although slightly more expensive than buying separate components, the kit is also a good way to start and contains enough sensitizer to make 60 4 × 5 in. (10 × 12.5 cm) prints. When you need to replenish, you can order specific chemicals separately. Bostick & Sullivan also ships the Euro Kit for either technique because "it was not economical to airmail [United States] water to Finland—the Finns have their own." This kit contains premeasured, mostly dry chemicals, in brown bottles with droppers on the side, to make 60 4 × 5 in. prints. The Formulary will send premeasured dry chemicals, too. You can request pre-measured ammonium citrate developer for cool tones tending towards neutral black and a bit higher contrast, and EDTA clearing agent.

The palladium kit is approximately one-half the price of the platinum kit. Since pure platinum is trickier to work with, grainier, and weaker in the deep hues, many printers combine palladium, which is less contrasty and warmer, with some platinum sensitizer. In my picture at the end of this chapter, I used 75 percent palladium and 25 percent platinum, but I know printers who use a 50/50 mixture. The color of the paper also affects the appearance of the print.

Both Bostick & Sullivan and the Formulary sell potassium oxalate developer, which renders warm tones, but is poisonous. Sodium citrate developer renders colder tones and lower contrast. You can also buy pre-mixed liquid developer, which is a combination of potassium oxalate and water or pre-measured dry chemicals in a plastic bottle from Bostick & Sullivan, or you can purchase it in the powder form from Photographers' Formulary and provide your own distilled water and bottle. In the beginning, however, you may want to order a second bottle of developer so that you can "top off" (see Item 15 below). Or, if you are going to mix your own developer, you will need to add 1 lb. (550g) ammonium citrate to 47.34 oz. (1400 ml) distilled water. Photographers' Formulary sends you dry pre-measured potassium oxalate for developer to which you add water and will need a tightly sealable bottle to store the mixed solution. Or, use the formula below to mix potassium oxalate developer.

To make the clearing bath, mix 1 tablespoon sodium sulfite with 0.35 oz. (10 g) oxalic acid (optional), 1 tablespoon EDTA, and 36 oz. (1 L) water in a tray. Change this recipe to a stronger solution by using the same chemicals but 18 oz. (1/2 L) water if you are working on very thick paper or cold press paper. Either Kodak hypo clear or Heico Permawash diluted as the manufacturer recommends, or 1 qt. (944ml) water combined with 2–3 tablespoons of citric acid will also serve as clearing baths. But the quickest clearing is accomplished in the bath I use: 1 tablespoon sodium sulfite, 1 tablespoon EDTA, and 1 qt. (1 L) of water.

Bostick & Sullivan sells a related process, Ziatype, which does not require a developer, and the color is controlled in the sensitizer. In addition, this "printing out" process allows you to watch the image form during the exposure, so that you can stop it when the print looks right.

Rockland makes a platinotype kit for medium- to high-contrast negatives, and Artscraft will make a kit to your specifications. Be aware that ferric oxalate and potassium chlorate will go bad after 3–6 months at room temperature or with

regular exposure to heat or ultraviolet light. The noble metals are stable and do not corrode, which is why we call them "noble."

If you are mixing sensitizers from scratch, you will need small amounts, as described on page 241 of ferric oxalate, potassium chlorate, potassium oxalate, potassium chloroplatinite for platinum and palladium chloride for palladium prints, sodium chloride, oxalic acid (optional), and gold chloride if you are going to tone the print. Purchase these chemicals from a reliable source (see the back of this book). Dry chemicals last longer, even after adding distilled water to solution 1 and 2, although the mixtures with the noble metals last for many years. In Europe, Fotospeed and Silverprint, listed in Supply Sources, sell the materials you will need.

3. Distilled water. If you are starting with dry chemicals, distilled water prevents mixing a bad batch of emulsion due to impurities in tap water. I also use distilled water or purified water to mix the clearing baths, and many printers use it for the required washes. Dipping your coating brush in clean distilled water and blotting out the excess before spreading the solution helps to prevent the brush from taking up too much emulsion.

4. Receiver. If you are printing on paper—and I recommend that you do before you experiment with other surfaces—you will notice that the paper type dramatically affects the resultant image. Such factors as the color of the paper can make the print seem more or less contrasty and a smooth or textured surface can influence the amount of detail captured. Rag paper is more archival, works best with these permanent emulsions, and tends to hold up when submerged in liquids for processing. Crane's Kid Finish, a good sheet to practice on, can be bought at stationery stores. It comes in cream (ecru) or white and in standard 8½ × 11 in. (21.5 × 28 cm) sheets of 25, 100, or 500 to a box. Photographers' Formulary carries Crane's cover 90 lb. wove finish (aka Crane's Platinotype) in 9 × 11 in. (22.8 × 27.9 cm) and 11 ½ × 14 in. (29 × 35.5 cm) sheets and will custom cut up to 26 × 40 in. (66 × 101.6 cm). Both are manu-

factured with enough sizing that you will not have to prepare their papers, but you might need to handle them carefully in the clearing baths so that they will not rip. A method that works well for me is to use nylon screening larger than the sheet of paper underneath the paper before you insert it in the first tray of liquid. With gloved hands you then can easily pick up the screening with the paper on top to move it from tray to tray. This method can be used with other delicate receivers, such as rice paper, calligraphy paper, and vellum. Or use the method on page 92 of Chapter 4, Creating the Photo-Printmaking Studio. One of the advantages of these surfaces is that you can easily employ the coating method I recommend: mixing the sensitizer with water, then coating the mixture, drying it, and then recoating and drying it (see Tips to this chapter) to ensure more detail in the final print. Vellum needs to be preshrunk, as explained in Chapter 4, because it tends to stretch when you coat it and will not lay down flat under the negative unless you coat to the edge of the sheet, then, as Christina Z. Anderson advises, trim that periphery before you expose it. You will be throwing out a little of the expensive emulsion. Anderson's books are listed in the Bibliography.

I like perusing art stores for unbuffered (platinum and palladium do not take to alkaline surfaces), smooth (because I prize detail) but absorbent rag papers, which tend to yield more sumptuous tones. William Schneider

(http://www.ohio.edu/people/schneidw/501/alternative_process.html) recommends vigorously brushing the sensitizer onto Strathmore 2-ply 500 Series Bristol and discarding the bottom layer or "ply," which tends to separate in the wash water. Kozo, made from mulberry bark and cotton abaca; Bienfang Graphics Rag Layout 360; and Stonehenge come highly recommended. All of these papers must be sized, as explained in Item 6 below.

Arches manufactures Platine, a 100 percent cotton, smooth, brightest white without artificial brighteners, and heavy (310 gsm) or the new

medium (145 gsm) weight paper that needs no extra sizing because the manufacturer has already applied an external size. Martin Axon, printer of Robert Mapplethorpe's platinum prints (http://www.platinumaxon.com/) tested this, the first paper specifically for platinum printing (although I also use it for other techniques) made by Arches. In Europe, your art store can call Arches directly. This expensive—my mother always said that you get what you pay for—paper is fantastic if you are going to coat platinum and/or palladium because its surface allows for easy coating, or you can combine platinum/palladium prints with other processes because Platine holds up under repeated immersion in liquid and needs no special preparation. Platine is such a comparatively bright white that the image looks higher contrast, so I use the double coat method, the recipe for which is featured below and uses added drops of distilled water, for more depth in the tones. Please note that, after repeated soakings with gum printing, you do need to re-size as explained in the Gum Bichromate chapter. Bostick & Sullivan and Photographers' Formulary (see Supply Sources) recommend Hahnemühle Platinum Rag paper for multilayered processes. Other equally sensuous papers are Bergger Cotton 320 and the relatively new Herschel linen-based Platinotype. The less inexpensive rag Revere Platinotype can be purchased in the one weight of 320 gsm/140 lb. Please remember that, despite using noble metals, non-archival paper can lessen the life of your platinum/palladium print, so stay away from papers that are not 100 percent rag.

Fabrics need to be natural (see page 166 of Chapter 7, Cyanotypes, for more details). The original Platinotype Co. sold sensitized linen, sateen, and cotton. Using painters' canvas stretchers (as described with step-by-step photos in "Cyanotype on Fabric" on page 166) conserves chemistry and facilitates working on fabric.

In the original patent, William Willis claimed that he applied platinum emulsion by either one or more coatings to "paper, *wood,* and other suitable materials" (italics mine). The wood need not be sized unless it is quite absorbent, but prepared as described in the cyanotype chapter on page 157.

In addition, Bill Winkler gives instructions for applying platinum/palladium images to glass at http://www.alternativephotography.com/wp/carrier-clear-coating-for-printing-platinumpaladi-umgold-and-pigment-on-glass/. Although I have great respect for his research and knowledge, the directions are loaded with chemical and scientific terms, and I advise that you check many of the components, such as formaldehyde, for serious health hazards.

5. Ultraviolet light. Sunlight can be used, but due to variances in ultraviolet strength according to time of day and season, dependable results can be difficult to obtain. Artificial exposure sources, as described in Chapter 4, Creating the Photo-Printmaking Studio, are more consistent—or use a sunlamp centered above and covering the emulsion. Do not look at exposure lights without ultraviolet-protective goggles.

6. Sizing. Rag papers usually are made with internal sizing, but if you use less expensive paper, rice paper, or absorbent paper such as Rives BFK, you may want to size both for technical reasons (to prevent the paper from absorbing too much liquid, thereby complicating even coating, reasonable exposures, and complete clearing) and aesthetic reasons (different sizings affect the color of the emulsion differently). I recommend the arrowroot or starch methods for warmer results and the gelatin size for cooler hues. See pages 90 for more details. Arrowroot sizing is not effective for multiple printings, however, such as gum over platinum or palladium.

7. Applicators. Look for a flat brush that is 1 in. (2½ cm) or more wide to meet most of your needs. My favorite applicator for showing the brush strokes in the finished print is the trusty Hake brush, available at good art stores. Its goat hair bristles are sewn to a flat, wooden handle and need to be evenly cut to approximately ½ in. (1.25 cm) so that they do not soak up too much emulsion. As

the hairs become browner with use, I just trim a small amount off to reveal clean bristles. Polyfoam will work, but tends to deteriorate after several uses. In addition, you must be watchful that the polyfoam brush does not take up too much of the expensive solution. Care needs to be exercised when coating the sensitizer on rag paper because too much pressure will abrade the paper. Camel hair brushes with trimmed bristles are fine too. Photographers' Formulary and Bostick & Sullivan sell different kinds of glass coating tubes to lay down a smooth layer while saving on chemistry. You can even use an atomizer to spray emulsion on the receiver if you lightly wipe the emulsion afterward with velvet—as in the modern version of the old-fashioned Blanchard brush described on page 91. Make sure that, whatever applicator you use, the emulsion does not come in contact with metal and it is not used for any other process. I moisten the brush in distilled water, blot it on a clean towel or paper towel, then set it aside while I prepare the sensitizer. The time that elapses before coating somewhat dries the brush; a slightly damp brush helps to prevent picking up too much chemistry when I am ready to coat.

You probably will want paper towels to wipe the bottle (see Safety) and the applicator as you work. In addition, when you are done with a studio session, you need to wash the bristles and blot them dry. If the brush is leaving dark marks as you coat, it may not be clean, so try soaking the bristles in clearing bath, then wash in water.

8. Printing frame. To ensure strict contact between negative or flat object and emulsion, and to avoid a blurry image, use a standard contact printing frame or make a sandwich with plate glass on top and Masonite or another piece of glass underneath. I have had bad experiences with foam core or foam rubber underneath because, after several uses, they end up with areas of different thicknesses and prevent strict contact between negative and receiver. Make sure the glass is clean and dry before each use. Foreign particles lodged in the glass can create dimples in the paper and block light, resulting in a print with marks that are the color of the paper. Or follow the instructions for building a frame on pages 80. The structure needs to accommodate with some extra room, the dimensions of the paper, wood, or fabric.

If you are using vegetation, such as flowers or leaves, place a sheet of plastic wrap from a grocery store or clear acetate from an art store above the emulsion. The heat from the exposure can cause the vegetation to "sweat," which causes stains. Dry and press vegetation beforehand for better contact and, therefore, better resolution.

9. Brown glass or opaque bottles with medicine droppers. If you are mixing stock solutions 1, 2, and 3 from scratch, you will need to purchase and label three light-blocking (glass is easier to keep clean) small bottles to store the stock solution and three droppers for making the customized emulsion for each print. Photographers' Formulary sells 35 ml (1.18 oz.) amber glass bottles with tight-fitting droppers, and they match up with their premeasured dry chemical kits for platinum and palladium. If you are using premixed solutions from Bostick & Sullivan, they ship sensitizers in clearly marked brown glass bottles with droppers on the side. The emulsion contrast is controlled by counting drops of each of the two ferric oxalate components; the third solution, which contains noble metals affect color. Do not use the same dropper for the different bottles of sensitizers. Please note that in the formulae for making the individual print's emulsion (Contrast Control Chart), below, you also add distilled water, then you use *two* coatings of the mixture.

Some printers recommend adding one drop of 3 percent hydrogen peroxide in a total of 20–30 drops of sensitizer if your print fogs (lessens in contrast and exhibits a brown stain), commonly caused by the use of old chemistry or by the accidental exposure of the emulsion to bright light. If you are mixing your own developer from powder, you will also need a plastic or glass 1½ qt. (1.65 L) container. Bostick & Sullivan ships their ammonium citrate developer as a liquid in a plastic bottle.

You can save leftover clearing baths in three properly labeled 1 qt. (1 L) plastic or glass milk bottles. It is not light-sensitive. In addition, Photographers' Formulary sells the Historic Process Laminated Reference Card for Palladium Processing (and other processes), an inexpensive and accessible resource to help guide work with palladium processing. You can use it next to a sink without fear of damage.

10. Five trays, dish tubs, or kitty litter pans. They must be nonmetallic and larger than the print—three hold the clearing baths and one is for the final wash water, and one is for the developer (or use a Pyrex™ baking dish as described later in this paragraph). If you use the sodium sulfite and EDTA recipe mentioned above (in Item 2, Chemicals), or if you use Hypo Clear, you will probably need only two trays. In addition, I use one Pyrex™ baking dish as both the developing tray and a first water wash because glass is easy to clean. You can also use plastic photo trays, but do not use them for any other processes.

 While the print is wet, I advise that you clear each one individually so as to avoid damaging the coating.

11. Siphon washer, safelight/tungsten bulb/low light, and drying rack. The siphon, available on eBay, works well to wash prints when attached to a tray in a sink. Or you can drill small holes near the top and in the sides of a dish tub or photo tray and gently run water directly from a hose connected to a faucet over the back of the print. Both methods allow clean water to enter while contaminated water drains off. You can blot the print afterward with a clean, soft sponge or air-dry it face-up on a rack. A rack protected from light and high enough off the floor so as not to attract dust also is useful for allowing the emulsion to sink in after it is coated, as explained in the step-by-step instructions.

 The sensitizer needs to be coated and dried away from ultraviolet light, which is found in the exposure unit and in normal fluorescent room lights. Work only under safelights, tungsten light, or a 60-watt yellow "bug" light available at a hardware store. I use a tungsten bulb 4 feet (1.2 meters) away because it allows me to better see the color and the placement of the coating.

12. Sheet of glass or Plexiglas™ (optional). Hold the developed print at an angle on a sheet of glass while doing the first wash with a hose. This system allows unused chemicals to drain off, preventing them from contaminating the print. Wrap masking or duct tape around the edges to prevent the glass from cutting you and to cushion it from breaking. Additionally, you may want to tape your substrate onto a different sheet of glass (because it can be easily cleaned) or a coating board while you apply the emulsion.

13. White bowl or saucer. I use white ceramic (never metal) for mixing the sensitizer drops because they are easier to see on white surfaces under subdued light. Some printers use a shot (jigger) glass or egg cup. When I used glass, I placed it on white paper so that the drops were visible.

14. Thirty-two oz. (1 L) beakers or measuring cups and tablespoon. You will need a container of distilled water for holding and rinsing out the coating brush, but make sure you remove excess water from the bristles before coating each print. A large beaker of hot water, a crock pot, or a hot plate come in handy for heating up the developer beaker to 120°F (49°C) for warmer tones in a palladium print and for warming the bottle of No. 3 platinum and palladium sensitizer, which has a tendency to precipitate out of solution. Glass beakers conduct heat more rapidly than plastic. If you are mixing your own solutions, you will need measuring utensils and a gram scale. Again, do not use metal. See Item 19. A tablespoon is used for measuring the EDTA powder for the clearing baths.

15. Funnel, coffee filters, tongs. Use a glass or plastic funnel to save prepared liquids or when mixing stock solutions from dry chemicals. Use tongs or wear heavy gloves to move prints in the clearing baths.

 I "top off" the developer, which is a method for enriching the developer with the noble metals.

After a print is in the wash, I use a funnel, and every so often, a funnel with a filter, to pour back the leftover developer into the bottle. Then, using a fresh solution of developer, I add enough more to reach the top of the bottle.

16. Newspaper or cardboard. Cover the coating area with newspaper or coat on the smooth side of corrugated cardboard into which you pushpin the paper.

17. Humidifier (optional) and heater. The coated paper can be humidified before it is used. You can build a humidifying box in which you place a fan and small humidifier set for 60 percent relative humidity. Jesseca Ferguson, who created the illustrations on page 242 of this chapter, always keeps her whole studio at 50–60 percent relative humidity, which she checks with a wall-mounted digital meter. Especially in cold weather when the air can dry out, adding humidity can help with the coating procedure. You may need to run the humidifier for an hour for Ziatype. Platinum, palladium, and ziatype are sensitive to cold, which can cause graining. Heat up the room to 75°F (23.9°C).

18. Protective gloves, mask, and apron. Wear heavy neoprene gloves while you work, a respirator for mixing powders, and an apron to protect your clothes from contamination.

19. Hair dryer and/or clothesline and pins. Use a hair dryer on the cool setting or a fan to thoroughly dry the emulsion before laying a negative on top. A clothesline and pins or a rack can be used to dry finished prints. Please note that in Item 11, a drying rack protected from light is recommended.

20. Pencil, tape. It may be easier to tape or tack the receiver to a table or board and draw an outline of your negative on it to facilitate coating the emulsion. Make a cardboard template, or use the cardboard package with which the film was boxed so that you do not accidentally damage the negative. In addition, I pencil notes about the number of drops, amount of exposure, and type of paper on the back of the print.

21. Typing paper and gram scale (optional). If you are weighing raw chemicals, they should not come in contact with metal or contaminants. Avoid this problem by placing a sheet of clean lightweight paper on your scale.

TIPS

You can use a yellow bug light or a tungsten bulb, rather than a safe light, to illuminate your working space. With this kind of lighting, you can see your coating more clearly.

After you mix the stock solutions, shake them in their individual bottles to mix them. Shake all solutions before you use them, just to make sure that no chemicals have precipitated out. Or, keep the platinum and palladium bottles warmed to make sure that the metal is in solution.

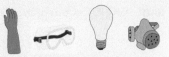

MIXING THE STOCK SENSITIZERS

Use a gram scale and be exact. This recipe is included if you want to mix from scratch, but I always skip this procedure and order the three premixed sensitizers from Bostick & Sullivan for the sake of my health and safety.

SENSITIZER NO. 1 (LOW CONTRAST)

Mix together:

- 1½ oz. (50 cc) distilled water at 100°F (38°C)
- 0.04 oz. (1 g) oxalic acid (optional)
- ½ oz. (13 g) ferric oxalate

Use at room temperature.

SENSITIZER NO. 2 (HIGH CONTRAST)

Mix together:

- 1½ oz. (50 cc) distilled water at 100°F (38°C)
- 0.04 oz. (1 g) oxalic acid (optional)
- ½ oz. (13 g) ferric oxalate
- 0.02 oz. (0.6 g) potassium chlorate for platinum *or*
- 0.01 oz. (0.3 g) potassium chlorate for palladium

Use at room temperature.

SENSITIZER NO. 3 (NOBLE METAL)

For platinum, mix together:

- 2 oz. (80 cc) distilled water at 100°F (38°C)
- 0.7 oz. (20 g) potassium chloroplatinite: crush it with a plastic spoon, then pour it into the water slowly while stirring

For palladium, mix together:

- 2 oz. (80 cc) distilled water at 100°F (38°C)
- ¼ oz. (8 g) palladium chloride: crush it with a plastic spoon, then pour it into the water slowly while stirring
- 0.2 oz. (6 grams) sodium chloride or table salt

SENSITIZER NO. 4 (OPTIONAL)

One to three percent gold chloride, a few drops to warm the tones and reduce the contrast of a platinum print or to tint a palladium print toward lavender. If you want only to change the tones and not reduce the contrast, add more drops of high-contrast (No. 2) and less low-contrast (No. 1) sensitizer. If gold chloride is used, do not replenish the developer as suggested in the Tips on page 246–247.

DEVELOPER

Mix together:

- 1 lb. (453.5 g) potassium oxalate
- 48 oz. (1.5 1) distilled water at 120°F (49°C)

The shelf life of #1 and #2 is approximately 3–6 months in a tightly stoppered brown bottle. The metal sensitizers and oxalate developer will last indefinitely in a tightly stoppered brown bottle.

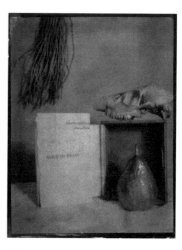

12.2a Version I: Solution No. 1, 9 drops; No. 2, 13 drops; No. 3, 24 drops; 5-minute exposure

12.2b Version II: Solution No. 1, 18 drops; No. 2, 4 drops; No. 3, 24 drops; 10-minute exposure

12.2c Version III: Solution No. 1, 14 drops; No. 2, 8 drops; No. 3, 24 drops; 12-minute exposure.

Jesseca Ferguson, *Sagesse des Enfants*, 8 × 10 in. (20.32 × 25.4 cm), palladium print from pinhole negative on Crane's paper, 1993. ©Jesseca Ferguson.

Jesseca Ferguson, who co-wrote the section on pinhole photography (pages 110–118) printed these three palladium images using one of her 8 × 10 in. pinhole negatives (Kodak Tri-X developed in Ektaflo diluted 1:15 for 2½ minutes). She used Bostick & Sullivan's premixed palladium chemistry, Crane's PS811 stationery, and an ultraviolet exposure unit. The mixtures and exposure times are listed above with each image. Notice how exposure time changes the lightness or darkness of the overall print, whereas the proportion of each sensitizer in the emulsion changes the contrast. Table 12.1 is the chart I use when I am making the platinum/palladium mixture to match my negative and paper.

Table 12.1 Contrast Control Chart for Platinum/Palladium Printing

Negative Contrast	Black-and-White Filter Comparison	Solution 1 (Number of drops)	Solution 2 (Number of drops)	Solution 3 (Number of drops) and equal number of drops of water	Emulsion Description
Very high	N/A	24	0	24	Very soft
Quite high	N/A	20	2	24	Quite soft
High	0	18	4	24	Quite soft
Contrasty	1	15	7	24	Soft
Normal	2	12	10	24	Normal
About normal	2½	9	13	24	Normal
Somewhat flat	3	6	16	24	Hard
Quite flat	4	4	18	24	Quite hard
Very flat	5	2	20	24	Very hard
Extremely flat	N/A	0	24	24	For extreme contrast

All drops are calculated for double coating an 11 × 14 in. (27.9 × 35.6 × cm) print. Increase drops by approximately 150 percent for 16 × 20 in. (40 × 51 cm) image or decrease for 8 × 10 in. (20 × 25.5 cm) image.

MAKING A PLATINUM/PALLADIUM PRINT

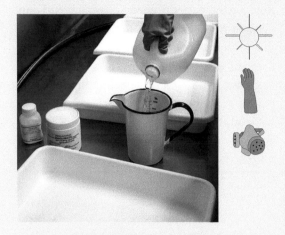

12.3 Prepare the Chemicals

2. Prepare the paper

Secure your paper to a smooth coating board or surface. Using a hard (e.g., 2H) pencil, lightly outline the image area. Be careful to handle the negative by its edges so as not to leave fingerprints in the image area. Allow a little extra paper for a test strip and for handling. If you use drafting tape to delineate the edges of the coating, you will obtain a precise border. Drafting tape is easy to remove after the print is in the wash water.

1. Prepare the chemicals

Set up three trays in a sink and mix exactly 1 tablespoon (14 cc) EDTA and 1 tablespoon sodium sulfite to 1 qt. (1 L) distilled water in each. You may find that the powder dissolves more easily in warm water, but use the baths at room temperature. Start to warm the No. 3 sensitizer bottle in a beaker of 90°F (32°C) water to dissolve the crystals, but use it at room temperature. Some printers warm the developer at this point, too.

12.5 Make the Sensitizer

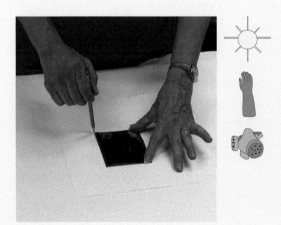

12.4 Prepare the Paper

3. Make the sensitizer

Referring to the chart on the page 242, drip the appropriate number of drops of each solution and distilled water into your saucer. Make only enough working sensitizer for one piece of paper. Return the stock noble metal solutions to warm, but not hot, water after using it and watch for crystalline deposits in that No. 3 solution, which you may have to heat up again.

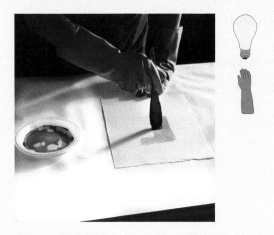

12.6 Coat the Paper

4. Coat the paper

Thoroughly swish the solution together, then puddle it in the middle of the image area. With a very slightly pre-dampened brush, quickly and evenly spread the emulsion in one direction, then flip the brush and go back in the opposite direction after each stroke. Next, lightly brush at a 90° angle until the emulsion dulls. Make sure the coating is even. With the remaining emulsion on the brush, coat a swatch for a test strip. (If you are mixing the sensitizer without water, I advise using only one coating.)

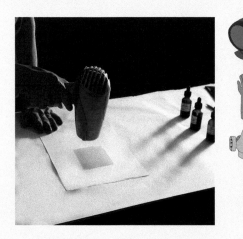

12.7 Dry the Paper

5. Dry the paper

Remove the paper from the coating board and allow it to sit face-up in the dark for 10 minutes while the emulsion settles in and partially dries. If you have added water to the emulsion, as I advise, let the first coating semi-dry before applying a second layer. Reposition it back on the coating area, then apply a second coating of emulsion. Wear a respirator with a toxic dust filter while using a hair dryer on the cool setting to finish drying both sides of the paper.

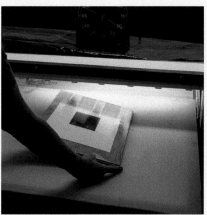

12.8 Expose the Print

6. Expose the print

Place the paper, coated side up, on a backing board and position the negative, so it reads correctly (which should be emulsions-down) on the emulsion. Lay this unit under heavy glass. Place the loaded print frame in direct summer sunlight for 1–5 minutes or under artificial ultraviolet light for approximately 5–25 minutes, or until the highlights show details. Different papers and types of negatives will affect the time.

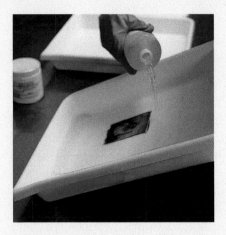

12.9 Develop the Print

7. Develop the print

Remove the paper and place it, image side up, in the developing tray held at a slight angle. The print develops quickly, so swiftly and evenly, pour a generous amount of developer over the exposed print and rock the tray for 1–2 minutes just to make sure development is complete and uniform. Or quickly immerse the print completely in a tray of developer, then rock the tray.

12.10 Wash, Then Clear the Print

8. Wash, then clear the print

Place the paper on a piece of Plexiglas™ angled in a sink. Gently hose the paper with water, then rock it in a tray of running or changing water for three minutes. Next, gently agitate the paper in three successive clearing baths for precisely five minutes each. When the first bath becomes discolored from use, after approximately three 8 × 10 in. (20 × 25.5 cm) prints, discard it. Move the second tray to the first position, the third tray to the second position, and mix fresh clearing agent for the third bath.

12.11 Wash the Print Again

9. Wash the print again

Drain the print, then use the siphon or tub method to wash it for 20 minutes, especially to remove iron and EDTA. Do not stream water directly onto the image. Blot excess water from the print with a clean, soft sponge and air dry on a rack, hang from a clothesline, or use a hair dryer or fan. Prints dry down considerably darker.

Return the used developer to the bottle and "top off" with fresh developer. (See item 15 under the Materials section of this chapter.)

TIPS

In my formula, oxalic acid, usually added to keep the highlights bright by getting rid of unwanted iron deposits, is optional, but I always use it.

In order to cut back on the cost of a platinum print and to warm its tones and reduce contrast, palladium sensitizer can be added when mixing the emulsion. The ratio I use is 25 percent platinum and 75 percent palladium, but just remember that the total number of drops of the No. 3 sensitizers, which contain the actual metals, should nearly equal the sum of the number of No. 1 and No. 2 drops used. In addition, the number of drops of water should be the same as the No. 3 mixture. This formula also reduces solarization—the reversal of tones—sometimes seen with pure palladium.

Use the more accurate plastic, rather than glass, eyedroppers.

Two thin coatings with the water-added formula above yield richer dark tones and allow you to make up for an uneven first layer. Some printers do not add water and apply one coat only. In addition, you can coat a sturdy substrate, expose a negative, process, dry a print, then recoat and re-expose with a different negative, process, and dry.

Always use the same ratio of platinum to palladium to ensure constant results. Even so, you may find that the same negative prints differently from session to session. Variances in the chemicals used by the paper manufacturer, not the platinum/palladium mixture, may be the culprit. Try printing on an entirely different paper and see if the same problems in print appearance arise.

Liquid ferric oxalate in the No. 1 and No. 2 sensitizer can go bad and cause black specks in the coating.

Eric Nielsen (http://www.ericneilsenphotography.com/HowtoPlat.html) also advises that if you mix the platinum and palladium together before adding ferric oxalate, the mixture will mature and have a warmer, slower effect than if the metals are kept separately and added one at a time to the coating solution, as my directions recommend. I have never tried this method.

In order to help protect the emulsion from the coating brush's ferrule you can cover the metal parts with clear nail polish or a line of super glue near the bristles.

If you notice areas of uneven darkness in the finished print, the solution might have pooled during coating or you may have poured the developer on unevenly. Next time, do not allow sensitizer to sit too long in one spot before brushing. If that does not work, do not pour developer directly onto the print; use a tray filled with developer, tilt the tray so as to collect the developer at one end, and then carefully enter your print into the tray and gently rock the developer over the paper.

Heated developer warms the tones in a finished print and keeps the constituent chemicals from precipitating out, but it also reduces image contrast and decreases development time. Therefore, to boost the contrast, add a little more No. 2 solution when mixing the emulsion and increase the exposure time (No. 2 also decreases the light-sensitivity of the emulsion) or add one drop of 3 percent hydrogen peroxide. Hot developer works more quickly, so be very careful to pour it on evenly and quickly, then to rock the print in the developer for two minutes, in order to avoid streaks. Do not worry about overdeveloping, because once the emulsion reaches its darkest tones, it will stop developing. Make sure the test print and the final print are developed at the same temperature.

Some printers, myself included, save used developer, claiming that as it ages it becomes "richer." We pour the developer back every

time it collects in the developer tray, replenishing the bottle with fresh developer, as described in Item 15 above. However, "topping off" is not recommended if you are using gold chloride or solely EDTA as the clearing agent. In addition, EDTA is recommended only with slightly acidic developers, such as ammonium citrate, but may not be effective with other developers.

Old developer makes a fine home for slimy mold. I have filtered the mold through a coffee filter in a funnel and continued to use the developer, but the safest solution is to buy fresh developer.

If you are making a pure platinum print, do not use the same replenished developer you used for palladium, and vice versa.

Wash the brush out thoroughly between each coating. Emulsion left on the bristles can become exposed and contaminate succeeding prints. To avoid soaking up too much emulsion, partially dry the brush.

Splotchy and mottled stains in the finished, dried print can indicate where the emulsion was not thoroughly dry before exposure. Wet emulsion can also ruin your negative. Grainy or mottled highlights can be caused by too

much humidity (over 70 percent). Drying the *back* of the coated paper on the hot setting of a hair dryer can help reduce the problem, but the temperature should not be above 120°F (49°C) or you may create dark spots in the final print. Condensation from the heat of the hair dryer meeting a cold coating surface can also cause mottling. Storing unexposed, coated paper with silica gel desiccant (I recycle the gel that comes with vitamin pills) in an air- and light-tight container is advised.

Exposures will vary according to the negative density, with very dense ones taking over a half hour. Keep a notebook of each print, its sizing and paper, age of the chemicals, what mixture you used, and exposure time. Then when you have a similar negative, you will know where to start. Exposures also will be longer when you use citrate, rather than oxalate developer, but I usually start my tests at six minutes.

If the overall print is too light, as in the first example of Jesseca Ferguson's print, above, most likely exposure time is too short.

Streaks in the print, running through shadows, midtones, and highlights may be caused by uneven development and may be particularly

12.12 Kay Kenny, *Weasel*, from the *Snowdreams* series, 15 × 20 in. (38.1 × 50.8 cm), platinum/palladium print of landscape on Platine watercolor paper with graphite and colored pencil drawings of animals, 2016. © Kay Kenny.

prevalent with hot developer. Try to develop the whole print promptly and uniformly next time.

Yellow highlights indicate insufficient clearing time or weak/exhausted clearing bath. Either increase clearing time, the concentration of EDTA, or mix fresh baths.

12.13 Laura Blacklow, *Bety's Mother*, Santiago, Atitlán, Guatemala, 3 ¼ × 4 ¼ in. (8.25 × 10 cm), palladium/platinum print developed with ammonium citrate on Arches Platine paper. ©L.Blacklow.

I have been volunteering at Fotokids (www.fotokidsoriginal.org) for over 20 years. The project was initially called Out of the Dump from its humble beginnings in the Guatemala City Dump, where thousands of people, including families, spend their lives combing through cast offs to sell to recyclers. Fotokids has served hundreds of at-risk Guatemalan and Honduran children affected by poverty and violence by giving them a chance to dream of a better life through vocational training and self-expression using photography, graphic design, and media technology as tools for creativity, leadership, and future employment. I feel fortunate to get to know the Mayan families of Fotokids students.

Technically, the child was in such deep shadow that he could not be seen in a test print. In order to correct the problem, I had to go back to the digital scan and make a curves layer in Photoshop® that opened the shadows before printing this version of the image. The chapter Making Negatives: Digital Method on page 135 explains much more.

You can clear a print after it dries, if it has been kept out of light.

Fogged (grayed) highlights can be caused from ambient fluorescent or ultraviolet light.

Flat, undifferentiated shadow detail can be caused by three reasons. The first is a negative that does not have any density in the shadows. If the negative is not so thin that there is no separation in the shadows, you can mix up a more contrasty emulsion and try exposing it again. Another reason could be that the paper is not sized properly, which can increase developing time and prevent thorough clearing, too. Paper and sizing are the crucial factors after negative density and emulsion contrast.

I make test prints before I create a final print. Cut a strip of paper one-third the size of your negative. Coat it with emulsion, dry it properly, then place a part of your negative with shadow detail, highlight detail, and midtones over the strip. Position the unit under glass, but cover two-thirds of it with opaque cardboard. Expose for five minutes. Move the cardboard and expose for another five minutes. Entirely remove the cardboard and expose for another five minutes. Process the test strip normally, dry it, then, under a good viewing light, choose a proper exposure for the finished print. The darkest strip, which is the first one exposed to UV light, received the most time while the lightest strip, the one exposed after you removed the cardboard, received the least amount of light.

Prints dry darker, and so they look different when wet than when dry.

For suggestions on coating fabric, refer to the Cyanotype on Fabric section at the end of Chapter 7.

NOTE

1 Greenough, Sarah, et al. *Steiglitz in the Darkroom.* Washington, DC: National Gallery of Art, 1992.

13.1 Wayne Firth, *Purington's Store*, Randsburg, California, hand-colored bromoil print on Kentmere Art Document paper, 6 × 9 in. (15.24 × 22.86cm), ©2016 Wayne Firth.

The print was made on non-supercoated paper, then the photographic image was bleached away. Afterwards, an ink image was created by applying Van Son lithographic ink to the damp print using a foam roller. The color accents were added with pencils after the print was dry.

Bromoil Prints

By Gene Laughter

Gene Laughter, a retired advertising executive, owned a fine-art photography studio and gallery, The Bromoil Factory, in Richmond, Virginia. He had won awards for his artwork and was the author of *Bromoil 101* (see Annotated Bibliography), founder and past president of the Photographic Art Network of Virginia, and the first U.S. member of the Bromoil Circle of Great Britain. He gave many talks and workshops on bromoil and was the originator of the International Society of Bromoilists. Sadly, this generous man died on February 14, 2017. Laughter's friend, Wayne Firth, whose bromoil print starts this chapter, took all the color step-by-step photos. I did the drawings. All other photo illustrations are Gene's work. (L.B.)

SAFETY

Pigment powders pose little immediate damage from ingestion or inhalation, but repeated exposure to small amounts of some pigments can cause chronic poisoning or other serious effects. To check on the effects of individual colors, read Shaw and Rossol's *Overexposure: Health Hazards in Photography*, listed in the Annotated Bibliography or look online.

Copper sulfate may cause skin allergies and irritation. Chronic ingestion can cause anemia. Wear a toxic dust mask and gloves.

Potassium bromide in large amounts can cause mental problems and skin rashes. Wear a toxic dust mask and gloves.

13.2 A bromoil print that Gene Laughter rendered in a photographic manner, which employed the use of both a brush and brayer for inking. The silver in the original photograph has been replaced by pigment, resulting in an archival print.

Potassium bichromate (also known as dichromate) is highly toxic by inhalation and is a suspected carcinogen. Skin contact may cause irritations and allergies. Wear gloves, goggles, and a toxic dust mask.

For safety warnings on black and white photography, please refer to the Chapter 5, Analogue Methods, from the fourth edition of New Dimensions, which can be obtained by contacting Laura through her website www.laurablacklow.com.

Naphtha can be highly irritating to the skin and eyes and is flammable. Wear gloves, make sure you have proper ventilation, and store naphtha away from open flames and lit cigarettes.

METHOD OVERVIEW

1. A low-contrast black-and-white photograph is made.
2. The photograph is bleached, tanned, and dried.
3. The original silver image is replaced by applying an oily pigment, such as lithographer's ink. The resultant print can be detailed or impressionistic, grainy or smooth.

MATERIALS

1. Brushes, scissors, foam rollers, newspaper. You can quickly and easily make your own brushes by modifying Williams-Sonoma pastry brushes, faux-finishing brushes, hog bristle shaving brushes, sash brushes, or artists' brushes. Using sharp scissors or barber's shears, simply trim the bristles at a 25–30° angle. Use VMP naphtha for cleaning tiles and brushes (see Care of Bromoil Brushes, later in this chapter). Newspaper also is helpful for cleaning the brushes.

A small 4 in. (10 cm) decorator's foam paint roller purchased at a building supply store may be used

13.3 Decorator's foam painting rollers, shaving brushes, cosmetic brushes, artists' brushes, basting and pastry brushes, and faux-finishing brushes may be used for applying ink to a bromoil matrix. © W. Firth.

for applying and evening out ink and for clearing highlights. The roller also can be used in combination with a brush.

2. Ink. Graphic Chemical and Ink Co. No. 1803 crayon black is the most popular ink used by bromoilists. No. 1903 dark brown may also be used, as well as any number of other colors. Each bromoilist may best determine whether to use only black or brown or to add additional colors. Van Son Rubber Base Plus V5151 black printer ink is also very good and is available in many colors at commercial printing supply companies.

Most lithographic inks come in a can, which should be tightly sealed after taking out the small amount to be used for a bromoil session. Take the ink from the can with an artist's spatula by scraping lightly with the blade. Do not gouge into the ink and form holes, which can dry out the contents. Use plastic (electric) tape to seal the lid.

3. Ink modifiers. To stiffen the ink, add a drop of melted candle wax or beeswax, artist's dry pigment from an art store, or magnesium carbonate from a litho supplier. To soften the ink, add a pinhead-size drop of plate oil or linseed oil purchased at an art supply store. A small drop of Canada balsam (see Art Craft Chemistry in the Supply Sources) may be added for more tackiness.

4. Inking tiles and palette knife. Purchase several smooth, white, ceramic bathroom-type wall or floor tiles in sizes from 4 in. (10 cm) to 12 in. (15 cm) square. Spread the ink on the tile with a palette knife, which can be found with oil painting supplies in an art store.

5. Small rubber brayer. Use a 1½ in. (4 cm) or 2 in. (5 cm) brayer for spreading the ink on the tile in a thin, perfectly smooth layer.

6. Inking support. A piece of beveled plate glass several inches larger than the print makes a perfect support for inking. The support may be tilted to your liking.

7. Photo blotter. Place the blotter on the inking support when drying the front and back surfaces of the bleached print (the matrix). Remove the blotter from the support before you begin inking.

8. Soft paper towels or flannel. Use a paper towel folded in quarters for a smooth pad with a flat surface to blot the surface water from the front and back of the matrix.

9. Cosmetic wedge, cotton balls, cotton swabs, or plastic wrap. All of these items can be used to clean a bromoil print.

10. Steel wool. Artists' grade extra-fine steel wool can be used to create texture in the final print.

11. Bleaching and tanning chemicals. Bromoil bleaching kits are available from Art Craft Chemistry or Bostick & Sullivan (see Supply Sources). These kits have premeasured amounts of the requisite dry chemicals, which are added to distilled water to make 1 qt. (0.95 L) each of the three stock solutions. You will need three brown bottles for storage. Measure and mix working solutions just prior to bleaching and tanning.

13.4 Bromoil Bleaching Kit. © W. Firth.

Bromoil bleaching kits make the preparation of the stock solutions simple. No weighing scales are necessary. Wear gloves and a toxic dust mask while you pour the contents of each of the three bags into separate 1 qt. (0.95 L) bottles and add distilled water to the top of each. Shake vigorously.

12. Hand-coloring materials. Dry bromoil prints can be enhanced with colored pencils, pastels, Peerless Water Colors, food coloring, and coffee.

13. Photographic paper. For many years, photographic papers have been in a state of flux, and many papers have been discontinued. Agfa Photo went out of business. For the bromoil process

most semi-matte fiber-based papers will work. Generally, semi-matte papers ink up better and far more easily than glossy or absolutely matte ones. You may have read that only non-supercoated papers will ink properly for bromoil. This was true many years ago, but not now. Many bromoil-ists, including Gene Laughter, actually preferred super-coated papers for bromoil. You may need to experiment with the paper a bit in order to come up with the proper amount of exposure during enlargement and the time and tempera-ture of the soak water. Also, several brands of non-supercoated papers produced specifically for bromoil are available in the United States and Europe. David Lewis (see Supply Sources) in Canada, makes special Bromoil paper. Do not miss George Smyth's site, https://bromoilpapers. wordpress.com/, where he keeps you up to date on papers and even using Liquid Light (Chapter 14). He discusses Ilford MG Fiber Classic (can be used with a bit of coaxing), Fomabrom N133 (not acceptable), Imago Bromoil Paper (superb, but might not be made as of the printing of this book), David Lewis Bromoil Paper (outstanding, but only comes in 8 × 10 in. [20.32x 25.4 cm] size), and Foma Fomatone 134 Classic VC FB Warmtone (available from Freestyle in many sizes, nice option with proper inks). The dealers are listed in Supply Sources.

14. Darkroom and black-and-white photo chemicals. Instead of conventional fixer, use a 10 percent solution of pure hyposulfate, available from Art Craft Chemicals, Photographers' Formulary, or Bostick & Sullivan, who sells pre-measured chem-icals following Gene Laughter's formula, all listed in Supply Sources. The simple way to make up a 10 percent solution is to pour the hypo crystals in a beaker to the 4 oz. (118 ml) mark and add this amount to 1 qt. (0.95 L) of water. Or, you can use liquid Kodak Rapid Fixer diluted as the manu-facturer recommends for paper, but without the hardening solution. Again, George Smyth saves the day with his list of suppliers at http://glsmyth. com/alt- process/bromoilists.asp.

15. Labeled trays. You will need separate trays for bleaching/tanning and the first soak, and either a tray with a siphon or an archival print washer.

16. Acetate, tape, pencil. Acetate sheets, available from an art store, or old sheets or ortho film are cut with a straight edge and stencil knife. The 2–3 in. (5–7.5 cm) wide strips should be 3 in. (7.5 cm) larger than the image and taped together at a 90° angle to each other to form an "L" if you plan on darkening edges and corners of the print. KleenEdge or low-tack tape, sold in some build-ing supply stores, is especially easy to use for this purpose. A pencil is helpful for keeping notes on the back of the print.

GUIDELINES FOR BROMOIL PRINTING

Bromoil is a marriage of photography, print-making, and painting. The printing and processing of the matrix are fairly inflexible procedures. A standard routine should be established and followed. After the matrix is prepared and is ready for inking, however, bromoil becomes a more freewheeling process with great latitude. One cannot properly direct another on how a bromoil print should look. It is an individual, creative process. The tips in this and the following sections will help you get started, however.

MAKING A BROMOIL PRINT

1. Selecting the image

Choose any black-and-white negative that fits your enlarger system. The negative size is not important. The best type of negative for bromoil should not be contrasty but should possess a full range of midtones and detail in both shadow and highlight areas.

2. Making a test print and guide print

In a conventional darkroom, make a test strip or a test print on fiber photographic paper to determine the best normal exposure and the optimum times for burning and dodging. This print is useful as a guide when inking the matrix to determine the tonal values and details you wish to bring out in the inking. Make a guide print and process it at the exposure determined in this step.

3. Exposing the print

Make a print for bromoil by opening up one stop more than the exposure for the guide

13.5 Making a Test Print and Guide Print. © W. Firth.

13.6 Exposing the Print. © W. Firth.

print if you are using super-coated paper (United States) or ¼ stop more if you are using nonsuper-coated paper (United Kingdom and Europe). Super coating is a hardened antiabrasive layer the manufacturer uses. Leave a safe edge, or white border, of at least 1 in. (2.5 cm) around the bromoil image for ease of handling later.

The print in the accompanying photograph was exposed a full stop more than the test print. The overprinting allows the gelatin of the super-coated paper to swell sufficiently later in the bromoil process.

4. Developing the print

Fully develop the print for three minutes in either Ethol LPD, Kodak Dektol 1:9, or Rodinal film developer (Photographers' Formulary, in Supply Sources, makes the equivalent) 1:30. Agitate continuously. Place the print in stop bath for 45 seconds or water bath for 5 minutes, and then fix the print in a bath of 10 percent solution of sodium hypothiosulfate or liquid Kodak Rapid Fix *without* the hardener added.

5. Washing, drying, and soaking the print

Wash for at least 30 minutes with a siphon washer in a tray or in an archival print washer. Gently blot off any surface water. Air dry for at least 6 hours. Super dry by holding a hair dryer on the hot setting 4 in. (10 cm) above the print until it is crisply dried. Completely soak the print for 5 minutes in a tray of water at room temperature. Drain it.

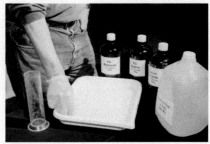

13.7 Bleaching the Print. © W. Firth.

6. Bleaching the print

Mix a tray of bleaching/tanning solution at working strength from 2⅓ oz. (70 cc) of 10 percent copper sulfate stock solution, 2⅓ oz. (70 cc) of 10 percent potassium bromide stock solution, and 1 oz. (30 cc) potassium bichromate stock solution. Add enough distilled water to this mixture to make 1 qt. (0.95 L), which will bleach/tan approximately eight to ten prints with an image size of 6 × 8 in. (15 × 20 cm).

Constantly agitate no more than three or four prints at a time while bleaching them for 8–10 minutes. Use tongs and gloves.

7. Washing and fixing the matrices

Wash these bleached prints, called *matrices*, for 10 minutes to remove traces of the bichromate.

Fix in a fresh bath of 10 percent solution or Rapid Fix without hardener for five minutes. Wash in running water at room temperature for at least 30 minutes. Gently blot off water. Air dry for at least 6 hours. Super dry (Step 5) again.

On many papers a faint latent image may be seen. Sometimes, one can see a greenish tan image. If there should be dark brown or black areas, however, you might have exhausted the bleach solution or printed too dark a photograph.

13.8 Washing and Fixing the Matrices.
© W. Firth.

8. Preparing the ink

Place a pea-size dollop of lithographic ink on one corner of the inking tile and spread it into a thin layer with the edge of a palette knife, as if you were spreading butter on toast. Using the brayer, spread out the ink into a perfectly smooth square patch on the tile. If you will be applying ink with a brush, roll the ink into a 2 in. (5 cm) square. If you will be applying ink with a roller, the square should be 1 in. (2.5 cm) or so larger than the roller.

9. Preparing the matrix for inking

Soak the matrix in a tray of tap water at 68–75°F (20–24°C) for 10–20 minutes. The actual time and temperature of the soak can vary with the degree of hardness of local water and with the photographic paper used for making the matrix. Soak only one matrix at a time, and keep it totally submerged by placing coins or pebbles on the safe edges.

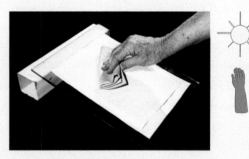

13.9 Blotting the Matrix. © W. Firth.

back of the matrix by gently rubbing, and blot dry all traces of water from the emulsion side of the bleached matrix.

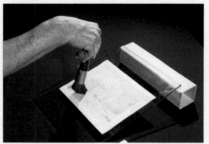

13.10 Inking and Resoaking the Matrix. © W. Firth.

10. Blotting the matrix

Place the matrix on blotting paper and remove every visible trace of surface water from both sides using a folded soft paper towel. Dry the

11. Inking and resoaking the matrix

Move the matrix, emulsion side up, to a plate glass support angled as needed for your comfort. Apply lithographic ink of the desired

stiffness (see the following Tips). The wrist is used as a fulcrum when inking. See the following section Brush Actions for Inking for detailed information on inking techniques.

Evaporation diminishes the differential swelling of the gelatin so that highlights readily and uniformly accept ink, making proper inking increasingly difficult. You may also notice the corners of the matrix beginning to curl slightly. Resoak the partially inked matrix for a few minutes in room-temperature water. During the resoak, reroll the ink on your tile with a brayer to even the ink. Blot the matrix dry again. Continue inking and resoaking until the bromoil print is complete.

TIPS

The best way to establish the time needed for the soak prior to inking (see Step 9) is to cut a matrix into quarters and experiment with inking it after soaking one piece for 10 minutes, another for 15 minutes, a third for 20 minutes, and a fourth piece for 25 minutes. With this test procedure, one can establish the proper lengths of future soaks. Write the information on the back of the print.

Immediately preceding a resoak of the matrix (see Step 11), remove any broken hairs or tiny bits of debris on the surface of the print with the pointed end of a kneadable eraser. Form a piece of plastic wrap into a ball and dab any ink blobs or overly inked areas while constantly turning the ball so that a fresh, clean area is always touching the print's surface.

Ink may be applied to the matrix either with a brayer, a brush, or a combination of brush and roller. Roller inking is much faster and easier than brush inking and imparts a more photographic, contrasty appearance to the print. The roller action eliminates all grain and softness. Brush inking renders a print with more grain. Many contemporary bromoilists combine the two by first applying a fast, even layer of ink onto the matrix with a brayer, then using the brush for the balance of the inking. Others use a brush for ink application and a roller for evening out the ink and for clearing the highlights.

When using a brayer for inking, tape the matrix to the glass with KleenEdge or low-tack masking tape so that the print will not curl around the brayer's roller. Slow rolling with downward pressure applies the ink, whereas rapid rolling with almost no pressure clears the ink and brings in fine detail. Turn the matrix and repeat the procedure with horizontal rolls. Do not be concerned with overall streaks. Return the matrix to its vertical position. Clear the brayer by rolling it onto a clean portion of a large tile until the ink is removed. Then rapidly and lightly use the brayer on the print to roll in all directions. This action clears the print and evens out the ink.

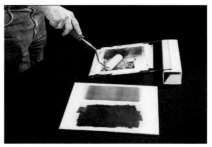

13.11 In daylight, use a 12 in. (30.5 cm) tile or two smaller tiles when inking with a roller. The darker patch of ink on the tile has been completely smoothed out with a brayer, and the lighter patch is the clearing area. Clear the roller by rapidly rolling on the light area before applying ink to the matrix. This procedure evens out the ink on the roller and allows you to apply a series of very thin ink applications. Do not try to apply too much ink at one time. © W. Firth.

When applying ink with a brush, rapidly and lightly tap the tip of the brush on the tile's smoothed-out ink patch, then tap the brush several times on a clear portion of the tile to even out the ink on the bristles. This second spot is the area you will work from when you place ink on the brush prior to inking the matrix. The first smoothed-out square is your ink reservoir.

You can use a foam roller to clear a brush-inked print, to bring out detail, and to even out any overinking. First, use low-tack masking tape to adhere the matrix to the inking support. With a rapid, extremely light touch, roll the foam roller across the print. If you want to bring back grain after a foam roller clearing, re-ink the print with a minimum of brushwork.

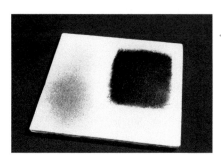

13.12 The light, perfectly smooth patch on the left is the one from which you will get your ink. Do not go directly from the ink reservoir patch to the print, or the brush will have too much ink unevenly distributed in the bristles. © W. Firth.

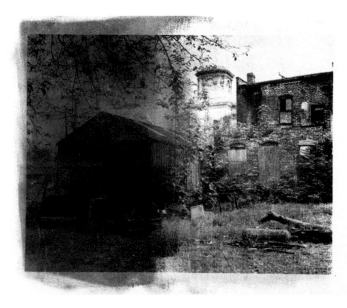

13.13 Clearing the print. © W. Firth.

Clearing: Ink has been applied to the left half of this matrix by slow forceful rolling with a foam roller. The right half has been cleared by rapidly rolling with a foam roller and no pressure.

In the latter stages of the inking process, a wet foam paintbrush or wet cosmetic wedge can be lightly rubbed onto the highlights to make them more brilliant and to increase the overall contrast of the bromoil. Do not apply any pressure; just let the weight of the wet wedge or brush do the work. A soaking-wet, soft paper towel also can be used to lightly wipe the entire surface of the inked print for the same purpose. Should more inking be required after this procedure, resoak the matrix and surface dry it before going back to brushwork. Otherwise, the gelatin in the areas that you have rubbed will absorb water and the swelling of the gelatin will be uneven. A wet cotton ball or swab also may be used for clearing small details.

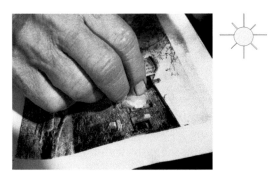

13.14 A soaking-wet cotton ball lightly wiped on highlight areas can increase contrast and make the highlights sparkle. If fresh ink is needed after rubbing with the cotton ball, the matrix must be resoaked in water to even out the swelling. © W. Firth.

To achieve an etching-like quality that emphasizes coarse grain and minimizes detail, use a hog-hair brush with hard ink and a minimum of brushwork. You may find it necessary to add a drop or two of melted candle wax or beeswax to the ink in order to bring it to a proper stiffness. Strive for a bold, broad, overall loose rendering by employing a very rapid brush action followed by a minimum of very light hopping (see following section, Brush Actions for Inking). Use just enough hopping to maintain an even quality of ink on the gelatin. Keep in mind that all ink applications should be applied with the objective of retaining the structure of the coarse grain; hold yourself back on the brushwork! Using crumpled plastic wrap to dab overinked areas can aid in achieving the etching-like appearance.

For a more photographic rendering, soak the print in very warm water until the swelling is greater than for hard-ink work. Then use a soft-hair brush with an easy-flowing pigment so that the image easily builds up rapidly. If brushwork is carried too far and too much soft ink is applied, the shadow areas will clog up, which requires one of these remedies: gently dab a ball of plastic wrap on the overinked portion, or place a sheet of tracing paper on top of the image and roll lightly with a brayer until you remove the excess ink. Afterward, even out the ink by hopping with a brush (see following section, Brush Actions for Inking) or rolling rapidly with a clean foam roller.

To make soft bromoil brushes for hopping and for applying soft ink without grain, visit the cosmetic department of a discount or beauty supply store and purchase either a blush brush, body brush, or cosmetic brush. Badger-hair shaving brushes also are ideal and readily available. Many artist's brushes are made of soft hair and can be easily trimmed into a stag-foot brush.

When using the walking-and-dragging or pouncing brush techniques (see the following section, Brush Actions for Inking), warm up the soak 5–10° and thin the ink if the details are not coming in properly after the initial inking stages. Resoak the matrix for five minutes while you rework the ink. Thin the ink by adding two pinheads of pure unstiffened ink of the same color. Or, add one small drop of plate oil, stand oil, or linseed oil to the ink from a toothpick. Rework the ink with the palette knife and a small, hard brayer.

If you plan to reuse the ink on the inking tiles for retouching or re-inking within 24 hours, keep the tiles air-proof and prevent the ink from drying out by carefully enveloping them in plastic wrap.

BRUSH ACTIONS FOR INKING

WALKING AND DRAGGING

13.15 Walking and Dragging. © L. Blacklow.

POUNCING

13.16 Pouncing. © L. Blacklow.

Walking and dragging: The brush is charged with ink, dabbed, dragged and lifted without the brush completely leaving the matrix surface. The brush is recharged with ink when necessary.

The purpose of the *walking-and-dragging* action is to coat the matrix with an initial thin layer of stiff, greasy ink. Place the toe facing away from you, load the brush with ink, and touch the top left corner of the matrix. Holding the brush firmly at a right angle to the matrix, press down until the heel also touches. Then, relax the pressure and move the brush slightly toward you, leaving a deposit of ink as you go. Repeat this action rapidly but gently while dragging the brush in a line from the top to the bottom of the matrix. When you reach the bottom, the toe of the brush leaves the surface of the matrix for recharging the brush with ink. Otherwise, the toe of the brush never lifts off the matrix. Overlap the original deposit of ink by walking and dragging the brush in a new vertical row. Continue to the bottom, recharge the brush, and repeat the walking-and-dragging procedure until the entire surface of the print is covered with a uniform light layer of ink.

Pouncing: This brush action will clear ink from the highlights and redeposit it in the lower midtones and shadows. Recharge the brush with ink as necessary.

The purpose of the *pouncing* action is to remove excess ink, thereby creating some contrast; to redistribute previously applied ink from the highlights to the midtones and shadow; and to build up the density of the image with additional ink. The brush is held firmly and vertically to the matrix, but now the stroke starts with the toe of the brush turned away from you and held approximately ½ in. (1.25 cm) from the matrix. With a gentle pouncing action, force the brush hairs to expand until the whole surface of the brush is in contact with the gelatin, then allow the bristles to spring away smartly as the brush returns to its original position of ½ in. from the surface. There is no dragging; the strokes should be carried out briskly, yet gently, in a circular pattern, with each stroke separate but close together. The brush should be recharged with ink after every five or six pounces. Pretend the brush is gently kissing the matrix. No force!

Pouncing is the brush action most often used for general bromoil inking. After walking and dragging, pouncing can also be used without ink on the brush to redistribute ink on the print from highlights to shadows. The walking-and-dragging action and pouncing are used together to build up the density of the ink and increase contrast.

A great deal of wrist action goes into pounc-
ing. The forearm stays in a fixed position and
the up-and-down motion of pouncing stems
entirely from the wrist. The gelatin matrix is
delicate, so do not bounce the forearm, or the
force will be transferred to the brush bristles,
which results in plugged-up shadows.

HOPPING

13.17 Hopping. © L. Blacklow.

Hopping: You can produce greater contrast
and clean the image with this bouncing
action. The brush should be cleared of any
ink prior to hopping by stippling it on a clean
piece of newspaper.

The purpose of the *hopping* action is to bring
out the details of the highlights and upper
tonal values as well as the shadows through
lightening the inked areas. The brush is held
vertically as for pouncing, but now it is held
loosely and is allowed to slide through the
fingers and bounce vertically off the surface
of the matrix. The weight of the brush falling
about 1 in. (2.5 cm) onto the matrix is the sole
force behind the bristles spreading. Hopping
is a bouncing, instead of a pouncing, action.

A more forceful hopping action, dropped from
2 in. (5 cm) above the gelatin surface, should
be used with extreme caution. Keep the han-
dle vertical and the toe away from you.

SWEEPING

To clear detail in the upper values, a more
vigorous variation of the hopping stroke,
sweeping, entails gently whisking the bristle
tip across the inked gelatin surface. The brush
handle is held at the extreme end away from
the bristles. The wrist acts as the fulcrum,
and the brush swings like a pendulum while
a rapid sweeping motion is executed.

COMMON BROMOIL INKING MISTAKES

1. Using too much force with the brush when apply-
 ing ink, thereby destroying detail and creating an
 uneven and splotchy print.
2. Going too quickly when inking. Have patience or
 you may lose some subtle aspects of your print.
3. Inking unevenly, which makes dark smudges on
 the print. This is often caused by failure to consist-
 ently smooth out the ink on the tile.
4. Thinking the print is finished when it actually
 needs more depth of inking. Prematurely stopping
 the inking results in faint areas on the image.
5. Generating a print that lacks contrast and is
 dominated by an overall muddy look. This com-
 mon error usually is caused by not performing the
 inking techniques carefully, not applying a good
 base of stiff ink first, and not using a wedge to
 clear the highlights.
6. Plugging up the shadows with excessive ink or ink
 that is far too soft.
7. Using ink that is too soft for the swelling of the
 matrix, resulting in blocked-up shadow and high-
 light detail.
8. Using too much ink on the brush, which creates
 plugged-up shadows and splotches in the print.
9. Failing to remove every water drop from the front
 and back surfaces of the matrix. This allows mois-
 ture to get into the brush bristles and later creates
 small white spots on the print.
10. Failing to consistently remove small hairs, lint, and
 bits of trash off the face of the print, causing ink
 build-up around and over this debris.

PRINT FINISHING AND ENHANCEMENT

When the bromoil matrix is soaked in water, the gelatin swells, and water retained by the swelling repels the greasy ink. However, when you apply ink to a dry print, the ink will be accepted evenly, both in the highlights and in the shadows. This is a simple concept, but it is also an effective print-finishing technique, because selected areas of an image can be strengthened and intensified. You as the bromoil worker have important manipulative controls, such as those listed in the following Tips section.

TIPS

You can dry an inked print for days or months, then re-ink it after a long water soak. In this way you can add a new color or obtain consistency in a series of prints.

With a semidry or totally dry print, you can darken the edges and corners. Tape two acetate straight-edge strips together at a perfect right angle and secure this mask along two of the image's edges as you gently, lightly, and slowly ink the edges of the image. Remember that any over-inking cannot be reduced unless you resoak the print and work the problem out with plastic wrap of hopping.

Lightly rub the surface of a completely dry and flat bromoil print with a dry paper towel or piece of soft flannel to increase contrast and give the image more brilliancy. Follow up by swabbing the face of the print with a wet paper towel or wet cosmetic wedge. Use a fast, light touch for both rubbing and swabbing.

To produce fine striations on the inked surface, use artist's grade extra-fine steel wool that contains no oil. Lightly wipe the surface of the completely dry print. Before you start this procedure, ask yourself, "Will striations enhance this particular image?" If you are not certain, do not do it, for there is no turning back once you have started!

Many bromoilists use Marshall's Oil Pencils (see Freestyle Camera Co. in the Supply Sources) or Berol Colored Pencils to hand color a bromoil print.

Peerless watercolors (see Peerless Color Laboratory in the Supply Sources), designed to sink into the gelatin layer of a photograph, can be used to tint bromoil prints. Their selective application is explained on page 145 of Chapter 2, Hand Coloring. For tinting, add cut pieces of the cardboard color to a tray of water, then soak the entire print in it for approximately 20 minutes.

Food coloring, such as that used to dye Easter eggs and cake icing, is available at pharmacies or grocery stores and can also be used for tinting. Mix 8–10 drops in 1 qt. (0.95 L) of water and add a tablespoon of white vinegar for brilliancy. Pour this mixture into a tray and immerse the bromoil print with a constant, gentle rocking motion. Pull the print out every few minutes until you have achieved the depth of tinting you want, then blot the print dry.

Coffee imparts a yellowish-brown shade to the print. Pour a cup or two of drinking-strength coffee at room temperature into a tray with 1 qt. (0.95 L) of water. Soak the bromoil print in this solution and pull the print out every two minutes for inspection. If you overtint, soak the print in fresh water until the coffee leaches out and reaches the tone that suits you. Tea can be used for a different sepia shade.

To mount the finished print, first flatten the picture by dampening the back and placing it overnight under a piece of glass weighted with books. Or, dampen the back and place the print in a dry mount press for two minutes at 200°F (93°C). Mount the bromoil print on four-ply, acid-free board with linen tape hinges. A window overmat adds protection.

CARE OF BROMOIL BRUSHES

Use VMP naphtha and a glass artist's brush-cleaning jar fitted inside with a metal coil for rubbing the brush tips. Clean your brushes after every studio session, but use artist's brush-cleaning soap only three or four times annually, because it has a tendency to dry the hairs. After cleaning your brushes, hang them to dry with tips facing downward.

With an ordinary hair comb or a wire brush, comb the bristles of your bromoil brushes prior to use. The teeth of the comb or wire brush separate any hairs that are stuck together and keep the brushes in fine order.

For each brush, make a hooded wrapper. Cut a thin plastic, acetate, or cardboard strip and wrap it around the bristles to hold them in place. Put a rubber band snugly around each brush wrapper. Store the brush in the wrapper after each cleaning to protect it and to keep it in proper shape.

George Smyth (http://georgesmyth.com/) is the creator of The Extras, a book and/or free download of his art work. The International Society of Bromoilists can be reached at www.bromoil.info, where you can read Gene Laughter's page, What Is Bromoil?; pertinent articles (including the last bromoil class of the millennium, conducted by Gene Laugher); technical information for related methods; and links.

The Bromoil Circle of Great Britain, www.thebromoilcircleof greatbritain.com, has links to other bromoil websites, members' gallery (including Gene Laughter's work), tutorials, history and materials suppliers in the U.K.

Laughter is known by bromoilists for his adaptation of supercoated papers for bromoil. The process was just about dead because the traditionalists insisted on using non-supercoated papers, which were being discontinued. Gene found a way around this by modifying the temperature and length of time of the water soak stage of the process.

14.1 Ann Rosen, *Iwasaki's in Prospect Park,* 40 × 40 in. (101.6 × 101.6 cm) framed, 31 × 31 in. (78.7 × 78.7 cm) unframed, hand-applied black and white emulsion, oil pastel, charcoal, pencil on Arches 300 lb. natural white, rough watercolor paper, 2002. ©Ann Rosen (See more of her work at www.annrosen.com.).

For over two decades, Rosen has been photographing families and the intermingling of ethnic and racial groups in Brooklyn, NY. Her project chronicles their diversity as exhibited through intermarriage, biracial adoption, and same-sex marriages. Rosen is inspired by how family members' gestures reveal their relationships, which she emphasizes by creating double exposures. After interviewing these subjects, Rosen writes their stories in detail, onto the frames.

14

Enlargement Emulsions and Tintypes

From the late nineteenth century, factories manufactured gelatin-silver emulsions that were coated onto papers of various pale colors and thicknesses, glass (also known as lantern slides and dry plates), silk fabric, and even flock paper. Emulsions were first made with gelatin-silver bromide in the 1880s and have been used ever since because the mixture was sensitive enough for an image to be projected/enlarged, rather than contact-printed, onto it and developed. A more thorough history of silver emulsion is at the beginning of the Daguerreotype chapter on pages 284. Despite the yearly decline in traditional black and white analogue methods, every time I take a class of Museum School students into the darkroom, an audible "Oooooo" can be heard when the enlarged image first appears in developer, so it seems that the "magic" still exists.

This chapter will concentrate on silver bromide black-and-white emulsions that can be coated onto a variety of surfaces and handled under an enlarger in a conventional photographic darkroom, yielding a continuous-tone image. Coat-on emulsions are made by numerous companies in the United States and Europe. Rockland's Liquid Light was the first on the market, and I remember being so excited after I bought it, that I took the bottle

out of the cardboard packaging only to totally ruin it because the container was clear plastic, allowing the emulsion to be exposed in daylight. Very soon after, Rockland started using black opaque bottles! Each brand of coat-on emulsion has its own characteristics, which are appreciated by its fans. In addition to their capabilities on paper, fabric, glass, metal, mirrors, and ceramics, all enlargement emulsions can be toned (Chapter 3) and hand colored (Chapter 2). These emulsions do not require a negative the same size as the finished print—although that is an option—but can be enlarged onto in a conventional black-and-white darkroom. They can be purchased premixed in photography stores and online retailers or ordered directly from the manufacturer (see Supply Sources). They cannot be used in sunlight; a darkroom is required.

SAFETY

Make sure your darkroom is well ventilated and that you wear protective gloves when working with enlargement emulsions and photo chemicals.

If you spray, rather than brush, emulsion, you might need a respirator that absorbs fumes. Each product is slightly different, so read the manufacturer's warnings.

Do not ingest; do not apply the emulsion to your skin. Use hot water and soap to remove emulsion from skin. May cause irritation to eyes and mucous membranes after eye contact and abdominal pain if swallowed.

Keep emulsion and chemistry out of the reach of children and pets.

Follow health precautions listed in my darkroom chapter in the fourth edition of *New Dimensions.*, which I will send you if you contact me through my website.

METHOD OVERVIEW

1. A negative is placed in the enlarger and focused.
2. In a traditional darkroom, under a safelight, emulsion is melted and coated on the support surface, then it is dried.
3. The negative is projected, or transparency is contacted, onto the sensitized surface, which is processed in black and white photographic chemicals to yield a positive, continuous-tone image.
4. The image can be toned (see Chapter 3).

MATERIALS

More detailed descriptions of materials are given in Chapter 4, Creating the Photo-Printmaking Studio.

1. Applicators. Emulsion can be applied with soft house painting or natural bristle artists' brushes; it can be rolled onto canvas or paper; with a pan underneath, emulsion can be poured onto, dipped into, or sprayed with an atomizer or air brush. Dilute the emulsion with water for spraying it on, but apply at least three layers, allowing each to partially dry before spraying the next coating. Another option for a smooth application of emulsion without brush marks on the outer edges is to purchase a glass coating rod, called a "puddle pusher," from suppliers such as Photographers' Formulary or Bostick & Sullivan, in 4 × 5 in. (10 × 12.7 cm), 5 × 7 in. (12.7 × 17.78 cm), 8 × 10 in. (20.3 × 25.4 cm), and 11 × 14 in. (28 × 35.56 cm). Clean utensils after contact with emulsion, and stay away from tools made of copper, brass, bronze, or iron, because they will react with the silver in the emulsion. I avoid sponge brushes because I have found that they create air bubbles in the coating. However, I read on www.alternativephotography.com, that going to the hardware store and purchasing a very inexpensive Shur Line ceiling trim paint edger with Quick Solution 4 Premium Pad Edger gives really smooth coatings. You have to make sure that you do not buy the disposable brush and handle or the foam pads.

 One other possible solution is to stir just a drop of Kodak PhotoFlo®, Black Magic LP-Masterproof,

or their equivalent surfactant into the working emulsion because they decrease liquid surface tension. Be careful, because they are eye irritants and can be extremely harmful if swallowed.

2. Beakers. See "Hot Water," Item 7 below. Additionally, you may want a small 50 cc (1.7 oz.) measuring cup, like the ones that come with cough medicine, if you are using Black Magic.

3. Chlorine bleach (optional). Hardened emulsion can be removed from a surface with solutions such as diluted Clorox or Purex Laundry Detergent. Remove stains from your hands with strong soap and hot water. Do not put your hands in fixer as one manufacturer recommends because alum hardener may cause skin irritations and allergies, and boric acid (a buffer in fixer) can be very toxic, with systemic effects.

4. Emulsion. All-purpose, black-and-white emulsions usually can be purchased in half-pint (236.8 ml), pint (500 ml), and quart (1 L) light-tight plastic bottles either directly from the manufacturer or from photography stores. Make sure that the instructions are packaged with the emulsion when you buy it. Solid gels at room temperature; they must be melted to a usable fluid. One pint covers approximately 16 square feet (1.49 square meters) or much more, depending on the absorbency of the surface coated. Different companies make reliable coat-on emulsions: the Rockland Colloid Corporation, the first that I know of to market an enlargement emulsion (Liquid Light©, still on the market), is sold as a single contrast (slightly high contrast, but able to be varied by using a soft developer) emulsion. They also can ship antifog solution. I use their AG-Plus, a high-density emulsion with more light sensitivity ($\frac{1}{3}$ stop faster), added contrast to approximately #3, and extra silver content for coating glass, metal (see Contemporary Tintypes, later in this chapter), plastics, and murals, although I use it on stationery-size rag paper because, even if the AG+© is a little more expensive, the blacks are so plush. It can be stored in a refrigerator for up to two years, but do not put it in a freezer. For highly absorbent materials like raw plaster, bisque ceramics,

cement, wood, bricks, and also for non-absorbent glass, china, glazed ceramics, and porcelain, the manufacturer recommends a surface preparation of clear, glossy oil-based polyurethane varnish or opaque alkyd paint that optionally can be tint. With materials like Plexiglas®, Lucite®, or plastic, apply a polyurethane pre-coat. I consider Liquid Light the workhorse of enlargement emulsions, and I always come back to it for its reliability and simplicity of use, and I am now partial to the richness of AG+ for all needs. Rockland makes Halo Chrome toner, which turns black and white photos into silver and white or silver and black prints, and a Tintype Parlor© kit, complete with black aluminum plates, AG-Plus© emulsion, special developer, fixer, and instructions. Another product on the market is Rollei (for long-term photographers, you may remember their terrific medium-format cameras?) Black Magic (Rollei partnered with Maco, the original maker), which is a superb group of products. If your negatives are consistent in contrast, their fixed-grade emulsion RBM24 or RBM23 or cold-toned RBM25 emulsion is for you, but if your transparencies vary in contrast, purchase the neutral-toned RBM33 or RBM35 emulsion, which is variable contrast (meaning, you can use photo filters to change the amount of gray). Only emulsions 23 and 33 need to be stored in a refrigerator, and Rollei says that you can also freeze them to extend their shelf life. For mural printing and making glass negatives, try cold black RBM2, which is a fixed grade 3 emulsion characterized by high edge sharpness.

Rollei manufactures RBM52, a hardener that does not contain toxic formaldehyde, and is added to the developer or the emulsion to make the coating less prone to damage, especially when it is wet. You can also use 52 for absorbent materials and porous surfaces like fabric and wood, and hardener RBM41 combined with 52 for preparing the surfaces of polished stone, glass, and metal in the proportions the manufacturer recommends. For non-porous surfaces like plastic, glass, metal, and ceramic tiles, the company advises a pre-coat of alkyd resin primer (opaque) or oil-based

polyurethane paint (transparent), available at art shops and hardware stores. Most paper does not require any preparation. Maco/Rollei also sells light-tight bottles for warming up small amounts of emulsion, which really eases a challenging task. That is, I used to fill a beaker with hot water in which I would immerse the emulsion, cap down, until some of it was liquefied. After the emulsion was melted, I would pour off a little into a white saucer, but I had to keep it melted by using another beaker of hot water immersed in a crock pot of water at approximately 120°F (49°C). Atop the beaker, I would rest that saucer, which was slightly larger than the mouth of the beaker so no water would mix with the emulsion. After coating, if some emulsion was left over, I had to cover the remainder with a piece of opaque black plastic so the safe light would not fog or pre-expose the emulsion. A liquid-proof dark bottle would have been easier! Photographers' Formulary sells an impressive array of developers and toners, and you can buy Ron Mowrey's book, *Photographic Emulsion Making, Coating, and Testing*, from them if you want to make your own from scratch. J House/Fotospeed, made in England and available throughout Europe, offers LE 30 fixed grade #2 Liquid Emulsion in 250 ml (8 oz.) and 1.25 liters (42.2 oz.), which you dilute to create enough emulsion for 125 8 × 10 in. (20.3 × 25.4 cm) prints. Store below freezing but slightly above 10°C (50°F). The Foto Speed Academy offers workshops and one-to-one tutoring. Norway-based Foma Fomaspeed Photographic Emulsion, medium contrast, with "high covering power," producing mildly warm toned to neutral images with most developers, spreadable on almost any surface, comes packaged with their separate Hard Hardener. The manufacturer recommends a waterproof coating of expoxide varnish on reactive surfaces, like metal, and includes complete instructions. It is excellent for mural printing due to the emulsion's high speed light sensitivity and is best used with "energetic" developers made by Foma. Silverprint, located in Poole, G.B., is a reliable company I have ordered from when I taught

a workshop in Cuba because they ship overseas and my country, the U.S., would not let me carry or ship chemicals there. Silverprint sells a high-silver content SE-1 emulsion, graded between #2 and #3 and packaged in 250 ml (8 oz.) and 1 L (1 qt.) amounts. It can be diluted with water and is "quite robust," so it does not need hardener. The Silverprint website quickly answers questions and may inspire you: https://www.silverprint.co.uk/liquid-light-se1-emulsion/. They also sponsor competitions. All packages of any brand emulsion should be marked on the outside with an expiration date, but you may want to label the bottle, too. Make sure it has been kept in a refrigerator where you buy it, then store it cold in your studio. However, any of these products, if shipped, can be negatively affected by the local weather (temperature, in particular).

Let the emulsion come to room temperature before you bring it into your darkroom to use. Do not unscrew the cap in white light and do not try to save diluted emulsion. Use only under red or yellow safe lights.

5. File/index cards. Available in stationery stores, 3 × 5 in. (7½ × 12½ cm) white index stock file cards or 3 × 5 in. pieces of the same material you will be working on are coated with emulsion and used for testing exposure times. I also advise that you run a fog test by coating cards with emulsion and allowing them to sit under the safelight for 10, 20, and 40 minutes without any image projected onto them. Process the cards normally, then look at them under a white light and see if the emulsion is clear (a good sign) or gray (it has fogged). The solution to a fogging problem is either to partially cover the safelight, or to move the safelight away from your coating, enlarging, and developing area.

6. Hair dryer. One with a cool setting helps to quickly dry the emulsion. Dry both back and front of the paper or fabric. Do not try to dry the emulsion with heat—this actually retards drying by melting it. You can air or fan dry the emulsion in total darkness for as long as 24 hours. Preheating the support surface with a hot hair dryer *before* you apply the emulsion, too, facilitates an even application.

7. Hot water and thermometer. Do not overheat, but use 130–140°F (54.4–60°C) water in a beaker or cup to melt the emulsion. You can also use a crockpot no higher than 120°F (48.8°C) to melt emulsion, but do not use the crockpot for cooking. A second beaker of lukewarm water is handy for storing and cleaning used brushes during a printing session; if the water is too hot, it will melt the glue that holds the bristles. In addition, a slightly warm and dry brush makes the emulsion spread more evenly. Emulsion that has not been hardened by fixer can be removed from a surface with hot water carefully applied on a brush.

8. Image. Any black-and-white negative that fits your enlarger system or color negative (the results are much less detailed, so either use a variable contrast emulsion with a high-contrast filter, or use the developer straight—with no water dilution), drawings or photocopies on pieces of acetate slightly larger than the opening in your negative carrier, or real objects such as leaves or flower petals placed in a glass negative carrier will do fine. Check Chapter 5, Generating Imagery: Analogue Methods, for more ideas. You can even work without an enlarger by using an overhead light or flashlight and contact printing the enlarged transparencies you have made for the other light-sensitive processes in a contact frame or placing objects onto a support coated with emulsion, as explained in the Tips section below. You can combine both enlargement and contact processes at the same time, as exemplified in the art work of Carol Golemboski, page 102.

9. Photographic darkroom and chemicals. You will need a conventional darkroom capable of printing black-and-white photographs, and it should include dark yellow or red safe lights, enlarger system, print easel, and four ridgeless trays. Black-and-white paper developer, fixer with hardener, fixer remover, tongs, and washing system should be used at approximately 68°F (20°C) or slightly cooler. Use my website, www.laura blacklow.com to contact me about obtaining the fourth edition of this book's chapter, With a Darkroom. Do not use a stop bath unless the manufacturer specifically recommends it. Instead, use two fixing baths. Avoid rapid fixers because they can bleach the image. Many of the emulsions are so sensitive to light, even a safelight, that they can fog. So, make sure you use the color of safelight that the manufacturer recommends at the proper distance from your enlarger and trays. (See fog test above, under Index Cards.)

For large surfaces the manufacturers recommend the option of using a slide projector, which are becoming rare, with either a black-and-white or color negative. Tape opaque black paper over the front of the lens with a hole approximately $1/8$ in. ($1/3$ cm) in diameter, cut in the middle to act as a diaphragm limiting the light output and sharpening the image. Rockland AG Plus is particularly suited for mural prints. At the Museum School, we use a traditional enlarger with a head that can be safely tipped towards a wall, where coated paper is tacked. Making large prints will increase the exposure time. For years, before the Photo Department acquired a special, rolling, stainless steel sink, the Museum School used a system of plastic troughs, inexpensively purchased as window box liners at a garden center, and the paper was rolled through each chemical separately. More about that system is elaborated in the Tips.

10. Refrigerator (optional). Cooling emulsion in a refrigerator from which the light bulb has been removed, also suggested by Lana Z Kaplan later in this chapter, under Contemporary Tintypes, helps speed setting up the emulsion and is advised before drying it, most particularly if you are using Black Magic.

11. Receiver. Paper, cloth, and raw canvas or oil-based gessoed canvas need no priming, although most raw canvas needs to be washed and dried before being used. If canvas is primed with acrylic gesso, you will need to add a coat of oil-based gesso or glossy polyurethane. I recommend practicing on paper, no matter what surface you eventually want to use, and you should use rag paper if you care about permanence. The color of the paper, even if it is a bright white versus an off white, will contribute to the emulsion's appearance. In room

light, you can use a sizing, such as gelatin (see Chapter 4) and below in Tips, which also produces a shinier surface, giving the illusion of a deeper black in the print.

An alternative method for prepping smooth surfaces, such as fired ceramics, china, enamelware, glass, and ceramic tiles, is two-part. First, clean by scrubbing with hot water and washing soda, sal soda, or sodium carbonate (such as Arm & Hammer washing soda stocked at grocery stores). Then, sub with gelatin and 2 percent chrome alum or Silverprint hardener made by mixing 1 teaspoon hardener with 1 teaspoon (3 g) unflavored gelatin from the grocer and 1 pint (450 ml) cold water, letting it stand and thicken for 15 minutes, then heating while stirring until the gelatin is dissolved. Carefully heat the metal or glass receiver so that as you pour the gelatin, it goes on evenly. Or use the inexpensive "subbing" kit from Rockland. Wear gloves to prevent finger prints, and flow the solution over the glass until the liquid does not bead, then place the receiver in a dish drain over night. More detailed instructions are included with the kit and a recipe is offered in *Silver Gelatin: A User's Guide to Liquid Photographic Emulsions* (see Reed and Jones in Annotated Bibliography). The preparation must be meticulous and you must leave no greasy—we all leave grease—fingerprints on the surface. Tips at the end of this chapter describe my method. In the United States, Sierra Custom Design (www.tilemagic.com) will reproduce your photos onto tiles. Rossato Giovanni (www.photo-ceramics.com) puts your pictures on porcelain in Italy. Etched glass does not require such extensive preparation—just a good wash. Rocks and seashells usually need little special preparation other than washing and possible coating with the gelatin size mentioned in the following Tips section, although I have even used a first layer of watered-down and dried emulsion without any exposure, but with processing, as a prep layer. Clean leather, roughed a bit with fine sandpaper, will work. My students have been frustrated working on plaster because it drinks up the photo chemicals used in processing. So, we have tried sealing the surface with satin and matte polyurethane varnish and brushing or pouring on developing chemicals with some success. Even wet media acetate, aka "Dura-Lar," can be used as a receiver with no preparation, but you have to handle it carefully so that the emulsion does not crack off.

Another acceptable method for preparing the aforementioned receivers and the recommended technique for metal and pre-primed canvas is a fresh coat with alkyd-based (opaque) primer. For a transparent finish, spray or brush one coat satin or gloss finish urethane-based varnish, which can be thinned with mineral spirits. Do not use water-based varnish or sprays. Rather than degreasing and hardening, but to help prevent air bubbles, coat with a foam brush and sand the dry primer or varnish with very fine sandpaper before applying the emulsion. With aluminum lithography plates, you need only degrease with alcohol or acetone. Copper should be neutralized with 3–4 oz. (89–118 ml) vinegar mixed with 1 qt. (1 L) water. Dry thoroughly afterward. Do not spray, but seal with a coating of matte polyurethane brushed on. Dry thoroughly again, then apply liquid emulsion.

My students like Black Magic Photo Gelatin for preparing shiny surfaces, used in conjunction with Black Magic Liquid hardener. With all these smooth and odd surfaces, let the emulsion set in total darkness for at least 24 hours.

If the receiver is warmed, even with a hair dryer, before coating, the emulsion will spread more easily (see Item 8).

12. Scissors, ruler, pencil. Cutting, rather than tearing paper under a safelight, is much easier, or tear paper in white light and bring it into the darkroom. While you are focusing the negative onto the paper and before you coat the paper, use a pencil to mark the area you want to cover. Draw the image's projected rectangle, which usually is delineated by the easel blades, so you know where to place the paper after it is coated. In addition, you may want to coat and develop only part of an image, so a pencil outline is helpful and can be erased later. I always use a pencil on the back

of paper to remind me of which emulsion I used, whether I used more than one coating, the f/stop and exposure time, and the brand of processing chemicals, as well as the dilution of the developer.

MAKING A PRINT WITH ENLARGEMENT EMULSION

Please note: different products require slightly different processing. Check the instructions packaged with the emulsion or the manufacturer's website.

14.2 Melt the Emulsion

14.3 Prepare the Darkroom

1. Melt the emulsion

Cover coating area with newspaper or oil cloth and place Liquid Light or other emulsion in hot water, with the tightly secured cap down. By very gently shaking the bottle, ascertain when you have melted only enough to use, rather than the whole bottle, a procedure which may take 15 minutes. Do not shake the bottle vigorously or you will create air bubbles in the emulsion.

2. Prepare the darkroom

Set up the following chemicals in smooth-bottomed trays larger than your paper, at approximately 65°F (18.3°C): Dektol or paper developer diluted with water as the manufacturer recommends, two trays of non-rapid paper fixer with hardener, fixer remover, and gentle water wash. You may choose a different developer, but the other chemicals should remain the same. Only Rollei makes stop bath for one of its Black Magic emulsions. If the manufacturer recommends it, add hardener to the developer in the proportion suggested. When first fixer exhausts, dump it, move the second tray to the first position, then make new second fixer. (See Tips for checking the effective life of fixer.)

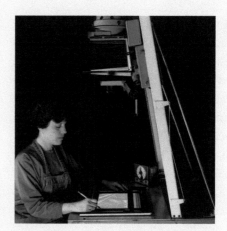

14.4 Prepare the Test Print ©David du Busc

3. Prepare the test print photo

Insert the negative into the carrier and the enlarger. With the aperture fully open, focus onto the actual surface you will coat. Adjust the blades of the easel if you are working on paper. If you are coating an object, such as a box, use tape on the enlarger's baseboard to indicate where you will replace the object after removing it for coating. Or, on a sheet of gray paper, trace around the border of the object, then turn off the enlarger light. Leave the lens fully open for the test.

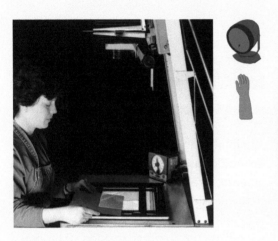

14.5 Make the Test Strips ©David du Busc

4. Make test strips

In a 130–140° F (54.4–60 °C) water bath, melt the emulsion. Pour out a small amount into a saucer that you can keep warm. Add hardener and a wetting agent, if the manufacturer recommends it and you need it. Thinly coat and dry the Liquid Light onto a spare piece of the same material as the proposed finished piece or white index card. Allow it to partially dry—until it is tacky—and apply a second thin coating. Cover up four-fifths of the coating with cardboard and expose the rest for 10 seconds. Move the cardboard so that three-fifths of the coating is covered. Expose another 10 seconds. Continue in this fashion, two-fifths, one-fifth, then remove the cardboard all together.

5. Process the test print

Rocking the tray, gently agitate the test print in developer for two minutes, then carefully move it to the first fixer for 30 seconds, and agitate regularly in the second fixer until the highlights are no longer chalky but are clear, which usually takes 10 minutes or more. Carefully enter the print into fixer remover/ hypo clear for two minutes while gently rocking the tray. To clean and to set the emulsion, gently rinse the print in cool water for 10 minutes. Wash the excess emulsion off the brush and wipe it dry.

14.7 Inspect the Test Print

6. Inspect the test print

Under white light, choose the test strip that has the richest blacks and most detailed whites. Keep in mind that you can burn and dodge as you would with conventional photographic paper.

14.8 Make the Image

7. Make the image

Remove the bottle from hot water, dry it, then pour a small amount directly onto the desired surface. Spread a thin coating by working the emulsion in with a clean, dry, warm brush. Holding the receiver at an angle to the safe-light, you can see whether you have made a thorough coating because wet emulsion is shiny. Allow that coating to semi-dry and become semi-dull for a few minutes, then coat a thin second layer in the opposite direction.

Carefully dry the emulsion with a fan or cool hair dryer, place the receiver under the enlarger, and expose it for the predetermined time. Burn and dodge, then process as in Step 5.

14.9 Finish the Image

8. Finish the image

Gently wash print in cool water for 15 minutes; wash nonporous receivers for one hour. Do not allow a stream of water to hit the emulsion or you may damage it. Thoroughly air dry flat.

A wrinkled print can be flattened by ironing on the non-emulsion side or with a dry mount press at 175°F (79.5°C) for 30 seconds.

TIPS

Enlargement emulsion works beautifully under sizing and gum bichromate prints (see Chapter 10) and the closely related casein (Chapter 11). I have successfully coated Silver Print Emulsion directly on egg shells with no surface preparation.

Most rocks do not need special cleaning, except ones you find at beaches that are covered with salt. All rocks need a precoat, which is accomplished by mixing one capful of liquid emulsion with 8 oz. (236 ml) water and applying this mixture to the rock. Dry it, then intentionally fog this coating by exposing it briefly to white light (a few seconds under the enlarger without a negative), process it in the chemicals, and dry it. Next, apply another layer of undiluted emulsion and proceed as described in this chapter. In order to obtain more detail with a three-dimensional object, keep the enlarger f/stop as closed down as you can.

If you are dipping glass in liquid emulsion as a coating method, adhere black paper the exact size of the image to the back, then seal the paper with contact paper over it. It is easy to peel off afterwards and, at the same time, to get rid of the scum that can stick to the back, Robert Kennedy advises. Wear gloves.

If the image fades over time, it was not cleared or washed long enough to remove the fixer or the fixer had gone bad. But processed correctly, the print will be permanent with a full range of tones from warm blacks to clean transparent highlights that reveal the texture and color of the material underneath.

14.10 Joelle Shefts, *Demeter/Persephone II*, 39 × 39 in. (99 cm.) oil paint and photo emulsion on canvas, 1999.

Joelle Shefts, whose background is in painting, applied four layers of Liquid Light to rigidly stretched canvas primed on the back with rabbit skin glue and prepared on the front with a light layer of acrylix to purposely crack the painting's surface. She enlarged a photo image to the area where she had applied emulsion, and then used a system of pumps, tubes, and troughs to process the still-stretched canvas.

Emulsion does not work on flannel but is great on cotton and polyester.

Emulsion must not be coated directly on to metal, because this would adversely affect the photo-chemical properties of the emulsion. "Receivers," above, details how to coat on metal.

Do not use a pre-coat of acrylic, latex, gesso, or artist's tube paints, all of which may provide a poor surface for adhesion. I have worked successfully with aerosol coatings of urethane. Before you coat, you must prepare hard and shiny surfaces, either with polyurethane spray or by degreasing. First, make tabs with duct tape and attach them onto the back of the receiver so that you can move the piece from tray to tray without getting (oily) fingerprints on the working plane. Next, make a paste of sal soda and water and gently rub it on the surface. Rinse until the water sheets, rather than beads, off. You can dry the substrate in a dish drain. Then, use the Knox gelatin mixture

described in Item 12. Apply this mixture to the glass with a sponge brush, and allow the glass to sit for eight hours so the gelatin bonds with the glass. Be careful that no dust or bristles, if you use a paintbrush, are captured in the coating. You can also use an atomizer to apply the gelatin, but you should put on one coating, let it partially dry, and immediately apply another coating.

14.11 Gretjen Helene, *Shape a Complete New Feeling*, 8 × 8 × 4.5 in., including light box (20.32 × 20.32 × 11.43 cm), Rollei Black Magic ™ on eggshell, wooden frame, LEDs, 2007–2011. ©www.gretjenhelen.com/egg.

The artist used enlargement emulsion to print images of two individuals embracing on the interior of a duck egg shell. The piece is presented as a niche, positioned in a light box, and illuminated from behind. It was part of an interactive installation engaging viewers to question their relationships with others. The title is from an accompanying prose piece that the artist wrote. She has also created more experimental work at www.GretjenHelene.com/egg. If you want a relatively undistorted image on a round object, try making a contact-size negative and tightly taping it to the surface of the round item after you have coated and dried the emulsion. (See Generating Imagery: Analogue Method for ortho film and Making Negatives: Digital Method for inkjet transparencies.)

With odd-shaped objects, you may want to tape a sheet of gray paper onto the easel and draw the shape's outline on the paper after you focus the negative. This procedure allows you to reposition the object correctly after removing it from the enlarger area and coating it with emulsion.

To make a hard, straight-edged coating, first delineate the area with masking or drafting tape, then apply the emulsion up to the tape and even over it, and let it dry. The tape will loosen up and pull off in the wash water later, leaving an even boundary.

Do not use plain steel or aluminum, copper or brass implements, or coat on these metals if they are untreated. Do use glass, enamel, stainless steel. I don't care much for plastic because it stains, but it will not harm the emulsion.

To keep paper (resting on plexi), and large pieces of glass and metal warm, which helps ensure a more even coating, I put it over the crock pot or tray of hot water. You can also use an old heating pad set to low underneath.

Too thin a coating will often appear as a gray, streaked image. For greater tonal range and richer blacks, however, apply two or three *thin* layers, allowing each coating to become almost, but not completely, dry before the next one is applied. Too thick a coating requires longer exposures, and it tends to crack.

If emulsion becomes too difficult to spread after it is poured from the bottle, thin it with *up to* 20 percent warm water before you coat. After running tests with Silver Print emulsion graded (*not* variable contrast) emulsion, I have settled on this method: mix 1 part emulsion with 1 part warm distilled water. Coat onto receiver. Let it partially dry, then brush on a second layer of diluted emulsion, applying brush strokes in the opposite direction to the first.

Add 1 part working developer with 10 parts emulsion and mix thoroughly before coating to create a more sensitive (faster) and more contrasty emulsion. For example, add 15 ml Dektol diluted 1:2 to 150 ml Liquid Light to add contrast, mix well, coat the same day. Once coated and dried, the substrate can be stored indefinitely.

Here is the sure-fire bubbleless coating method relayed to me by Bart DeVito formerly of Luminos Photo: 2¼ oz. (66.5 ml) emulsion, ¼ oz. (7.4 ml) distilled water, and ¼ teaspoon (1 ml) pasteurized heavy cream. Mix gently with a glass rod under the safe light before coating. Artist Ann Rosen, whose art work opened this chapter, used this recipe for her prints on Saunders Waterford paper.

Wipe the mouth of the bottle and the brush after each use. If the emulsion on the brush is left under a safe light or exposed to white light and accidentally mixes in with fresh emulsion, the coating can look fogged and gray. Always replace the bottle cap after each use.

Enlargement emulsion is easily affected by age and heat; however, emulsion fresh from the manufacturer is not as light-sensitive and may require a longer exposure. As it ages, the emulsion will become faster, but it is not quite as light-sensitive as most photographic papers, so keep the enlarger lens one or two stops more open than the image would print on regular photo paper.

If you are contact printing an enlarged transparency and do not have access to a darkroom, merely flash an overhead light bulb in a safe-lighted room.

If you are air drying the emulsion, which can be important with glass and metal substrates, make sure you do it for 24 hours in *complete* darkness. If you are air drying paper in the dark, it will take approximately 3 hours. Do not try to dry in a plastic bag or box.

Before using a hair dryer, turn it on in the dark. Check that the heat wires are not emanating a glow that could fog the emulsion. To correct such a problem, hold the dryer at least 3 ft. (.9 m) away from the coating.

If you are inexperienced in a darkroom, read the section, With a Darkroom, from the fourth edition of this book by contacting me through my website, www.laurablacklow.com.

In order to prevent fogging, try mixing a 10 percent solution of either potassium or sodium bromide and adding 1 oz. (30 ml) to 1 qt. (1L) developer to maintain the color.

If the emulsion bubbles or peels while you are processing the image, make sure you prepared the receiver correctly. Bubbles will show as little shiny specks on the dried print. Larger bubbles are more noticeable. The best way of preventing bubbles in the coating is to make sure the emulsion is free from them in the first place, by skimming the surface with a glass rod that has been dipped in emulsion and by

not shaking the bottle. If darkroom chemicals are hotter than 70°F (21°C) the emulsion can melt or smudge.

Make sure that you do not use a stop bath (except with one of the Black Magic emulsions), do use a hardener in the fixer, and fix long enough. Insufficient fixing time or weak/ stale fixer also will cause brown splotches. (This is a problem I often see with beginners.)

With emulsion protected from exposure, test the fixer with white lights on by squirting only a few drops of Edwal Hypochek™ in the fixer. If the Hypochek turns cloudy, the fixer is exhausted and should be changed. Use of a rapid fixer can bleach or cause yellow stains, while insufficient fixing time or weak/exhausted fixer can cause brown stains in the finished print.

14.12 *Hanging the Great Picture for display at the Art Center College of Design, Pasadena, CA,* Liquid Light on muslin, 31 × 107 ft. (9.58 × 32.74 m), 2007. Courtesy The Legacy Project, Photo by Mark Chamberlain.

Mark Chamberlain, one of the collaborators on the largest photo in the world, wrote, "There are not many venues large enough to install this monster, but Art Center had converted a supersonic jet-testing wind tunnel for their exhibition and classroom use. It was perfect for displaying such a large piece." Made with the world's largest camera obscura employing a 6 mm pinhole lens. (See Pinhole Photography, page 110.) The 3,375-square-foot (313.5 m) muslin canvas was coated with 80 liters (21 gal.) of liquid emulsion, and the development was done in an Olympic-sized trough with pumps 18,000 gal. (68,137.4 l) of black and white chemicals. It was part of the documentation of El Toro Marine Corps Air Station in Irvine, CA , a 4,800 square acre (12,432 square kilometer) military base that was closed in 1999 and is being transformed into the largest urban park in the western U.S.

For processing big pictures, when chemical trays may not be large enough to hold the whole image, try either of these methods: (1) after enlarging onto coat-on emulsion the developer can be applied with a sponge or atomizer to a portion of the print at a time. First, lay the receiver down flat. Then use a clean sponge or atomizer to pre-wet the emulsion with cool water where you do *not* want an image, or use Maskoid™/liquid friskit, available at art stores, to prevent developer from attacking that area. The water will slow down the developer so that you can go back into that region after you have applied developer to all other areas. You can continue with this method as you stop and fix the print. (2) For developing mural-size images on canvas or paper, use different flower troughs, found in plant nurseries, to hold the different chemicals. Make sure the troughs are long enough to fit your canvas or paper. When you are ready to develop the image, you may need someone to help you roll the paper or canvas through the chemicals in one direction, then unroll the paper or canvas through the chemicals and roll to the other end. Wear protective gloves.

Enlargement emulsion usually does not need an after-coating, but if moisture or handling will be a problem, finish a dried image with varnish, shellac, lacquer, acrylic spray, or polymer medium. To dull a glossy print, apply matte spray, available at art supply stores. Sprays can be toxic if inhaled, so a respirator should be worn when you use them.

The Rockland Colloid Corporation, manufacturer of Liquid Light, will answer specific questions. Their contact information is in Supply Sources.

14.13 Lana Z Caplan, *Subway Sleepers 1 and Subway Sleepers 2*, 8 × 10 in. (20.3 × 25.4 cm), tintype, edition of three, 2014. From the series *Subway Sleepers, Bejing*, ©Lana Z Caplan.

This series began when Caplan was invited to China in 2012 to create work for a museum exhibition. At that time, she learned that many workers commuted three to six hours each way, every day. Seeing people sleeping on the subway was not something new to the New York-based artist; however, the sleepers in New York were often either drunk, homeless, or pretending to sleep to avoid eye contact with fellow riders. In Beijing, the subway seemed to be a borrowed space in which many riders caught the only sleep they would get that day, sometimes standing propped up by the surrounding crowd. Caplan converted the original color images to black and white in Photoshop®, then had a lab make slides that projected via an enlarger onto the plates. This portrait series renders the digital into the historic tintype form, referencing both nineteenth century death portraits and meditating on the effects of modern labor.

CONTEMPORARY TINTYPES

By Lana Z Caplan

Please read this whole chapter, from the beginning, before attempting to make a tintype.

As *The Focal Encyclopedia of Photography* (see Zakia and Stroebel in the Annotated Bibliography) explains, tintypes/ferrotypes were first introduced by Frenchman A. A. Martin and had a laterally reversed image like the daguerreotype (see the closely related process, Becquerel, Chapter 15). Popular in the 1850s, the ferrotype originally was a black lacquered plate with a wet, syrupy collodion emulsion, but dry gelatin was used in the 1880s. Because they were cheap, easy to produce, rugged, and fast, the ferrotype played a substantial role in the democratization of photography. Itinerant photographers could develop the plates in trays inside the bellows of the camera or in containers suspended beneath slots in the bottom of the camera. In South and Central America, before color Polaroids were available, I saw itinerant street photographers using this method, and it was a wonder to watch. (L.B.)

MATERIALS

1. Darkroom with red safelight, or a makeshift equivalent, explained in more detail by contacting me at my website to read the "With a Darkroom" chapter that used to be part of New Dimensions. A briefer explanation appears at the beginning of this chapter, with complete step-by-step photos. Make sure you use black and white paper—not film—developer and black and white powder fixer but, for tintypes, without hardener, detailed earlier in this chapter in the Materials section.

2. Liquid emulsion. See Materials, page 269, at the beginning of this chapter. There are two ways to make tintypes using liquid emulsion: use any of the commercially available ones, or make your own emulsion with a recipe like this one from Mark Osterman: http://thelightfarm.com/Map/DryPlate/Osterman/DryPlatePart4.htm.

3. Large format camera with a sheet film back, as detailed in Chapter 15, Contemporary Daguerreotypes, or a positive—not a negative—transparency of your image, such as the Pictorico transparency method described in Making Negatives: Digital Method, Chapter 6.

4. Sheets of aluminum, coated with black paint. Purchase thin aluminum in the printmaking area of an art store, or look for roofing tin or shimming sheets at the hardware store. Cut the metal to fit the camera's film holder or trim to the finished image size if you are enlarging in a darkroom.

5. Two shallow trays made of glass, plastic, or stainless steel, for developer and fixer, slightly larger than your desired image size.

6. Image. You can use a large format camera loaded with a coated aluminum plate fitted in a film holder and shoot directly. Aluminum is best because it is thin, light, and will fit in the holder. Or, you can place the coated plate under an enlarger in the darkroom. Since tintypes are a positive-to-positive process, you will need a positive image to project from the enlarger. In the film holder of the enlarger, you can use a transparent black-and-white digital positive made from any digital file (see Chapter 6), an ortho film positive (see Chapter 5), or a color or black-and-white slide (black and white is preferable because the enlargement emulsion is sensitive to a range of gray tones, whereas color slides will produce very low contrast images).

MAKING A CONTEMPORARY TINTYPE

1. Degrease the metal plate as explained earlier in this chapter and then coat with a thin, even layer of black gloss or matte spray paint or asphaltum used by printmakers for hard ground etching and found in an art store. You need to have black as the base for your image.

2. Melt the emulsion as described in this chapter, being careful not to bring it to a boil. (I heat a saucepan of water on a hot plate set to low-medium heat in the darkroom. I put the liquid emulsion bottle in the saucepan and keep it there until I am read to coat.) Warm the metal on a hot plate or on a sheet of glass that is placed over a tray of hot water to help ensure ease of even coating.

3. Under a red safe light (amber can fog emulsion), quickly pour the warm liquid emulsion onto the plate, then spread it by tipping the plate from corner to corner, allowing gravity to move the emulsion across the dry, blackened surface. Then, use your gloved fingers or a glass or Lucite rod, such as a Puddle Pusher from Photographers' Formulary, to even the coating. You have to do this quickly or the emulsion will start to cool and glob up before being spread evenly across the surface.

4. Allow the plate to dry flat in a completely dark, cool area, such as a refrigerator—I have a small one in my darkroom (make sure to remove the white light bulb) or on top of cold packs on a level surface. You can also let the plates dry in the darkroom, flat on a table. Turn off the safe light. The drying area should be dust-free and allow air to circulate, so a tight box is not a good idea.

5. After one to two hours (depending on the size of the plate, thickness of coating, humidity and temperature), you can turn on the safe light and check to see if the coated metal is completely dry. It will appear less glossy and have a gray hue, rather than the white color of the freshly coated plate. Now you can insert the plate into the camera with a dark slide over it or place it under the enlarger. A typical exposure on a sunny day in a 4 × 5 in. (10.2 × 12.7 cm) camera varies with the choice of emulsion and thickness of the coating. You will have to make a test strip with a variety of exposures. To make a test strip in the camera, you can pull the dark slide at equal intervals, while carefully timing between each pull. Essentially, you are changing the shutter speed with the additional exposures, so keep the f/stop the same.

If you are working in the studio with lights, make sure they are daylight balanced. (The emulsion will not react readily to the red/amber spectrum of tungsten balanced lights, which is why you can use a red safe light when coating.) A good place to start is f/8 @ ½ second.

A 5 × 7 in. (12.7 × 17.78 cm) enlargement in the darkroom with a normal density positive will be approximately 30 seconds to 3 minutes at f/4 with the enlarger lens 3 feet (1 m) above the plate. Again, make test strips (see Step 3 of this chapter). If, after development, your plate remains black or there is a faint image, you need to expose longer. If after development your image has no deep blacks in the shadows, you need to expose for less time.

6. Develop the plate in approximately 25 oz. (750 ml) normal paper developer mixed with 1.2 oz. (35 ml) exhausted fixer for one to two minutes. The image can continue to develop as long as it is left in the developing bath, so use a timer and keep your time consistent to your test strip. Do not use stop bath. Fix for 2–5 minutes, or until all the milky areas have cleared.

7. Final wash in a gentle stream of cool water for 10–20 minutes.

TIPS

When you make test plates with different exposures, make sure you keep careful notes and that you maintain exact development times and temperature around 68°F (20°C) but never above 70°F (21.1°C).

After development, while the plate is still wet, it is fragile, so be careful not to scratch or touch the surface. Once dry, the surface can still be scratched, but not easily. Try the tape method in the Tips section, page 276, earlier in this chapter so you do not need to touch the surface.

By adding exhausted fixer to the developer, the shadows will clear more fully and reveal the black metal plate. (One way to create exhausted fixer is to pour some stop bath into it, then use Hypochek as explained earlier in this chapter.) Spent fixer will increase image contrast.

Developer exhausts quickly and will leave a silver residue on the image, so change the developer after 3–5 plates are put through it.

I use powdered fixer without hardener. Fixer also exhausts after a series of plates, at a rate of about two times more slowly than developer.

Rockland Colloid sells emulsion (their Ag+© is preferred) and plates you can coat to make tintypes. See http://rockaloid.com/darkroom-emulsions. They also sell the Tintype Parlor kit, which contains eight 4 × 5 in. matte black aluminum plates, AG-Plus© high-sensitivity emulsion, special developer, fixer, and complete instructions for use at http://rockaloid.com/tintypes._

In the U.K., check out_http://www.wetplate supplies.com/wetplate-collodion/pre-mixed-kits.html, because they carry tintype supplies plus kits for other alternative processes covered in this book.

Check http://thelightfarm.com/Map/TLF Tutorials/tlftutorials-handmade-silver-gelatin-emulsions.htm, which offers a clear how-to on making your own black and white emulsion. (L.B.)

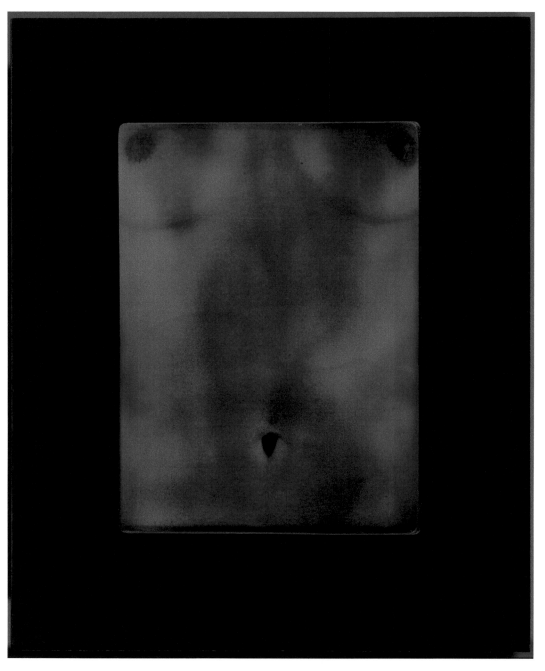

15.1 Chuck Close and Jerry Spagnoli, *Untitled Torso*, 20.6 × 15.5 cm (8 ⅛ × 6 ⅛ in.) Framed: 31.8 × 26.7 cm (12 ½ × 10 ½ in.) Daguerreotype (full plate) 2001. ©Chuck Close. The J. Paul Getty Museum, Los Angeles.

Considered a Photo Realist painter, Chuck Close collaborated with Jerry Spagnoli, whose daguerreotype is on page 295 , to create a series of close-up nudes. Both artists are interested in the daguerreotype's ability to render clear detail. Both were challenged by the technical task of needing long exposures but trying to control sharpness while the model breathed, which Spagnoli managed with strobe lights, and the process's mechanical inconsistency from plate to plate, which Spagnoli worked on overcoming. Close stated, "A body is a road map of a person's life, as unique and expressive as any face. The wrinkles and effects of gravity are beautiful. . . This work is my celebration of the body, and the daguerreotype is the prefect medium of that celebration."[1]

15

Contemporary Daguerreotypes (Becquerel Process)

By Laura Blacklow, with assistance from Tyler Treadwell

Some historians note that the root of photography has been as a physical object, from the first publicly announced process, the Daguerreotype, with its exceptionally detailed, direct positive image on a polished silver plate through William Henry Fox Talbot's inventions on paper (see the chapters on Salt Printing and Van Dyke Brown Printing) to the popular tintypes (see Contemporary Tintypes, page 279) to the photo album. Only recently, with the advent of virtual imaging, has the medium lost it material presence. I theorize that photography's original manifestation as a tangible object is one of the reasons for contemporary artists' renewed attraction to the historic processes.

Each daguerreotype is a one of a kind and possesses an authority; most are delicate, defined, of substantive weight, small enough to be held in your hand, when angled change from positive to negative and "transcend reality: [They] appear to float in space behind glass."[2] Given that they are created by the action of photons (fundamental electromagnetic particles) on solid silver, there is no visible grain, unlike modern film. In addition, one sees a mirror image on a mirror-like surface.

In 1839, Louis-Jacques Mandé Daguerre, a painter of scenes and fabricator of dioramas, gave his name to the first *practical* photographic process using a camera, announced at a meeting and followed by a publication

of the French Academy of Science. Legend has it that he accidentally discovered the light sensitivity of silver iodide by leaving a silver spoon on the surface of an iodized plate in the spring of 1831.[3] But he rode on the shoulders of centuries of experimenters. For instance, historians know that simple lenses had been around Europe since the thirteenth century in the form of eye glasses and probably before that in the Middle East (Arabian mathematician Ibn Sahl calculated the shape of lenses at the end of the first millennium C.E.; scholar Alhazen wrote about lenses and their relationship to the human eye 300 years later) and in ancient Greece (a burning lens was mentioned in a play by Aristophanes in 424 B.C.E.). In the mid-seventeenth century, J. C. Sturm created a portable camera obscura, a light-tight box with a reflex mirror and focusing lens, based on the original camera obscura, which was a darkened room with a pinhole that directed light rays to form an inverted image on a screen, as described first by Chinese philosopher Mo-Tin in the fifth century B.C. E. William Wollaston in 1812 devised the first landscape lens, with approximately an f/14 aperture. This British inventor also worked on creating the camera lucida, used as a drawing aid and consisting of a flat surface on which drawing paper was placed, then connected to an armature with a lens/prism system above.[4] The "artist" would look through the lens and see the paper and the scene, which she or he would "trace." Although this procedure sounds easy, we know that men like William Henry Fox Talbot were frustrated by their inability to render, and that frustration drove Talbot to develop "photogenic drawing," as he called his new invention of photography.[5] However, we realize that even in the Renaissance, artists Leonardo da Vinci, who also wrote about his use of the camera obscura, an Italian term that means darkened room, and Canaletto in Italy, Albrecht Durer in Germany, and Dutch painter Jan Vermeer used optical devices to help create their artworks, although the camera obscura was mainly used to safely observe the sun and solar eclipses.

Meanwhile, in 1725–1727, German chemist Dr. Johann H. Schulze experimented with the light sensitivity of silver coatings until he mixed chalk, nitric acid, and silver in a flask, accidentally creating the first light-sensitive amalgam, when he noticed a darkening on the side of the flask exposed to sunlight. He also disproved that heat could have the same effect. Although Schulze could not figure out how to make permanent the contact prints he made from stencils with this mixture, photography really was an expansion of his findings. Early in the nineteenth century, Thomas Wedgwood made silhouettes of sitters and, along with Sir Humphrey Davy, contact printed photograms of opaque objects by coating silver nitrate on leather (you can coat silver-based Van Dyke brown solution on leather; see Chapter 8), but again, they could not figure out how to make the images stable when shown in light stronger than that emitted by a candle.

J. Nicéphore Niépce[6] had figured out, by 1817, how to partially fix a silver chloride (silver salted) negative on paper that had been inserted in a camera lucida. Some consider him the inventor of photography because, by 1826, he had taken the first photograph, a direct positive, from nature with a camera, using a pewter plate coated with bitumen of Judea (a petroleum product), exposed for eight hours and washed in oil of lavender. Niépce was the first to use a camera with a bellows for focusing and an iris diaphragm for different f/stops. Daguerre partnered with Niépce, and they experimented with a polished silver plate coated with tree resin and distilled oil of lavender mixed with alcohol, sensitized with iodine fumes, and inserted in a camera lucida. Niépce died before the big breakthrough created by Daguerre's further experiments, based on coating a copper plate with silver, fuming

it with iodine vapors to form silver iodide, exposing the plate soon after, developing it in (extremely toxic) heated mercury fumes, and fixing the image in salt and water, which he eventually changed to sodium thiosulfate (suggested by Sir John Herschel of cyanotype fame), then rinsing the plate in water. In 1840, Alexander-Edmond Becquerel, who was one from a line of scientific family members, introduced the less dangerous process, closely related to the method described in this chapter: a silver-coated daguerreotype plate fumed with iodine vapors and underexposed in a camera, developed/intensified by a secondary after-exposure under red glass (which eliminated the need for mercury), fixed, and washed.

As Alyssa Salomon pointed out in an e-mail to me, in the mid-nineteenth century, the study of photography, light, and optics captured the best minds of the generation, much the way high-tech has done in our era. Another quote, this time from Salomon's artist statement: "We see only light reflecting off the world, never the world itself."

SAFETY

Susan Shaw and Monona Rossol, in *Overexposure: Health Hazards in Photography*, a book I respect and recommend as indispensable, advise practitioners only to use the Becquerel process for one reason: the traditional daguerreotype uses mercury. To paraphrase Shaw and Rossol, most forms of mercury are extremely hazardous, even if proper precautions are taken and expensive industrial ventilation is used. In addition, the cost of proper environmental disposal of mercury is prohibitive for most photographers. Mercury vapors are odorless, hard to detect, and almost impossible to control in the environment and on clothing. Not only are mercury salts corrosive to the skin, but they also affect the mucous membranes and the

respiratory tract. When dumped in the ocean, mercury can be toxic to life there.

Acute or chronic mercury poisoning primarily affects the nervous system but also severely damages the gastrointestinal system and kidneys. Symptoms such as muscle tremors, irritability, and psychic disturbances were well known by the mid-nineteenth century among hatters who used mercuric nitrate to make felt hats; thus, the expression "mad as a hatter." Some early Daguerreotypists probably suffered from mercury poisoning.

Iodine vapors are hazardous by inhalation (acute and chronic respiratory problems), ingestion (intense corrosive damage and may be fatal, even in small amounts), and concentrated exposure to skin (deep, slow-healing ulcers and hypersensitivity reaction) and eyes (severe and painful burns). Chronic exposure to iodine halogens can cause severe symptoms of poisoning and nervous system damage. *Make sure there is local ventilation of vapors and you always wear goggles, gloves, and a proper respirator.* Inhalation of iodine gas can lead to respirator problems or even death—this is particularly troubling since iodine converts to a gas at 68°F (20°C). In *The World Journal of Post-Factory Photography*, Issue 4, Dec. 1999 (see Annotated Bibliography), Bob Schramm describes building a fuming hood as follows: "I found a blower unit with plastic fan blade and sealed motor designed to exhaust a large darkroom, which I figured meant it could really suck air . . . out of a small fume hood and withstand corrosive chemicals. The fume hood is about 3 ft. (0.9 m) square by 4 ft. (1.2 m) high, with an interior waterproof electrical receptacle, a red safelight with a white work light. The vertically sliding glass door on the front is made from a storm window. The frame is 2 × 4s bolted together. The top, bottom, and side panels are ¾ in. and ½ in. marine plywood screwed onto the frame, sealed at every joint with silicone. Internal surfaces got

several coats of black enamel, caulked with more silicone. The blower exhausts air into a 6 in. (15.25 cm) diameter duct that goes through the wall and up over the studio roofline. . . . I also installed a red light and a sign outside the studio which says 'Do Not Enter The Studio When The Red Light Is On!' But I keep the door locked anyway." Smart and considerate man! A simple test for the effectiveness of a hood is a lit candle at the opening where your face and body will be. The flame should bend toward the vent and away from you.

Gold chloride is moderately irritating, but can cause severe skin and respiratory allergies if not handled properly, and chronic inhalation can cause anemia, liver, kidney, and nervous system damage. It is usually used with sodium thiosulfate (i.e., sodium hyposulfite, hypo, fixer) in the gilding stage. This second chemical is highly toxic by inhalation, and ingesting large quantities can cause purging. Old hypo solutions can decompose and form toxic sulfur dioxide gas. Do not heat sodium thiosulfate nor contaminate it with acid unless you do so in a fume hood. Discard used hypo responsibly.

Wear gloves, goggles, and respirator with acid gas and dust cartridges throughout the polishing, sensitizing, and fixing procedures.

Always store chemicals away from your living space and out of the reach of children and pets.

METHOD OVERVIEW

1. A metallic plate is coated evenly with silver and polished. This challenging procedure can be eliminated by buying pre-coated plates, which are then exposed at 70°F (21.1°C) to iodine crystals that emit iodine fumes and combine to produce silver iodide, a light-sensitive amalgam.

2. In dim light, the plate is inserted in a large format camera or contact-printed under glass and exposed to light.

3. After removing the plate from the camera, it is further intensified by "continuation rays" (Becquerel's term) to bright light beneath red rubylith or orange amberlith acetate.

4. Under a safe light, the plate is fixed in a solution of sodium thiosulfite and water, and unused iodine crystals are removed, revealing the image more clearly.

5. The image is washed and may be gilded in gold chloride solution for more permanence and to help harden the image.

MATERIALS

More detailed descriptions of materials are given in Chapter 4, Creating the Photo-Printmaking Studio.

1. Plate. Daguerreotypist Eric Rickart uses recycled copper roofing plates, which he must have electroplated with silver. But the most reliable method for a beginner is to buy precoated plates. The only sources I have found for precoated plates in North America are Theiss Plating (www.theissplating.com/) and Mike Robinson's Century Darkroom (http://centurydarkroom.com/) for silver-clad copper plates and even daguerreotype portraits in Canada, both of which are listed in Supply Sources. After you receive the plates, inspect them for imperfections before you use/pay for them. We found that the silver layer can be used three times at most, providing you polish it before each use. After the silver is worn, you can send the plate to Theta Plating (http://www.thetaplate.com/), listed in Supply Sources, for replating. In addition, Theta will coat a polished copper plate you provide them. The plates from Theiss, which have a brass base, sometimes appear to be two sided, but there is a "wrong" side (just remnant silver from the plating process) and a thicker, smoother coating, which is the "right" side. It appears that Theiss also experiments with the metal upon which the silver is plated, so each shipment might be of different thickness no matter what you request. Daguerreotypist Bob Shlaer makes relatively inexpensive and easy-to-use test strips by cutting

pieces of sterling silver flat wire, available from jewelry-making suppliers, but the light-sensitivity of such metal may be different from the plate you use. Still, I think this method suggests some creative uses for an image on metal!

2. Contact printing frame. The frame should be larger than the plate and will be used when you develop the exposed plate to sunlight under thin (3 mil or ⅛ in. is sufficient) but ultraviolet-blocking red rubylith masking film. However, if you choose not to use a camera but to contact print a negative onto the sensitized plate, a frame is indispensable, too. If you do not want to buy one, I have described how to make a frame in Chapter 4.

3. Large-format camera or pinhole camera, black focusing cloth, and "altered" film holder or antique plate holder or contact-size negative. Daguerreotype plates are thicker than sheet film, so a traditional large-format film holder must be used *without* the dark slide, which would scratch the plate if forced. Instead of a dark slide, you can carefully put the loaded film holder into an opaque black plastic bag. Although you have to insert the plate into the camera once you are in bright light, the short amount of time between taking the film holder with plate out of the black bag and entering it into the camera will have no effect if you are quick.

In addition, you can prepare three narrow strips of mat board the same thickness as the plate, approximately ⅛ in. (2 cm), and the same width as the frame of the film holder. Glue each strip along the front edges of the film holder, thus compensating, like a shim, for the thickness of the plate, after focusing. Daguerreotypist extraordinaire Jerry Spagnoli uses a different method: he racks the back of the film plane area (rear extension) backward to match the thickness of the plate after he focuses. I also took a Daguerreotype workshop with Jerry, and it was excellent because he comes prepared with the necessary materials and is impressively knowledgeable.

If you find an antique plate holder, you need not worry about scratching the plate; the dark slide does not touch the silver surface, and you need not worry about making up for the focus problem. Another choice is the Kodak film pack holders, which are available on eBay. Cut two pieces of black foam core the size of the holder to fill the gap between the back and the plate. These film pack holders have many advantages: you load the plate from the back so you do not touch the fragile front, they are compatible with Graflock-backs for many large-format cameras, they require no expensive adaptations, and the plate is in the same plane as the ground glass so no focusing adjustment is required. The film pack holders can be purchased in different small sizes, but the 4 × 5 in. back fits similar sized plates perfectly.

Another choice is to contact-print negatives to the plate, rather than to use a camera. Starting with flat negatives is advised.

4. Opaque black bag. You can recycle and reuse the plastic that photo paper is packaged in, make a wrapping from 4 ml mulching plastic found in a good hardware store, or order black plastic bags from Recognition Systems/AFM Products (see Supply Sources). If you find an antique plate holder made for daguerreotype, you need not worry about black bags. We have not talked to a daguerreotypist who has said that inserting the plate into a film holder without scratching it is easy, and we assume that one of the reasons that the old timers used mats around their images was to hide the edge imperfections.

5. Strong tape, ruler, and scissors. Because you should not touch the plate once it is polished, or you might deposit fingerprints, make a "lift" from cloth or duct tape secured to the back and doubled over onto itself. (This system also can be used when coating metal with liquid enlargement emulsion, see Chapter 14.) In addition, we use scissors to precut strips of tape so we can attach the plate to a Pyrex™ container's cover when we are fuming it. A ruler is handy after focusing as explained below.

6. Tripod. If you are using a large-format camera, rather than contact printing with a negative, the exposures probably will be around five minutes,

so the camera needs to be still if you want to control the clarity.

7. Trays. You will need two nonmetallic photo trays or glass baking dishes; one will be for fixer and one will be for water. You may want a third for a final bath of distilled water.

8. Desk lamp or night light with 15- to 25-watt bulb. When you are sensitizing the plate in a darkened room, you need to see the color change from the effects of the iodine vapors. If you direct a desk lamp toward a wall and not the plate, 3 feet away, you will have enough light. The nineteenth-century method was to secure yellow tissue over a small window. Still, for the last five seconds of the fuming, no light should be on.

9. Two buffs of velvet or chamois. One buff will be used for rouge, available from jewelry suppliers, and the other will be kept clean. At the school where I teach, there is an excellent buffing system in the small metals area. However, you can buy a bench grinding wheel at a hardware store, remove the grindstones, and replace them with soft cloth polishing wheels. Machine polish, then hand buff to achieve a mirror-black finish. We found this phase full of challenges, such as not scratching the plate and keeping it free of contaminates, but success can be in the polishing. Better yet, daguerreotypist Bob Schramm recommends purchasing a polisher from a jewelry supply company because it will have no vibrations that could cause fine scratches in the silver. To reuse a plate, polishing is a crucial step in making a proper surface for daguerreotyping, and our predecessors used deerskin. If you look at some of the old texts, such as *Silver Sunbeam* (see Towler in Annotated Bibliography) or go online, you might find a buffing stand with wood boards and clamps that you can build yourself. Mike Robinson of Century Darkroom (see Supply Sources) sells silver clad copper plates in many sizes and you can send copper plates to be silver-coated and polished to Theta Plate, Inc. (http://www.thetaplate.com/silver-plating/) in Albuquerque, NM and Reliable Plating in Chicago (http://www.reliableplating.com/silver.html).

10. Vacuum cleaner. The small particles of silver that fly when you are buffing should not be breathed in. Additionally, after your studio session, vacuuming your buffing and working area while wearing a respirator is good for your health and to keep plates dust-free.

11. Mats of acid-free board. Even if you do not want to present your daguerreotype in the traditional way, under glass, once it is finished, you will need to create a matte so that the plate does not touch the rubylith and glass in the contact frame during the making of the image. Cut a window approximately $1/16$ in. (1 cm) smaller on each side than the edges of the plate. In addition, when fuming the plate in a Pyrex™ box, Alyssa Salomon wonders if you could try cutting a double mat to hold the plate to the cover. Cut one matte out of ridge cardboard the size of the plate, another slightly smaller. Glue the two together on three sides. Place the plate in the holder face down and tape the matte to the lid such that the plate is between the smaller matte and the lid.

12. Fuming box or Pyrex™ dish with top and photo tape. You can buy a fuming box from K. Azril Ismail at https://agno3solution.wordpress.com/contact/ in the U.K. Until you know that you are committed to this process and want to invest in expensive equipment, we suggest you go to a grocery store and buy a glass storage container larger than the plate and approximately 4 in. (10.25 mm) deep. It comes with a plastic top that fits tightly.

13. Exposure meter. The approximate ISO of a sensitized plate is 0.004, but you can use the meter to keep notes on how bright the light (the exposure value) is as compared to how long the exposure is. Note time of day (exposures late in the afternoon and in the morning are significantly different than at other times because the light can be golden and because of the filtering affect of the atmosphere). The exposure has to be in the range of 1½ stops over or under in order to see an image. If you know the old zone system, you can meter for the whites and then locate the darkest areas in relationship to the highlights. The tonal range in the scene is the number of stops between the lightest and darkest

points, yet Becquerel plates only can reproduce as much as three stops, but this is a rarity, with the beginner getting 1½.

14. Thermometer and siphon washer or hose. You will need a darkroom thermometer to measure the temperature of wet ingredients and keep them around 68°F (20°C). In addition, the room temperature should be near 70°F (21°C) when fuming the plate. The siphon washer helps to direct a gentle stream of water over the plate as the last step.

15. White gloves. We used white cotton gloves whenever we handled the dry plate in order to avoid contaminating it with fingerprints. You can also use disposable unpowdered nitrile and latex gloves; the fit is snug and there is no extra lint.

16. Hair dryer. If you warm the plate before exposing it to the iodine vapors, you will help ensure a more even sensitizing layer, but do not warm the iodine crystals. Additionally, a hair dryer will remove plate condensation, which we found formed due to cold weather. If the weather gets too cold, expose indoors through a window.

17. Timer/watch. You will need to time the exposure and development under rubylith.

18. Notebook and pen. We cannot emphasize enough how important it is to take detailed notes. Daguerreotyping/Bacquerrel takes quite a bit of work to control, and your efforts will be made easier if you have careful notes on each step.

19. Chemicals. Pure crystal iodine sensitizes the plate; you will need 1 oz. (30 g) of the flaky, not ball, type, which lasts indefinitely if properly handled and stored. The U.S. Department of Justice advises: "Iodine crystals, which are used legally for a variety of commercial and medical purposes, frequently are used illegally to produce high quality d-methamphetamine. Iodine crystals may be purchased from a variety of businesses . . .

Iodine also is widely available on the Internet. One online pharmacy, for example, sells iodine crystals in ounce quantities for approximately $14 . . . Companies in several countries throughout the world produce and sell iodine crystals commercially." I found it on eBay, too.

Sodium thiosulfate (specify "pentahydrate," which is easier to mix in water), available from Photographers' Formulary or Bostick & Sullivan (see Supply Sources), fixes the plate; you will need at least ½ lb. (250 g) because you have to mix fresh fixer with each studio session. A 5 percent solution of gold chloride, available through either of the aforementioned suppliers, is used to gild the daguerreotype.

20. Protective gloves, respirator, goggles, funnel, lab coat that stays in your work space. Store the respirator in a sealed plastic bag to lengthen its life. A small funnel helps pour the iodine back into a bottle after use. For the hand polishing stage, wear heavier gloves such as rubber-coated garden gloves, but *do not* use those gloves when you actually work in the garden!

21. Rubylith or amberlith. These colored acetates are used in the offset printing businesses, and we have purchased rubylith from a good stationer and at art supply stores such as Dick Blick (http://www.dickblick.com/products/ulano-rubylith-masking-film/).

22. Glass and Filmoplast p-90 tape or similar archival tape (optional). Available at framing stores, these supplies are used for the traditional presentation of a daguerrotype image under sealed glass and in some kind of protective case, to avoid dust and scratching the surface. The tape is also helpful for making sure no iodine fumes leak out of the storage bottle.

TIPS

Commercial daguerreotype studios often placed a sitter in front of large windows to get maximum light. The walls were painted white, and mirrors were employed to reflect more onto the subject, who was encouraged not to dress in blue and to use powder to whiten the face. This information inspired Alyssa Salomon: "I have painted still-life objects a matte pale blue to manage tonal ranges." Since the plates were—and still are— only sensitive to blue light, blue glass over windows would reduce the concentration of light without decreasing its effect on the plate, while making the studio more comfortable and reducing the posing time for the cus-

15.2 Oscar Muñoz, *Aliento/Breath*, photo-serigraph impression with grease on steel discs, each disc 7 ⅛ × 7 ⅛ in. (18 cm), 1995. Photo ©2008, Thierry Bal. Courtesy INIVA, the artist, and Sicardi Gallery, Houston TX.

"Since Muñoz's first darkroom witness of an image appearing in a developing tray, photography . . . figures as a metaphor for . . . the pregnant moment between latent and visible image, between being and not, between memory and forgetting."[7] When the viewer first approaches one in a series of polished steel discs, it acts as a mirror. But when the observer breathes onto the disc, they bring to life the images of deceased victims of civil and drug wars, photos the artist has culled from newspaper obituaries in the city of Cali. Although Muñoz is silk-screening onto metal, it seems that the experience of his work is similar to that of a daguerreotype, where past and present seem to collapse on a tangible mirrored surface.

tomer. This description may give you an idea of the amount of light needed, but remember that daguerreotypes, made in the traditional manner with bromine fumes and mercury development, are much more light-sensitive than the becquerel process.

Due to the lens optics, you always get a mirror image of the subject.

The image was made more obvious and more stable by *gold toning*, also known as *gilding*. Most daguerreotypes, except the earliest ones, were gold toned by using a special holder with an adjusting screw to clamp the plate horizontally, and then pouring a small volume of (usually) dilute gold chloride solution over the image. The plate was heated from below with a spirit lamp (a lamp that burns a volatile liquid fuel such as alcohol) to speed the reaction. When it had reached the right color, the gold chloride was poured off, the plate rinsed with distilled water and then dried over the spirit lamp.[8]

The original daguerreotypes were covered with glass, framed in oval or specially shaped brass mattes, and housed in leather locking cases lined with velvet. However, if you look at old Daguerreotypes, you will see, for example, a jewelry box, cameo, watch fob, lockets, snuff box, calling card box, appointment book, purse, and cosmetic case.

Carefully storing the chemicals after you are done is important. We found that, after we poured the iodine crystals back into its brown bottle and locked it in a fireproof metal cabinet, paper and acetate on a nearby shelf turned brown. So, we kept the crystals in its glass bottle and sealed the top with electrical tape (you can also use Filmoplast tape), then put the bottle in a locking plastic bag to prevent future leaks. The tape may eventually become brittle due to the corrosive affects of the iodine, so check if you need to replace it. In addition, we put a desiccant, recycled from

vitamin pills, in the bag in order to prevent a moisture problem. You can also buy calcium chloride desiccant in a hardware store. If you have a fuming hood, store the iodine there.

MAKING A CONTEMPORARY DAGUERREOTYPE

15.3 Prepare the Plate

1. Prepare the plate

With precut pieces of photo tape, attach the Pyrex™ plate to the dish's top or insert it in the fuming box slot, silver facing down. Either be careful not to touch the plate or wear cotton gloves. Heat the plate with a hair dryer. In a well-ventilated area, pour an even layer of iodine crystals into the glass receptacle. Put the top on and make sure it fits tightly.

15.4 Fume the Plate

2. Fume the plate

Wait 20 seconds then quickly take off the cover of the Pyrex™ or slide out the plate from the fuming box. Check the color. The silver should have turned pale yellow. Put the top back on for 15 seconds. Take the top off, and you will see the silver change from yellow to pale orange. Put the top back on for 20 seconds, and when you look again, the plate should have turned to a pale purple. We found this first cycle of color, all pastel shades, took 55 seconds. Keep checking the color every 15 seconds, and you will see the plate go through a second, more saturated sequence of color that starts with deep yellow in 30 more seconds, deep magenta in 25 more seconds, and clearly blue-green in 20 more seconds. In a proper fuming box, the times will be shorter. (This second cycle is optional, as some find it tends to make the final image muddy in the blacks.)

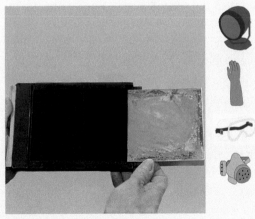

15.5 Finish Preparing the Plate

3. Finish preparing the plate

Turn off the light and fume the plate for 5 seconds more. With a safelight on, quickly remove the tape from the plate and carefully

put it in the film holder, sensitized side visible. Wrap the holder and plate in opaque plastic, making sure not to touch the sensitized surface. Or, insert the plate into a film pack holder and insert the dark slide. If you are not using a camera, now is the time to put the plate under a negative in a contact printing frame, then put the unit in an opaque bag and skip the next step.

15.7 Develop the Plate

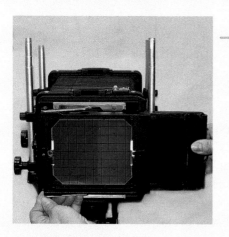

15.6 Set Up the Camera

4. Set up the camera

Secure the camera to the tripod and focus through the ground glass. Quickly remove the film holder and plate from the black bag and insert it into the camera back, plate toward the lens. Open the camera lens to f/5.6, and leave the lens open for approximately 1½ minutes on a sunny day or in an environment with lots of reflected light. We found longer exposures were needed on overcast New England days. After the exposure, remove the plate and holder and swiftly put it back in the opaque bag. Do not be disappointed if you do not see an image—you shouldn't!

5. Develop the plate

Open the back of the print frame and, under a safelight, place the plate, face up, on top of the inside backing. Position the precut mat above the plate, then the sheet of rubylith on top, making sure it does not touch the plate. Last, replace the glass and close the unit. Take it to the sun and let it develop for approximately one hour in indirect summer light or direct overcast light.

Afterward, bring the unit to a room with subdued tungsten light, and remove the layers to see if the plate has turned a light gray, like tarnished silver. You should see a faint image at this point. If it is magenta, it needs more development.

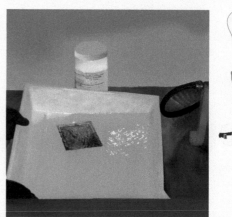

15.8 Fix and Wash the Plate

6. Fix and wash the plate

In a tray, mix 1 oz. (28 g or 2 tablespoons) hypo with 32 oz. (900 ml) water at 68°F (20°C); always use fresh fixer. You can also use salt and water, explained in the Tips, below. If you can smell a strong odor from the fixer, it is too old or too strong. Gently rock the plate in the hypo/fixer for 30 seconds. Under subdued light you should see the image start to clear as the unused iodine is removed.

Leave the plate in the fixer for twice that time (the rule of thumb is, "twice the time it takes to clear"). Move it (the tape lifts in Item 5 above will help you) to the wash tray, but not directly in the stream of gently running water for one minute, then to a still bath of distilled water for a final soak of one minute.

Immediately air dry it on a slight angle so that the water runs off.

TIPS

We found this technique to be one of the most difficult we had ever attempted; it takes a lot of patience, careful notes, and analysis. We were fortunate to contact experienced artists—daguerreotypists seem to be a small and closely-knit group—who were forthcoming with advice. If you can find a good workshop or demonstration on the Becquerel process, we recommend it. Jerry Spagnoli, whose work appears twice in this chapter—once as a collaboration and once on his own—offers trainings and is an impressively knowledgeable, prepared teacher.

Keep the room temperature at approximately 70°F (21°C) as you sensitize the plate. If the room is cooler, sensitizing will take longer. You might wait 5–10 minutes for the sensitizer to stabilize before exposing the plate, but if you wait much longer than that to continue the procedures after fuming, you may create problems.

Begin by taking pictures outdoors. If your camera is focused on many neutral tones, try to get a bit of sky in your first trial exposures.

To trouble shoot, be aware that problems usually occur in the polishing, fuming, or exposing stages.

The plate will be clear if you underexpose in the camera. Overexposure, common even with the originators of the process, can turn a portion of the image, such as the sky, blue. (I

15.9 Jerry Spagnoli, *1/22/16*, 16 × 20 in. (40.6 × 50.8 cm), Daguerreotype, 2016. ©Jerry Spagnoli. All rights reserved.

When Spagnoli began shooting with cumbersome 11 × 14 in. (28 × 35.5 cm) and 16 × 20 in. (40.6 × 50.8 cm) view cameras to make large-plate daguerreotypes, he realized that, rather than work on location, he would need to access a more controlled environment without destroying a sense of discovery. And so, he now creates a precarious arrangement of common water glasses on the surface of a mirror that also reflects sun light while illuminating the glasses from behind. Spagnoli emphasizes why he is "using the glasses to modulate light. It·s not about the glasses. It's about light, which the daguerreotype is uniquely qualified to depict. . . The surface of the mirror, the surface of the plate, light bent and shifted by the shapes and then projected in turn by the plate to the viewer. There's a seamless relationship between the materials and the medium." Additionally, Spagnoli states, "One of the striking things about working on this series is that it highlights for me just how quickly the sun actually moves (or rather, how fast the earth spins). . . The blue tone seen in a daguerreotype plate is the natural result of overexposure and is one of the characteristics of the medium that I frequently exploit. It is referred to as 'solarization,' which in this series seems particularly apt."

find it appealing, as exemplified by Spagnoli's daguerreotype of glasses in Figure 15.9.)

The image will be blue or magenta if you underdevelop it in the print frame.

Page 226 of *Overexposure: Health Hazards in Photography* (see Shaw and Rossol in Annotated Bibliography) states: "Fixing of Becquerel is done with a weak solution of salt and water; a zinc or aluminum rod is used to galvanize the silver iodide layer. This method minimizes image fading, which tends to occur if the plate is fixed in hypo."

Because the $^5/_{10,000}$ in. (0.5 mm) silver coating and the plate do not actually absorb chemicals, a brief final wash suffices.

The earliest method for hand coloring daguerreotypes was to spread a thin layer of varnish onto the image after fixing, washing, and drying. This coating allowed powdered pigment mixed with gum arabic to be applied with a fine brush or cotton.

You can buy a protective case that also is decorative from http://www.casedimage.com/equipment-used-for-making-daguerreotypes/CasedImage.com. Their cases are made according to the methods of E Anthony, the Daguerreian period casemaker, which he describes in detail in his catalogue of 1854. It is "a wooden box, covered in Morrocan goatskin leather on the covers and skiver on the rails [sides]."

The Contemporary Daguerreotypes website, http://cdags.org/, has news, a forum, items for sale by members, materials safety data sheets, bibliography, and more.

15.10 Lindsey Beal, *Foundations: Split Busk*, 4 × 5 in. (10.16 × 12.7 cm), Daguerreotype (Becquerel method), 2014. Courtesy of the artist. (You can see more of her work at www.lindseybeal.com).

Beal's work combines historical and contemporary women's lives with antique photographic processes. She is interested in the photograph as object and often includes sculpture, papermaking, and artists' books into her production.

NOTES

1 Rexler, Lyle. *New York Times*, Art/Architecture; Chuck Close Rediscovers the Art in an Old Method, March 12, 2000.

2 Artist's statement by daguerreotypist and sculptor Alyssa C. Solomon.

3 Crawford, William. *The Keepers of Light*. Dobbs Ferry, NY: Morgan & Morgan, 1979, p. 25.

4 One of the modern camera lucidas for purchase is made by http://neolucida.com/.

5 In British society, an educated man had to be able to draw, so Talbot named his book about his invention, *The Pencil of Nature*. He rushed to make public his discovery of 1835 when he heard about Daguerre. He used a portable camera obscura fitted with a microscope lens to make a paper negative, then a positive from that negative, of a window at his home, Lacock Abbey, now a museum near Oxford, England. His was the first editioned book with photo illustrations.

6 Niépce also made the first photo etching, a contact print from a drawing of Pope Pius. The basis of this process became the foundation for daguerreotype. In addition, he was the first to understand the principal of a latent, or invisible, image that becomes apparent through development.

7 Glessing, Jill. "Oscar Muñoz: Photographies," *Afterimage* (Jan/Feb 2015), vol. 42, no. 4.

8 Marshall, Peter. http://photography.about.com/library/weekly.

16.1 Juliana Swatko, *Kenoten*, 142 × 44 cm (56 × 17 in.), layered image, a digital print made from multiple exposed color negative, inkjet on photo paper. © 2014 Juliana Swatko.

This image combines my interest in experimental image making and a fascination for botany and garden design. I have used a speculative method of image production, where the content of the images cannot be calculated before they are developed, beyond the use of a shooting strategy that can be repeated. The images this method produces are in a sense visual hybrids, as the system for their production is akin to that of a gardener: grafting and breeding plants to create new varieties, the photograph brings together both natural and man-made elements in unexpected convergences. Many exposures are layered over each other, defying the documentary nature of photography and evoking a sensation of moving through the location, with points of focus as well as peripheral vision, as you would experience when viewing the world without a camera.

16

Visual Hybrids

LAYERED IMAGERY

By Juliana Swatko

This section looks at a range of ways to produce layered imagery in both black and white and color, using film and digital printing methods. Interesting creative work can be done using film, which is digitally scanned, corrected, and processed using Photoshop® prior to digital output. (See Chapter 6, Making Negatives: Digital Method, which explains scanning in detail and printing in black and white, but not color, as employed in this chapter.)

Layered image-making techniques through multiple exposures can provide scope for more individual and rich results. The unpredictable nature of using a speculative working method is an important element in this kind of image-making. Darkroom-based photography always had the capacity to produce unexpected results which could be investigated further but was lost in the use of programmed image production; this method allows the artist a

similar chance for investigation. It seems that since digital photography overtook analogue, that spirit of adventure has been progressively removed from the medium, which might be one reason why there is now a resurgence in analogue processes as photographers seek to recapture that excitement. Here, I will outline strategies to produce imagery that provides that exhilarating feeling of the magic of analogue processes.

MULTIPLE EXPOSURE

The most direct means of layering images on film for use as the final outcome or for color printing in the darkroom is through the use of in-camera multiple exposure.

The main principal to keep in mind with in-camera image layering is that any areas of black or dark shadow in a subject (the positive) will remain unexposed on the film, so will contain space for another image to reside. Areas of white or bright highlight will be fully exposed and so dense that no more photographic

information can be added. So the final image you produce will only be layered in areas that were the dark.

As exposures combine on the film negative and become denser, it produces a lighter final image. With every exposure you place on the same frame, you will double the density for that frame; therefore, for a correct exposure you will need to deliberately underexpose by a stop for every frame that is layered together. Past a point, you would capture very little, so three exposures are usually as much as is advisable unless you are working in a very dark environment.

There is always the option to use a multiple exposure function on a digital camera, but this is limited by the camera's sensor area (one frame), so unless images are merged after the

shooting, you will get the format provided by the camera. An example of such a multiple exposure, using a digital camera is shown in Figure 16.2, which was merged from shooting several analogue color photograms.

However, using film provides more interesting and unexpected avenues for image layering, due to the possibility of re-running the film through the camera by using the frame advance on a 35 mm analogue or medium format camera to create uneven frames, which can merge images in interesting ways. Images made on film may be scanned and easily corrected in Photoshop®, as explained in the next tip, below.

SCANNING FILM

Chapter 6, Making Negatives: Digital Method, explains in detail how to scan a color image and make corrections with Photoshop®, starting on page 128, and is relevant to the following instructions.

TIPS FOR COLOR CORRECTION OF SCANNED FILM

Use the eyedropper tools in the curves tool adjustment layer (Layer > New Adjustment Layer > Curves) to place the black point in an area that is intended to be full black, which will place all other tones in the correct place. You can find which of the eyedropper icons is the one for black point by holding your cursor over the eyedropper icons in the curves dialogue box until a label appears. Once the correct dropper is selected, move the cursor to the picture area's black and click on it. The picture will be adjusted.

An interesting result can also be gained by inverting an image to negative (use command + i on the keyboard) and next returning to curves, use the black eyedropper tool in the same way, and then invert image back to positive, producing very bright whites.

16.2 Juliana Swatko, *Flow*, 17 × 25 cm (7 × 10 in.), inkjet on photo paper, 2016. ©Juliana Swatko.

Digital print of multiple exposure of two analogue color photograms.

16.3 Juliana Swatko, *Everglades/Oak Point*, 143 × 20cm (56 × 8 in.), inkjet on photo paper, 2014. © Juliana Swatko.

Layered image, made by rewinding the color negative film and shooting over the first black and white photos copied on a copy stand.

Use levels (Layer > New Adjustment Layer > Levels) to adjust the balance between highlight, shadow, and mid tones, and correct the image to ensure there is detail visible in highlights. (You accomplish this change by moving the triangle-shaped sliders under the schematic: the dark triangle adjusts the shadows, the gray triangle in the middle regulates the midtones, and the white triangle alters the highlights.)

Any final adjustments can be made using the layers menu and picking color balance and vibrancy tools. Again, once those layers are added, you move sliders or type in numbers to effect changes.

To review, with film you can:

Use the multiple exposure function on the camera.

This allows a number of exposures to be made on the same frame without the film advancing, but you must underexpose deliberately by one stop for each exposure made.

(Digital cameras can make this adjustment automatically in the tool settings.)

Rewind the film and run it through the analogue 35mm camera again.

For each pass through the camera, you must underexpose by one stop to halve the amount of light reaching the film to produce a readable image. It is important not to completely rewind the film, or you can lose the leader that you need to re-insert it a second time. (Note: this method cannot be used with medium format cameras.) The easiest way to ensure ending up with film that is not too dense but can be scanned and printed is to set the ISO to twice the recommended ISO and then taking your light reading. This will result in all of the exposures being half normal and provide the correct exposure when two are combined.

This method can be quite unpredictable, as the frame lines do not generally line up in the second trip through the camera, so the film has new divisions, which provide an interesting merge in the compositions. Using shadow areas at the edges of the images will enhance the merges. It is impossible to predetermine what the images will look like, so this technique can provide some very unexpected results in the way the images layer on the film.

When rewinding the film, it is important not to wind it back into the canister, as it can be difficult to retrieve the film tongue. (It can be pulled out using a strip of double sided tape attached to a piece of film pushed into the film gate until it catches.) And so, it is best

16.4 Juliana Swatko, *Leaf*, in-camera multiple exposure, Type C print, 50 x16 cm (16 × 20 in.), 2000. ©Juliana Swatko.

to place the camera close to your ear and listen when rewinding, counting a turn for each frame. When you hear a small click, it is the film coming off the take-up spool. Stop immediately when you hear it and your film tongue will remain out.

Another interesting method for image layering is to shoot black and white images on a copy stand (using a tungsten light source and day light film) and then combine that exposure with color imagery shot in day light, or shot again on the copy stand if you wish to control the resulting image.

While using a copy stand is somewhat more predictable in terms of what images are brought together, it is still unpredictable in terms of how the images will actually merge together owing to the light and darks of the combined images.

USING MEDIUM FORMAT FILM AND CAMERA

This is the method I have most used in my image layering work; as for me it produces the most unpredictable results. I have used both contemporary and vintage cameras, but the most successful for me has been the Holga camera, which is the most basic of cameras with almost no camera functions apart from two exposure settings and a flash.

The Holga camera (a fixed focus, low tech, plastic camera (L.B.)) allows the film to be moved through the camera as much or as little as you wish because there is no film advance as found in 35 mm cameras, and the resulting images merge over one another in a most interesting way.

There are a number of other inexpensive plastic cameras, such as the Diana and the Lomo.

16.5 Juliana Swatko, *Pitcher Plant*, Inkjet print of three images overlayed using a Holga camera loaded with 120 film, 92 × 30 cm (36 × 12 in.), 2014. © Juliana Swatko.

16.6 Juliana Swatko, *Everglades Gardens*, Digital print using black and white medium format color film, processed in C41 chemistry, 127 × 43 cm (50 × 17 in.), © 2014. ©Juliana Swatko.

16.7 Juliana Swatko, *Kykuit*, Digital print of five images overlayed using Holga camera, 153 × 43 cm (59 × 17 in.), 2014. ©Juliana Swatko.

16.8 Juliana Swatko, *Bells*, Digital print showing color aberration from light leaks in Holga camera using 120 film, 92 × 30.4 cm (36 × 12 in.), 2014. ©Juliana Swatko.

They tend to leak light, which can add some interesting color aberrations to the images.

For all of these methods you can scan the film and correct it in Photoshop® and print the image digitally, or the film can be printed in the darkroom, if you have access to a color darkroom. If you don't, there may be places in your own area where time in a color darkroom can be rented.

FILM

Working with layered imagery involves the understanding of some fundamental principles of the action of light on photographic materials and of the behavior of light's primary colors when used for color imagery. There are alternative methods of film processing which can be used for the production of variations on "normal" color, produced through the Cross Processing of color film. This is the deliberate processing of a slide or negative film in the chemistry intended for other the other type of film, as explained below.

Color films come in two types:

1. Negative: Is the most commonly used and most easily available color film, which is processed in C41 chemistry, producing a color negative, and is then scanned or printed directly onto photographic paper and viewed by reflected light. This type of film can be processed at most commercial processing labs.

2. Positive: Also known as slide, reversal, or transparency and it produces a color positive on film, which is viewed by transmitted light. Slide film is processed in E6 chemistry, which is now less common but can still be done at many professional labs.

There are also two sorts of these films for use under different light conditions, as film is calibrated to see one particular color temperature as white light.

1. Daylight film: Is balanced for 5500 K on the Kelvin scale, intended for use in day light or with electronic flash, which is the equivalent of day light.
2. Tungsten film: (type B)_Is balanced for 3200 K on the Kelvin scale, which is used with 3200 tungsten Photographic lights (hot light sources).

CROSS PROCESSING

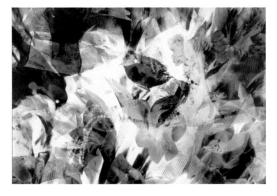

16.9 Juliana Swatko, *Blue Bird*, Type C print made with a cross processed slide film, 40.64 × 50.8 cm (16 × 20 in.), 2000. ©Juliana Swatko.

The main difference between the makeup of negative and positive color film is a masking layer found in the negative film, which is an overall reddish brown color intended to reduce contrast when color printing.

Slide film processed in the C41 chemistry (intended for negative color film) produces a negative, which does not have this masking layer. Thus, the contrast in a print made from such a negative is increased and can produce some striking results if used with colorful subject matter.

Cross processing poses no issue for the lab doing the processing, as the films are essentially the same material, but either with or without the masking layer.

The color varies with different brands of films, so it is a good idea to do some tests to find a brand that suits your own vision. Interesting color results may also be gained by using tungsten film shot under fluorescent light and then cross processed, producing high contrast and vibrant blues.

Conversely, color negative film may be processed in the E6 chemistry intended for slide film. The main issue in going this way is that the film picks up speed in the processing, producing an under exposed negative, which needs to be pushed in the processing—usually by two stops—but depending on the subject and lighting this is not hard and fast. The masking layer will add a pinkish cast to the film, which decreases with push processing. This may be quite easily corrected in Photoshop from a scanned film.

It is advisable to do a test film and get the lab to do a clip test, where they push process (extend the development time) short pieces clipped off the film at one, two, and three stops. When you evaluate the results, you can determine the appropriate number of stops you need to push the film. These color

16.10 Bracketed slide film. ©Juliana Swatko.

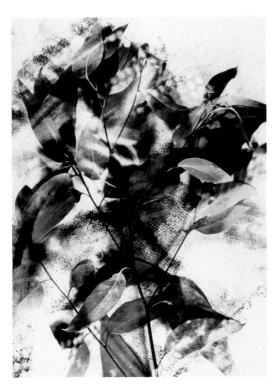

16.11 *Blue Leaves*, 2000, multiple exposures. ©Juliana Swatko.

qualities can be used quite effectively with the multiple printing process in the next part. Prints made from cross processed positive film will print in negative colors, exhibiting high contrast and rich color.

LIGHTING YOUR IMAGES

When all three of light's primary colors (red, green, and blue) are projected equally, it produces white light. When they are mixed in varying amounts, you can get unusual color effects. So it can be interesting to use studio lights with color gels of two or three of the light primaries, as shadow areas in the image can take on secondary colors, where two of them mix in varying degrees. And where three mix you will get the complementary colors. Unlike pigments (reflected light), the complementary, or opposite, colors of the light primaries are the printing primaries (cyan, magenta and yellow).

TIPS

The Darkroom, in Fresno California, specializes in cross processing and even hosts contests: https://thedarkroom.com/cross-processing-film/. (L.B.)

I use a local Australian company, Camera House, which is a chain of labs that will do chemical processing for both 35mm and medium format negative film.

CHROMOSKEDASIC PAINTING

By Birgit Blyth and Laura Blacklow

Chromoskedasic, a term coined by B. W. Rossiter of Kodak, means color by light scattering. Black and white photographic papers contain silver salts that form tiny particles when exposed to light and chemicals. Silver particles that are roughly the same size will scatter certain wavelengths of light and absorb others, producing a specific color. Artist Blyth learned about the process in a November 1991 article in "Scientific American" written by Dominic Man-Kit Lam with Alexandra J. Baran.

SAFETY

Make sure you respect these chemicals; heed the manufacturer's safety warnings or look up the Materials Safety Data Sheet before you start.

Be meticulous about protecting your skin from color stabilizer, activator, and acids; they can be extremely dangerous.

Avoid overheating solutions.

Make sure you properly ventilate your darkroom; wear an approved respirator with organic vapor and acid gas cartridges (and, if the stabilizer has formaldehyde, use a respirator with a formaldehyde cartridge).

Never pour water into a concentrated acid, but carefully add the acid to water.

Dominic Man-Kit Lam advises practitioners to assemble all necessary materials and dilute all needed solutions before removing the photographic paper from its protective box.

MATERIALS

1. Black and white darkroom (see New Dimensions in Photo Processes, Chapter 5 of the fourth edition, or consult a traditional photography book or contact the author through her website, www.laurablacklow. com, to get a scan from her).

2. Black-and-white chemicals and photographic paper (different papers, based on their silver con-

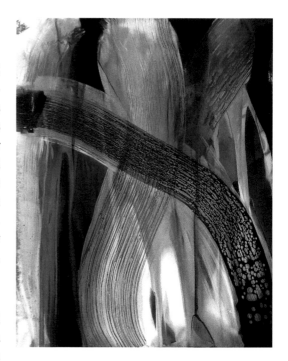

16.12 Birgit Blyth, *Untitled 14*, 16 × 20 in. (40.6 × 50.8 cm), chromoskedasic painting on Ilford multi-grade, glossy b/w paper, 2015. Courtesy of Carrie Haddad Gallery, Hudson, N.Y.

Blyth used a foam brush to apply Kodak stabilizer and Kodak accelerator to the paper's emulsion without ever employing a photo image and not knowing exactly what results she would obtain. She uses different masks, such as Vaseline, Sobo glue, and tape. Blyth is attracted to the chromoskedasic process because of the mystery and experimentation it allows her, a balance between control and surprise, much like the approach that one of her inspirations, Morris Louis, used when painting on canvas.

tent, yield different results, and warm tone versus cool tone paper produce slightly different colors). Blyth uses Ilford multi grade RC paper glossy, Ilford warm tone matte fiber paper, or double weight Bergger prestige variable CB fiber paper.

She also employs one part Kodak Ektamatic S30 or other color Stabilizer diluted with 9 parts water at 68°F (20°C), 1 part Kodak S2 or other color Activator mixed with 9 parts of water, Sprint Print developer or equivalent paper developer diluted to the working strength recommended by the manufacturer (in the past, she has used it at half strength), stop bath for black and white paper, black and white paper-strength fixer without hardener, and hypo clear.

3. Water for washing the prints and distilled water for diluting chemicals.

4. Six photo trays or dish tubs larger than the paper for developer, water rinse, stop, fixer, hypo clear, and final wash.

5. Fluorescent light.

6. Measuring cup that hold at least ¼ to ½ cup (59–118 ml) liquid and larger ones for diluting the stock chemicals.

MAKING A CHROMOSKODESIK PRINT

1. You can start with or without a photographic image. If you want a photographic image, enlarge as you would normally onto photographic paper under safe-lighted conditions, then immediately after you have exposed the paper to the image, do *not* develop and process it, but go to the next step.

 If you do not care about a photographic image, begin by exposing black-and-white photo paper to dim red light for approximately 5 minutes, then proceed to Step 2.

2. Under a safelight, pour ¼ to ½ cup (59–118 ml) of the 10 percent stabilizer solution onto the paper and brush or swirl it in a desired pattern. You can see areas emerge as light yellow. Next, pour a small amount of 10 percent activator solution followed by 50 percent to full strength paper developer solution. These chemicals produce reds, oranges, yellows, greens, blues, and grays.

3. Expose the paper to a fluorescent lamp light for 5 minutes; in areas where no chemistry has hit the paper, it will turn pink.

4. Finally, immerse the paper in a bath of fixer for a minute, then turn the fluorescent lights on, and you can watch the color changes occur.

5. Carefully rinse the paper with water and allow it to dry. Sometimes the colors change further with washing.

TIPS

There are many possible variations on these directions. For instance, you can selectively administer the color chemicals before enlarging, wash the paper, place Plexiglas™ or masonite under it, then enlarge onto the paper and process as you would normally for a black-and-white photograph. Or, if you put the paper in developer with a white light on before you put it in fixer, the paper will turn black where no chemicals have been painted.

In addition, you can try Arista Black and White Chromoskedasik Activator and Stabilizer or their ECO Pro B & W developer.

Sometimes Blyth begins by applying rubber cement or Maskoid to prevent an area of paper from staining. Then, she paints with a brush or sprays the chemicals with an atomizer.

Lam suggests using a rag to spread solution or a fountain pen dipped in the activator for drawing an outline. Sometimes he finishes the chemically treated paper by exposing it to fluorescent light for 30 minutes, then he applies a 50 percent solution of fixer with a spray bottle over the entire piece of photographic paper. After 20 minutes, he washes the paper with water and air dries it. *Wear a high quality respirator!*

You can purchase liquid stock activator and stabilizer solutions in quart bottles as special order items at a good photo store or online. Blyth uses Freestyle Sales (http://www.freestylephoto.biz).

You can vary the strength of the stabilizer and activator. Stabilizers usually produce yellow, and activators lean toward orange. Adding Dektol produces red-orange or deep red to brown.

The temperature of the chemicals affects the colors produced, so experiment.

Berg toners can be selectively applied after your chromoskedasic picture is done to further change colors (see Chapter 3).

LUMEN PRINTING

By Joseph Moccia

Lumen printing can be done by photographic novices, as well as experienced darkroom artists. Some of the rewards for trying this method are its ease, affordability, and the surprising

16.13 Joseph Moccia, *Arnold Arboretum*, 8 ½ × 11 in. (21.59 × 27.94 cm), lumen print on black and white variable contrast fiber paper, 2015. ©J. Moccia.

I started with two sheets of panchromatic ("normal") black and white 4 × 5 in. (10.16 × 12.7 cm) film. In a totally black room, I loaded each one into a large format film holder. In the dark, I cut ½ in. (1.27 cm) masking tape into strips, and I applied the tape as methodically as possible onto the film, leaving space between each row of tape. I envisioned putting the tape down so that each piece of film was the opposite of the other. That is, if I took two shots without moving the camera, the part of the scene that was partially obscured by the tape on one film, would be unobstructed in the other. Next, I went outside and set up a 4 × 5 camera and exposed the films separately. When I finished shooting, I returned to the black room and removed the tape before processing the film. Later, I took the dry negatives to a light table and carefully cut them along the path where the tape had been and arranged only the pieces that had had the tape on them, in order to recreate the landscape. The collage was scanned (Chapter 6), printed as a negative onto Pictorico OHP (page 139) and made into a lumen print on outdated paper. I think of the images as commentary on how we humans need to control nature and also how much control I can give up in taking pictures.

Any matte paper, after painted chromoskedasically and dried, easily takes hand-coloring techniques (see Chapter 2).

discoveries, which I find to be an important part in this experimental technique. The same type of paper will turn different colors due to variables such as humidity, light source, exposure time, and the object or negative you use. (When you're starting, I advise that you control these factors in order to more easily achieve consistent results.) Although I have used a negative, it is not necessary to start with a photographic transparency, because the black and white paper will show the effect of any object placed on top of it.

Jerry Burchfield (see http://138.23.124.165/exhibitions/burchfield/) is credited with having coined the term "lumen" and was one of the first artists to master and conceptually deal with the technique. A lumen print can be as simple as arranging objects on a sheet of black and white photo paper and placing it in sunlight to the complexity of creating a mixture of processes, such as using a digital negative with objects in an ultraviolet exposure unit or making a lumen print on an unusual surface coated with Liquid Light™ (Chapter 14), which you later tone (Chapter 3). No matter what your end goal is, in lumen printing there are some constants: a light source, preferably with a high ultraviolet output; a silver halide substrate; and conventional darkroom fixer. The two best sources for exposure are a UV exposure unit (see Chapter 4) and the sun. The choice of silver halide materials for making a lumen print include, but are not necessarily limited to: black and white photo paper, color photo paper, color negatives, black and white negatives, and liquid enlargement emulsions. The only other materials needed to complete your lumen print are fixer and water.

SAFETY

Make sure to always use gloves and tongs when handling chemicals and work in a well-ventilated area.

Old fixer, aka "hypo" solution, can produce highly toxic sulfur dioxide gas, so discard fixer that no longer is clear in color. In addition, repeated exposure to sodium thiosulfate or powdered fixer can cause eye irritation and skin dermatitis; wear protective gear when using it.

Dispose of excess chemicals by finding a silver recovery center near you, or a center for disposing of chemicals. Silver that has been leached out and incorporated into fixer can be detrimental to the environment and city water supplies.

Do not store chemicals near food, and keep them away from children or pets.

For safety, never add water to chemistry, but always add chemistry to water.

Once mixed, sodium thiosulfate should remain stable for at least one year at room temperature in an opaque bottle.

Never look at the ultraviolet bulbs without protective goggles.

METHOD OVERVIEW

1. Under a safe light, a few pieces of color or black and white paper or film are removed from their packaging and put into an opaque bag to be opened under regular room light.
2. An enlarged negative is placed on the photographic paper, preferably in a contact print frame, or an object is placed on top of the frame.
3. Ultraviolet light is projected through clearer parts of the negative or around the object, hitting the light-sensitive coating, which causes the silver halide crystals to change colors.
4. The negative or object is removed, and the paper or film is placed into their respective fixers, and then a wash bath.

MATERIALS

1. Substrate. The easiest and most affordable light-sensitive base is expired black and white analogue paper. Older, even out-of-date, paper generally contains more silver if it is not R.C. (resin coated) and often can be found for free or at a substantially reduced price. More silver allows for a more vibrant color in most situations. I suggest using paper first because it is flat, easily obtained, and you can make tests strips quite easily to see how the paper reacts to light. If you cannot find expired paper, then new store bought paper works just the same.
2. Chemicals. Fixer is available at photography stores, but do not use rapid fixer because it seems to pull back the colors much more than hypo fixer or use two-part rapid fixer without part B. I buy 250 g (8 oz. or 1 cup) at a time of powder sodium thiosulfate, available through many of the suppliers listed at the end of this book. Prepare the solution by thoroughly dissolving 1 heaping tablespoon into 1000 ml (1.05 qt) warm water at approximately 86°F (30°C) and allowing it to cool to room temperature before using. If you are using Blix for color prints try using only the fix and maybe a lesser amount of bleach or none at all. Fixer remover or hypo clear helps with the longevity of prints on fiber photo paper and is available at photography stores and online suppliers.
3. Two or three trays or tubs larger than the print. The number of trays or dish tubs (from a grocery or housewares store) depends on whether you are using hypo-clear. At minimum, have one tray for fix and another for a final rinse. You will need to label the trays: fix, hypo clear, and final wash. I find that photo trays without ridges are better for evenly distributing the processing liquids on the print's surface.
4. Siphon washer. For washing prints, this gadget, available on eBay, works well when attached to a spigot and then to a photo tray in a sink. Or, you can drill small holes up the sides of a dish tub or photo tray and gently run water directly from a faucet onto the back of the print. Both methods allow clean water to enter while contaminated water drains. If you do not have running water, fill the wash tray with water, agitate the print by rocking the tray for 20 seconds, then dump the water and refill the tray.

Keep repeating for 20 minutes for a final wash if you do not use hypo clear and wear gloves.

5. Image. To make a positive print, rich in detail, either use a negative transparency slightly smaller than the paper/film you are using, or try real objects. Even semitransparent objects, such as leaves, show the veins after proper exposure. Dry and press plants for better contact and, therefore, better resolution. If you are using fresh vegetation, such as flowers or leaves, place a sheet of plastic wrap from a grocery store or clear acetate from an art store above the emulsion and below the plant. The heat from the exposure causes the vegetation to "sweat," which can cause stains. However, this reaction can also trigger the emulsion to change color in unexpected ways; and so, plastic wrap should not be used if you are a more experimental photographer. In addition, to produce more interesting colors within your image, plant material and colors from the plant itself can leech into the paper and remain even after the washes. If you are exposing the paper outside and not in an ultraviolet unit, and you do not use glass, carefully pin in place or tape directly onto the paper cuttings that can blow about or are not flat. Just bear in mind that anything you use will leave a mark on the photo paper. Another method for holding items in place is to use a small amount of rubber cement that can be rolled off the paper after the exposure. If your paper is exposing outside, watch for shadows during its exposure; it is possible to catch shadows on the emulsion. If you are using a negative, the more contrast in the negative the better; some small details of the negative might be lost especially if the negative is thin, meaning less contrast.

6. Light. Although most sources of light can be used, such as a fluorescent or incandescent bulb, the time needed to create an exposure with these sources can be daunting, taking months to obtain the same results as several hours of sunlight. The best sources of light, as previously mentioned, are ultraviolet exposure units (see Chapter 4 for directions on building one) and sunlight. Different qualities of light will decide how much time a proper exposure will take. For instance, a cloudy day during the New England winter season makes an exposure take much longer than a clear sky in the summer when the sun's UV rays are at its strongest. An opaque material, such as the bags that photo paper is packaged in or opaque cardboard, is helpful when testing exposure times. Bags are also useful if you prefer to collect different test strips and process them all at once.

7. Printing frame. To achieve good contact between the negative or flat object and emulsion, use a printing frame bought from one of the makers listed in Supply Sources; plate glass with other sheet of glass or Masonite; or follow the instructions for building a frame on page 80. By using one of these print frames, you will be ensuring against blurry imagery by weighting down the negative, and if you have a split-back frame, you can inspect the image without moving the negative. If I am using a printing frame without a hinged back, I create a hinge by splitting a length of clear tape half on one edge of the negative and half on the photo paper. I always keep a lookout at my local thrift store for a used printing frame with a split back–because it is an easy and affordable way to ensure sharp results, especially when using a negative. Make sure glass is larger than the image, not the kind that protects against ultraviolet rays, and is clean and dry before each use. Foreign particles lodged in the glass can create dimples in the print.

8. Tape. If you are not using a hinged printing frame, use clear removable tape to form a fulcrum between the edge of one side of the negative and the substrate. The tape ensures that the negative does not move if, after you have placed it on the coated and dried paper, you want to check on the emulsion color as it is exposing. Do not press the tape down too hard, or it will lift up the emulsion when you try to remove it later. I tap the tape against my clothes to pick up a little lint and, therefore, make the tape less sticky. You can also buy at an arts and crafts store artist's or drafting tape, which is made to not stick too firmly or leave an acid residue behind.

MAKING A LUMEN PRINT

1. Prepare the substrate

In an area that is not directly in the sunlight or UV light source, place your object(s) or negative(s) emulsion side down onto the light sensitive side of the photo paper. Place the flat objects inside your print frame and secure all components. Position the print frame glass side up either into your exposure unit or out doors, where it can receive sun exposure for extended periods of time. Try planning on an exposure of at least one hour in summer light or a UV exposure unit. Use a scrap piece of the same photo paper to help determine when you might want to pull your substrate from UV exposure, keeping in mind that the fix, which is necessary, will pull the color back some. It is always hard to predict what color the silver halides will fix to, and every manufacturer's formula is different. I suggest having several strips or a second piece of the substrate without a negative or object on it, covered with an opaque material, and over time revealed to UV exposure. Start with 20 minutes, then an hour, then two, and so on, to get an idea of how exposure time affects the paper color.

2. Fix the image

Once you think the paper has changed color *beyond* the point you found most interesting, remove your substrate from light, remove your objects or negative, and place solely the paper in the fix tray. While gently rocking the tray, fix for the time the manufacturer suggests. Usually, fiber paper needs more time in fix than resin coated paper.

16.15 Hypo Clear and Final Wash

3. Hypo clear and final wash

After you have fixed your image, place fiber paper in hypo clear for the manufacturer's suggested amount of time, while gently rocking the tray, then use tongs or gloved hands to move it to the final wash for 20 minutes. Often, the manufacturer advises that resin coated paper is not put in hypo clear, and the final wash is a dramatically shorter period. After you have washed for the suggested amount of time, allow your image to dry before making any adjustments with the next print.

16.14 Fix the Image

TIPS

Because the exposures are measured in hours, trying to figure out the right moment to pull your test print from ultraviolet light will take the longest amount of time in this process. I suggest that, when you're thinking of starting this procedure, you just lay test strips on your UV table or outside under glass and pull them during various times, such as an hour, two hours, four hours, and six hours. After each exposure, place a test strip in a light-tight bag until they're all ready and you can fix them at the same time. In this way, if you have exposure times spread out over hours or even days or weeks, you will not have to worry about constantly preparing trays for fix and wash. You will also be ensuring that there are less variables.

Consider using your materials or light in ways that augment your intentions. Maybe your exposure lasts as long as a candlestick takes to burn out, or your exposure lasts one full year because you are referring to the passage of time. Thinking about why you're choosing lumen and how your image is created can add a lot more depth and meaning to your piece.

Experiment with different substrates and light sources, such as fire light or moon light, and use the different methods to give you different ideas; experimentation is half of the fun to lumen printing.

If you are using a paper or film that you want to preserve, make sure you remove solely the sheets you will use under a safe light or in a pitch black room because photo paper is sensitive to many light sources and can be ruined.

Always turn off the UV light before you judge the color and never look at the bulbs without protective goggles. Very slight coloration might occur while you are preparing your substrate but shouldn't have much effect on the final image.

Exposure times vary, but in a UV unit fitted with black light fluorescent bulbs, as described in Chapter 4, I have used one hour. Outside, in the summer New England sun, which I prefer because it doesn't cost any money, use electricity, or take as long, exposures can take 30 minutes to a few hours.

Maintain consistent fixer, hypo clear, and wash times. Cities use different amounts of a chlorine derivative in water, so you will have to watch to see when the wash water begins to bleach the colors in your lumen print.

Annotated Bibliography

Many of these books are available through Photo-Eye, 376 Garcia Street, Santa Fe, NM 87501, USA (Tel: 505-988-5152, www.photoeye.com/bookstore; e-mail: webmaster@photoeye.com).

HISTORY AND THEORY

Atkins, Anna, with text by Lynn J. Schaaf. *Sun Gardens: Victorian Photograms*. New York: Aperture, 1985.

Barnes, Martin. *Shadow Catchers: Camera-less Photography*. London: Merrell Publishing, 2012.

Great artists like Adam Fuss, Pierre Cordier, Susan Derges, Floris Neususs, Garry Fabian Miller.

Batchen, Geoffrey. "Len Lyle Shadowgraphs," *Aperture* #13, Winter, 2013.

Cameraless portraits, some combining text.

Batchen, Geoffrey. *Emanations: The Art of the Cameraless Photograph*. Munich and London: Prestel Publishing, 2016.

Boni, Albert. *Photographic Literature*. New York: Morgan & Morgan, 1962.

International bibliographic guide to general and specialized literature on photographic materials and applications.

Bruce, David, ed. *Sun Pictures*. Greenwich, CT: New York Graphic Society Ltd., 1974.

Reproductions of Hill-Adamson calotypes from the Victorian era.

Buckland, Gail. *Fox Talbot and the Invention of Photography*. Boston: David T. Godine, 1980.

Burns, Nancy Kathryn, and Kristina Wilson. *Cyanotypes: Photography's Blue Period*. MA: Worcester Art Museum, 2016.

Catalogue for an exhibition by the same name, including work by the author of this book and Jesseca Ferguson (Pinhole, Chapter 5) among others.

Eder, Josef Maria. *History of Photography*. New York: Dover Publications Inc., 1978.

Gassan, Arnold. *A Chronology of Photography: A Critical Survey of the History of Photography as a Medium of Art*. Athens, OH: Handbook Co., 1972.

Gernsheim, Alison, and Helmut Gernsheim. *Creative Photography*. New York: Bonanza Books, 1962.

History from 1826–1962.

Gernsheim, Helmut. *The Origins of Photography*. Revised 3rd ed. New York: Thames on Hudson, Inc., 1983.

Gilbert, George. *Photography: The Early Years.* New York: Harper & Row Publishers, Inc., 1980.

Heckert, Virginia. *Light, Paper, Process: Reinventing Photography.* Los Angeles, CA: J. Paul Getty Musuem, 2015.

Chapters on Marco Breuer (reproduction in Gum Printing chapter of this book) and other experimental artists.

Hirsh, Robert. *Seizing the Light: A Social and Aesthetic History of Photography* (3rd edition). Oxfordshire: Routledge/Taylor & Francis Group, 2017.

If you see a book by Hirsh, you can count on it being clearly written and offering new ideas.

Holme, Bryan, ed. *The Gallery of World Photography/Photography as Fine Art.* New York: Dutton (1st American edition), 1983.

Three-part series of paperbacks with fine reproductions ranging from the obscure to the famous.

Ivins, William M., Jr. *Prints and Visual Communication.* Cambridge, MA: MIT Press, 1978.

A significant text on the history and understanding of the relationship of photography to printmaking. Remember: like printmaking, photography started as documentation of the visible, as well as an image.

John Michael Kohler Arts Center. *The Alternative Image. An Aesthetic and Technical Exploration of Nonconventional Photographic Printing Processes.* Sheboygan, WI: John Michael Kohler Arts Center, 1983.

Jones, Bernard, ed. *Encyclopedia of Photography.* New York: Arno, 1974.

Reprint of 1911 edition of *Cassell's Cyclopedia of Photography.* Includes formulae. Available through Ayer Co. Publishers (www.ayerpub.com).

Jones, Bernard, ed. *The Encyclopaedia of Early Photography.* London: Bishopsgate Press, Ltd., 1985.

Jussim, Estelle. *Visual Communication and the Graphic Arts: Photographic Technologies in the 19th Century.* New York: R.R. Bowker Co. (a Xerox Education Company), 1974.

Furthers Ivins's theories with insight into photomechanical processes and advertising.

Kasher, Steven. *America and the Tintype.* New York: International Center of Photography, 2008.

Catalogue of sensational images drawn from the permanent collection of the Center.

Kennel, Sarah, Dianne Wagoner, and Alice Carver-Cubik. *In the Darkroom: An Illustrated Guide to Photographic Processes Before the Digital Age.* New York: Thames & Hudson, 2010.

From Talbot to Warhol, illustrated.

Kraus, Hans P., Jr., research and text by Larry J. Schaaf. *Sun Pictures: The Harold White Collection of Works by William Henry Fox Talbot.* New York: Hans P. Kraus, Jr. Fine Photographs, 1987.

Lietze, Ernst. *Modern Heliographic Processes.* Rochester, NY: Visual Studies Workshop Press, 1974.

Reprint of 1888 text, including formulae for brown and blue printing and toners for them.

McCabe, Constance. *Steiglitz in the Darkroom.* Washington, DC: National Gallery of Art, 1993.

Pamphlet includes microscopic blowups of Alfred Steiglitz's different print techniques.

McDermott, David, Peter McGough, and Mark Alice Durant. *A History of Photograpy.* Arena Editions, 1998.

Salt prints, gum, palladium, and cyanotpes about contemporary culture.

Nadeau, Luis. *Encyclopedia of Printing, Photographic, and Photomechanical Processes: Volumes 1 and 2*. Fredericton, New Brunswick, Canada: Atelier Luis Nadeau, 1994.

Information on over 1,500 reproduction processes.

Persinger, Tom, ed. *Photography Beyond Technique: Essays on the Informed Use of Alternative and Historical Photographic Processes*. NY and London: Focal Press/ Taylor & Francis Group, 2014.

Chapters of and by Craig Barber (lead photograph, Platinum/Palladium chapter), France Scully Osterman (author, Salt Printing chapter), Mark Osterman (photo reproduced in salt printing chapter), Jessseca Ferguson (author, pinhole section), Jerry Sapgnoli (photograph in Becquerel/Daguerreotype chapter), and myself.

Rexer Lyle. *Photography's Antiquarian Avant Garde. The New Wave in Old Processes*. New York: Harry N. Abrams, 2002.

Concentrates on practitioners of processes covered in this book.

Rinhart, Floyd, Marion Rinhart, and Robert W. Wagner. *The American Tintype*. Columbus, OH: Ohio State University Press, 1999.

Most of the illustrations are in the Floyd and Marion Rinhard Collection at The Ohio State University.

Romer, Grant B., and Brian Wallis, eds. *Young America: The Daguerreotypes of Southworth and Hawes*. New York: ICP/ Steidl Publishing, 2005.

Catalogue from an exhibition about the 1845–1862 partners from Boston who photographed many notable Americans and scenes, such as Niagara Falls and Civil War volunteers in a downtown park. When you see essays by Romer (of the Eastman House Museum) or the insightful Wallis (from New York's ICP), read them. You will be provoked, I am sure. Fascinating array of reproductions, and it's not just because I live in the Boston area.

Sheehan, Tanya, and Andres Zervigon. *Photography and Its Origins*. New York: Routlege/Taylor & Francis Group, 2015.

This collection of 16 original essays, illustrated with 32 color images, showcases prominent and emerging voices, such as Geoffrey Batchen and Dan Estabrook, in the field of photography studies. Really well done and worth reading.

Talbot, William Henry Fox. *The Pencil of Nature*. New York: DeCapo Press, 1969.

A facsimile of the 1844–1846 edition, with an introduction by photo historian Beaumont Newhall.

Time-Life Books. *Caring for Photographs*. New York: Time-Life Books, 1982.

Contains a chapter by George Tice on platinum printing.

Time-Life Books. *Frontiers of Photography*. New York: Time-Life Books, 1979.

Chapters on "Mixing the Media" and "Photography's Changing Images."

Time-Life Books. *The Print*. New York: Time-Life Books, 1982.

Chapters and great reproductions on "A Revolution in Printmaking."

Towler, J. *The Silver Sunbeam: A Practical and Theoretical Text Book on Sundrawing and Photographic Printing*. Dobbs Ferry, NY: Morgan & Morgan, 1969.

Reprint of 1864 edition.

Victoria and Albert Museum. *Shadow Catchers: Camera-less Photography*, Catalogue of display at the V&A South Kensington between 13 October 2010 and 20 February 2011.

Wall, Edward John, and Frederick James Mortimer. *The Dictionary of Photography.* Boston: American Photographic, 1938.

Ward, John, and Sara Stevenson. *Printed Light: The Scientific Art of William Henry Fox Talbot and David Octavius Hill with Robert Adamson.* Edinburgh: H.M.S.O. (for the) Scottish National Portrait Gallery, 1986.

Wilde, Ann, and Jurgen Wilde, eds. *Karl Blossfeldt: Working Collages.* Cambridge, MA, and London: M.I.T. Press, 2001.

Translated from a Schirmer/Mosel edition in German. Brilliant turn-of-the-nineteenth-century proponent of the New Objectivity in German Photography also made contact print sheets of cyanotype images collaged with brown and gray photographic prints. Never before shown, and amazing!

Wilson, Edward Livingstone. *Wilson's Photographics.* Reprint of 1881 ed. P.O. Box 958, Salem, NH: Ayer Co. Pub. Whitefish, MT: Kessinger Publishing LLC, 2007.

A series of lessons, accompanied by notes, of all the processes that are "needful in the art of photography."

Witkin, Lee D., and Barbara London. *The Photograph Collector's Guide.* Boston: Little, Brown and Co., 1980.

Zakia, Richard, and Leslie Stroebel. *The Focal Encyclopedia of Photography.* Boston and London: Focal Press, 2007.

Well-researched, comprehensive array of subjects and an explanation of just about anything you could want to know about photography from its beginning to digital. Extraordinarily reliable.

SELECTED CONTEMPORARY PRACTIONERS

Bowman, Stanley. *Translations: Photographic Images with New Forms.* Ithaca, NY: Herbert F. Johnson Museum of Art, Cornell University, 1979.

Reproductions of work by innovators Bea Nettles and Robert Fichter; important rejuvenators of historic processes Robert Heinecken, Joan Lyons, H. H. Smith, and Todd Walker; others.

Chadwick, Helen. *Enfleshings.* New York: Aperture Press, 1989.

Extraordinary use of liquid emulsion and photocopies in provocative installation by a British artist who died young.

Clark, Denis Miller. *Within This Garden: Photographs by Ruth Thorne-Thomsen.* Chicago: Aperture/The Museum of Contemporary Photography, Columbia College, 1993.

Clever pinhole photos.

Coe, Brian, and Mark Haworth-Booth. *A Guide to Early Photographic Processes.* London: Victoria and Albert Museum and Hurtwoood Press, 1984.

Coleman, A. D., and Lynn Warren, eds. *Robert Heinecken: Photographist.* Chicago: Museum of Contemporary Art, 1999.

Pictures of all major work in the 30-year career of this innovator and conceptual artist.

Dugdale, John. *Lengthening the Shadows Before Nightfall.* Santa Fe, NM: Twin Palms, 1995.

Reproductions of 8 × 10 in. cyanotypes.

Ess, Barbara. *I Am Not This Body: Photographs by Barbara Ess.* New York: Aperture Foundation, 2001.

Pinhole pictures.

Fuss, Adam. *Pinhole Photographs.* From the Photographers at Work Series, Washington, DC: Smithsonian Institution Press, 1996.

Grundberg, Andy, and Robert Rosenblum. *Mike and Doug Starn.* New York: Harry N. Abrams, 1990.

Inventive use of materials, from toned photo murals to ortho film as the image (see their work in Chapter 3).

Hitchcock, Barbara. *The Polaroid Book*. Los Angeles: Taschen America, 2008.

Comprehensive survey of the Polaroid Collection, showcasing over 400 artworks. Why did I fill out all the paperwork after being invited to add my work, then forget to mail it in? This book is terrific!

Hitchcock, Barbara, and Deborah Klochko. *Innovation/Imagination: 50 Years of Polaroid Photography*. New York: Harry N. Abrams, 1999.

Hoy, Anne H. *Fabrications: Staged, Altered, and Appropriated Photographs*. New York: Abbeville Press, 1988.

Graulich, Gerhard, Edgar Lissel Räume/ Picture Rooms 1996–2000. Austria: EIKON Sonderdruck #5, Wien, 2000.

The artist has used entire rooms to construct pinhole cameras.

Luciana, James, and Judith Watts. *The Art of Enhanced Photography: Beyond the Photographic Image*. Gloucester, MA: Rockport Publishers, 1999.

Morell, Abelardo. *A Camera in a Room, Smithsonian*. Washington, DC: Smithsonian Institute Press, 1995.

Pinhole black-and-white photographs.

Nettles, Bea. *Flamingo in the Dark. Knights of Assissi, Turning Fifty* are but a few of the self-published titles. Urban, IL: Inky Press.

Some are on demand at Lulu.com or www. beanettles.com or fax 217-337-0096.

O'Neil, Elaine, and Julia Hess. *Mother Daughter: Posing as Ourselves*. Rochester, NY: RIT Cary Graphic Arts Press, 2009.

Co-author of the toning chapter (page 59) this book contains selenium toned black-and-white photographs that span over two decades.

Spagnoli, Jerry. *Jerry Spagnoli: Daguerreotypes*. New York: Distributed Art Publications, Inc. 2006.

His work is featured in the daguerreotype chapter, page 285 of this book.

Walker, Todd. *Todd Walker Photographs*. Carmel, CA: Friends of Photography, 1985.

Known for a lifetime of innovative printmaking, especially gum printing (Chapter 10).

SELECTED GENERAL HOW-TO BOOKS

Airey, Theresa. *Creative Photo-Printmaking*. New York: Amphoto Books, 1996.

Anderson, Christina. *Alternative Processes Condensed*. Bozeman: Self-published, 2007. www.alternativephotography.com.

Anderson, Christina. *Experimental Photography Workbook, Fourth Edition*. Bozeman: Self-published, 2005. www.alternativephotgraphy.com.

Fifty-plus processes, student work examples.

Anderson, Christina. *Gum Printing and Other Amazing Contact Printing Processes*. Bozeman: Self-published, 2013.

Not only gum, but also casein, kallitype, and others. Impeccable technical information. Great sense of humor!

Arnow, Jan. *Handbook of Alternative Photographic Processes*. New York: Van Nostrand Reinhold, 1982.

Over thirty processes. One of the first of the contemporary how-to books.

Baldwin, Gordon. *Looking at Photographs: A Guide to Technical Terms*. Los Angeles and London: J. Paul Getty Museum in association with the British Museum Press, 1991.

Barnier, John, ed. *Coming into Focus: A Step-by-Step Guide to Alternative Photographic Printing Processes*. San Francisco: Chronicle Books, 2000.

One of the only available contemporary descriptions on daguerreotypes before my chapter.

Crawford, William. *The Keepers of Light: A History and Working Guide to Early Photographic Processes.* Dobbs Ferry, NY: Morgan & Morgan, Inc., 1979.

History and detailed directions on gum, blue, brown, and other processes. Not only did this book help me technically, but it also still is full of relevant history and theory.

Ctein. *Post Exposure: Advanced Techniques for the Photographic Printer* (2nd edition). Boston: Focal Press, 2000.

Enfield, Jill. *Jill Enfield's Guide to Photographic Alternative Processes: Popular Historical and Contemporary Techniques* (2nd edition). Oxford, UK: Focal Press/Taylor & Francis Group, 2017.

I do not know of a better artist to clearly explain albumin (with a recipe for what do to with unused egg yolks!) wet plate collodion, and photo-images on ceramics, just for starters.

Enfield, Jill. *Photo Imaging: A Complete Guide to Alternative Processes.* New York: Amphoto, 2002.

Many techniques, including tintype and kallitype.

Farber, Richard. *Historic Photographic Processes.* New York: Allworth Press, 1998.

Flynn, Deborah. *Imaging with Light Sensitive Materials.* Rochester, NY: Visual Studies Workshop Press, 1978.

Frederick, Peter. *Creative Sunprinting.* Boston and London: Focal Press, 1980.

Gassan, Arnold. *Handbook for Contemporary Photographers.* Boston, MA: Thompson Delmar Learning, 2005.

Chapters on black-and-white, color, and nonsilver (photo-printing) techniques and on color critiquing.

Hattersley, Ralph. *Photographic Printing.* Englewood Cliffs, NJ: Prentice-Hall, 1977.

Chapters on duplicating film, photographic silkscreen printing, special-effects screens, cyanotype, negative and print retouching and coloring, and mural prints.

Hindley, Geoffrey. *Working with Light-Sensitive Materials.* New York: Van Nostrand Reinhold, 1978.

Hirsh, Robert. *Photographic Possibilities: The Expressive Use of Ideas, Materials, and Processes* (3rd edition). Burlington, MA: Focal Press. 2009.

Mostly about black-and-white photography, but chapters on toning, widely used alternative processes, and altering photographic concepts. He is one of the most reliably inspiring authors.

Horenstein, Henry. *The Photographer's Source.* New York: Pond Press/Simon & Schuster, 1989.

This catalogue of equipment, workshops, services, etc. also includes chapters on hand-coloring, pinhole, and nonsilver processes.

House, Suda. *Artistic Photographic Processes.* New York: Amphoto Books, 1985.

Howell-Koehler, Nancy. *Photo Art Processes.* Worcester, MA: Davis Publications, 1984.

Kodak Publications. *Creative Darkroom Techniques.* Rochester, NY: Kodak Publications, 1974.

Gum, photo-silkscreen, toning, and other special effects.

Kosar, Jaromir. *Light Sensitive Systems: Chemistry and Application of Non-Silver/Halide Photographic Processes.* New York: John Wiley and Sons, 1965.

Nettles, Bea. *Breaking the Rules: A Photomedia Cookbook, Third Edition.* Box 725, Urbana, IL: Inky Press, 1992.

Assumes reader knows black-and-white darkroom technique, but many color repro-

ductions of this influential artist's work. www.beanettles.com/bookorder.

Newman, Thelma R. *Innovative Printmaking.* New York: Crown Publishers, Inc., 1977.

Two- and three-dimensional prints; photo and nonphoto methods with and without a printing press. Another of the early contemporary books.

Reed, Martin, and Randall Webb. *Alternative Photographic Processes: A Working Guide for Image Makers.* Sterling Publishers, 2000.

Reed, Martin, and Randal Webb. *Spirits of Salt.* London: Argentum Press, 1999.

Reeve, Catherine, and Marilyn Sward. *The New Photography: A Guide to New Images, Processes, and Display Techniques for Photographers.* Englewood Cliffs, NJ: Spectrum/Prentice-Hall, 1984.

Handmade paper and alternative processes, interview with artist Robert Heinekin.

Stone, Jim. *Darkroom Dynamics: A Guide to Creative Darkroom Techniques.* Boston: Focal Press, 1979.

Chapters on high-contrast negatives, Liquid Light, toning, hand-coloring.

Stroebel, Leslie, and Richard Zakia, eds. *The Focal Encyclopedia of Photography: Third Edition.* Boston: Focal Press, 2007.

Nine hundred pages from over 90 experts describing processes from antique to digital photography, including four pages on "nonsilver processes" by Judy Natal.

Van Keuren, Sarah. *A Non-Silver Manual.* Lansdowne, PA: Self-published, 2004. Updated and free from her website

Includes instructions for alternative processes and pinhole photography, with supply prices. Not for beginners. Available from the author at 6 Hereford Place, Lansdowne, PA 19050, or from Photo-Eye or http://www.alternativephotography. com/non-silver-manual/.

Wade, Kent. *Alternative Photographic Processes.* Dobbs Ferry, NY: Morgan & Morgan, 1978.

Imaging on glass, metal, fabric, tile, etc. This is a hard-to-find book full of ideas and information.

SPECIFIC PROCESSES

TRANSFERS AND LIFTS

Baker, Robert, and Barbara London. *Instant Projects.* Cambridge, MA: Polaroid, 1986, 1992.

Handbook of demonstrations, including building pinhole and stereo cameras and making separation negatives for casein and gum printing. You don't need Polaroid materials to use this book, and it contains inspired lesson plans for teachers.

Schminke, Karin, Dorothy Simpson Krause, and Bonny Pierce Lhotka. *Digital Art Studio: Techniques for Combining Inkjet Printing with Traditional Artist's Materials.* New York: Watson-Guptill Publications, 2004.

Clear and useful instructions; most complete book that I know of on the subject.

Tourtillot, Suzanne. *The New Photo Crafts. Photo Transfer Techniques and Projects for Fabric, Paper, Wood, Polymer Clay, and More.* New York: Lark Books, 2001.

TONING AND HAND COLORING

Airy, Theresa. *Creative Digital Printmaking.* New York: Amphoto Books, 2001.

Section on hand coloring digital prints.

Anchell, Steve. *The Variable Contrast Printing Manual.* Boston: Focal Press, 1996.

Explanation of reason, methods, and hints for toning plus appendix containing some recipes for mixing toners from scratch.

Davidson, Jerry. *From Black and White to Creative Color.* Ontario, Canada: Pembroke Publishers Limited, 1994.

Davidson, Jerry. *Light Up Your Darkroom: How to Tone, Tint, and Retouch Black-and-White Prints.* Markham, Ontario, Canada: Pembroke Publishers Limited, 1987. Published with the assistance of Berg Color-Tone, Inc.

Dorskind, Cheryl Machet. *The Art of Handpainting Photographs.* New York: Amphoto Books, 1998.

Thorough description of subtly applying oil-based colors.

Henisch, Heinz K., and Bridget A. Henisch. *The Painted Photograph 1839–1914: Origins, Techniques, Aspirations.* University Park, PA: The Pennsylvania State University Press, 1996.

Over-painting employed in daguerreotypes, tintypes, porcelain, glass, lantern slides, and textiles.

Laird, Sandra, and Carey Chambers. *Handcoloring Photographs: Step by Step.* Buffalo, NY: Amherst Media, 1997.

Mallinckrodt Chemical Works. *The Chemistry of Photography.* St. Louis, MO: Mallinckrodt Chemical Works, 1940.

This wire-bound, hardcover book, which cost 50 cents then, contains 16 pages of formulae still applicable today for "changing the neutral black image to a more pleasing or more appropriate color."

Marshall, Lucille Robertson. *Photo-Oil Coloring for Fun or Profit.* Washington, DC: Larum Pub. Co., 1964.

Could she be related to the founders of Marshall's photo oils?

Martin, Judy, and Annie Colbeck. *Handtinting Photographs.* Cincinnati, OH: North Light Books, 1989.

McKinnis, James. *Hand Coloring Photographs.* New York: Amphoto Books, 1994.

Showcases color reproductions from many commercial artists and techniques different from mine—he recommends using colors straight out of the tube, but I say don't trust anyone else to manufacture the color you want.

McKinnis, James A. *Photo Painting, The Art of Painting on Photographs.* New York: Amphoto Books, 2002.

Murray, Elizabeth. *Painterly Photography: Awakening the Artist Within.* San Francisco: Pomegranate Artbooks, 1993.

Polaroid SX-70 manipulated pictures.

Newman, Richard. *Toning Techniques for Photographic Prints* Buffalo, NY: Amherst Media, 2002.

Rudman, Tim. *The Photographer's Toning Book: The Definitive Guide.* New York: Amphoto, 2003.

Sepia, tea, and other non-commercial toners, etc.

Sanderson, Andrew. *Hand Colouring and Alternative Processes: B & W Photo Lab.* Switzerland: RotoVision SA, 2002.

Schaub, Grace, and George Schaub. *Marshall's Hand-Coloring Guide and Gallery: The Tools and Techniques Using Marshall's Materials.* Chicago, IL: G & G Schaub Publishers and John G. Marshall Co., a division of Brandess/Kalt/Aetna Group, Inc., 1994.

Wall, Alfred H. *A Manual of Artistic Colouring as Applied to Photographs.* Reprint of 1860 ed. P.O. Box 938, Salem, NH: Ayer Co. Pub., 2009.

A practical guide to artists and photographers.

Winser, Cheryl. *The Art of Hand Coloring Photography.* Cincinnati, OH: North Light Books, 1995.

Out of print, so hard to get.

Worobiec, Tony. *Toning and Handcoloring Photographs.* New York: Amphoto Books, 2002.

GENERATING IMAGES: ANALOGUE METHOD

Anschell, Steve. *The Darkroom Cookbook* (2nd edition). Boston: Focal Press, 2000.

Duren, Lista, and Billy McDonald. *Build Your Own Home Darkroom*. New York: Van Nostrand Reinhold, 1982.

Holter, Patra. *Photography Without a Camera* (2nd edition). L.I.R. Box 429, Yonkers, NY: Van Nostrand Reinhold, 1980.

Great ideas for experimental photographers and teachers on a limited budget. Out of print, but can be purchased.

Hutchings, Gordon. *The Book of Pyro*. Granite Bay, CA: Bitter Dog Press, 1992.

Available from Bostick & Sullivan, this detailed manual tells all about one of the oldest developing agents treasured by large-format photographers.

Seely, J. *High Contrast*. Boston: Focal Press, 1980.

Wall, E. J., and F. L. Jordan. *Photographic Facts and Formulas*. Reprint of 1940 text. Englewood Cliffs, NJ: Prentice-Hall, 1975.

Tables, formulae.

Wilks, Brady. *Alternative Photographic Processes: Crafting Handmade Images*. Burlington, MA and Oxford, GB: Focal Press/Taylor & Francis, 2015.

Fun book that covers installation, darkroom manipulations, office copier options, and more.

Zimmerman, Philip. *Options for Color Separations: An Artist's Handbook*. Rochester, NY: Visual Studies Workshop Press, 1980.

Bountiful ideas for photographers and nonphotographers for making negatives. Unfortunately, out of print, but well worth looking for a used copy.

Pinhole

Chernewski, Anita. *How-To Make Three Corrugated 8 × 10 Pinhole Cameras: Wide-angle, Normal, Telephoto*. Pinhole Format Co., 1999.

Instructions and materials included.

Evans, John. *Adventures with Pinhole and Home-Made Cameras: From Tin Cans to Precision Engineering*. East Sussex, England: RotoVision, 2003. www.rotovision.com.

Jesseca Ferguson says: Good overview of contemporary pinhole/eccentric cameras and the images they produce.

Renner, Eric. *Pinhole Photography: Rediscovering a Historic Technique* (3rd edition). Boston: Focal Press, 2004.

Jesseca Ferguson says: Wonderfully comprehensive overview of pinhole photo from the editor/founder of *Pinhole Journal*; lots of pinhole photos, history, "how-to" section, etc. A must!

Shull, Jim. *The Beginner's Guide to Pinhole Photography*. Buffalo, NY: Amherst Media, Inc., 1999.

This is the latest version of Shull's classic how-to pinhole book, *Hole Thing Manual*. Incredibly clear and helpful. (L.B.) Can purchase from www.icp.com.

Smith, Lauren. *The Visionary Pinhole*. Salt Lake City: Peregine Smith Books, 1985.

DIGITAL NEGATIVES

Burkholder, Dan. The New Inkjet Negative Companion-Digital Negatives Made Easy. 2013. http://www.danburkholder.com/store/c1/Featured_Products.html.

Chavez, Conrad. *Real World Adobe Photoshop CS5: Industrial Strength Production Techniques*. Berkely, CA: Peachpit Press, 2010.

So clear and close to current versions of Photoshop®.

Farace, Joe. *Getting Started with Digital Imaging: Tips, Tools, and Techniques*. Boston: Focal Press, 2006.

Includes a CD-ROM of all steps outlined in the book.

Nelson, Mark I. *Precision Digital Negatives*.

This is an illustrated electronic book that you can purchase and download at www.precisiondigitalnegatives.com. Specifically for the processes in this book and more.

CYANOTYPE

Fabbri, Malin, and Gary Fabbri. *Blueprint to Cyanotypes: Exploring a Historical Alternative Photographic Process*. Self-published, 2006. www.alternativephotography.com/books.

Hewitt, Barbara. *Blueprints on Fabric*. Loveland, CO: Interveave Press, 1995.

Lots of direct methods for making images. From the former owner of Blueprints-Printables, www.blueprintables.com.

Ware, Mike. *Cyanotype: The History, Science and Art of Photographic Printing in Prussian Blue*. London: Science Museum and National Museum of Photography, Film and Television, 2004.

From the chemist and practitioner who invented a new cyanotype process comes a book of history and information. Now a collector's item.

BROWN PRINTING

Stevens, Dick. *Making Kallitypes*. Boston: Focal Press, 1993.

GUM BICHROMATE

Gassan, Arnold. *The Color Print Book*. Rochester, NY: Light Impressions Corp., 1981.

Information on color separation negatives, gum bichromate, and Kwik Printing included with other subjects.

Lewis, Eleanor, ed. *Darkroom*. New York: Lustrum Press, 1977.

Chapter on contemporary artist Betty Hahn and her gum prints.

Nadeau, Luis. *Gum Bichromate and Other Direct Carbon Processes*. Fredericton, New Brunswick, Canada: Atelier Luis Nadeau, 1987.

Scopick, David. *The Gum Bichromate Book* (2nd edition). Boston: Focal Press, 1991.

Extensive instructions, including negative prep, color separation techniques, and Kwik Printing, in addition to 15 step-by-step instructions on the gum printing process.

Whipple, Leyland. *The Gum Bichromate Printing Process*. Rochester, NY: George Eastman House, 1964.

Wilson, Helena Chapellin. "Gum Bichromate Printing," *Darkroom Techniques* (June 1981), pp. 40–44.

PLATINUM/PALLADIUM PRINTING

Arentz, Dick. *Platinum & Palladium Printing*. Boston: Focal Press, 2000.

Nadeau, Luis. *The History and Practice of Platinum Printing*. Fredericton, New Brunswick, Canada: Atelier Luis Nadeau, 1994.

The first printing of this revised edition in English has a tipped-in platinum print. German language edition published by Lindemanns Verlag, Stuttgart, Germany.

Rexroth, Nancy. *The Platinotype* (2nd edition). Yellow Springs, OH: Violet Press and Photographers' Formulary Press, 1977.

Now a collector's item.

Rice, Ted. *Palladium Printing, Made Easy*. Santa Fe, NM: Eagle Eye Text Production, 1994.

Detailed instructions on chemistry, negative-making, paper, processing, and finishing for palladium prints. Includes

advanced palladium techniques such as toning and the use of different developers. Available only through Photo-Eye. Watch for Rice's forthcoming book on platinum printing from 35mm and color negatives.

Shillea, Thomas John. *Instruction Manual for the Platinum Printing Process*. Philadelphia: Eastern Light Photography Ltd., 1986.

Precise instructions, carefully researched with safety data, available from Photographers' Formulary.

Sullivan, Richard S. *Labnotes*. Van Nuys, CA: Bostick and Sullivan, 1982.

Readable and funny instructions on platinum, palladium, and Kallitype, plus generally helpful tips on coating, exposure calculation, brushes. From half of the Bostick & Sullivan team.

Sullivan, Richard, and Carl Weese. *The New Platinum Print*. Santa Fe, NM: Working Picture Press, 1998. www.bostick-sullivan.com.

Also contains instructions for digital negatives.

BROMOIL

Laughter, Gene. *Basic and Advanced Bromoil Inking* (video). Available from Photo-Eye and Bostick & Sullivan.

Laughter, Gene. *Bromoil 101: A Plain English Working Manual and User's Guide for Beginners in the Bromoil Process*. Self-published, 1997.

Available from Photo-Eye Books and Bostick & Sullivan.

Lewis, David W. *The Art of Bromoil and Transfer*. Ontario: Self-published, 1995.

Available through Photo-Eye Books and Photographers' Formulary (see Supply Sources; out-of print, but can try www.abebooks.com).

Nadeau, Luis. *History and Practice of Oil and Bromoil Printing*. Fredericton, New Brunswick, Canada: Atelier Luis Nadeau, 1985.

ENLARGEMENT EMULSIONS

Eastman Kodak. *Making a Photographic Emulsion*. Rochester, NY: Pamphlet #AJ-12, 1936. http://www.freepatentsonline.com/2110491.html

Morgan & Morgan. *The Morgan & Morgan Darkroom Book*. Dobbs Ferry, NY: Morgan & Morgan, 1980.

Includes a chapter on "Liquid Light."

Reed, Martin, and Sarah Jones. *Silver Gelatin*. New York: Amphoto Books, 1996.

Not a stone left unturned in this text, including mixing enlargement emulsions (Chapter 14 of *New Dimensions*) from scratch.

DAGGUEREOTYPE

How to Make a Daguerreotypes. Embree Press, 1991.

Out of print, but worth looking for.

Sobieszek, Robert A., ed. *The Daguerreotype Process: Three Treatises, 1840–1849*. New York: Arno Press, 1973.

HYBRID PHOTO AND CHROMOSKEDASIC

Neblette, C. B. *Neblette's Handbook of Photography and Reprography: Materials, Processes and Systems*. New York: Van Nostrand Reinhold, 1977.

One of the few I know of besides this one with instructions on how to paint chromoskedasically.

SALT PRINTING

Anderson, Christine Z. *Salted Paper Printing: A Step-by-Step Manual Highlighting Contemporary Artists*. New York: Routledge, 2017.

Reilly, James M. *The Albumen and Salted Paper Book*. Rochester, NY: Light Impressions Corp., 1980.

RELATED PROCESSES

Bunnell, Peter. *Non-Silver Photographic Processes: Four Selections, 1886–1927*. New York: Arno Press, A New York Times Company, 1973.

Reprint of original manuscript on photogravure, gum bichromate (by DeMachy), oil and bromoil processes, and platinotype (platinum print).

Croner, Marjorie. *Fabric Photos*. Loveland, CO: Interweave Press, 1989.

Davies, Adrian. *Focal Digital Imaging A to Z*. Boston: Focal Press, 2005.

Reasonably priced paperback with over 1,000 definitions and explanations. Supported by updated website.

Davies, Adrian, and Fennessy, Phil. *An Introduction to Electronic Imaging for Photographers*. Boston: Focal Press, 1998.

Electronic imaging in down-to-earth language. Includes copyright-free CD-ROM, playable on both Macintosh and IBM computers.

Ephraims, Eddie. *Creative Elements: Darkroom Techniques for Landscape Photography*. New York: Amphoto Books, 1993.

Greene, Alan. *Primitive Photography: A Guide to Making Cameras, Lenses, and Calotypes*. Boston and London: Focal Press, 2002.

Haffer, Virna. *Making Photograms: Creative Process of Painting with Light*. New York: Hasting House/Amphoto Books, 1969.

Hedgecoe, Johen. *The Photographer's Handbook*. New York: Alfred P. Knopf, 1995.

A brief explanation of everything photographic from A (ambrotype) to Z (zoom lenses).

Koenig, Karl P. *Gumoil Photographic Printing*. Rev. ed. Boston: Focal Press, 1999.

Kolb, Gary P. *Photogravure: A Process Handbook*. Carbondale, IL: Southern Illinois University Press, 1986.

Laury, Jean Ray. *Imagery on Fabric*. Lafayette, CA: C&T Publishing, 1992.

Nadeau, Luis. *Modern Carbon Printing*. Fredericton, New Brunswick, Canada: Atelier Luis Nadeau, 1986.

Robinson, Henry Peach, and Abney Wivelesley. *The Art and Practice of Silver Printing*. New York: Arno Press, 1973.

An 1881 reprint.

Sims, Ami. *Creating Scrapbook Quilts*. Flint, MI: Mallary Press, 1993.

Sobieszek, Robert A., ed. *The Collodion Process and the Ferrotype: Three Accounts, 1854–1872*. New York: Ayers Co., 1973.

Reprint of 1911 text.

Towler, John. *The Silver Sunbeam*. New York: Morgan & Morgan, 1974.

Textbook on sun drawing and photographic printing. Wet and dry processes, with collodion, albumen, gelatine, wax, resin, and silver.

Victoria and Albert Museum. *Camera-less photography: Techniques*.

Information on and wonderful examples of photogram (Chapter 5), chemigram (chromoskedasik) (Chapter 16), lumen (Chapter 16).

Worobiec, Tory, Ray Spence, and Tony Worobiec. *Photo Art: In-Camera/Darkroom/ Digital/Mixed Media*. New York: Amphoto Books, 2003, and London: Collins and Brown Limited, 2003.

Multiple printing, infrared, toning, pinhole, scanner as camera.

"BRICK AND MORTAR" ORGANIZATIONS

Alchemy Studio
Phoenix, AZ
http://alchemy-studio.net

Workshops in Italy and Arizona.

Art Students League of Denver
200 Grant Street
Denver, CO 80203
http://asld.modvantage.com

Loads of workshops for all abilities, such as pinhole, tintype, glass plate, etc.

Glen Echo Park Photoworks
Glen Eco Park, MD
http://glenechophotoworks.org

Situated in the amusement park I loved as a child(!), this group rents both analogue and digital community darkrooms, offers free coffee and critiques, employs teachers like Jonathan Goell for still life and Mac Cosgrove-Davies and Scott Davis in Historic Processes, plus many digital courses.

Gruppo Rodolfo Namias
Via Argonne 4
Parma, Italy
Care of the Circolo Fotografico Il Grandangolo
http://www.grupponamias.com

Founded in 1991, their beautifully designed web site, with information in several languages, states that they meet regularly at different sites. They share recipes, exhibitions, etc.

Penumbra Foundation
36 East 30th Street, NYC
http://www.penumbrafoundation.org

Non-profit with workshops, library, lectures, residencies, studio rental, tintype studio. Houses the Center for Alternative Photography.

Alternative Photographic Supplies Training Centre
34 Wierzbowa Street,
Gdynia, Poland
http://www.photoworkshops.pl/?p = 59

Heavy on the nude (that means: female) pictures, but lots of alt process technique workshops.

MAGAZINES AND JOURNALS

Camera Arts

The magazine folded, but maybe your library kept copies of its quality reproductions, darkroom and digital articles, and equipment and product reviews.

Camera and Darkroom Photography

It was good while it lasted. Your library may have old issues.

Fiberarts

Completely online at http://fiberartnow.net

Geared toward artists/craftspersons, the magazine has published articles on photo-printing on fabric and related subjects.

Photo Techniques (formerly *Darkroom & Creative Camera Techniques*)

Website: www.phototechmag.com

They ceased publishing in 2013, but they still publish articles on subjects such as casein (Chapter 11 of this book) and light painting, etc. Bimonthly, usually with one article related to photo-printmaking.

View Camera Magazine

Website: http://www.viewcamera.com

Although no longer being published, "the journal of large-format photography" promises to send you, if you subscribe, six of the most recent issues, and the website shows current articles, workshops, and more.

The World Journal of Post-Factory Photography

Post Factory Press
61 Morton Street
New York, NY 10014

http://unblinkingeye.com/Articles/Post/post.
html

Edited by knowledgeable, spunky, and humorous Judy Siegel. Each issue focused on a process and examined its contemporary practice, history, and abundant technical information. No longer printed, but you can find past issue at the unblinkingeye. Do not miss it!

INTERNET

Alt-Photo-Process @Vast.unsw.edu.au

Printer and author Luis Nadeau recommends this site, which seems to stop at 1995, but is a trove of information.

http://www.albumen.stanford.edu

A whole lot on the albumen process, including a demonstration and literature.

www.alternativephotography.com

Articles and how-tos, books, chat, gallery, technical information, processes, and suppliers. Almost inconceivable that one person can organize so much excellent information, but every printer I know goes to this site and supports it.

www.apug.org

Analogue Photography Users Group, with forum, traditional and historic photo processes, classified ads.

www.bostick-sullivan.com

For information in the United States about the Alternative Photographic International Symposium (APIS).

cdags.org

Contemporary daguerreotypy, including New Daguerreian Journal, gallery, technology for sale, workshops, safety, blog, etc.

http:home.earthlink.net/ ~ trans40/hopperlist

A master list of bromoil websites on the Internet may be found here.

www.cfaahp.org

Center for Alternative and Historic Processes. Workshops in New York City. No digital.

www.daguerre.org

Website of the Daguerrereian Society, 3043 West Liberty Avenue, Pittsburgh, PA 15216-2460. Tel: 412-343-5525. Bi-monthly newsletter, symposium.

www.newdags.com

"Portal to the world of contemporary daguerreotypes—the people who make them and how it is done."

http://unblinkingeye.com/Articles/articles.
html

This web site is a treasure! A how-to, who's-out-there, and where-do-I-find it website.

http://rmc.library.cornell.edu/adw/adw.asp

Collection of 13,000 end-of-the-nineteenth-century historic architectural photos from the first president of Cornell University, Andrew White, including albumen, wet collodion, albums of the Middle East, gargoyles and grotesques, and travel pictures taken across the U.S., Mexico, and the Middle East.

http://www.usask.ca/lists/alt-photo-process-l/

Goes way back with archived articles, from university of Saskatchewan, Canada

http://phsne.org

The non-profit Photographic Historical Society of New England offers a terrific yearly sale of old equipment (Photographica), monthly meetings with lecturers (I was one), and annual journal.

http://www.mikeware.co.uk/mikeware/Resources.html

The inventor of the new cyanotype process maintains a web site with alt photo paper and chemical suppliers, instructions for processes, free book downloads, other websites, lists and forums, collections, and much, much more.

SOME PINHOLE WEBSITES

www.pinholeday.org
www.pinhole.com

HEALTH AND SAFETY

If you have questions about materials you are handling, call your local Department of Public Health. Other organizations you can contact are:

The Art and Creative Materials Institute
https://acmiart.org

An international association of about 200 art, craft, and creative material manufacturers. Their AP (Approved Product) Seal identifies art materials that are safe and that are certified in a toxicological evaluation and The CL (Cautionary Labeling) Seal identifies products that are certified to be properly labeled. Located at Duke University's Division of Occupational and Environmental Medicine.

Arts, Crafts and Theater Safety
181 Thompson Street, #23
New York, NY 10012
http://www.artscraftstheatersafety.org

ACTS is a not-for-profit corporation that provides health, safety, industrial hygiene, technical services, and safety publications to the arts, crafts, museums, and theater communities. The Museum School, where I teach, has hired president, founder, chemist, and artist Monona Rossol to inspect the photography facility. Publishes a monthly newsletter updating health and safety issues by the Rossol, co-author of the authoritative book *Overexposure,* listed below.

Ilford 24-Hour Emergency Response Hotline
http://www.ilfordphoto.com/healthandsafety/default.asp

Material Safety Data Sheets (MSDS) in many languages.
Website: www.msdssearch.com

Contains information on health effects of exposure and safety precautions, such as storage, handling, and emergency procedures related to a chemical product.

Canadian Centre for Occupational Health and Safely (CCOHS)
https://www.ccohs.ca

Not only personal protective equipment and physical problems, but also mental health topics.

OSHA (Office of Safety and Health Administration)
https://www.osha.gov

This U. S. Government office has lent impressive help over the years, especially to workers (at art schools, too!) who have filed complaints. A–Z index. Publications Office also, at Room N-3101, 200 Constitution Avenue, NW, Washington, DC 20210.

BOOKS

McCann, Michael. *Artist Beware.* New York: Lyons & Buford, 1992.

McCann, Michael. *Health Hazards Manual for Artists.* New York: Nick Lyons Books, 1985.

Shaw, Susan, and Monona Rossol. *Overexposure: Health Hazards in Photography* (2nd edition). New York: Allworth Press, 1991.

Absolutely the most thorough, well-organized book on health, safety, and legal issues about photography. Should be required reading in order to make intelligent and informed choices about your materials and procedures. In the United States, call the authors' hotline with questions: 212-777-0062.

Supply Sources

HEALTH AND SAFETY PRODUCTS

Please refer to the Annotated Bibliography for organizations, web sites, and books to assist in your selection of safety products.

Drägerwerk AG & Co. KGaA
Moislinger Allee 53-55
Lübeck, Germany 23558
International/Germany
Tel: +49 (0) 451 882-0
Fax: +49 (0) 451 882-2080
Website: www.draeger.com

Respirator masks and diver's neoprene gloves. Offices worldwide.

General Scientific Safety
525 Spring Garden Street
Philadelphia, PA 19123
Tel: 800-523-0166 or 215-739-7559
Fax: 215-922-5740

Grainger
100 Grainger Parkway
Lake Forest, IL 60045
Tel: 847-535-1000
Fax: 847-535-0878
Website: www.grainger.com

Large global supplier of safety products and more. Ships worldwide 160+ countries. Over 130,000 products including gloves and ventilation. Will ship worldwide. Can order by phone, e-mail, or online.

PHOTO-PRINTMAKING PRODUCTS

Adorama
42 West 18th Street
New York, NY 10011
Tel: 212-741-0063
Website: www.adorama.com

Contact printing frames, Fotospeed toners, Spot Pen hand coloring pen sets, Marshall Color sets, videos and books, and professional temperature controllers. My contacts in Guatemala use them for their good prices on digital.

Alternative Photographic Supplies
Szlachetna Fotografia S.C.
Wierzbowa 34
81-588 Gdynia
Pomorskie, Poland
Phone +48 793015354
www.alternativephotographicsupplies.com

Everything from large format to pinhole, equipment, matting and framing, alternative printing materials, paper, raw chemicals, books, pigments, inks for bromoil, alt process exploration kit (with cyanotype, Van Dyke, salt print, paper, brushes, bottles), workshops, and newsletter. They are practitioners, who test products before they sell them.

Antec, Inc.
721 Bergman Avenue
Louisville, KY 40203
Tel: 800-448-2954 or 502-636-5176
Fax: 502-635-2352
E-mail: info@kyantec.com
Website: www.kyantec.com

Special list of chemicals for alternative processes, but other needed chemicals in their regular catalog in 25 g increments.

ArtChemicals of Copper Harbor Company, Inc.
2300 Davis Street San Leandro, CA 94577
Tel: 510-637-8708
E-mail: info@artchemicals.com
Website: www.artchemicals.com

Wide range of chemicals used for processes in this book and lab supplies and safety equipment, certified green company.

Arches ® Papers
Website: www.Arches-papers.com

These are the folks who brought out the magnificent Platine 100 percent cotton paper, perfect for almost any process in this book. They also supplied paper to Van Gogh, Matisse, Picasso, Dali, Warhol, and others and have been making papers in Europe since 1492.

ArtCraft Chemicals, Inc.
P.O. Box 382
Altamont, NY 12009
Tel: 800-682-1730 or 518-986-4281
Fax: 518-355-9121
Email: artcraft@peoplepc.com
Website: www.artcraftchemicals.com

Most alternative photo chemicals, including bleaching. Prepackaged kits, bulk chemicals, glyoxyl, and monthly specials.

Atlantic European Ltd.
Basement 16-28 Tabernacle Street
London EC2A 4DD
Tel: 0207-377-8855
Fax: 0207-374-6180
E-mail: office@atlantisart.co.uk
Website: www.atlantisart.co.uk

Selection of Escoda brushes, paper, and pigments for other processes. Open seven days a week.

Badger Graphic Sales, Inc.
1225 Delanglade Street
Kaukauna, WI 54130
Tel: 920-766-9332
Fax: 920-766-3081
Website: www.badgergraphic.com

Huge selection of large format cameras as well as lenses, chemistry, films, developers, and photo chemistry supplies. International shipping.

Omega/Brandess
626 Hanover Pike, Suite 102
Hampstead, Maryland 21074
Tel: 410-374-3250
Fax: 410-374-3184
Website: www.omegabrandess.com
E-mail: customerservice@omegabrandess.com

Toners as well as films/cameras and darkroom supplies. In addition to toners, Berg makes gold protective solution, brushes, dehardener, Berg Bath, *From Black & White to Creative Color* (book), and retouching kits. To stock Berg products, your photo dealer should contact Omega/Satter.

Blue Printables (see Fabric Suppliers)

In addition to the items mentioned under Fabric Suppliers, they also sell cyanotype precoated on 90 lb. watercolor paper and decently priced blueprint chemicals.

Bostick & Sullivan
P.O. Box 16639
Santa Fe, NM 87592
Tel: 505-474-0890
Toll free number: 877-817-4320
Fax: 505-474-2857
Website: www.bostick-sullivan.com for online catalog

They ship dry chemicals and pre-mixed solutions for all processes in this book, premixed kits for platinum and palladium, Pictorico OHP transparency, glass coating rods plus equipment, Mike Wares cyanotype process kit, books, and rag papers. Check out their ziatype process; kits for cyanotype, Van Dyke, gum, and kallitype; terrific and relatively inexpensive print frames and exposure units; HOBO 5 × 7 and 8 × 10 point-and-shoot cameras. They sell pre-measured bromoil chemicals that follow this book's bromoil chapter author, Gene Laughter's, formula. Call them (it's a family affair) for technical advice and info regarding the yearly Alternative Photo International Symposium. There is a chat group. They are personable and knowledgeable.

B & H Photo• Video• Pro Audio
420 9th Avenue
NYC 10001
Tel: 800-856-5456
Website: https://www.bhphotovideo.com

Not only cameras, books, software, and used and new b/w darkroom equipment, but also scanners, printers, lectures/workshops, aluminum plates for tintype (Chapter 14), sizing, toners, amber bottles, and alt process chemicals. For instance, for cyanotype (Chapter 7) alone, they carry products from the Photographers' Formulary, Fotospeed, Lomography, and Blue Sunprints pre-coated paper and fabric. Closed Friday afternoon to Sunday morning. Free shipping for most orders over $49 U.S.

Build.com
402 Otterson Drive,
Chico, CA 95928
Tel: 1-961-4963
Fax: 1-800-375-3403
Website: https://www.build.com

They have the light fixtures indispensable to building your own exposure unit and will ship overseas. In addition, they recommend https://www.1000bulbs.com/product/2220/F-20T12BL.html?gclid = CODx7pk2dlCFUINfgod8csHYA to connect to the exact bulbs needed for exposures. (See Chapter 4 for instructions.)

Bulb Direct Holding, LLC
7911 Rae Boulevard
Victor, NY 14564
Tel: 1-800-772-5267
Local: 585-385-3540
Fax: 585-385-4976
E-mail: sales@bulbdirect.com
Website: bulbdirect.com

Specialized lamp supplier. They have black-light fluorescent tubes if you want to make an ultraviolet exposure unit.

Camera Lucida Company
Roger Vaughn
7 Bexley Court
Reading RG30 2DY
Great Britain
Tel: 0118-959-6704
E-mail: info@camaeralucida.org.uk
Website: www.cameralucida.org.uk

Carefully manufactured portable device, the camera lucida, based on the ones used by Fox Talbot and other founders of photography to enable them to draw. This is the method that David Hockney theorizes was used by Renaissance artists, Ingres, Warhol, and others. Can use outdoors, with studio setups and with photographs.

Canson-Talens, Inc.
21 Industrial Drive
South Hadley, MA 01075
Tel: 800-628-9283
Website: www.en.canson.com

U.S. distributor of L'Aquarelle. Want to know obscure facts about paper? They have a glossary for you going back to their founding in 1557 in Europe!

Caswell Inc.
7696 Route 31
Lyons NY 14489
Tel: 855-227-9355
Website: www.caswellplating.com

You can buy kits from electroplating supplies to buffing compounds.

Century Darkroom
245 Carlaw Ave
Toronto, ON M4M 2S1, Canada
Tel: 416-469-8128
Email: mike@centurydarkroom.com
Website: www.centurydarkroom.com/

Supplier of silver clad copper plates in many sizes for daguerreotypes. Offers workshops and daguerreotype portraits as well.

Chicago Albumin Works
PO Box 805
174 Front Street
Housatonic, MA 01236
Fax: 413. 274-6934
Website: http://www.albumenworks.com/traditional_printing/

No longer in Chicago nor selling pre-coated albumen and other printing out papers, they do make digital negatives for contact printing from your files, and they know how to tailor to the process you plan on using. In addition, they offer printing services in many traditional techniques.

D. F. Goldsmith Chemical & Metal Corp.
909 Pitner Avenue
Evanston, IL 60202
Tel: 847-869-7800 (collect calls accepted)
Fax: 847-869-2531
E-mail: goldchem@aol.com
Website: www.dfgoldsmith.com

The least-expensive source I know of for silver nitrate; $50 minimum order required. I have ordered from them and attest to their reliability.

Edwards Engineered Products
9521 Pasatiempo Drive
Austin, TX 78717
Tel: 512-267-4274
Fax: (website says "no fax options" but to email with items you want, then call with your credit card number) 512-716-1914 and 866-546-1299
Website: www.eepjon.com
Email: eepjon@aol.com

Ultraviolet light sources with cooling fans, coating tubes, some vacuum frames, and even mechanical tray agitators. Loaner UV light units for teachers, and Matt's handy dandy picture hanger(!).Trade-up option with some products.

Falkiner Fine Papers
Shepherds Inc.
30 Gillingham Street
Victoria London SW1V 1HU
Tel: 020-7233-9999
Website: store.bookbinding.co.uk

Wide range of bookbinding material and tools as well as many papers and books on bookbinding.

Firstcall Photographic Limited
Cherry Grove Rise
West Monkton, Taunton
Somerset TA2 8LW
United Kingdom

Tel: +44 (0) 1823 413 007
Fax: +44 (0) 1823 413103
E-mail: sales@firstcall-photographic.co.uk
Website: www.firstcall-photographic.co.uk

Fotospeed cyanotype, salt printing, and liquid emulsion; Rockland blue print, Liquid Light, and toners; Rollei Black magic; First Call printing out paper; b/w and color darkroom and digital equipment. Shipping within 24 hours of receiving order. Discount cameras, digital inkjet sheets for T-shirt transfers.

Fotospeed
Unit 6, Park Lane Industrial Estate
Park Lane, Corsham
Wilts SN13 9LG
England, U.K.
Tel: +44 (0) 01249 714555
Fax: +44 (0) 01249 71499
Website: www.fotospeed.com

Alternative process supplies including their own enlargement emulsion, black-and-white chemicals and papers, coating rods, contact printing frames. This company is dedicated to alt. processes and offers Van Dyke, cyanotypes, gum, palladium platinum kits, and photo linen.

Foma
Hemsveien 23
Hof 3090, Norway
Phone: 004799264846
Website: www.fomafoto.com

Fomaspeed Photo emulsion, b/w printing paper and chemicals.

Freestyle Camera Co.
5124 Sunset Boulevard
Los Angeles, CA 90027
Tel: 323-660-3460 (information)
800-292-6137 (orders only)
Website: www.freestylephoto.biz

They ship UPS postage free (in continental 48 states), a less-expensive lith film, such

as Aristatone, under their own label, plus enlargement emulsions, darkroom supplies, photo-offset plates, nonsilver kits, pinhole cameras, pinhole photography kits, Arista mural paper, Kentmere/Harmon paper, and Foma Fomatone bromoil paper, Maco Genius supplies, and Marshall hand-coloring materials.

Glazer's Camera
811 Republican St.
Seattle, WA 98109
Tel: 206-624-1100
Toll Free: 800-225-8442
Fax: 206-624-8065
Website: www.glazerscamera.com

Camera store that stocks darkroom supplies, chemicals, papers, films, etc.

Graphic Chemical and Ink Co.
728 North Yale Avenue
Villa Park, IL 60181
Tel: 630-832-6004
E-mail: sales@graphicchemical.com
Website: www.graphicchemical.com

Online catalog with wide range of papers, engraving, and etching supplies.

Hunter Penrose Ltd.
32, Southwark Street
London SE1 1TU
United Kingdom
Tel: 0171 407 5051
Fax: 0171 378 1800

Printmaking supplies.

Jerry's NY Central
111 4th Ave
New York, NY 10003
Tel: 212-473-7705 or 646-678-5474
Website: www.jerryspaletteshop.com

Wide assortment of paper including thin papers to print on, such as interleafing and air-mail stationery (captures detail).

Jerry's Artarama
6104 Maddry Oaks Ct.
Raleigh, NC 27616
Tel: 800-827-8478
Website: www.jerrysartarama.com

Tons of art supplies, from printmaking, pigments for gum printing, brushes, and more.

Ilford Photo
Ilford Way, Mobberley
Knutsford, Cheshire, WA16 7JL, England
Tel: +44 (0) 1565 65 0000
Website: www.ilfordphoto.com

Manufacturer of sheets and rolls of black and white photo paper for toning and hand-coloring and Harman Direct Positive paper mentioned in the pinhole section of Chapter 5, Generating Imagery: Analogue Methods, and holographic(!) plates. Cannot find their Ilford Ortho Plus sheet film on their website, but I know they make it and that stores like B & H sell it. Website lists rental darkrooms and stores in the Western Hemisphere.

Imperial Plating Co.
7030 W. 60th Street
Chicago, IL 60638
Tel: 773-586-3500
Fax: 773-229-0962

I have not used them, but they have been recommended for daguerreotype plate coating.

InkAID
Ontario Specialty Coatings
22564 Fisher Road
Watertown, NY 13601
Tel: 888-424-8167 (24 hours, orders only)
Fax: 315-782-7771 (prefer orders by fax)
Website: www.inkaid1.com

Iridescent metallic, white, and clear precoat and inks to prepare and print digital images on 3D surfaces, aluminum, wood, paper, acrylic, and almost any receptor you can feed through an inkjet printer. Makes my head spin

with ideas. Also, lenticular devices to make still images appear animated! Also available at Charrette's and Daniel Smith in the U.S.

Intaglio Printmakers
9 Playhouse Court
62, Southwark Bridge Rd.
London SE1 OAS U.K.
Tel: 020 7928 2633
Website: www.intaglioprintmaker.com

Litho inks, paper, etching presses, engraving, screen printing.

International Center for Photography
250 The Bowery
New York, NY 10012
Tel: 800-688-8171
Fax: 212-857-0000
Website: www.icp.org

They sell "Hole-On Ex Make & Shoot Pinhole Camera Kit" for constructing a cardboard camera and "Flights of Fancy," a kit for making a wooden pinhole camera, and they host exhibitions.

The Italian Art Store
9 Tulip Street
Summit, NJ 07901
Tel: 800-643-6440
Fax: 973-644-5074
Website: www.italianartstore.com

Jumbo sash brushes for bromoil.

Harman Technology Limited
Ilford Way, Mobberley, Knutsford
Cheshire, WA16 7JL, England
Tel: +44 (0) 1565 65 0000
Toll Free Tel: 1-888-372-2338
Fax: +44 (0) 1565 872734
Website: www.kentmere.co.uk

They bought Kentmere and are the company behind Ilford Photo, listed above. Distributor of fine art black-and-white paper, Kentmere Fineprint Variable Contrast, while stocks last.

Look up dealers in the United States, U.K., Canada, South America, China, Japan, etc.

Lazertran LLC.
3580 NW 56th Street, Suite 100
Fort Lauderdale, FL 33309
Phone: 800-245-7547
E-mail: si@lazertran.com
Website: www.lazertran.com

Dorothy Imagire, who authored sections on transfers and lifts, says: "They are a wonderful company with several different products, including Lazertran Inkjet, Lazertran Silk, Lazertran Etch, Lazertran Inkjet textile Transfer paper for white cloth and Lazertran Inkjet textile Transfer paper for dark cloth, and psychedelic Inkjet colors."

T.N. Lawrence & Son Ltd.
208 Portland Road
Hove BN 35QT
U.K.
Tel: 01273-260260
Fax: 01273-260270
Website: www.lawrence.co.uk

Suppliers for artists/printmakers: lith inks, rollers, brushes, Lazertran for transfers, watercolors, and array of papers. Sale items on-line only. Other store in Cornwall.

David W. Lewis
457 King Street
P.O. Box 254
Callender, Ontario POH 1HO
Canada
Tel: 705-752-3029
E-mail: dlewis7@cogeco.ca
Website: www.bromoil.com

More than ample choices of oil bromoil brushes, color pigments, chemicals, bromoil papers, and transfer presses, as well as The Art of Bromoil and Transfer (see Annotated Bibliography).

TheMagicTouch
(International Sales and Supplies)
Benzstrasse 17
64807 Dieburg
Germany
Tel: +49 6071 921 800
Fax: +49 6071 921 821
E-mail: iss@themagictouch.com
Website: www.themagictouch.com

You can purchase transfer sheets that use color and black-and-white copying technology to relocate imagery on paper, fabric, ceramics, wood, metal, and glass. They also sell heat-press equipment, mugs, and (of course—they are in Germany) steins. Distributers and workshops in many countries.

Hans O. Mahn Gmbh & Co. Kg
Brookstieg 4
D-22145 Stapelfeld/Hamburg, Germany
Website: www.mahn.net

Rollei (Black Magic), Fotospeed (dyes, toners, and kits), Bergger paper, Maco and Agfa and Kodak supplies.

McManus and Morgan
2506 West 7th Street
Los Angeles, CA 90057
Tel: 213-387-4433
Website: www.mcmanusandmorgan.com

An art store that specializes in papers—thousands to choose from.

Metal Finishing Technologies
60 Wooster Court
Bristol, CT 06010
Tel: 860-582-9517
Email: sales@mftech.com
Website: www.mftech.com

I have not used them, but they coat plates for daguerreotypes.

William Paul & Associates, Ltd.
27 Holland Avenue
White Plains, NY 10603
Tel: 800-962-4050/914-761-0010
Fax: 914-761-0508
E-mail: wmpaulltd.@aol.com
Website: www.wmpaulstore.com

They used to carry an array of ortho film, but they do not show any on their website now. Iron-on and other transfer papers seem to be in stock.

Peerless Color Laboratory
2934 County Road MN
Stoughton, WI 53589
E-mail: chris@creativemode.com
Website: www.peerlesscolor.com

Manufacturer of Nicholson's Peerless Transparent Water Colors in sheet (fabulous for traveling) and liquid form for over 115 years. They produce a Complete Edition Book with 15 color sheets or the Trial Edition Book with the same 15 colors in smaller sheets. Individual sheets and liquids are available in over 200 different colors. They cover the first $2.50 of shipping in the U.S.

Philben Litho Supply Company Inc
600 Hartle Street, Unit C
Sayreville, NJ 08872
Tel: 800-274-4523
732-851-5741
Fax: 732-851-5744
Website: www.philben.com

Gum Arabic recommended by gum printer extraordinaire Judy Seigel. They also sell lith/ortho film, UV units and bulbs, rubilith masking film, registration pins useful in casein and gum printing, and b/w darkroom supplies. Must fax or send order form.

The Photographers' Formulary, Inc.
P.O. Box 950
7079 Hwy 83 N
Condon, MT 59826
Tel: 800-922-5255
Fax: 406-754-2896
E-mail: formulary@blackfoot.net
Website: www.photoformulary.com

They supply small or large quantities of numerous chemicals plus instructions explaining principles and theories for alternate photo processes, as well as black-and-white and color photography. Also, some books and apparatus (beakers, thermometers, etc.). Monthly specials, gum arabic. The most reliable source and gentle employees I know of for all the light-sensitive technique chemicals; they also run summer workshops (www.workshopsinmt.com) for black-and-white and many of the processes in this book (including my "Cyanotypes & Artists' Books" during the summer) in an area of Montana "boasting some of the best wilderness lands in the Rocky Mountains." Only ship within the United States.

Mitsubishi Imaging (MPM), Inc.
555 Theodore Fremd Avenue
Rye, NY 10580
Tel: 800-765-9384
Fax: 914-921-2495
Website: www.diamond-jet.com/pictoricotop.aspx

They make the incomparable Pictorico (derived from the Spanish word for "picturesque") OHP inkjet transparency film for digital negatives.

New55Film
New55 Holdings, LLC
72 Nickerson Road
Ashland, MA 01721
Tel: (508) 296-0610
Email: support@new55.net (Sam Hiser, CEO)
Website: http://www.new55.net/company/

European distributor in Vienna: https://the.supersense.com

They make large format positive/negative black and white film with superb detail and tonal range.

Pinhole Resource
224 Royal John Mine Road
San Lorenzo, NM 88041 USA
Tel: 575-536-9942
Email: pinhole@gilanet.com
Website: www.pinholeresource.com

Pinhole Resource sells books, catalogs, pinhole cameras (many of which are handmade), zone plate shutters, books, including legendary Eric Renner's own big pinhole book), kit for turning a room into a camera obscura(!). Three times per year, from 1985–2006, they published Pinhole Journal (a fascinating publication devoted to pinhole photography around the world), and back issues are available. Make sure you see the catalog from "Poetics of Light," the exhibit Eric and Nancy Spencer curated, and stay tuned for Worldwide Pinhole Photography Day. A pinhole-related website, http://pinholeday.org/events/index.php, will tell you more and lists workshops.

John Purcell Paper
15, Rumsey Rd.
London SW9 0TR U.K.
Tel: 020 7737 5199
Fax: 020 7737 6765
Email: jpp@johnpurcell.net
Website: www.johnpurcell.net

Fine collection of artists' papers.

Quality Plating Co.
420 S. 500 West
Salt Lake City, UT 84101-2208
Tel: 801-355-7424
Fax: 801-355-7820
Website: www.qualityplating.com

They have been "plating with pride since 1955," for Daguerreotype plates.

Recognition Systems
30 Harbor Park Drive
Port Washington, NY 11050
Tel: 516-625-5000
Fax: 516-625-1507
Website: www.dotworks.com

These are the nicest folks, who still do business with personal attention. They sell opaque black bags that I have recommended for storing coated light-sensitive paper and mixed chemicals, contact papers and films, unruled and orange masking sheets. Their main office is in England.

Rockland Colloid LLC
PO Box 3120
Oregon City, OR 97045
Sales: 503-655-4152
Technical Support: 914-413-3000
Fax: 866-737-0174
Website: www.rockaloid.com

Makes Liquid Light© and AG + ©; platinotype and blueprint kits; black and white fabric and paper sensitizer; toners; colorants; inkjet transparency film and transfer sheets; tintype kits; wet transfer paper; toner for firing photo images on ceramics; Select-a-Color photoresists for permanent color prints on sheet metal, ceramics, illustration board, and wood (I have used it on paper). As far as I know, they were the first to make enlargement emulsions, and it's comforting to know that such a reliable company just keeps going.

Rollei
Website: http://rolleifilm.com

Black Magic Emulsion, Rollei Ortho Film and lith (high contrast) developer, and where to buy them.

Salis International, Inc.
301 Commercial Road, Suite H
Golden, CO 80401
Website: www.docmartins.com

Distributor of Dr. Ph. Martin's Synchromatic Transparent (brilliant, permanent) Watercolors for hand coloring and Liquid Frisket that I use for masking areas before toning (it even comes in two strengths). They have been "coloring outside the lines" since 1934.

Silverprint
Unit 26, Albany Business Park
Cabot Lane, Poole
BH17 7BX
United Kingdom
Tel: 01202 051 180
E-mail: sales@silverprint.co.uk
Website: www.silverprint.co.uk

Materials and equipment for platinum/palladium, salted paper, gum bichromate, etc. Will supply chemistry in small quantities. Some high-quality black-and-white papers, bromoil materials, toners, Hahnemuhle Platinum Rag paper, student discounts, and some free shipping. Reasonably priced silver nitrate for brown printing, pre-coated colored (!) cyanotype paper and fabric, color C41 film processing kit that you might use as described in the Hybrid Color Photography chapter and in its subsection, Chromoskedasic painting. Specialty films, like Maco Genius and pinhole supplies. Also ship with reliability worldwide (I used them to send chemicals to Cuba, where I was teaching a workshop, and they arrived on time to the correct address).

Daniel Smith Art Materials
4150 Frist Avenue South
Seattle, WA 98134
Tel: 203-223-9599
Fax: 1-206-224-0404
Second store in Bellevue, Washington
Website: http://www.danielsmith.com

Huge array of watercolor pigments. The Smith brand is well-respected and comparatively reasonably prices, and many gum/casein printers swear by them. Tips and tutorials on their webpages. Flat shipping rate.

Szlachetna Fotografia S.C.
Wierzbowa 34, 81-001
Gdynia, Poland
Tel: 48-793015354
Email: r.brzozowski@szlachetnafotografia.com.pl

Carries impressive number of supplies, such as rag paper, coating tools, chemicals and kits for most processes in my book (pinhole, gum, cyano, salt, bromoil and more), bottles, books.

Team Plastics Inc.
3901 W 150th St
Cleveland, OH 44111
Tel: 800-931-8326
Fax: 216-251-7341
Email: www.teamplasticscom.homestead.com

Ask for their laser acetate overhead transparent .004 polyester film (i.e., copier film) to make transparencies on your laser printer after you check with the manufacturer.

Testfabrics, Inc.
PO Box 3026
West Pittston, PA, 18643
Tel: 570-603-0432
Fax: 570-603-0433
E-mail: info@testfabrics.com
Website: www.testfabrics.com

You can find pH papers, mentioned in Chapter 9, Salt Prints, thermometers, gram scales. For

platinum and palladium, Chapter 12, they not only carry droppers, but the more exact pipette syphons and syringes. More about them in the Fabric Supplier section, below.

Theta Plate, Inc.
3330 Princeton NE
Albuquerque NM 87107
Tel: 505-880-1856
E-mail: info@thetaplate.com
Website: www.thetaplate.com

You can send plates there to be coated with different metals, and silver is needed for daguerreotype and Becquerel (Chapter 15).

Universal Light Source
1553 Folsom Street
San Francisco, CA 94101
Tel: 415-864-2880
Website: www.ulsi.net

Decent prices on Super Actinic 420 nm bulbs, which some photographers recommend for much faster and slightly more contrasty (cleaner high values) exposures with platinum/palladium.

The Vermont Country Store
P.O. Box 3000
Manchester Center, VT 05255
Tel: 802-362-8440
Website: www.vermontcountrystore.com

They sell modern-day oilcloth, "still easy to wipe clean and won't crack," typewriters, and other hard-to-find specialty items.

View Camera Store
P.O. Box 19450
Fountain Hills AZ 85269-9450
Tel: 480-767-7105
E-mail: viewcamerastore@gmail.com
Website: www.viewcamerastore.com

They sell the BTZS large format film processing tubes which are great for saving chemistry and large format camera accessories and lenses, as well as miscellaneous darkroom supplies, Ilford papers, and Ilford films.

Wet Plate Supplies
Unit 15-16 Highlode Industrial Estate
Ramsey, PE26 2RB U.K.
Tel: +44 0 1487 813447
Website: http://www.wetplatesupplies.com/

Very large selection of alternative process supplies from Bromoil to Wet Plate Collodion to Cyanotype. Fotospeed enlargement emulsion, tintype plates, raw chemicals, and much more. They also have a modest camera selection and alternative process accessories. Ship to EU countries, even though U.K. has pulled out.

Williams-Sonoma
Website: www.williams-sonoma.com

Located in many large-city shopping malls in the United States, they carry basting and pastry brushes good for bromoil and other processes.

FABRIC SUPPLIERS

Blueprints on Fabric
20504 81st Ave SW
Vashon Island, WA 98070
Tel: 800-631-3369
E-mail: info@blueprintables.com
Website: www.blueprintables.com

Fabric artist Linda Stemer and partner Susan McKeever market and ship worldwide precoated pieces of cyanotype cotton and silk, treated fabric by the yard, and adult and youth T-shirts pretreated with cyanotype solution. They will preshrink and pre-coat paper. Also sell bulk cyanotype chemicals. You can purchase Barbara Hewitt's *Blueprints on Fabric* (see Annotated Bibliography) at a discount price, nature print transparencies (beetles, rhinos, lizards, dinos, etc.), and untreated fabric from their company. Wholesale prices for stores, groups, and schools.

Pro Chemical and Dye Co., Inc.
126 Shove Street
Fall River, MA 02724
Tel: 800-2-BUY-DYE (228-9393)
Fax: 508-676-3980
E-mail: promail@prochemical.com
Website: www.prochemicalanddye.net

They ship paints, Pebeo fabric pens, and natural fabric dyes and thickener to prevent dyes from bleeding, which allows for more control when hand coloring. They carry Setacolor Transparent Dyes for sun printing, respirators, tough gloves, scales, and cotton and silk by the yard. Looks like their inexpensive fabric frames might work for coating chemicals onto stretched cloth. You can find pH papers, mentioned in Chapter 9, Salt Prints, thermometer, gram scales. For platinum and palladium, Chapter 12, they not only carry droppers, but the more exact pipette syphons and syringes.

Testfabrics, Inc.
PO Box 3026
West Pittston, Pennsylvania, 18643
Tel: 570-603-0432
Fax: 570-603-0433
E-mail: info@testfabrics.com
Website: www.testfabrics.com

Wholesale prices on desized, scoured, and prepared for dyeing fabrics and fabric swatch booklets to individuals. Unsized 100 percent cotton, silk, and linen by the yard, tablecloths, T-shirts, scarves, dust bunnies(?!), accessories related to costumes, translucent thread. On occasion they sell cotton seconds on an "as is" basis. You can find pH papers, mentioned in Chapter 9, Salt Prints, thermometer, gram scales. For platinum and palladium, Chapter 12, they not only carry droppers, but the more exact pipette syphons and syringes. Shipping worldwide.

Equivalent Imperial and Metric Measurements

SOLID MEASURES

U.S. and Imperial Measures		Metric Measures
Ounces	Pounds	Grams
1		28
2		57
3		85
3.5		99
4	¼	113
5		142
6		170
8	½	227
9		255
12	¾	340
16	1	454
18		510
20	1 ¼	567
24	1 ½	680
27		765
28	1 ¾	794
32	2	907
36	2 ¼	1021
40	2 ½	1134

LIQUID MEASURES

Fluid Ounces	U.S.	Imperial	Milliliters
	1 teaspoon	1 teaspoon	5
¼	2 teaspoons	1 dessertspoon	10
½	1 tablespoon	¾ tablespoon	15
1	2 tablespoons	1 ¾ tablespoon	30
2	¼ cup	3 ½ tablespoons	59
4	½ cup		120
5		¼ pint or 1 gill	148
6	¾ cup		177
8	1 cup		237
9			266
10	1 ¼ cups	½ pint	296
12	1 ½ cups		355
15		¾ pint	444
16	2 cups		473
18	2 ¼ cups		532
20	2 ½ cups	1 pint	592
24	3 cups		710
25		1 ¼ pints	739
27	3½ cups		799
30	3 ¾ cups	1 ½ pints	887
32	4 cups or 1 quart		946
35		1¾ pints	1035
36		4 ½ cups	1065

agitate: Constant rocking motion of materials in liquids to ensure even coverage.

analogue/analog: Has come to mean anything that is not digital. Traditional photography that uses film or emulsion.

analog: The visuals we are used to in a non-digital environment, which actually comes from a stream of continuously variable data in the form of light energy, with variation being represented by varying quantities of luminosity. An analog image is made up of some sort of marks on film or paper that collectively create the picture you see.[1]

aperture: The opening in a lens that adjusts and controls the amount of light allowed to pass through to the lens. Usually described as an *f/stop* or *f/number*.

archival: Having a quality of maximum permanence.

banding: Interruption of graduated shades caused by the loss of tonal data. Appears as a distinct line between two tones.

Becquerrel: A form of Daguerreotype.

binary: A computer machine language that depicts letters, numbers, and symbols as sequences of the two digits 0 and 1, or as sequences of "off" and "on." The numbers symbols are indicators, not actual numbers that turn on or off little switches. This 0-1 unit is called a *bit*, which is a reduction from the phrase BInary digIT. Digit gives us the term *digital*, and 8 bits = 1 byte, from which terms like *megabyte* and *kilobyte* come.

bit: See *binary*.

blow up: To make an enlargement.

bracketing: Purposely shooting a camera exposure correctly, then overexposing one shot and underexposing another shot.

burning or **burning in:** Giving more light than the normal exposure to a selected area of the emulsion or digital image by adding more exposure to that particular area. Burning usually makes that area darker; the technique often is used to retain more detail in the highlights.

camera lucida: An optical aid for drawing, often portable, that consists of a prism that focuses rays of light from a scene onto a sheet of paper that can be seen and "traced."

camera obscura: Latin for "dark room" and used by some Renaissance painters. An outside scene would be projected through a small hole in the wall of a room onto the opposite (white) wall and would appear inverted. Evolved into a smaller, portable, darkened boxes that used a lens, mirror, and/or ground

glass to aid in drawing and, eventually, in early photography.

capture: Act of taking and saving a picture digitally.

clipping: Highlight and shadow values that have gone completely black or completely white, losing detail in a digital image.

color management: A control for getting consistent and accurate matches from your input device (scanner, camera, telephone) to your computer monitor to your output device (usually, a printer).

color separation: The process of dividing full-color originals into the primary process printing colors: magenta, yellow, and cyan.

contact frame: See *printing frame.*

contact print: A photographic image made from a negative or positive placed on the surface of sensitized paper, film, or printing plate, and exposed to light.

continuous-tone: An image containing gradient values as well as black and white.

contrast: Differences in tones in a picture.

copy: (1) Any furnished material or artwork to be used in printing; (2) in typography, written rather than visual image; (3) in electrographics or copier art, an interpretive print or reproduction.

correct reading: Facing the same direction as the original.

cursor: A moving indicator on a digital device's screen that shows the position where a user can make a selection or enter type. See *mouse.*

curves: Graphs in digital image software showing how input is related to output**.**

Daguerreoytpe: First successful photographic process introduced publicly (1839). The image was exposed directly through a camera onto a polished silver plate.

darkroom: A light-tight area, either com-

pletely dark or specially illuminated, for handling light-sensitive materials.

dense negative: A reversed-tone transparency so dark that it transmits very little light.

density: Measure of opacity of an image. The emulsion buildup in a negative or positive. The greater the exposure to light and the longer the developing time, the more solid the density.

developer: A solution rendering latent images visible after exposure in analogue photography.

digital: Electronic data representing information as numbers, based on discrete binary digits, for processing by a computer. See also *binary.*

digital imaging: Using computer devices and processes for producing pictures.

dimensional stability: The quality in a support of not changing its size by shrinking or stretching.

dodging: Holding back some light on an area of the digital image or the analogue emulsion during an exposure. Dodging usually renders that area lighter and often is used to retain more detail in the shadows.

duplicating film: Film that does not reverse the image but repeats it negative-to-negative or positive-to-positive. See *film.*

easel: The device, usually a metal frame, for holding light-sensitive materials flat under the enlarger during an exposure.

electrographics: The use of copy machines, such as Xerox™, to generate art.

emulsion: A light-sensitive coating on film or paper.

enlarger: Equipment for projecting small transparencies to larger formats in a darkroom.

exposure: Subjection of a photo-sensitive coating or digital image to the action of light.

exposure unit: The source or system used to shine the appropriate ultraviolet light onto photosensitive emulsion.

eyeballing: Judging registration or exposure of images by visual inspection.

ferric: Substance that contains iron.

file format: Basic structural database with instructions on how to encode, save, and extract electronic information in a file. May include, for example, RAW, JPEG, TIFF, and EPS.

film: A light-sensitive material on a clear base.

fixer: A solution that removes unexposed silver halides (light-sensitive metallic compounds) from the emulsion and makes the analogue image stable and impervious to white light. The amount of time the emulsion spends in the fixer is called the *clearing time.* Fixer is also known as *hypo.*

flat: The sheet of stripped-in negatives used to expose a photo-sensitive surface underneath. Also, a term used to describe an image without much contrast.

flatbed scanner: Optical tabletop device in which flat analog art is held level on a glass platen much like an office copier while a sensor passes over or under it and converts it into digital information. The image then can be manipulated on a computer, shows little, if any, depth, and can be purchased with an attachment for scanning transparencies.

fog: Density in the negative or print caused by errant light or chemical action not related to the normal formation of the analogue image. See *safelight.*

f/stop or **f/number:** Fixed sizes or settings for lens apertures.

gelatin: A binder made from animal parts used as a support for the light-sensitive particles in certain emulsions, as sizing that fills in pores on the surface of paper, or as a method for printmaking instead of using a plate to accept ink.

generation: Each succeeding stage in reproduction from the original.

grain: (1) The direction in which most fibers lie in paper; (2) silver particles on film and paper, not usually visible unless viewed under magnification.

graphic arts film: A variety of orthochromatic films.

gray scale: A strip of standard gray tones ranging from black to white, used to measure tonal range and contrast. Also called a *steptable.*

hardware: All the components of a computer system except the programmed instructions (software).

heliography: An obsolete term for printing processes that depend on the sun (or ultraviolet light).

high contrast: An image or process that yields only black and white, or shadow and highlight.

highlight or **high key:** The brightest light accents in the subject. Therefore, the lightest of whitest parts in the positive and the darkest areas of a film negative.

histogram: Digital graph showing how a complete array of values in an image are distributed. The height of the graph represents the number of pixels, or picture elements, in the image at any particular value.

hypo: An abbreviation of the obsolete term for the chemical sodium thiosulfate (hyposulfite of soda) used to fix the image on some photo emulsions after development. The term also refers to the baths compounded with it. See *fixer.*

inkjet: A type of printer that interprets digital information and recreates an image or text by spraying electrostatic droplets of ink onto a substrate.

input: All methods of obtaining information into a computer, such as a scanner, smart phone, or digital camera.

intensification: In photography, to increase the density of a negative or color in a print.

interpolation: See *resampling*.

ISO: A number assigned by the International Standards Organization, which indicates film speed or its equivalent camera sensitivity to light. Used to be known as ASA for the American Standards Association.

laser printer: An apparatus used to transfer type and graphics from a computer or copy laid on a glass platen onto a substrate ("hard copy"). Very strong light waves first draw the image, in the form of high-resolution dot patterns, onto a metal drum in the printer, which then electrostatically attracts dry ink powder (toner) to itself, in much the same manner as an office copier.

latent image: The invisible analogue representation in the emulsion after exposure, later made visible by development.

layout: Drawing or sketch of proposed printed piece.

levels: One of the Adobe Photopshop® correction tools to modify the distribution of tones in an image.

light table: Equipment used for viewing and preparing transparencies, consisting of a translucent glass or plastic top with lights behind that shine through to illuminate the surface.

line: Processes and images that comprise black and white without intermediate gray tones.

line shot: High-contrast reproduction of original material.

lith or **litho film:** Also known as *ortho* film because it is not sensitive to red light waves and is commonly employed in photolithography.

loupe: Magnifier for checking image details.

low key: Shadow or dark values.

mask: Opaque material used to cover selected image areas during the exposure.

mercerized: Treatment under tension with caustic soda to give cotton cloth more strength and receptiveness to dyes.

middle tones or **midtones:** Shades between highlights and shadows.

mouse: A physical device used to move the cursor on a computer screen. Usually, buttons on either side of the mouse (left click and right click) can control certain digital operations, while the wheel in the center can move the screen up or down. See *cursor*.

negative: (1) An image in which the values of the original are reversed (usually on film); (2) a process in which the tones are reversed.

noise: Unwanted electronic information, showing up in a digital image as lighter pixels in an otherwise dark-toned area.

nonrepro blue: Special blue marker that does not show when photographed.

opaque: (1) A condition in which no light is allowed to pass through; (2) special markers or paints that block light; (3) to block out unwanted areas on transparencies before printing.

optics: Physical study of light and how it reacts with and to other materials.

orthochromatic: Analogue photo surfaces insensitive to orange and red light but sensitive to visible blue and green light.

panchromatic: Analogue photo surfaces sensitive to blue and green visible light and some of the red spectrum.

photogram: A photo image produced without using a negative or camera by allowing an object or stencil to cast its shadow directly onto the recording surface.

photorealism: Exceedingly "realistic" or representational style of drawing or painting, popular in the 1970s and 80s and based on photographs, rather than live observation, as the source.

photosensitive: The quality of reacting to light through chemical action.

Pictorialists: During the end of the nineteenth and beginning of the twentieth centuries, an international aesthetic movement of photographers who manipulated a scene to convey emotional, rather than "documentary," content.

pigment: Particles used to give color, body, or opacity to a semiliquid artists' material.

pixel: The smallest component of a picture that can be individually processed in an electronic imaging system. The smaller and closer together the pixels, the clearer the image. The term pixel is short for "picture (pix) element (el)." Pixels are often called dots, as in dots per inch (dpi).

pixellization: A digital effect produced by dividing an image into groups of coarse square tile shapes, which display the averaged value of the picture elements they contain. See *pixel*.

positive: Photo surface containing an image in which the dark and light values correspond to the original subject.

posterization: Separate black-and-white negatives, each of which records either the highlights, the middle tones, or the shadows of the same image. In printing, usually each negative is used with a different color.

press type, press tape, press graphics: Materials with adhesive backings that will stick to other surfaces when pressed down. They can be used in making transparencies. Also known as "pressure-sensitive graphics."

printing frame or **contact printing frame:** A shallow unit, usually made of wooden edge, glass plate, and backing, for holding negatives in strict contact with the emulsion during an exposure. In practice, light shines through the top glass, through the negative, and onto the photo emulsion.

print washer or **syphon washer:** Equipment for the flow of clean water and the elimination of dirty water.

profile: International Color Consortium (ICC) profiles are descriptions of a specific output device used by image software to match colors from one input or output device to another.

rag paper: Made from the degeneration of linen and cotton, as opposed to wood pulp.

register: Fitting two or more images in exact alignment with each other, or repeating the same image on top of itself.

resampling: Also known as interpolation, or altering the image file to augment or reduce the number of pixels. When a file is permanently reduced in size, data are lost; if a file is increased in size, arbitrary data are added.

reversal: The basis of most analogue photography, which is the conversion of a negative to a positive (or a positive to a negative).

right reading: See *correct reading*.

rubylith: A red adhesive paper, acetate marker pen, or tape used to opaque or block out portions of an image during exposure. Different manufacturers have different names for the same kind of product.

safelight: A special darkroom lamp used for illumination that does not harm the sensitized materials. Image density resulting from too much exposure to a safelight is called *fog*.

saturated solution: A liquid and chemical mixture so concentrated that no more of the chemical can be dissolved in it.

scanner: A machine that captures visual information and transforms it into digital data.

shadow: The darkest parts of a positive; the clearest parts of a film negative. Low-key areas in a computer image.

sizing: Treatment of paper that gives it resistance to the penetration of liquids or vapors.

sliders: When using certain adjustment layers in Adobe Photoshop™, small triangles or buttons (in Lightroom™) that move along a path appear below the window. By moving these sliders, you can control changes to the image.

software: Programmed instructions that tell computer hardware equipment what textual, graphic, or other informational functions to perform.

stat camera, graphic arts camera, copy camera, or **process camera:** The instrument with which photographic transparencies can be made, consisting, at least, of a light-tight area for holding film, a lens to direct and focus the image, a place to put copy or original artwork, and a light source. Although there are differences between stat cameras and copy cameras, the terms are commonly used interchangeably. With the advent of home scanners and computers, these cameras are becoming rare.

stock solution: Main concentrate of liquid chemistry from which working mixtures are made.

stop bath: A solution that halts development of emulsion, usually acetic acid.

stripping: The positioning of negatives or positives on a flat prior to exposure.

support: The surface onto which an emulsion is coated.

test strip or **test print:** A photosensitized support exposed to light and developed in a systematic way, so that bands of different exposures indicate what the finished image might look like. A guide for determining the exposure of the final picture.

thin: A transparency of overall low density, or tending to be fairly clear.

thumbnail: A collection of stored digital images that may be displayed as a series of small representations, like viewing slides on a light table or a contact sheet in photography, rather than one by one in a projector.

transparency: An image that transmits light through part of it. A transparency can be in the negative or positive, handmade or photographic, large or small (a photographic slide).

ultraviolet light: Electromagnetic radiation having a wavelength shorter than the visible portion of violet in the spectrum but longer than X-rays. Sunlight is a common source of ultraviolet light.

vacuum frame: A glass and metal device employing an air pump for holding copy and reproduction material in place during exposure.

wetting agent: A liquid bath for film to help prevent dirt and water spots and to make the film attract less dust. It usually is the last bath the film touches in the development procedure.

white light: The visible spectrum of light, whether artificial or natural.

wrong reading: Facing the opposite direction from the original.

NOTE

1 Sesto, Carl. *The Macintosh Designer's Guide to Digital Imaging.* New York: Wiley Computer Publishing, 1996.

Index